PARIS 1937

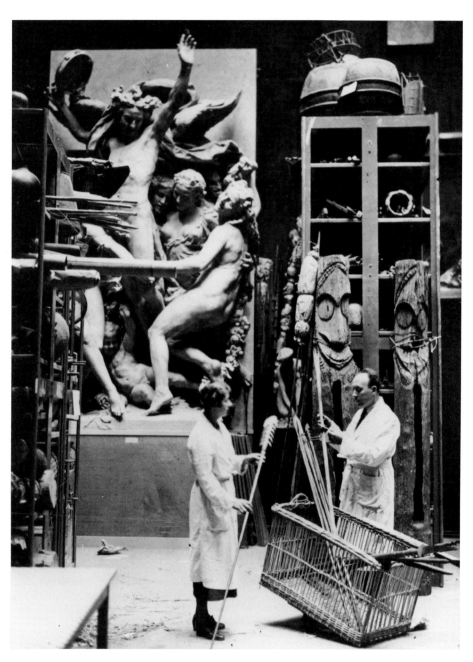

Artifacts from the Musée de l'Homme stored temporarily in the closed galleries of the Musée des Monuments Français during renovations of the Palais de Chaillot, 1935. Photo from the collection of the Musée de l'Homme, Paris.

PARIS
1937

WORLDS ON EXHIBITION

——————

JAMES D. HERBERT

CORNELL UNIVERSITY PRESS

ITHACA AND LONDON

First published 1998 by Cornell University Press.

LIBRARY OF CONGRESS CATALOGING-IN-PUBLICATION DATA

Herbert, James D., 1959–

Paris 1937 : worlds on exhibition / by James D. Herbert.

p. cm.

Includes bibliographical references and index.

ISBN 0-8014-3494-7 (cloth : alk. paper)

1. Art, Modern—20th century—Exhibitions—History. 2. Art—Exhibitions—History—20th
century. 3. Ethnological museums and collections—France—History. 4. Exhibitions—France—
History—20th century. 5. Surrealism—France—Exhibitions—History—20th century. 6. Exposition
internationale (1937 : Paris, France). 7. Art and society—France—History—20th century.

T805 1937 B1H37

907'.444'361—DC21 97-35973

Design: Christine Taylor
Composition: Wilsted & Taylor Publishing Services
Printed in the United States of America.

Cloth printing
10 9 8 7 6 5 4 3 2 1

Not only do all the museums of the world together today
represent a colossal accumulation of riches but,
more important, the combined visitors of these
museums of the world represent without a doubt
the greatest spectacle of a humanity liberated
from material concerns and devoted to contemplation.

We need recognize that the galleries and the objects of
art are nothing but a container, the contents of which are
constituted by the visitors: it is the contents that
distinguish the museum from a private collection. . . .
The paintings are nothing but dead surfaces, while in the
crowd occur those interplays, those flashes, those
streams of light described in technical terms by the
authorized critics. On Sundays at five o'clock at the exit
from the Louvre, it is interesting to admire the flood of
visitors visibly animated by the desire to be like the
celestial apparitions which still ravish their eyes.

The museum is a colossal mirror in which man
finally contemplates himself in all his aspects, finds
himself to be literally admirable, and gives in to
the ecstasy expressed in all the art magazines.

—Georges Bataille, "Musée," *Documents,* 1930

CONTENTS

ILLUSTRATIONS

PREFACE

This is a book about, in times of scarcity, an excess of things; more things than anyone could really hope to manage. Though narrowing its attentions to a particular place (Paris) and a remarkably thin slice of time (eight months from the early summer of 1937 until the first weeks of 1938), this book nonetheless embarks upon the study of a monumentally large world's fair as well as a museum's evocation of peoples not invited to that commercial gathering, a permanent installation of medieval sculptural casts and a fleeting retrospective of French artistic masterpieces, a municipal art gallery proudly proclaiming its aesthetic broadmindedness but also a private gallery's presentation of Surrealist works insistently beyond the city's cultural purview. Each of these exhibitions, moreover, played out (at least the fantasy of) an abundance of material accumulating in Paris: salable goods or ethnographic artifacts from around the world, countless bits of ornament from the French provinces molded in plaster, room after room of works of French art, Surrealist detritus.

It is the reigning hypothesis of this book that such abundant accumulations inevitably promulgated their own shortages, engendered their own mismanagement. They did so not only owing to certain specific historical limitations and antagonisms that constrained the mounting of global displays in Paris of the late 1930s—though such constraints will emerge as a major topic in the pages that follow. It is also the case, my argument will have it, that in grasping after an excess of things, one (now as then) always ends up laying one's hands on the *excess*, as a mere formal property, rather than on the *thing* as a material essence. Whether striving to comprehend the world through the dexterous maneuvers of market economics, or those of ethnologic practice, or those of historical study or of the enterprise of art, many a discipline ultimately finds that the real objects of its interest have, awkwardly, slipped through its fingers. Rather than bemoan these potential failures to grasp the world made up of things, however, this book will explore instead the enormous productivity of such acts of disciplinary mismanagement of their own resources.

Fittingly for a book about abundance and shortfalls, I have enjoyed an excessively

generous supply of support from my friends and colleagues during its conception and production, while thereby accumulating a substantial intellectual debt to them all; brief acknowledgments such as this can only begin to discharge accounts. Tim Clark, Dan Herbert, David Joselit, Julia Lupton, Richard Meyer, Keith Moxey, Fred Orton, Richard Shiff, Lisa Tiersten, Anne Wagner, and Sarah Whiting all took the time and care to read all or parts of this manuscript; the argument has benefited enormously from their collective insights. Charles and Monique Whiting caught many a missed nuance in my translations from the French. Audiences that have listened attentively and responded with sagacity to excerpts of this text delivered in lectures at the University of California, Berkeley, at the University of Leeds, and at the Getty Research Institute have given me a firm hold on that frequently ephemeral entity, the scholarly community.

I am most grateful to the Getty Grant Program, the George A. and Eliza Gardner Howard Foundation, and the President's Research Fellowships in the Humanities program of the Office of the President of the University of California for providing fellowship support that freed up valuable time to write. Both the University of Southern California and the University of California, Irvine provided funds to defray research and publication costs. The staffs at the libraries of the Musée des Monuments Français, the Musée de l'Homme, and the Petit Palais kindly opened their archives to me. As the photographic credits reveal, I relied heavily on the Resource Collections of the Getty Research Institute as a source for many of the illustrations. Adam Boxer of Ubu Gallery in New York proved an indispensable font of information concerning photographs taken of the Exposition Internationale du Surréalisme. Two journals have allowed republication of portions of this book that previously appeared in their pages: Chapter 1, as "The View of the Trocadéro: The Real Subject of the Exposition Internationale, Paris 1937," *Assemblage* 26 (March 1995): 94–112; and Chapter 2, as "Gods in the Machine at the Palais de Chaillot," *Museum Anthropology* 18 (June 1994): 16–36.

It has proved a true and rare pleasure to work on this project with the crew at Cornell University Press. Bernie Kendler's enthusiasm has been matched only by his dry wit; Terry McKiernan demonstrated a flexibility in scheduling that no author really has a right to expect; and Charles Purrenhage's deft hand exemplifies copyediting at its best, simultaneously exacting and respectful. Were I not so impressed with the remarkable speed of the whole process of editing and production at Cornell, I would regret that our felicitous working relationship had to come so swiftly to an end.

Finally, my special thanks to Cécile Whiting, who not only heads the list of those with whom I have delighted in the exchange of ideas, but also has—more than anyone should be called upon to do—learned to manage many of my excesses. And to Nicole, of course, that special girl who has made our household something more than itself—and taught me a thing or two along the way about the pleasures that can be found in the impossibility of managing it all.

JAMES D. HERBERT

Los Angeles
April 1997

PARIS 1937

INTRODUCTION

———

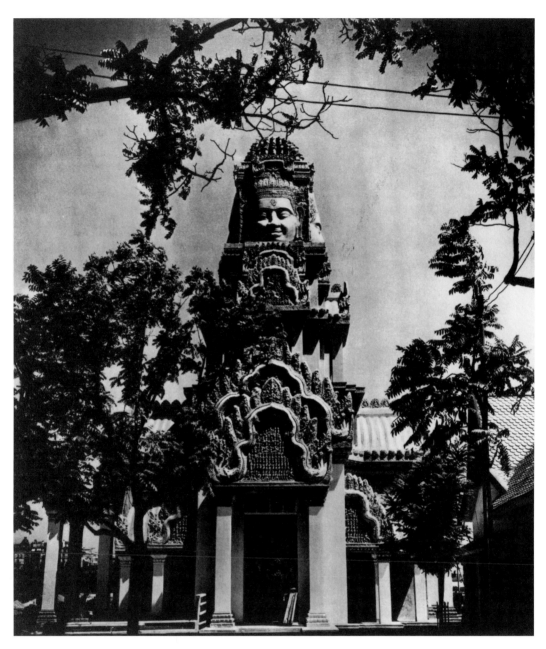

FIG. 1. *Central Temple, French Indochina Section, Exposition Internationale des Arts et Techniques dans la Vie Moderne Paris 1937*. Livre d'or officiel de l'exposition internationale des arts et techniques dans la vie moderne *(Paris: [Imprimerie Nationale], 1937), 222. Photo courtesy of the Getty Research Institute, Resource Collections.*

GLOBAL SPECULATIONS

—

Here it all was, awaiting the gawkers: the fastest airplanes, the latest fashions, the temple of Angkor Wat! The Exposition Internationale des Arts et Techniques dans la Vie Moderne Paris 1937, extending its principal axis from the crest of the Trocadéro Hill on the Right Bank across the widened pont d'Iéna to the traditional home of Parisian world's fairs beneath the Eiffel Tower in the Champ de Mars, promised a comprehensive and up-to-the-minute survey of human accomplishment. From the collection of pavilions each devoted to some specific French industry or trade to the palace heralding the most recent scientific discoveries, from the proud edifices erected by forty-two sovereign nations and empires to the string of exotic structures housing the natural and cultural resources of the French colonies, this exhibition of global proportions presented to residents and visitors in the French capital, those willing to part with the price of admission and some shoe leather, nothing less than the world.

Well, not quite all the world. The Exposition Internationale des Arts et Techniques laid a distinct emphasis upon all things commercial—even the architectural fantasy based on the temples of Angkor (fig. 1) served as nothing so much as an enormous decorative centerpiece to a circle of boutiques offering the wares of French Indochina for sale to passersby. All that which fell beyond the sphere of contemporary commerce had to take up residence elsewhere. Atop the Trocadéro Hill on the periphery of the fairgrounds, for instance, rose the Palais de Chaillot, a structure newly renovated with funds released for the fair's physical improvements, even though its contents were not part of the Exposition Internationale des Arts et Techniques. Two museums, reconceived and reinstalled for the occasion, occupied most of these new halls: the historically oriented Musée des Monuments Français, in which plaster casts of architectural ornament evoked a medieval society of probity that predated the emergence of the modern market in France; and the ethnologic Musée de l'Homme, which displayed artifacts gathered from among those peoples living at the corners of the planet seemingly not yet

3

touched by the expansive forces of the global market. These two museums, extending the temporal and geographic horizons of the Exposition Internationale des Arts et Techniques, worked as if in concert with that larger exhibition to bring into view the full range of human experience in the world.

Well, still not quite all. Neither the interested spheres of commercial affairs nor the ostensibly organic societies of medieval manor or primitive tribe, as contemporaries conceived them, could well play host to the purportedly autonomous and disinterested practices of aesthetic appreciation associated with the high arts of Europe. The three institutions situated upon or adjacent to the Trocadéro, in other words, provided no adequate forum for the expression of the artistic realm of human activity, at which the nation of France in particular could claim such enduring and unrivaled accomplishment. To redress this deficiency, the cultural administrations of the French state and of the city of Paris each bestowed upon the capital during the run of the world's fair a massive art exhibition, the two competing with yet also complementing each other. The Chefs-d'œuvre de l'Art Français, the nation's offering, surveyed nearly two millennia of artistic production on French soil, while the municipality's Maîtres de l'Art Indépendant documented the cosmopolitan breadth of recent art originating in Paris. Where the Exposition Internationale des Arts et Techniques took the pulse of the moment in the applied arts and techniques, where the museums in the Palais de Chaillot examined the artifactual records of societies long past or distant and isolated, these art exhibitions together proclaimed the eternal and universal character of the French aesthetic.

And still, not all. These exhibitions and installations, collectively, may have claimed to represent all that was the world, but they thus could not be that which the representation of the world was not. As if filling this paradoxical gap of the "that which is not this," the Exposition Internationale du Surréalisme inveighed, from the halls of the private Galerie Beaux-Arts in early 1938, against all that had come before it in the procession of globally ambitious initiatives then closing their doors or fading into the routine of permanence. The "surreal" formulated by this "Exposition Internationale" of a different stripe played with and against—perhaps replacing, perhaps supplementing—whatever it was that had constituted the "real" that the earlier exhibitions and museum installations of 1937 had attempted to place on view.

Regarded on its own, each endeavor (even those with an ostensibly national focus, we will discover) bespoke the sheer audacity of holding global aspirations within the particular area of its disciplinary expertise: commercial, historical, ethnologic, and aesthetic; or, in the case of Surrealism, that which was not these. Taken as a whole, the constellation of displays conveyed a less certain message. On the one hand, the exhibitions and installations of 1937 and early 1938 together enacted a felicitous division of representational labor, parceling out reasonable proportions in the monumental task of presenting the world in its myriad manifestations within the public and private spaces of the French capital. Indeed, the claim of each display to its own disciplinary competence

depended essentially on the set of differential definitions of various fields of knowledge achieved only through the juxtaposition of each against the others. The museums in the Palais de Chaillot justified their missions by mounting in their galleries that which could not be seen in such commercial arenas as the Champ de Mars; the state and municipal exhibitions of art professed to express eternal verities of the sort that eluded installations concerned with more mundane affairs; Surrealism declared itself to perform that which more conventional art could never accomplish. On the other hand, that very allotment of separate portions of human experience into the purviews of a number of discrete disciplinary practices necessarily highlighted the insufficiency of each on its own, and thus potentially of the whole taken together. That the opening of a fair taking the world as its concern immediately called for a supplement (and called for it again, and again) opened up the possibility that some missing supplement (and then yet another, and another) might still be needed to render the comprehensive survey, finally and definitively, complete.

Beyond this potential pitfall, a greater difficulty—one of a more elemental character—haunted the exhibitions and installations of 1937 and early 1938. The world was to show itself here, certainly; and yet "here" consisted of only a handful of exhibition halls and public plazas distributed unevenly over a handful of hectares within the boundaries of one city, tucked away in northern climes along a mere peninsular offshoot of its massive Eurasian continent, which itself covered but a small section of the surface of the globe. No, the world obviously would not make an appearance in the French capital; only its representation could. And that representation stood in relations of both insufficiency and excess to the world itself: insufficient, to the extent that it lacked the fullness and completeness commonly attributed to that world; excessive, to the extent that it supplemented that world with something beyond itself, that it abstracted from the world a duplicate image to be viewed in Paris. Thus while the various displays of global scope perched along the Seine over the period of one year may have indulged in unbridled hubris, that conviction necessarily engendered as its own perfect complement a potential incertitude grounded in the inevitable mismatch between the world and its iteration in representation.

This disjunction between ambition and realization, this strange marriage of audacity and uncertainty, need hardly be considered unique to the Exposition Internationale des Arts et Techniques and the institutions correlative to it; always it lies intrinsic in some manner, I would venture, within the human enterprise of representation. Nevertheless, a couple of factors make Paris of the late 1930s a particularly fruitful time and place in which to examine its operation. First, both the presumption of entitlement toward having it all and a pressing anxiety over the possibility of fundamentally losing one's grasp had, in this setting, hit new peaks—and assumed unprecedented urgency. By the early decades of the twentieth century when the task of filling in all the remaining blank spaces on the world map promised finally to reach completion, the great European nations—authors of that initiative and authorized by it—could imagine that the entirety

of the globe would soon fall within the ken of its various intellectual technologies: not just its sciences of geography and ethnography, but also the incorporative powers of its imperialist systems of economics and politics, and even the aesthetic appreciation of its most adventurous artists and connoisseurs. Yet at this culminating moment of apparent global mastery, the nation of France faced off against a pair of developments that shook to the core any confidence it may have had in attaining that all-too-elusive triumph. The worldwide economic depression, which had come late to France but had sunk in profoundly, raised basic questions about whether the mechanisms and models of the market economy possessed the means adequately to comprehend and regulate France's own internal affairs, let alone those of empire or world. Simultaneously during the late 1930s, the French looked across the Rhine (in all sectors of the press, at least, a virtual obsession) to witness a fascist Germany, now ensconced for half a decade and growing in force and assurance, that not only proposed disturbingly different and often rather mystifying conceptions of everything from society and race to science and aesthetics, but also threatened a belligerence that endangered a cherished French notion of a world happily and fully integrated through the forces of economic cooperation and aesthetic universality. The magnitude of these propitious and nefarious developments, together, imparts a clarity to the dynamic of disciplinary success and failure, as the stakes involved in the display of the world in Paris in 1937 and early 1938 reached frightening heights.

Second, this plethora of exhibitions and installations of global compass filling the French capital over the short period of a year confers a singular visibility to the processes by which the disciplines built upon one another's strengths but also revealed one another's deficiencies. This book, both noting parallels across disciplines in their presentations of artifacts and highlighting the many instances when disciplines strove forcefully to distinguish themselves from their peers, proposes to take full advantage of that rendering of ideologies and institutional practices into the realm of the visible.

Certainly all the disciplines placed by this book under its own scrutiny shared the capacity to put things on exhibit, to display their accumulated artifacts before the eyes of those viewers circulating in the French capital in 1937 or early 1938. Yet despite this basic similarity, not all the visual objects shown in the exhibition pavilions or museum and gallery halls of Paris remained commensurate with one another; some were attributed with greater value, with greater perspicacity, with higher truth. Specifically, certain artifacts enjoyed the authoritative sanction of the aesthetic: these works and these works alone were credited with the capacity to inhabit the privileged orbit of art. This book divides itself into two parts according to the absence or presence of that aesthetic endorsement at the various sites of display. Part One explores the Exposition Internationale des Arts et Techniques and the two new museums in the Palais de Chaillot, none of which directed their attention primarily toward artistic matters, while Part Two investigates the art exhibitions offered by state and city and the counteroffering by the Surrealists, all of which either explicitly embraced the privileges of the aesthetic or actively at-

tempted to repudiate them. Why the ascriptions and refusals of aesthetic auspices should matter, and how art and art criticism operated in a manner that will permit us to compare them to other disciplines left uninflected by art, will prove to be issues of some intricacy; an Entr'acte will intervene between the two parts of the book as a means of introducing some broad considerations on these topics. Ultimately, I believe, only an analytic frame such as this that contains disciplines espousing the aesthetic as well as those ignoring or disdaining it can discover the special powers and limitations differentially attributed to the work of art.

I will insist, from the start and throughout this argument, on the crucial paradox underlying the rendering of all things visible. Precisely to the degree to which the world in its great extent and diversity became the object of perception in the form of its visual manifestations within the exhibitory spaces of Paris in the late 1930s, the world itself retreated into the invisibility of being that absent thing to which the objects on display referred only from afar.[1] As did the representational division of labor among institutions, this mutual implication of visibility and invisibility presents two aspects, one fatal and one fecund. On the one hand, it manifests the inherent failure of visual semiosis (indeed, all forms of semiosis; the case of the visual simply illustrates the process in an especially perceptible manner) ever to present—to make present—that which it represents, because it always only presents it again within the field of signification, from which the thing to be represented must always remain absent. On the other hand, this failure on the part of the exhibitions and installations of 1937 and early 1938 produced nothing short of the world itself; the world as something residing elsewhere, certainly, but nonetheless necessarily there as that entity capable of giving rise to, capable of providing the real foundations for, all subsequent representations of it in such places as the Parisian displays. Inverting commonsense notions about the direction of causality, I will repeatedly explore how, within the specific historical setting I take as my object of study, the invisibility at the core of the visible manifest in Paris generated the real world elsewhere out of the stuff of representation; at least as much as the visible in Paris, insofar as it was surrounded and confined by the invisible that lay elsewhere beyond its reach, permitted the generation of representation out of the real world.[2]

The interplay of the visible and the invisible in the Parisian exhibitions and installations of the late 1930s did not limit itself to the production of the real world elsewhere, however. Just as important to these institutions as that which they put on display was the question of for whom—or for what—the displays were to be mounted. What individuals, what entities, could aspire to obtain the knowledge about the world contained (and not) within this collection of representations claiming global scope? And yet again, what entities could know of those entities; who could learn that the world had been learned? Ultimately, I will repeatedly argue, the issue takes on theological dimensions, as one display after another resorted to the positing of some species or other of gods capable of overseeing it all, both the world and the representations of it, as well as underwriting the necessary connections between the two. Given the essential invisibil-

ity of the world elsewhere and the resulting unverifiability of any linkage between that world and its visible representations on display in Paris, the exhibitory institutions of 1937 and early 1938 depended absolutely on the divine intervention of that guarantee: as Voltaire would have it, if gods did not exist, it would be necessary to invent them (the same, I would add, could be said of the real world). In one sense, the gods remained unknown and invisible: as the guarantors of the efficacy of the disciplines of display, they could hardly become the objects of the collective vision of those disciplines without immediately thereby requiring the existence of some higher divinity to sanction that secondary act of perception. Omniscience itself need remain beyond the range of vision. In another sense, the very necessity of such gods required that they somehow be figured visually at (or beyond) the exhibitions in Paris. And indeed, these gods, as we will witness in the pages to follow, assumed a wide variety of unexpected guises through the exhibitions and installations of the late 1930s: a ship upon the celestial seas, an unseen eye in the Eiffel Tower, a capitalist entrepreneur assuring eternal happy returns or a scientist doing the same, the spirit of aesthetic continuity and universality, a Surrealist manager of Surrealist managers. Repeatedly, the nation will take up the role; a recurring subtheme of some importance within this book will be the transcendence—frustrated or actuated—of the concept of France at a particularly turbulent moment in its history (although how exactly one went about figuring that concept of nation presented complications of its own). The gods thus proved as paradoxical an entity in Paris during the late 1930s as had the real world. Just as the real world retreated into the invisible when it was rendered visible through its figuration in the Champ de Mars and other spots within Paris, the necessarily invisible gods provisionally gave themselves up to the visible when the all-seeing divinities were invested in such representational figures as those proposed by the Parisian displays.

We might commence this study, then, with the following guiding picture of the *situation* of things—in the sense of how things were situated, which sites they were to occupy. The Parisian exhibitions and installations of 1937 and early 1938, as well as the disciplinary practices to which they gave expression, all operated within the realm of the visible; indeed, their very operation constituted, realized, the visual as such. And yet that visual realm manifested itself, with confidence and with anxiety, only owing to the existence of two sets of invisible entities lying beyond the horizons of its own field of perception. Two sets consisting of the real world and the gods, residing (as it were) in opposing directions from each other—to the extent that one could point outward from the visible in the direction of an invisible entity (we will witness various attempts thus to point). The collective institutional practices of the exhibitions and installations that performed the representation of the world in Paris during the late 1930s found themselves sandwiched between such entities and dependent upon the frame they provided; the invisible entities nonetheless existed only as necessary projections cast out by those same institutional practices beyond their own purview of the visible.

From the standpoint of the disciplines within the visual realm, the real world and the gods possessed a certain complementary character: the former justified faith in onto-

logical existence (preceding all perceptions of that which exists), the latter faith in epistemic certainty (which perceives all acts of perception). Yet that complementarity always remained curiously unbalanced, since the real world could see neither the disciplines nor the gods, while the gods espied both the disciplines and the real; we will witness myriad effects stemming from that epistemic disequilibrium. The complex interplay between that which could be seen and that which could not, and each by whom and in which circumstances, will emerge in the pages to follow as a frequent dynamic across a variety of disciplines; through such networks of vision lie the paths of power, projected and real. Indeed, a principal task of this book will be to explicate the investments of such power, activated by the intricate intertwinings of visibility and invisibility, at specific sites within the urban fabric of Paris: atop the esplanade of the Palais de Chaillot overlooking the world's fair, within the hidden laboratories of the Musée de l'Homme, at the far end of Hall 18 of the Chefs-d'œuvre de l'Art Français, within the social swirl of tuxedoed gentlemen and ladies in evening dress at the dramatic vernissage of the Exposition Internationale du Surréalisme. I propose, in short, that we can map the topology of a specific constellation of ideologies as it manifested itself through a set of visual (and invisible) interactions realized (or not) within the actual space of a city (and in the spaces projected beyond it) at a given moment in time.

The book itself appears within a different historical moment, certainly, but faces similar opportunities and constraints; it operates within a like topology of insight and imperception. The writer of this text, and presumably its readers, will be proceeding on the faith that some set of significant events in the history of global exhibitory practice actually transpired some sixty years ago in the streets and halls of Paris, and that some sort of meaningful and justified comprehension of those events is recoverable here and now on these printed pages. All this, without ever denying the projected and invisible character, the ultimate unverifiability, of both that antecedent reality and that subsequent claim to truth. Together, then, we will by necessity be working within our own limited realm of the visible, metaphorically comparing and ironically contrasting the exhibitions and installations that fall within our perception, much as the individual disciplines active in Paris during the late 1930s justified their own missions in complement with and in contrast to the others. Many of the parallels between disciplines I propose should ruffle no one: the attributes shared by the financial capital of commerce and by the cultural capital of art, or the structural similarities uniting the semiotic exchange of signs to the economic exchange of commodities, will prove obvious enough, and I am hardly the first to profit from them.[3] Other juxtapositions will derive much of their potency from their jarring oddness: when, for instance, gods descend to regulate the market in signs or commodities, or when science abstracts an ethnographic fact in a sense akin to that of the abstractions of painting. Through such parallels and juxtapositions, in the chapters that follow I will attempt to render visible within the present the historical dramas of the past, striving to see beyond merely the visually manifest to that which lies in the hazy yet crucial zones of projection and faith.

A number of exhibitions and their concomitant disciplines that fall within the sweep

of this book depended for their successful operation on the processes of "speculation": the calculated return on a venture of capital, the formulation of scientific hypotheses based upon the best available evidence. This book will play upon those meanings, will work to realize them using the accumulated historical material at my disposal. But I would wish above all for this essay to reinvest that term with some of the richness of its etymological origins, as this book—like the exhibitions and installations it analyzes—subjects the world and its gods to the scrutiny, to the speculation, of its many and varied observers.

PART ONE

THE TROCADÉRO

——

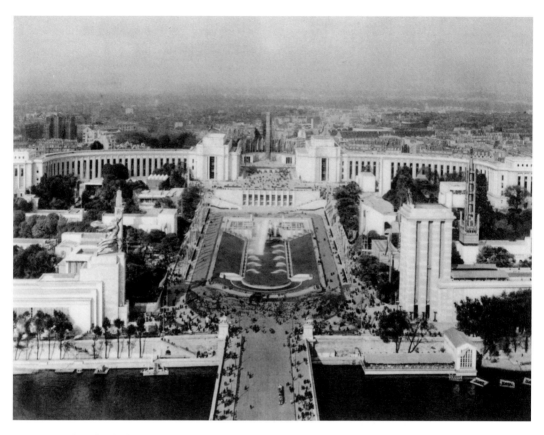

FIG. 2. *Palais de Chaillot, viewed during the Exposition Internationale des Arts et Techniques dans la Vie Moderne Paris 1937.* Edmond Labbé, Rapport général: Exposition internationale des arts et techniques dans la vie moderne, *11 vols. (Paris: Imprimerie Nationale, 1938–40), vol. 2, pl. 69. Photo courtesy of the Getty Research Institute, Resource Collections.*

CHAPTER ONE

THE VIEW OF THE ESPLANADE

———

**It can be said that the gazes of the world are
currently turned toward the [Trocadéro] Hill.**
G. Charensol, "Sur la colline de Chaillot,"
Femme de France, 1 August 1937

Down came the scaffolding in 1937, revealing a magnificent new prospect over the city of Paris. The vast esplanade of the Palais de Chaillot (fig. 2), suspended between two refurbished wings poised atop the rise of the Trocadéro, had broken through the hulking center of the old Palais du Trocadéro. Officials in charge of the Exposition Internationale des Arts et Techniques dans la Vie Moderne Paris 1937 had, as part of a general campaign to clean up and improve the western side of the city on the occasion of the world's fair, prompted the extensive transformations of the palace: sober neoclassical façades of the righteous modernist variety now bedecked the wings, masking the surviving sections of the exotic Hispano-Moresque relic dating from the Exposition Universelle of 1878. Yet the esplanade, not these clean wings, emerged as the principal feature of the new structure, for the terrace possessed remarkable visual command. In 1937 it oversaw not only the city, but also the world itself, laid out in microcosm in the pavilions of the Exposition Internationale des Arts et Techniques crowded into the gardens of the Trocadéro and the Champ de Mars below (fig. 3).

It has, of course, always been audacious cultural work for the world's fairs of the nineteenth and twentieth centuries to attempt to encompass the globe within a limited expanse of urban real estate; the Exposition Internationale of 1937 only redoubled the hubris by presuming to offer a single place from which to grasp it all. The greatest consequence of the esplanade, however, stemmed not from the global ambition to which it gave expression, but rather from its incapacity to realize precisely that ambition. For

only when the fair could not fully embody the world, only when the esplanade lost its absolute omniscience, did the impossible goal of true global command threaten to become possible.

NOWHERE AND EVERYWHERE

The Exposition Internationale des Arts et Techniques condensed the varied domains of the globe, roughly grouped by type, into the cityscape of Paris (fig. 4). Extravagant national pavilions occupied the heart of the exhibition grounds, the area spanning the Seine River from the base of the Eiffel Tower to the gardens of the Trocadéro; most famously, Albert Speer's neoclassical tower for Germany, with its National Socialist eagle perching atop a swastika, faced off against Vera Mukhina's enormous *Worker and Collective Farm Woman*, striding forth in the name of the Soviet Union (fig. 3). After canvassing the exhibits contained in such pavilions, visitors could continue on to the Centre Régional, to the south along the Left Bank. Here, the various provinces of France displayed their wares in buildings of appropriate regional styles: timbered façades and a tile roof for the Normandy Pavilion, white stucco with brightly colored trim for the Riviera. Indefatigable souls could then cross to the long and narrow Ile des Cygnes, where the diverse French colonies materialized in structures ranging from a Barbary palace flanked by a narrow Arab street for Algeria to the architectural improvisation on the temples of Angkor for Indochina (fig. 1). "In a few hours we have just completed a genuine world tour!" exclaimed M.-L. Berot-Berger in his essayistic handbook for the Exposition Internationale; formulations of this type, which frequently extolled the rapidity of a tour through the exhibition compared to the dilatory eighty days of Jules Verne's Phileas Fogg, acquired the ubiquity of a cliché in the vast literature generated around the Exposition Internationale des Arts et Techniques.[1]

The exhibition, its champions maintained, not only attained geographic comprehensiveness; it also presented the world to its viewers with striking immediacy. Artisanal goods produced in foreign lands, displayed in abundance, served to embody absent nations. Such handcrafted objects, insisted Marc Chadourne in the pages of the *Livre d'or officiel* of the Exposition Internationale des Arts et Techniques, bore the incontrovertible stamp of all essential features of their place of origin: "No need to be an ethnographer to understand, in investigating them, the close ties linking object to man, to the region, to the flora and fauna of the country. Because of a determining influence to whose law the artisan submits, the subtle spirit of the landscape and its creatures is enclosed within the most humble substance or the most modest accessory."[2] Supplementing salable goods on display were great numbers of indigenous artisans, imported for the occasion, who demonstrated on site the sort of work that left this purportedly authenticating impress (fig. 5). A world's fair devoted to relaunching a stagnant global economy,[3] the Exposition Internationale des Arts et Techniques ostensibly became one all-encompassing commercial field of production and exchange; the world, through its artisans and artifacts, emerged fully present on the Champ de Mars.

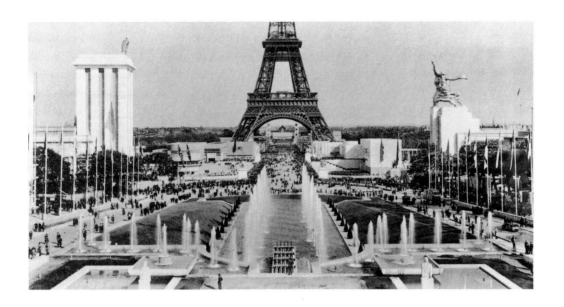

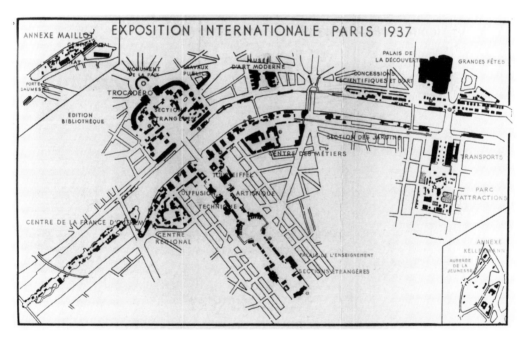

FIG. 3. *(top) Grounds of the Exposition Internationale des Arts et Techniques dans la Vie Moderne Paris 1937, viewed from the esplanade of the Palais de Chaillot. Edmond Labbé,* Rapport général: Exposition internationale des arts et techniques dans la vie moderne, *11 vols. (Paris: Imprimerie Nationale, 1938–40), vol. 2, folio annex, pl. 22a. Photo courtesy of the Getty Research Institute, Resource Collections.*

FIG. 4. *(above) Plan of the Exposition Internationale des Arts et Techniques dans la Vie Moderne Paris 1937.* Exposition internationale arts et techniques Paris 1937: Guide officiel *(Paris: Société pour le Développement du Tourisme, 1937), 213.*

A certain willed misrecognition characterized this attitude toward the world's fair: its visitors, indulging a fantasy of completeness and proximity, suspended their awareness that the displays were but mere surrogates for the actual distant lands represented. As André Warnod expostulated in his book-length essay on the Exposition Internationale des Arts et Techniques: "As soon as you pass through its gates . . . you are . . . in a land that is located nowhere and everywhere at the same time. A land where all notions of distance and time are confounded."[4]

Yet where the likes of Berot-Berger and Warnod subscribed to the fantasy, others proved less eager to suspend disbelief. Robert de la Sizeranne's trenchant critique, though directed toward the thematically more focused yet still monumentally large Exposition Coloniale Internationale mounted in the Bois de Vincennes east of Paris in 1931, cuts with equal ease to the core of the Exposition Internationale des Arts et Techniques, since the displays at Vincennes and those on the Ile des Cygnes differed little in their essential features:

> A voyage? . . . No, it is not a voyage, nor the impressions of a traveler that you will find here. A voyage . . . requires two things that are foreign to the object of travel itself: space and time, which is to say, two elements that the advancements of science do not create, but tend on the contrary to reduce and even to suppress. Certainly the miracle of modernity, that of the Exposition Coloniale, is no less important, but it is something entirely different.
>
> . . . Things have come to us by magic, but it is only their appearances that have come. They do not have that density that surrounds us, that oppresses us and bathes our five senses when we go to them and live among them. Only the picturesque ambiance is restored; and even that could not be done entirely.

La Sizeranne is not here questioning the credibility of any particular artifact presented at the Exposition Coloniale Internationale; elsewhere he praises "the perfection of the examples chosen."[5] The passage decries, rather, the inherent loss of the distance and time that separate objects from one another in their indigenous locales, the ephemeral mortar that cements things, like so many bricks, into their place of origin. From La Sizeranne's perspective, distance and time—the confounding of which Warnod extolled as a crucial element in the fantasy of a fair fully adequate to the world—could never be embodied in the artifacts on display in Paris.

One camp of observers willed a fantasy of a world completely embodied in authentic artifacts and living artisans, then, while another fretted over an exhibition offering nothing but disembodied "appearances." All the fixings for a well-fought ideological conflict, it might seem; except that both sides could actually entertain both positions. Berot-Berger and Warnod were hardly so naïve as to believe, really, that they had been physically transported from the Champ de Mars to foreign lands. And La Sizeranne, despite his worldly-wise skepticism, could also indulge in the pleasure of being beguiled by the show: "We have rubbed elbows with the most distant and diverse races and in listening to them have lost all sense of time in a dream. . . . We leave Vincennes, our eyes

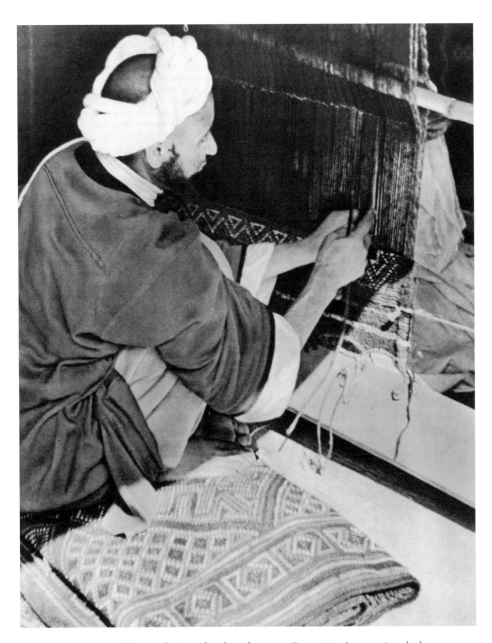

FIG. 5. *Artisan working in the French colonial section, Exposition Internationale des Arts et Techniques dans la Vie Moderne Paris 1937. Edmond Labbé*, Rapport général: Exposition internationale des arts et techniques dans la vie moderne, *11 vols. (Paris: Imprimerie Nationale, 1938–40), vol. 4, pl. 12. Photo courtesy of the Getty Research Institute, Resource Collections.*

filled with images from three continents and twenty islands, our heads buzzing with twenty centuries of history. . . . It is an enchantment."[6] These formulations, taken together, are the symptoms not of ideological conflict but of contradictory belief: apparently all parties could conceive of the Exposition Internationale des Arts et Techniques as an enchanting embodiment of a fully present world and *simultaneously* recognize that it was merely a representation of distant territories and things, themselves necessarily separated by time and space from the Champ de Mars.[7]

Herein lay the generative miracle of the Exposition Internationale des Arts et Techniques: out of this contradictory belief sprang forth—as if from nothing, *ex nihilo*—the real world. The two sides of the belief produced *from within that belief itself* a profound sense of loss: the hard skepticism of recognition regretted precisely that which enchantment affirmed: presence, embodiment.[8] And that regret had the effect of projecting the lost quality of presence outward into a world ostensibly lying beyond the exhibition's representations. When La Sizeranne wrote "Things have come to us by magic, but it is only their appearances that have come," his words had the effect of positing an independent world of "things" capable of yielding derivative "appearances." In the very act of failing to grasp the real within the nowhere of its fantasy, the Exposition Internationale des Arts et Techniques, in a much greater accomplishment, produced the real world everywhere else, everywhere beyond the Champ de Mars.[9]

Even as mere appearances projecting the real elsewhere, artisans and their goods on display fell short of representing the full economic activity of the globe. "It isn't good enough to produce, we must also sell!" declared Edmond Labbé, general commissioner of the Exposition Internationale des Arts et Techniques, as he dreamed of a world's fair able to stimulate a moribund world economy.[10] Accordingly, the success of the Exposition Internationale—as economic stimulus and as representation—depended on some manifestation on the Champ de Mars of the "global clientele" envisioned by the adjunct general commissioner Paul Léon.[11] Within this field of figuration where imported artisans and their goods personified worldwide production, the 34 million French and foreign visitors to the exhibition, as they purchased souvenirs and sampled regional comestibles, stepped neatly into the role of representing this "global clientele" at the Exposition Internationale des Arts et Techniques.

By the same logic we have already witnessed in relation to artisans and artifacts, a contradictory belief held toward such an appearance of purchasing at the exhibition undoubtedly had the effect of projecting real consumption, like real production, elsewhere. The presence of consumers at the world's fair, however, also opens for us a new line of inquiry: if tourists played the part of consumers within the exhibition's figuration of world trade, who was meant to consume this representation of global production and consumption? If the visitors were a crucial component of the Exposition Internationale des Arts et Techniques, of this object representing world commerce, who was its subject? Conceivably, the visitors could do double work and bear witness to the spectacle in which they themselves performed. Nevertheless in 1937, a different subject hovered above the exhibition grounds.

Consider the presentation—an allegory, really—of the dynamics of the exhibition shown on the cover of the *Guide officiel* (fig. 6). The image relies on the most obvious of symbols to stand in for the planet: a globe (it is not the world itself since the lines of latitude and longitude score its surface) arrests its rotations at a convenient moment, positioning the nation of France directly before our eyes. And yet on this sphere of light-blue seas and dark-blue land masses, the country of France is oddly absent. A void of un-inked cream paper gives the appearance that France, including the meridian line bisecting the country, has been completely excised (in a chauvinistic gesture, the line is the Paris Meridian, which the French had only conceded to the Greenwich standard in 1911). In its place, a tricolor ribbon encircling the globe symbolizes the nation: France has been displaced off the surface of the sphere. Beyond sails the unmistakable ship of the Parisian city seal, as if it were the head from whose shoulders the arms of France emerge to encompass the globe. In a redundant gesture, a second tricolor banner seemingly wraps around the catalogue itself, like an old-fashioned schoolchild's book strap. France embraces the world twice—the world represented by the globe, the world represented by the exhibition represented by the catalogue—while maintaining its difference from that world.

Consider also a second image, largely homologous with the first: the cover of the marketing periodical *Vendre* dated May 1937 (fig. 7). With its lashes transmogrified into its name, the eye of the Exposition Internationale des Arts et Techniques is on the world—or rather, on the globe whose image is reflected on its cornea. However, a glint of light sparkles off the surface, blinding out that section of the globe corresponding to the location of the French capital. Paris, represented ironically as the space of its absence, becomes the animating spirit, the consciousness residing in the twinkle of the eye of the Exposition Internationale des Arts et Techniques.[12] In both images, France—or more precisely its putative spiritual center, the city of Paris—grasps the world from afar: France becomes the transcendent subject for whom the exhibition's representation of the world is performed.

This figure of the transcendent subject offers the solution to an enigmatic fact: there was no Pavilion of France at the Exposition Internationale des Art et Techniques. Pavilions of the various regions filled the Centre Régional, of course, but no one could possibly mistake Provence, Lorraine, or even the Ile-de-France for the transcendent subject of France. Likewise whole sections of the grounds were devoted to the displays of French industrial and agricultural prowess—the Aeronautical Pavilion, the Fashion Pavilion, the Pavilion of French Wines, and so forth—but these represented France's resources, not France itself. France was nowhere present at the Exposition Internationale des Arts et Techniques as the object of global knowledge, but everywhere present as the subject of that knowledge. And that transcendent viewer, like the real world, always resided elsewhere, beyond the representational surfaces of globe and of exhibition grounds.

Nevertheless, that "elsewhere," just as it had its place on the cover of the *Guide officiel*, could actually be given a location in the urban landscape of Paris: the Palais de

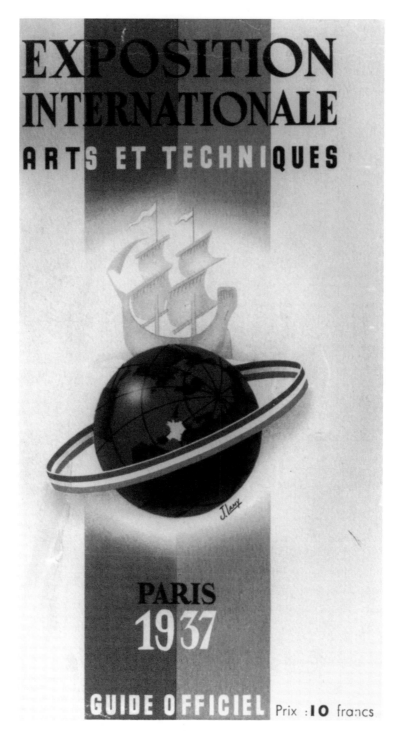

FIG. 6. *Cover,* Exposition internationale arts et techniques Paris 1937: Guide officiel *(Paris: Société pour le Développement du Tourisme, 1937).*

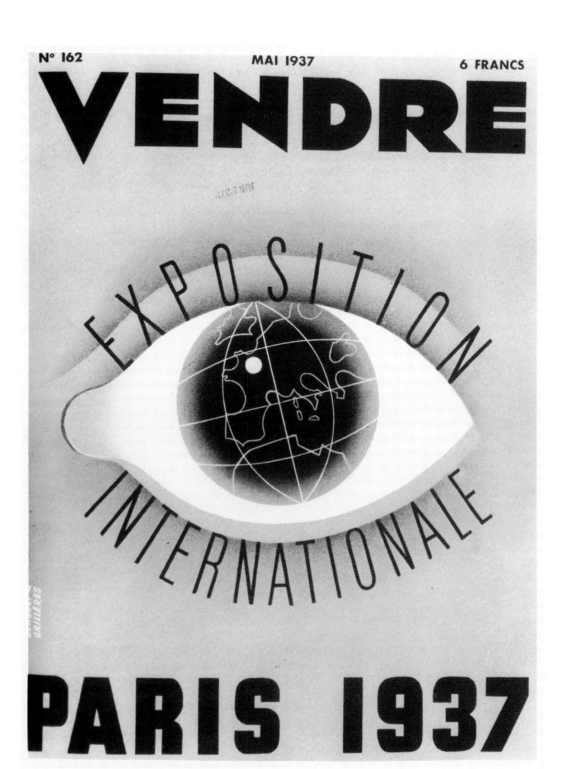

FIG. 7. *Cover,* Vendre, *no. 162 (May 1937).*

Chaillot atop the Trocadéro Hill rising above the Champ de Mars on the Right Bank (fig. 2). Organizers of the exhibition had accomplished two tasks when they ordered the renovations of the old Palais du Trocadéro. The floor space of the museums installed in its wings, most notably the Musée des Monuments Français and the Musée de l'Homme, increased more than twofold (see Chapter 2). And an opening was cut through the building providing a passageway from the much frequented Place du Tro-cadéro to the Trocadéro gardens. This second change yielded an extraordinary pan-oramic view of the Champ de Mars from the esplanade of the Palais, the perfect place from which to see the Exposition Internationale des Arts et Techniques.

That the Palais de Chaillot connoted Frenchness seems beyond doubt: its austere classicism spoke to many French viewers of, in the words of the essayist Robert Lange, "the glory of some of our most beautiful structures" in "the classical monumental tradition of French architecture."[13] Indeed, commentators on the new structure main-tained that the Palais de Chaillot reestablished a salubrious Frenchness on a site previ-ously given over to the exotic. The art critic Louis Gillet commended the transforma-tion in the pages of the *Revue des deux mondes*: "All the mediocrities, all the little ornamental miseries, have been reabsorbed, effaced, replaced by a great accord in the French manner that offers a complex mixture of urbanity and nobility, of civility and austerity."[14] Foreign tourists visiting from various corners of the world, like their French counterparts, undoubtedly looked up the slopes past other national pavilions to behold the backdrop of the Palais's ostensibly French classical façade.

Yet the Palais de Chaillot never represented France at the Exposition Internationale des Arts et Techniques as the object of global knowledge, as if it were a national pavilion, since its contents were not part of the fair. "Although housed in a monument included within the walls of the Exposition," cautioned the *Guide officiel*, "[the museums] are not part of it";[15] the Musée de l'Homme, in fact, did not open to the public until 1938. Even the guide's claim about the monument's inclusion within the perimeter of the exhi-bition was excessive, since the structure formed rather a section of that boundary: the building's western walls looked down on public byways. In relation to the Exposition In-ternationale des Arts et Techniques, the Palais de Chaillot existed less as a destination than as a passage; to enter the space of the exhibition, visitors needed to traverse the frontier marked by its walls between mundane Paris and the fantastic world on display.

In fact, the new opening between the wings of the Palais received the official designa-tion of *Entrée d'honneur* for the Exposition Internationale des Arts et Techniques.[16] Normatively, one commenced one's tour of the world here, and countless itineraries prescribing routes through the exhibition began or concluded with the esplanade be-tween the two wings of the Palais de Chaillot (fig. 8). This platform was a place of gene-sis and teleology, from which, godlike, recent arrivals at the Exposition Internationale des Arts et Techniques could behold the newly created world and declare it to be good, and those departing could pass last judgment on the world overlooked by the esplanade of the Palais.

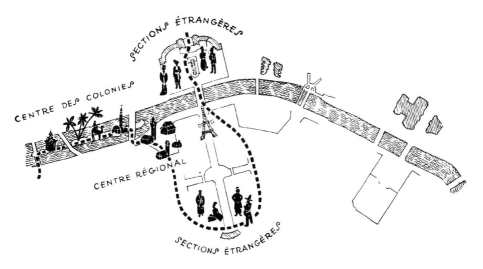

FIG. 8. *Diagram of an itinerary through the Exposition Internationale des Arts et Techniques dans la Vie Moderne Paris 1937. G. Charensol, "Sur la colline de Chaillot," Femme de France, 1 August 1937.*

And what an overview it was! In many respects, the essence of the new Palais de Chaillot, its *raison d'être*, consisted of the vista it provided of the Champ de Mars, and of the city of Paris beyond (fig. 3). Exclaimed the museum official André Dezarrois: "It is from the new terrace of the new Palais du Trocadéro that the eye takes possession of this ephemeral and Babylonian City."[17] The esplanade hovered above the world of the exhibition much as the ship of Paris sailed above the globe on the cover of the *Guide officiel* (fig. 6); the wings of the Palais embraced the exhibition grounds like the tricolor ribbon encircled the world. The view of Paris beyond the exhibition grounds only reinforced the authority of the point of observation. Gillet's comment that "it is a unique site, the equal of which you would search for in vain in any other European capital," led him to the expansive conclusion: "There is hardly any site that possesses such a commanding view";[18] implicitly the esplanade commanded not only Paris but the other capitals of Europe, and by extension the world.

The *Catalogue général officiel* thus did not err when it dubbed this "incomparable observatory" on the periphery of the exhibition grounds "the center of the Exposition,"[19] for the Palais de Chaillot was the center of the exhibition in the same way in which it embodied Frenchness: as the subject of knowledge—Dezarrois's "eye tak[ing] possession"—that has the rest of the world, centered at the bottom of the hill, as the object of its gaze.

THE REAL SUBJECT

The privileged spot of the esplanade of the Palais de Chaillot, however, was not only a place from which to see: it could be, and was in practice, seen. One architectural feature more than any other assured that the esplanade fell under the vision of another entity:

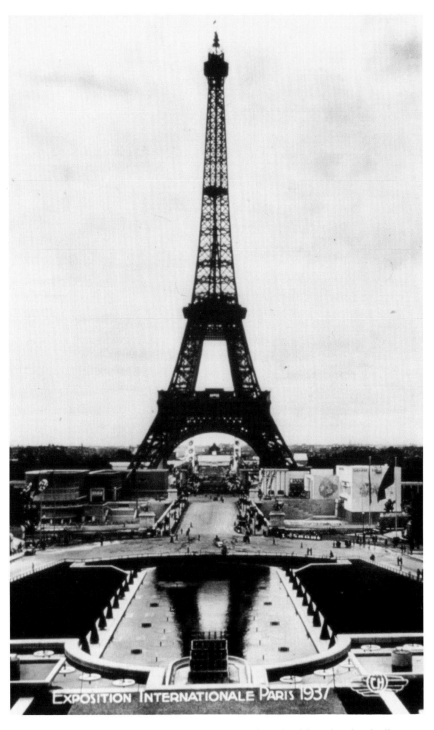

EXPOSITION INTERNATIONALE PARIS 1937

FIG. 9. *Postcard, Eiffel Tower, viewed from the esplanade of the Palais de Chaillot during the Exposition Internationale des Arts et Techniques dans la Vie Moderne Paris 1937.*

standing foursquare in front of the Palais de Chaillot soared the Eiffel Tower (fig. 9). I venture that anyone who has stood on the esplanade, in 1937 or since, has experienced some version of the dislocation whereby the sense of panoramic command gives way to the disconcerting recognition that the tower dominating the prospect is looking at *you*, all the same.[20] And when that happens, the esplanade cedes visual command to that observation tower.

Gillet was undoubtedly one of many visitors to the Exposition Internationale des Arts et Techniques who took advantage of the Eiffel Tower to oversee the entirety of the exhibition grounds, including the Palais de Chaillot: "If you go up to the second platform of the Eiffel Tower, you will have a bird's-eye view of the ensemble. . . . In front of you, to the north, the brilliant semicircle of the new Trocadéro embraces the inclined oval of lawns and greenery, with its striking layout of terraces and reflecting ponds. This central area is the place of honor; it is reserved for foreign nations" (fig. 2).[21] The subject of omniscient knowledge had taken up new residence, hovering directly above the exhibition grounds through the good offices of Eiffel's technology. As Roland Barthes has written of the view from the tower: "One can feel oneself cut off from the world and yet the owner of the world."[22]

Now, through an extraordinary stroke of luck that is (literally) too good to be true, the Eiffel Tower as transcendent subject actually spoke for itself in 1937; with the assistance of a ghostwriter named E. de Gramont (a *nom de plume*, in turn, for Elisabeth de Clermont-Tonnerre), the tower published, on the occasion of the Exposition Internationale des Arts et Techniques, a volume entitled *Mémoires de la Tour Eiffel*. De Gramont addressed the Eiffel Tower in a preface in order to establish its omniscience: "Are you not the most eminent personality in Paris? . . . You have seen so many things!" But from then on the tower voiced its own observations. It surveyed the entirety of the Exposition Internationale, and took note of the exhibition's commercial focus: "The Exposition of 1937 sets up its pavilions on the two banks of the Seine, which becomes the principal artery of this large movement of peoples and commerce." With its recent acquisition of radio equipment, moreover, the Eiffel Tower knew the events of the world—not just of the exhibition representing it—in a manner to which no mortal could aspire: "Hadn't I already linked Paris with the various cities of the colonies? I was the first to talk with Dakar and Bamako; I am perhaps the only one in France who knows in detail the French colonial empire."[23]

It would be tempting to regard the relation between the Palais de Chaillot and the Eiffel Tower as a straightforward transference of the location of the transcendent subject; except that no sooner did the Eiffel Tower emerge as a place of observing than it, like the esplanade of the Palais de Chaillot, also became something to be observed. "Maupassant often lunched at the restaurant in the Tower," Barthes begins his famous essay,

> though he didn't care much for the food: *It's the only place in Paris*, he used to say, *where I don't have to see it*. And it's true that you must take endless precautions, in Paris, not to see the Eiffel Tower. . . .

The Tower is also present to the entire world. . . . As a universal symbol of Paris, it is everywhere on the globe where Paris is to be stated as an image. . . .

The Tower (and this is one of its mythic powers) transgresses . . . [the] habitual divorce of *seeing* and *being seen*; it achieves a sovereign circulation between the two functions; it is a complete object which has, if one may say so, both sexes of sight.[24]

When the tower became a feminine object of vision—the *Guide officiel*, for instance, belittled the forty-eight-year-old structure as *une dame d'un certain âge*[25]—the transcendent subject receded from its place above the Champ de Mars, just as it had regressed from the esplanade of the Palais de Chaillot: it went elsewhere, to all those places from which the Eiffel Tower could be perused. And from such places the tower functioned (it still does) as the "appearance" of Paris. It represented Paris for the rest of the world just as the artifacts at the Exposition Internationale des Arts et Techniques represented the rest of the world for Paris. If the transcendent subject—like the real world—existed elsewhere, beyond the exhibition's field of figurations, the Eiffel Tower as an object of vision was no longer a place for it to call home.

From the grounds of the exhibition to the esplanade of the Palais de Chaillot, from the esplanade to the Eiffel Tower, from the tower to . . . ; but clearly we are caught here on the train of infinite regress. To extrapolate the obvious conclusion: in 1937, there *was* no place in Paris of unequivocal omniscience, no place for the transcendent subject definitively outside representation.[26] In the very process of being designated the location of the transcendent subject, a given place becomes the object of attention of some other subject—and thus that site transmogrifies into a figure for an entity no longer transcendent. The transcendent subject could exist only where it would not be caught in the exchange of gazes—in the classic position of the voyeur, it sees without being seen—and thus that subject could not be embodied, be given a material presence, in the urban space of Paris.[27] Much as the contradictory belief activated by the artifacts on display cast the real world out beyond the Champ de Mars, the architectural setting of the fair projected the transcendent subject beyond the bounds of the exhibition grounds, projected it elsewhere.

Rather than chase after such fundamentally elusive entities—we will never catch them, never locate ourselves within them—let us return to that center of the exhibition's dynamic, the esplanade of the Palais de Chaillot. What happened there, when the real world and the transcendent subject fled elsewhere? What was the nature of this spot, all-seeing and yet seen? In order to avoid the vertiginous lunge into infinite regression described above,[28] let me pose the problem in a slightly different manner than I did before: not, What did one see from the esplanade of the Trocadéro? but, rather, How did one see oneself, when one looked from the esplanade elsewhere? I will answer this question twice, first in the abstract sense of the generalized viewer posited by the dynamics of the setting—a hypothesized figure I will refer to as the "spectator." I will then repeat the inquiry in the more concrete terms of specific historical actors, investigating how well—or how poorly—living persons came to fill the position of the spectator.

Looking down on the world embodied in the pavilions on the Champ de Mars (fig. 3), the spectator regarded itself as the subject of that object, and—from its own experience of looking toward the Eiffel Tower—it could well imagine how such an object would view its subject. The world of the Exposition Internationale perceived the spectator—so the spectator imagined—as the unseen entity taking stock of the globe. Yet in the very process of thus appearing before the world, the spectator felt itself, from the perspective of the world, becoming engaged in an exchange of glances. The spectator atop the Palais, to be precise, saw itself both being seen as the French classical façade at the periphery of the exhibition and—like the ship of Paris and the tricolor of France on the cover of the *Guide officiel* (fig. 6)—embracing with its French wings the globe from a position beyond that globe's surface, remaining outside the range of terrestrial vision. Through this fundamental contradiction—appearing, or not, from the Champ de Mars as the seeing unseen of the nation—the spectator could come to consider itself the exhibition's figure (as, in turn, the spectator took the Eiffel Tower as its own figure) for the impossibility of embodied transcendence, for the production of transcendence, elsewhere. In a word, the spectator imagined itself to be French—for this position of uncertain transcendence was exactly the status of the nation as seen from Champ de Mars.[29]

Looking up to the Eiffel Tower (fig. 9), conversely, the spectator regarded itself as the object of that subject, and—again, from its own experience, in this case the experience of looking toward the exhibition grounds—it could imagine exactly how it as an object was beheld by that subject. The disembodied subject appearing unseen in the Eiffel Tower espied on the esplanade—so projected the spectator—both physical bodies fully present on the Palais de Chaillot (the "distant and diverse races" with whom La Sizeranne "rubbed elbows" in his moment of enchantment) and human figures merely personifying, within the representation of the Exposition Internationale des Arts et Techniques, the consumption of the fair's salable products (Léon's "global clientele"). Through this contradiction, it follows, the spectator considered itself, when caught in the sights of the Eiffel Tower, that transcendent subject's device for the miraculous production of the real, elsewhere (as, in parallel fashion, the spectator treated the exhibition grounds as its device for that same purpose). Thus—to push one step further—the gaze from elsewhere, so the spectator imagined, posited the spectator as the physical incarnation of the human act of viewing; in a word, that gaze fixed the spectator as man ("man," I say, for this term best captures the embodiment of viewership, Barthes's masculine "sex of sight").

Looking down and looking up from the esplanade thus constituted complementary, but also contradictory, gestures. Looking down, the spectator by necessity repudiated embodiment, its latent characteristic associated with the real world manifested below; this move enabled the spectator's identification with the transcendent subject of the nation. Looking up, conversely, was for the spectator to recognize its difference from the transcendent subject—the spectator had a body, the transcendent subject did not—and thereby to acknowledge a similarity between itself and the real world.

The spectator thus manifested a contradictory belief, here directed not as earlier toward the artifacts on display, nor toward the Eiffel Tower, but toward itself. From its own perspective on the esplanade looking elsewhere, the hypothesized spectator appeared to itself (through the eyes attributed to others) both as "French" (when it looked down on the fair as representation of the real world) and as "man" (when it looked up at the Eiffel Tower as figure of the transcendent subject). The "Frenchman"—henceforth my term for the spectator's self-image, how the spectator regarded itself being regarded from elsewhere—emerged thus as an impossible entity, combining elements from beyond both horizons of the esplanade. If the artisans and artifacts formulated the real world beyond the grounds of the Champ de Mars, if the infinite regress of omniscience projected the transcendent subject elsewhere, the Frenchman paradoxically figured the embodiment of omniscience right there, on the esplanade of the Palais de Chaillot.

An internally inconsistent, impossible entity, then; but one potentially of great power, the manifestation of an abstract nation within the real world. This was a position with full theological resonance: not, as earlier, the omniscient God of creation and last judgment, but rather the figure of Christ as the material embodiment on earth of the transcendent spirit. The Frenchman in this manner constituted the real subject, the human body that took command of the globe.

WAR AND PEACE

Who, then, could presume to step up to the esplanade and actually assume the position of the hypothesized spectator; what mere mortal could presume to aspire to the exalted status of the Frenchman? In posing this question, we need not be naïve about the powers of a single institution, of a single site such as the esplanade, to forge a link fast and true between all material bodies and a given abstract collectivity. All the visitors crossing through the *Entrée d'honneur* to the Exposition Internationale des Arts et Techniques had obviously already been subject throughout their lifetimes to an uninterrupted barrage of ideological commands and appeals conjoining them to and cajoling them into the nation and countless other competing or complementary social collectivities. The esplanade played into and against those previous solicitations, reinforcing or counteracting their effects, while the visitors in various manners played with the pull exerted by the esplanade. The issue thus becomes the following. To make themselves French (or resist the entreaty), how and to what degree could each of the embodied visitors to the Exposition Internationale in 1937 identify (once again, or not at all) with the transcendent subject of the nation; or, described conversely, how did the transcendent subject of France come to invest itself (again, or not) in these real bodies to form (reform, or fail to do so) Frenchmen?[30]

When prognosticating the suitable audience for the Exposition Internationale des Arts et Techniques one year before the occasion, General Commissioner Labbé attempted to finesse his way around such difficult questions as these. "Since we want to

make [the exhibition] a vast synthesis, a synthesis as complete as possible of all the activities characteristic of life of modern France, it will allow us to take stock of the exact extent of our resources, our strengths and weaknesses."[31] The pronouns do all the work in this seemingly platitudinous declaration: "we" begins as a definite group of living men charged with organizing the Exposition Internationale des Arts et Techniques, transmogrifies into the collectivity of "us" destined to learn the lessons of the world's fair, and finishes, in the form of the possessive "our," by marking the national character of that group. To know France with the omniscience of the synthetic vision promised by Labbé, and accordingly to know oneself as French, one needed only to follow the reassuringly human footsteps of Labbé and his fellow organizers across the threshold of the Exposition Internationale des Arts et Techniques.

Labbé's grammatical elision between the exhibition's leaders and the national group that followed proved somewhat selective, however: the general commissioner pitched his pied-piper tune above all to certain individuals within the polity. If the Exposition Internationale des Arts et Techniques was meant to "revive the economic vitality of France," Labbé envisioned the "masters of money" as the key audience to inform, and perhaps to enchant, with this display of national resources. "It is up to the capitalists who are capable of doing it, to take the lead, to support with all their might, before it is too late, the enterprise called France! In any case, the Exposition will only be able to contribute significantly to the resumption of business, it will only be able to stimulate a measured intensification of exchange, if we gain the confidence of the capitalists." The rest of society—Labbé referred to these others variously as "the crowd of consumers" suffering from a "reduced purchasing power" (Frenchwomen, *maîtresses de maison* rather than *maîtres de l'argent*, undoubtedly belonged in this category), "the working people" crippled by "unemployment"; most frequently simply as "the mass"[32]— would benefit from the capitalists' economic foresight. Presumably members of the mass who regarded themselves as Frenchmen would come to see the world through these capitalist eyes—for Labbé offered no other perspective.

Passing through the *Entrée d'honneur* on opening day, however, the visitor was confronted by something down on the Champ de Mars that seriously disrupted any collective self-image forming up on the esplanade of capitalist and worker happily united as Frenchmen. The grounds below revealed a exhibition conspicuously unfinished. The wave of spontaneous yet widespread strikes that swept the nation during the early summer of 1936—paralyzing enough to deliver a serious blow to the fledgling government of the Popular Front—extended to the construction sites of the Exposition Internationale des Arts et Techniques. With the resulting delays, an already tight construction schedule was strained to the breaking point: the opening of the exhibition in 1937 had to be delayed from May 1 to May 24. Even well into August, pavilions fenced off and towers still clad in scaffolding glared forth as the physical reminders, all too visible from the esplanade, of a country riven by labor strife. A handwringing journalist Lucien Corpechot drew the equation between fair and nation with ease: "What is taking place at

the work sites of the Trocadéro and the Champ de Mars is, unfortunately, the exact image of what is happening in French society, where the incoherence of the leadership classes has driven the fourth estate to revolution!"[33]

It was not just that the working classes incarnated in this manner by their visibly uncompleted tasks thereby became the object of the capitalist's oversight from the esplanade.[34] (The irony runs thick here, both in the technical sense that the working class was represented in 1937 only by the trace of its lack of full presence in 1936, and in the colloquial sense that had the class completed its work on time its existence would have become invisible by opening day.) It was also that the manifest signs of class conflict marked a rift in the polity of France itself. Unlike the busy artisans in the colonial pavilions seemingly content in doing their part by fashioning wares for the world market, the French workers charged with building the Exposition Internationale itself had in essence refused to step up to the platform of concerted national economic revitalization. The French nation, no longer whole, found half itself displaced away from the Trocadéro and onto the grounds; part of Frenchness thereby emerged as the object of knowledge—an object, moreover, pitted against its subject. Accordingly, visitors crossing the esplanade in 1937—no matter what their class—could never fully imagine themselves as the embodiment of omniscient Frenchness; instead, they witnessed the dispersal of such Frenchness, the disaggregation of the polity, across the Champs de Mars.

Compounding the difficulty, the Eiffel Tower, that figure of the elusive transcendent subject hovering above the Exposition Internationale des Arts et Techniques, also loomed high as a beacon of an epoch—*la belle époque*, to be precise—when France ostensibly did not suffer the divisions of class. In the concluding article to a remarkable set of essays published in the *Revue des deux mondes* recapitulating the history of world's fairs in France, Raymond Isay lamented the better world of "social peace" as well as "military peace" represented by the Exposition Universelle of 1889, for which the Eiffel Tower had served as centerpiece. That exhibition, he declared, "gave expression to France in its entirety—democratic, humanitarian, and generous France, prompt to offer to the laboring masses more knowledge and more well-being." All of France had stood united against the attempted *coup d'état* of Boulanger earlier that year, continued Isay, but the spirit of cooperation could not be maintained: "Since the day following [the Exposition of] 1889, a skepticism, a weariness, a *fin-de-siècle* irony has manifested itself toward the Expositions." The war and its grim aftermath, moreover, had destroyed any hope of a France united, free of internal conflict: "It appears that the real consequences of the war, hidden at first by surviving aspects of the previous era and by the irrational euphoria of the first years of peace, are only today becoming manifest. It seems that, at long last, we are witnessing the laborious, the painful birth of the true twentieth century. The next Exposition must reflect that birth."[35] Fittingly, these words appeared on 1 May 1937, the date of the exhibition's inauguration *manqué*—and of International Worker's Day—when the failure of the classes to work together for the purported betterment of France was most conspicuous.

The Eiffel Tower—for Isay, the "sublimation of the national genius"[36]—thus not only hinted at a fugitive omniscience, it also embodied that lost day when all citizens of the nation could seemingly join together as Frenchmen. If the transcendent subject began its infinite regress at the Eiffel Tower, so too the impossible amalgam of nation and body was there displaced out of the present and into the past. "Is it not curious that the 'star attraction' [«*clou*»] of 1937 is a work that dates from 1889?" wondered Gillet;[37] curious it was, and tragic ("optimism, this time, appeared difficult," he bemoaned)[38] as visitors to the esplanade beheld the ideal national collectivity, seemingly theirs by rights, recede into the depths of time.

Social *and* military peace, Isay had regretted; and if the Eiffel Tower incarnated a lost harmony of classes, at the other end of the axis demarcated by the Eiffel Tower and the Trocadéro appeared an expression of the coveted concord of nations. Rising behind the Palais de Chaillot in the center of the Place du Trocadéro, the column of the Monument de la Paix, built for the world's fair although just outside its walls, heralded the spirit of international amiability (fig. 2). This monument, in contrast to virtually all other structures at the fair, glorified no single country; an exedra featuring the flags of the forty-two participating nations, including that of France, cradled its base (fig. 10).

It proved rather easy to ridicule this particular bit of exhibition architecture. Those maintaining a sardonic tone toward the world's fair could deride the tower's dimensions—"truncated, spindly," quipped Pierre d'Espezel in the *Revue de Paris* in August 1937[39]—inadequate to the task of filling the yawning gap between the Palais's two wings and thereby capping off the vista from the Champ de Mars. Dominating the prospect instead, large advertisements mounted on the mundane façades beyond the thin pillar belittled the noble sentiments of peace—even the professional postcard photographer, presumably skilled in the careful framing of an image, couldn't quite rid the scene of the lingering savor of Benedictine and *savon*.[40] Nor were the monument's historical resonances particularly felicitous: its tiered friezes evoked the Roman Column of Trajan, a commemoration of military conquest,[41] if not indeed the Colonne de la Grande Armée in the Place Vendôme, that still gut-wrenching reminder of class warfare during the Commune of 1871 when the column was toppled by the Communards only to be reerected by a contrite Third Republic.

Nevertheless, the problems raised by the monument may have lain less with its troubles in conveying a message of peace than with the concept of peace itself, for the sentiments of international equipollence suggested by the structure with its forty-two flags further eroded the possibility of locating oneself as the omniscient Frenchman on the esplanade. In order to serve as a forum for international economic exchange, the Exposition Internationale des Arts et Techniques needed to establish itself as a level playing field on which nations, like sporting gentlemen, could engage in fair and good-spirited competition. Athletic metaphors flowed freely on this point; "a peaceful tournament . . . a peaceful competition," fancied Lange.[42] Indeed, economic activity imagined as good sport, in which participants presumed one another's commensurate stature and

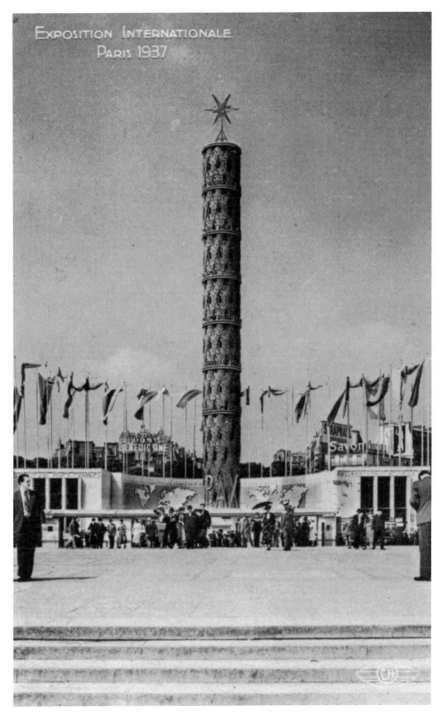

FIG. 10. *Postcard, Monument de la Paix, Exposition Internationale des Arts et Techniques dans la Vie Moderne Paris 1937. Photo courtesy of the Getty Research Institute, Resource Collections.*

mutual respect, offered perhaps the only worthy alternative to rivalry of a more belliger-
ent sort—a possibility weighing heavy on many minds owing to the rapid remilitariza-
tion taking place on the other side of the Rhine and the active civil war in progress
across the Pyrenees.[43]

It might be possible to argue that the strikingly modernist Spanish Pavilion, erected
by the beleaguered Republic and featuring Picasso's enormous *Guernica* as a cry of
pain from civilians at the mercy of Franco's atrocities, constituted, within the perimeter
of the Exposition Internationale des Arts et Techniques itself, a representation of such
proscribed military aggression (fig. 11). Yet despite the notoriety of that pavilion fol-
lowing the Second World War for its purported cultural prescience of larger conflicts to
come and notwithstanding the place of honor awaiting it in the exploding postwar
industry of Picasso hagiography, the Spanish Pavilion and the impassioned mural it
contained proved so out of touch with the larger program of the world's fair that in
1937 both were virtually ignored in the literature, official and journalistic, generated
around the Exposition Internationale des Arts et Techniques. The *Guide officiel,* for
instance, treated the Spanish Pavilion like any other, mechanically lauding its docu-
mentation of the nation's arts, its economy and system of labor, its education, and its
geography; Picasso's large, confrontational painting received no mention.[44] And even
the long-winded Gillet, publishing the lengthiest journalistic assessment of architec-
ture at the world's fair in the always verbose *Revue des deux mondes,* joined the rest
of his colleagues in wasting nary a drop of ink on the offering from Iberia.[45] Over-
shadowed—literally by the infamous spire of the German Pavilion soaring high above
it just to the east, figuratively by the larger theme of the world's fair—the Spanish Pavil-
ion in no manner managed to disrupt the ostensibly pacific games of global economic
exchange.

To gather nations like sporting gentlemen necessarily implied the multiplication of
legitimate nationalities surveying the economic playing field represented by the Champ
de Mars. The figure of the Frenchman, in short, could no longer lay claim to being the
sole incarnation of transcendent nationalism; omniscience had to be shared. A great
deal of official effort went into permitting other nations, in the name of international
parity, to assume the position of the transcendent subject. Consider, for instance, the
second illustration in the photographic album entitled *Album officiel* and bearing the
signature of Labbé on its flyleaf (fig. 12). Following an initial image establishing the nor-
mative overview from the esplanade, which treated the German Pavilion as one more
object of French knowledge authorized by the reassuring presence of the Eiffel Tower,
the second picture features Speer's monument from the perspective of visitors within
the exhibition grounds, visitors now the object not of the gaze from the esplanade or the
Eiffel Tower, but rather of the German eagle's bird's-eye view. The captions through-
out much of the album, moreover, appear in French, German, and English; whether
from the omniscient perspective projected onto the exhibition's various national towers
or from the armchair view of the owner of the album itself, France was not alone in

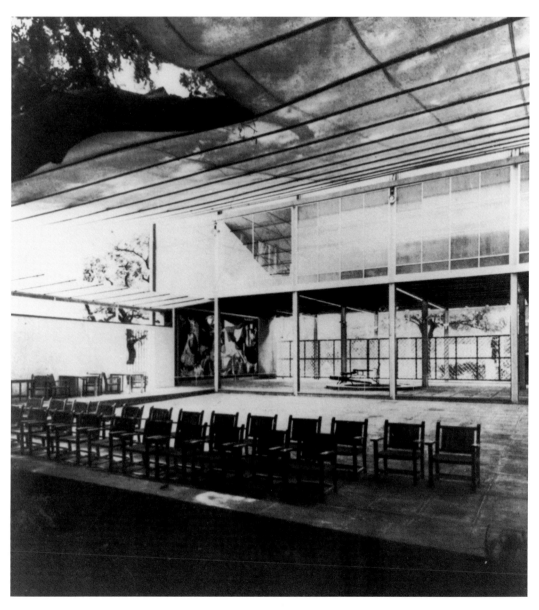

FIG. 11. *Interior, Spanish Pavilion, Exposition Internationale des Arts et Techniques dans la Vie Moderne Paris 1937.*

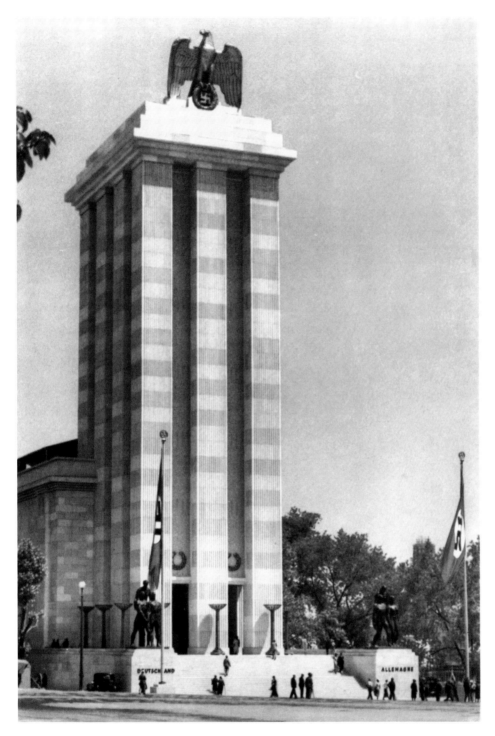

FIG. 12. *German Pavilion, Exposition Internationale des Arts et Techniques dans la Vie Moderne Paris 1937*. Exposition internationale des arts et techniques appliqués à la vie moderne, Paris 1937: Album officiel *(Paris: La Photolith, 1937)*.

perusing the world through the means of the Exposition Internationale des Arts et Techniques.

Despite its laudatory mandate of pacifism, this multiplication of the instances of national omniscience entailed several compromising consequences. If the requirements of social peace displaced the figure of the Frenchman out of the present and into the *belle époque*, the imperative of international peace fragmented the Frenchness invested in the esplanade into a myriad of commensurate nationalities. And through that fragmentation, the Palais de Chaillot ceased to serve as a spot were visitors in 1937 could step with assurance into the shoes of the Frenchman. How, in the end, were visitors meant to regard themselves on the esplanade: as embodiments of, in Labbé's words, "the France of the Exposition 1937" or, in Warnod's, as "citizen[s] of the Exposition . . . belong[ing] to that multiple and diverse race of visitors to the Exposition"?[46]

Even this uncertainty constituted a relatively happy outcome for the exhibition: the alternative proved much worse. The difficulty arose when not all nations present chose to subscribe to the principle of international commensurability and mutual respect. "Nothing is spared in order to persuade the passerby that each country is the greatest in the universe," complained Espezel as he sensed a battle for national "superiority" pitched somewhat above the tenor of peaceful competition.[47]

If, as the *Guide officiel* insisted, the layout of the grounds was meant to insure a "subordination" of "particular elements" to the "overall plan" most clearly expressed by the clarity of the exhibition's grand axes, two nations in particular violated the fragile equilibrium.[48] The imposing towers of Germany and the Soviet Union, facing off against each other at the base of the Trocadéro gardens, dwarfed the surrounding pavilions and dominated the axis running from the Trocadéro to the Champ de Mars (fig. 3). These structures, seemingly incommensurate with the rest of the fair, transgressed the principles of good sportsmanship and fair play. The two sculpted figures atop the Soviet Pavilion, Albert Flament objected, were "totally out of proportion"; they exemplified "the bad manners, the excess of pride and the vain pretensions" that "make a distasteful impression on the French, an impression shared, in front of this audacious paroxysm, by foreign visitors."[49] France had started the friendly international tournament of the Exposition Internationale des Arts et Techniques, but it did not quite know what to do with nations such as this that fought dirty to win.

Listen, finally, to the stunningly prescient formulation appearing within Espezel's condemnation of the Exposition Internationale des Arts et Techniques:

> As far as the perspective from the Trocadéro to the Champ de Mars is concerned, you will pardon my saying so, but it has turned out disastrously.
>
> Place yourself high up in the open space that has taken the place of the Palais [du Trocadéro], where the view of the domes and the hillocks of southern Paris could be wonderful. It is not enough that the ridiculous carcass of the Eiffel Tower interrupts everything [here we can see the past of 1889 impose itself on Espezel's image of perfection in the present]; it [also] has to be that, from the two sides of the Champ de Mars, the gesticulating colossi of the Soviets defy the eagle of Germany that lies in wait for them.[50]

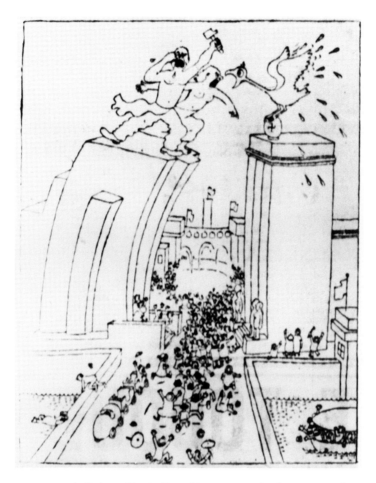

FIG. 13. *A. Dubout, "At the Exposition: once again, these two are the ones fighting."* Candide, *15 July 1937. Photo courtesy of the Hoover Institution Library, Stanford University.*

Whether we read this awaiting as the anticipation of the two nations embracing in the Hitler-Stalin pact of 1939 or as the Nazi eagle preparing to seize its Soviet prey across the eastern front in 1941—or whether, from the reactionary perspective of the pages of *Candide*, one projects all impending aggression instead onto the Soviets (fig. 13)—it is clear that the Exposition Internationale des Arts et Techniques, despite the pacific intentions of its French organizers, had become a forum for the expression of dangerous nationalist belligerence. In the Trocadéro gardens, in short, the forces of war threatened to pinch off at its middle the axis of social and military peace demarcated by the Eiffel Tower and the monument to the concord of nations situated in the Place du Trocadéro.

The fragmentation of the Frenchman in the name of international amity thus did more than preclude visitors to the Exposition Internationale des Arts et Techniques from assuming for themselves its character as the embodiment of national omniscience; the French failure in 1937 paved the way for embodied transcendence of a different sort

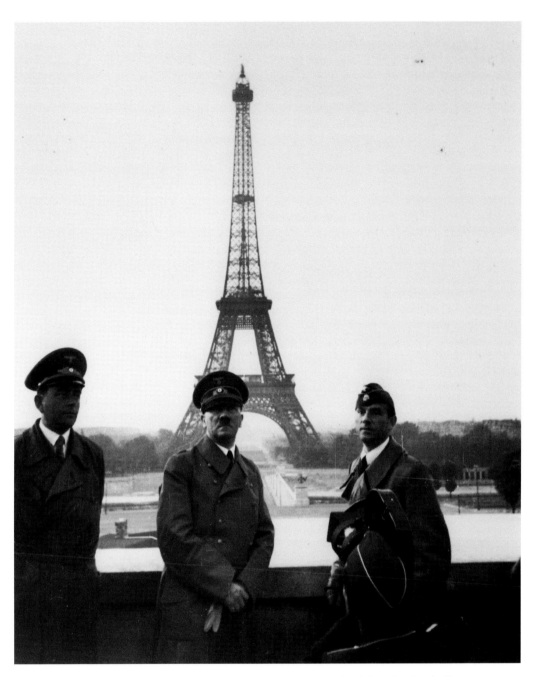

FIG. 14. *Hitler (with Albert Speer and Arno Breker) on the esplanade of the Palais de Chaillot, 23 June 1940. Photo no. 242-HLB-5073-20 from the collection of the National Archives, Washington, D.C.*

of real subject shortly thereafter. Three years following the world's fair, on the morning of 23 June 1940, when he had but three hours in Paris during his only visit to the freshly defeated French capital, Hitler included on his limited itinerary a stop at the esplanade of the Trocadéro (fig. 14). Transfiguring what in 1937 had failed to serve as a French national viewpoint into his own Pan-European but decidedly Germanocentric vision, Hitler claimed possession of the world and its resources. The fascists' ostensible binding of classes together as tightly as a bundle of sticks—achieved, of course, only through the radical exclusion of all manifestations of social difference from the definition of the German polity itself—could purport to draw social harmony out of the past and into the present and future of the Thousand-Year Reich. The National Socialist articulation of a Greco-Aryan race of *Übermenschen* promised to subsume the world's diverse cultural heritage into the glorification of a single, incommensurate nation.

Hitler on the esplanade in 1940 proposed resolutions (frightening ones) to all contradictions formulated by the Exposition Internationale des Arts et Techniques, save one: the most important one, the most productive. The Führer went to the Trocadéro, after all, not just to see from the esplanade, but also to be seen there: a cameraman in the foreground records the event on moving film while the photographer of this picture snapped the still. Hitler viewed the real world from the omniscient platform of the esplanade; he assumed the role of transcendent subject. Yet performing his acquisitive gesture for the witnessing world through these widely distributed images, he also asserted himself as the physical embodiment of the German will to power (phrased in its converse form: the German will to power asserted itself through the specific corporeal form of the Führer). The impossible entity that was Hitler on the esplanade purported, terrifyingly, to incarnate the transcendent subject of *das deutsche Volk*, and thereby set out to master the real world.

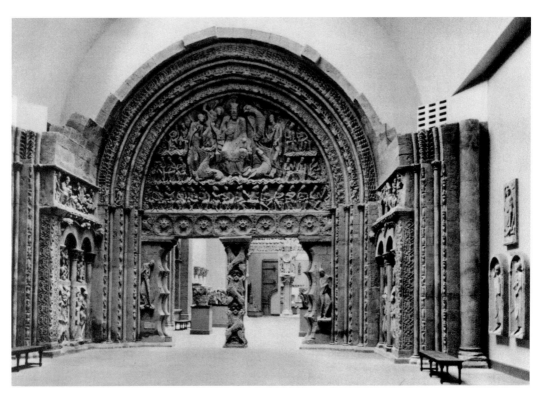

FIG. 15. *Interior, medieval galleries, Musée des Monuments Français.* La renaissance 21 *(August 1938): 14.*

CHAPTER TWO

GODS IN THE MACHINE

———

For a great colonial nation such as France, there is
a capital interest in studying native peoples.
M. H. Ducos, Chambres des Députés,
26 March 1931

Where the commercially oriented and self-consciously contemporary Exposition Internationale des Arts et Techniques would not venture, the two freshly installed and re-christened museums in the Palais de Chaillot, the Musée des Monuments Français and the Musée de l'Homme, dared tread.[1] The Musée des Monuments Français, filled primarily with casts of medieval architectural ornament, evoked the historical past, while the ethnologic Musée de l'Homme presented a series of ostensibly pristine societies isolated from modern Western civilization. These sets of displays stood as the perfect counterparts, respectively the temporal and spatial complements, to a world's fair devoted almost single-mindedly to a celebration of the modern economic activity of the global powers and their allegedly integrated colonies.[2]

The two worlds housed in the Palais de Chaillot that seemingly lay beyond the compass of modern commerce were, nonetheless, credited by the museums that represented them with economies of their own. Indeed, in relation to a depressed global market perceived to be profoundly wracked by imbalances between production and consumption and thereby troubled by the accumulation of onerous surpluses, the precapitalist feudal era conjured forth by the Musée des Monuments Français and the extracapitalist primitive world purportedly on display at the Musée de l'Homme emerged in the late 1930s as model economies ostensibly kept naturally in balance, untainted by surplus. "Kept naturally" is a paradoxical formulation, of course, since an economy "naturally" in balance would have no need to be "kept" in such a state. The two museums in the Palais de Chaillot actuated precisely this paradox, as each posited some regulatory divine

41

force overseeing from outside the seemingly natural economies—economies of goods, economies of signs—they manifested in their galleries. And on this point the logic (and illogic) of the museums rejoined that of the Exposition Internationale des Arts et Techniques, as all three called upon powerful external entities, *dei ex machina*, to maintain—or regain—their respective worlds free of surplus, in perfect balance.

WHERE CATHEDRALS ONCE SPOKE

The extensive reconstruction of the Palais atop the Trocadéro Hill not only mandated a reinstallation of the two major museums housed within,[3] it also prompted the reconception of their missions. Envisioned in the 1870s by an aging Viollet-le-Duc as a means to legitimate the art of the Middle Ages by juxtaposing casts of Romanesque and Gothic sculpture to Greek and Roman copies, the Musée de Sculpture Comparée, which since 1882 had occupied both wings of the old Palais du Trocadéro, had by 1937 rather lost its purpose. Viollet-le-Duc's proposition having been amply demonstrated and the art of the Middle Ages having gained widespread acceptance—so maintained Paul Deschamps, chief curator of the museum during its period of transition in the late 1930s—the casts from French cathedrals no longer required the validation-by-association provided by classical copies.[4] Although allocated a substantial increase in space within the vastly expanded northern wing of the new Palais de Chaillot, Deschamps and his staff, supported by the directors of the Musées Nationaux, decided to devote the newly rechristened Musée des Monuments Français exclusively to casts from the territory of France, now supplemented by painted copies of French frescoes and reproductions of stained glass. The new institution thus appealed to the cultural nationalism of its French spectators. Claimed Deschamps retrospectively about the institution he helped create: "Those who visit the Musée des Monuments Français, after having contemplated so many witnesses of our past, take away from it, if they are French, a deep satisfaction, a kind of pride."[5]

Pride in France, by the argument of the new museum, consisted principally of pride in its medieval past. Though the museum had, since its founding, obtained casts from works dating from later periods and the staff claimed chronological coverage extending into the eighteenth and nineteenth centuries,[6] the core of the collection, revealing its le-Ducian origins, derived overwhelmingly from Romanesque and Gothic edifices. The grandest galleries, those on the ground floor with lofty ceilings capable of housing Romanesque vaults and Gothic spires, were given over entirely to the Middle Ages and early Renaissance, and virtually all contemporary photographs of the museum featured these spaces (fig. 15). Only these halls were unveiled in late August 1937, rushed and provisionally, in order to coincide with the Exposition Internationale des Arts et Techniques; the upstairs galleries of sculptural copies from the late Renaissance and modern period were not opened to the public until months, almost certainly years, after the reinauguration of the Musée des Monuments Français.[7] Visitors to the museum, who were destined, in the words of Deschamps, to "be impressed by the ardent passion of

our artists who during so many centuries have labored for the glory of our country," would in the late 1930s have been "impressed"—like the casts on display, for that matter—exclusively by the art of the Middle Ages.[8]

The medieval casts in the Musée des Monuments Français, in which contemporary viewers could take patriotic pride, connoted a certain vision of the nation. Other cultural definitions of France were, of course, available at the time—they even appeared on the Trocadéro Hill. The uncredited writer of the booklet *La colline de Chaillot et le nouveau Trocadéro*, for instance, located the modernist-classical structure in which the Musée des Monuments Français was housed "firmly in the French monumental tradition and in the harmony of Paris," which was to say, in "the great French monumental tradition of Mansart, Gabriel, Ledoux, Percier, Fontaine, etc."[9] The classical France evoked by such architects was a civilization of absolute monarchs and Corsican emperors, a nation-state where decrees—be they arbitrary *lettres de cachet* or a rational *Code civil*—were handed down from the central authority of Versailles or Paris; the architecturally modern aspects of the Palais de Chaillot claimed for the republican present filiation to this classical legacy of centralization.

The artifacts within the Musée des Monuments Français conjured forth instead an organic society of local parishes and autochthonous lords; this was a world in which the institutions of church and state seemed to reflect directly the local conditions of agrarian production. Joan Evans, a historian from Oxford publishing in 1930 for French readers on the history of their country during the Middle Ages, lauded the grounded nature of medieval society: "The social conditions of the era compelled men to live off the land, rather than by commerce or industry." Hence, continued Evans, "the entire edifice of the State was based on the land."[10]

This hermeticism of the feudal group during the Middle Ages, according to numerous descriptions of the era penned in the 1930s, followed from the simple cyclical character of the medieval economy: with its perfect match between production and consumption, no surpluses could leave the closed system. "Whether it is a question of Negro tribes, of the duchies of the Middle Ages, or of the Greek republics," declared Henry Mandel in a nontechnical monograph on economics published for the general public in 1932, "their economic character is always the same; they are groupings within which the cycle of production and consumption realizes itself without a gap from the collection of solar power in the form of energy or of matter until its utilization and its dispersal."[11] Mandel's formulation, however, somewhat puts the cart before the horse: it was not that the coordination of production and consumption discouraged surpluses, but rather that the impossibility of generating a surplus forced the perfect match of production and consumption. As the noted historian Henri Pirenne claimed in his work of 1927 titled *Les villes du moyen-âge*: "Nothing incited the peasant to demand from the soil a surplus that it would have been impossible for him to dispose of, because he no longer had access to markets" ("no longer"—Pirenne is here assuming the existence of a market economy in classical times).[12] Even the potentially surplus wealth tithed to the

local manor or parish, continued Pirenne, eventually returned to the community: "As a general rule, silver [*argent*] was hoarded by its holders and most often transformed into plateware or into church ornaments, which could be melted down in case of need"— emergencies, undoubtedly, such as the common defense of the populace.[13] No surpluses accumulated, then, in this society where everything produced by the group returned back to it; and with all things tied to the soil, no institution extrinsic to the local community could hope to flourish.

All this changed—so accounts from the 1930s maintained—with the development of cities, national markets, and a new class of urban merchants, the bourgeoisie. In contrast to feudal society where all "wealth . . . is based on landed property," Pirenne argued,

> with the bourgeoisie, a class of men takes its place in the sun, a class whose existence is in flagrant contradiction with that order of things. For it is, in full force of the term, a class of uprooted people. . . . Through this class the possibility of living and enriching oneself through the sole activity of selling or producing exchange values manifests and affirms itself with growing force. . . . A new notion of wealth appeared: that of mercantile wealth, consisting no longer in land but rather in money or in commodities appreciable in money.[14]

The urban bourgeoisie abstracted wealth—in both the literal and the figurative senses of the verb—from its previous rural base. They removed it physically from the countryside, turning cities into vast depots of exchangeable articles. And they transmuted goods, objects of consumption, into commodities, entities of exchange; things within the market, in short, became values. Surpluses, far from being precluded by the closed structure of the economy, constituted the lifeblood of this new class, for the items entering the market were nothing other than—could only be—those goods not immediately consumed at the site of production. Without a series of exchanges intervening between the production of an object and its consumption in use, without the deferral of use through the suspension of excess production in the abstracted category of exchangeable value, the trading class could hardly exist.

Several decades earlier, Marx had, of course, diagnosed this same economic transformation marking the entrance of Europe into its age of capitalism. I turn to Marx not because I believe he articulated some transcendent economic truth, nor because I would claim he directly inspired the economic writers from the 1930s that I cite (although, obviously, in some cases he did). Rather, Marx's nineteenth-century theories, I would maintain, made possible—they constitute a condition of possibility for—virtually all twentieth-century writings on economics, since they opened the door onto a rigorous analysis of the commodity and of the accumulation of surpluses. When, according to Marx, exchange consisted of direct barter or the straightforward trade of one good for another facilitated through the medium of money, production and consumption closely matched each other as people obtained goods with the sole purpose of consuming them. Wrote Marx: "The circuit C—M—C [Commodity—Money—Commodity]

starts with one commodity and finishes with another, which falls out of circulation and into consumption. Consumption, the satisfaction of wants, in one word, use-value, is its end and aim." With the advent of the modern market economy, a new logic came to reign: "the conscious representative" of "the circulation of capital" known as the "capitalist" ventured money into the market to purchase goods not in order to consume them, but rather to resell them for, once again, money: M—C—M.[15] Here again we have, generated by the exchange of surplus goods suspended between production and consumption, the double abstraction of the new economy: commodities in the market, not in the manor; value "appreciable in money" (Pirenne's phrase) rather than in use.

The concept of "surplus," however, takes on a second life within this logic, for no capitalist could ever be satisfied with the conversion of an initial amount of money at the beginning of a transaction into an equivalent amount at its end, the tautological M—M. The capitalist expects a profit. Marx articulated the point: "The exact form of this process is therefore $M—C—M'$, where $M' = M + \Delta M =$ the original sum advanced, plus an increment. This increment or excess over the original value I call 'surplus-value.' The value originally advanced, therefore, not only remains intact while in circulation but adds to itself a surplus-value or expands itself." Thus capitalists not only trade *in* surplus goods, they also trade *for* surplus value—a surplus of surpluses, an ever increasing deferral (in the form of the accumulation of capital) between production and consumption. Unlike the medieval community in which goods and needs ostensibly stood in stable balance, the market in commodities was recognized to be structurally unstable, for it could survive only by constantly expanding, generating ever more surpluses. "The movement becomes interminable," concluded Marx. "Money ends the movement only to begin it again."[16]

In the late 1930s, the contrast between a mythically balanced Middle Ages and an unstable market of commodities manifested itself anew, with the conspicuousness of a monument and the clarity of a polemic, on and around the Trocadéro Hill itself. The Palais housing the Musée des Monuments Français, after all, had benefited from extensive internal renovations and acquired its new façade only owing to its attachment to the Exposition Internationale des Arts et Techniques. Indeed, while the museums inside were not officially part of the world's fair, the new Palais de Chaillot was frequently hailed as the permanent souvenir left behind in the city after the departure of the temporary pavilions from the Trocadéro gardens and the Champ de Mars.[17] And if the Musée des Monuments Français embodied the organic communities of the Middle Ages, the Exposition Internationale des Arts et Techniques represented in microcosm the modern world market. Paul Léon, adjunct general commissioner of the Exposition Internationale des Arts et Techniques, stressed the international character of this showcase of wares destined for trade: "More than forty nations have responded to our call, anxious to show off [*mettre en valeur*] their national economy, on a sales counter exposed to the global clientele."[18] A striking contrast, then, confronted the visitors to the Exhibition as they stood in the Champ de Mars and imagined the contents of the Palais

upon the hill above: on one hand, the hermetic, rural communities of the Middle Ages evoked by the casts of medieval vaults and spires; on the other, a vast arena for international commerce in the heart of a major world metropolis, where all objects—to literalize Léon's idiom—were to be "placed in value."

(Lest I be misunderstood, here or later: we need not ourselves subscribe to this assessment of a hermetic and balanced Middle Ages, nor to that of any of the other ostensibly perfect organic communities projected elsewhere by the disciplines of the late 1930s. It would not prove difficult, I am sure, to uncover myriad instances of wanton surpluses and crippling shortages throughout the medieval era in Europe; the same would be true of any time or anywhere else. Indeed, a basic implication of my general argument would be that the abstraction of surpluses of various sorts remains an ineluctable aspect of the human condition in all times and places, and is not simply reserved for the capitalist era. The point I have been making in the preceding paragraphs—and will continue to make repeatedly throughout this book—is rather that actors in a given historical setting and moment can take cognizance of their own inevitable abstractions and surpluses in part by mythically projecting a lack of these qualities onto a different historical era, or onto some distant and mysterious society.)

In 1937, after nearly a decade of global economic depression, the modern world market that stood in contrast to the seemingly equilibrated Middle Ages was—need it be said?—deeply troubled. Commentators of the day, in fact, frequently characterized that trouble as stemming from an imbalance run amok, a disequilibrium in which surplus production vastly outstripped consumption. Mandel's economic primer, unambiguously entitled *La crise: Ses causes, ses remèdes*, described the woeful state of affairs: "The economic world in which we live finds itself in a disequilibrium unknown before today. . . . The world is helpless, it no longer knows what to do with its wealth, it curses the abundance of riches and is incapable of *distributing* them in a reasonable manner."[19] An "abundance of riches," a surplus of surpluses—this would seem to be the formula for a successfully expanding economy. Except that the only way that value thus extracted from the market could register itself as value—and the only way for the economy to continue to grow—was for that surplus to reenter the market, to begin again the cycle ("the movement becomes interminable") of M—M'. Precisely that recirculation, economic diagnosticians feared, had ceased to occur during the 1930s. Edmond Labbé, general commissioner of the Exposition Internationale des Arts et Techniques, explained:

> The crisis under which we suffer, some have said, is a crisis of confidence. The purchasing power of the mass of consumers has decreased considerably. This decrease derives, in part, from the timidity of capital, from the cautiousness of the capitalists. Periods of crisis are—what a scandal!—periods of hoarding. Everyone well knows that in normal times an industrial enterprise is destined not only to produce certain wares [Marx's C], but also to make the capital that nourishes it bear fruit [Marx's M—M'] National and international competition has made investments less and less "profitable" [«*intéressants*»] less and less "certain." Thus, the crisis in confidence.[20]

Value, abstracted (in two senses) with the invention of the market and the interruption of the seemingly immediate matching of production to consumption, was abstracted yet again when that value left the market and was hoarded instead. Built on an imbalance, the market collapsed entirely when surpluses failed to recirculate and thereby failed to generate more production *and* consumption for the sake of exploiting a new differential between them. Prosperity required that surpluses be returned to the market *as if* there would always be a demand for them—for they ceased to be surpluses, and ceased to hold their value, if they were not potentially consumed. Thus the following constituted Mandel's ideal (*ideal*, I say, because its *immediate* realization would actually kill the market by draining not only all surplus value, but also all surpluses held in suspense between production and consumption, which is to say, all value in exchange): "The main principle, on which depends the prosperity of the economic unit no matter what its state of evolution, is above all the equilibrium between production and consumption."[21] A reequilibration of production and consumption could never be achieved, it needed always to be deferred, but the system depended on that impossible balance constantly being striven after.

The immediate, visible manifestation of the Depression—"the purchasing power of the mass of consumers has decreased considerably"—was, therefore, only a symptom of the lack of the recirculation of capital. But that lack of recirculation was itself but a symptom of a deeper, underlying cause: a lack of confidence on the part of the capitalists. Capitalists, in short, had become misers. Marx had described the relation between capitalists and misers in the following manner:

> Th[e] boundless greed after riches, th[e] passionate chase after exchange-value, is common to the capitalist and the miser; but while the miser is merely a capitalist gone mad, the capitalist is a rational miser. The never-ending augmentation of exchange-value, which the miser strives after, by seeking to save his money from circulation, is attained by the more acute capitalist, by constantly throwing it afresh into circulation.[22]

Curiously, however, this relation reverses itself in time of crisis: realizing that the happy spiral by no means need continue forever, that M did not inevitably enrich itself to become M′, the smart investor withholds his stake. Labbé himself recognized this possibility: "Seemingly, the capitalists' cautiousness is legitimate; inactivity appears provisionally less dangerous than activity; let us await the return of prosperity before we once again place our wealth in circulation."[23] Marx's miser may have been suffering under the illusion that money had value independent of its placement in the market, but the capitalist venturing into the crisis market—into any market, for that matter—was equally deluded in believing his investment was *ipso facto* justified.

Whence—following this line of reasoning—an escape from the crisis of confidence in the market? One could not count on enlightening those capitalists "gone mad," because as actors within the drama of a bad market they were acting with perfect rationality, protecting their vulnerable capital. One needed, rather, to reestablish the delusion that the spiral of M—M′ could continue indefinitely, that the constant enhancement of

surplus value through its circulation in the marketplace was actually headed toward the reequilibration of production and consumption (though, of course, that ever increasing surplus was nothing other than ever greater deferred consumption). One needed, in short, renewed faith—blind faith, perhaps—in the market system itself.

Gods can inspire faith, to be sure—and presumably the divine father of the medieval cathedral rewarded his faithful by insuring the equilibrium of that era's hermetic economic system while punishing those who violated its laws.[24] But Labbé, choosing to phrase his argument in terms of the classical gods rather than the Christian one, was no visionary awaiting divine intervention to preserve the modern economy: "The goddess Prosperity will not miraculously redescend to earth from the mysterious Olympus, where she has taken refuge." Capitalists themselves, no longer mere players inside the market, were to assume this role of the *deus ex machina*, miraculously interceding, as if from outside, to thwart the otherwise tragic outcome of the market in crisis. Entreated Labbé, the prophet of profit: "It is up to the capitalists who are capable of doing it, to take the lead, to support with all their might, before it is to late, the enterprise called France!" And the Exposition Internationale des Art et Techniques—hence Labbé's engagement in these issues—could serve as the celestial chariot by which such gods made manifest their presence on earth:

> In any case, the Exposition will only be able to contribute significantly to the resumption of business, it will only be able to stimulate a measured intensification of exchange, if we gain the confidence of capitalists—producers and nonproducers alike. . . .
>
> Today, when a "psychological shock" and the "return to confidence" are constantly the question of the hour, the Exposition of 1937 appears as an attempt at galvanization, capable of provoking in all branches of labor and industry that fruitful emulation, that step forward along the path of progress, that would mark, if not the return to the Golden Age, at least a significant attenuation of the crisis.[25]

As an alternative to reestablishing faith in the market in this manner, Marx and his followers in the twentieth century would have exploited the market's contradictions in order to imagine the complete and final abolition of its extraction of surpluses. Here the dramatic paradigm would be not the *deus ex machina* of Euripides's *Medea* but the vengeful Furies of Aeschylus's *Eumenides*; the chorus of the working class demands a realignment of the balance, in this case not of justice but of production and consumption, so that ideally goods might pass spontaneously (in Marx's famous phrase) "from each according to his abilities, to each according to his needs."[26]

Despite their differences, the capitalist and Marxist lines of thought nonetheless shared the fantasy of a better world—precluded certainly by the current crisis, if not by the market system itself—that could achieve an equilibrium of production and consumption, a perfect circulation of goods. And each counted on some actor external to the market itself—the capitalist demigods descending from above, the vengeful masses welling up from below—to rectify current imbalances. Someone, in either case, was

called upon to act; gone were the days when a beneficent Christian God simply oversaw a society seemingly preserved in balance by its nature alone.

The organic society of the Middle Ages evoked by the Musée des Monuments Français was thus, from the perspective of visitors to the Trocadéro Hill in 1937 who were anxious about the economy, not so much something realized within the museum as something lost from the world. Passing the Musée des Monuments Français as they traversed the *Entrée d'honneur* of the Exposition Internationale des Arts et Techniques between the two arms of the Palais de Chaillot, visitors descending to the exhibition below retraced the path of history: in the words of the title of François Simand's economic monograph of 1934, *De l'échange primitif à l'économie complexe*.[27] The Middle Ages were something left behind; regretted perhaps, perhaps (from a Marxist or liberal perspective) censured for its hierarchical social structure, but in any case irrevocably sunk into the recesses of the past. The modern world no longer lived by the principles of hermetic recirculation; it no longer counted on gods Christian or classical for its well-being; it had released its grasp on the ostensibly natural balance of production and consumption that characterized the medieval community. And thus the Musée des Monuments Français represented the lessons *forgotten* from the past. "These churches that spoke through their thousands of characters in stone or in stained glass," lamented the renowned historian of medieval art Emile Mâle with an old man's regret, "these churches . . . [are] no longer listened to by anyone."[28]

In the Musée des Monuments Français, the medieval world was placed at a remove in a second manner as well. "One should note the very special character of the Musée des Monuments Français," explained Deschamps; "it contains no original works. Only copies appear there, as exact as possible and in the precise dimensions of the originals."[29] The pretense that one could survey the cultural riches of the provinces without leaving Paris, that, in the words of Deschamps, "art lovers will be able, in a few steps, to take their tour of France,"[30] depended on the duplication, the reiteration, of the authentic original so that it could be viewed in the city without disturbing its fundamentally rural roots. The museum, in casting its replicas, thus produced surplus copies of an organic provincial essence, and that surplus—as with the commodity—was abstracted in both the literal and the figurative sense. The forms of medieval portals and tombs were transported from the countryside to the urban center; thus, from the perspective of the museum visitor, a spatial distance from the medieval essence complemented its temporal remove. "In spite of the perfection of their presentation, one senses that [the casts] will always miss their native atmosphere," Jean Maréchal demurred in *Le petit parisien*: "Detached pieces, they seem to regret the edifice from which they were separated."[31]

More intriguingly, the Musée des Monuments Français transmuted physical objects—actual, material chunks of carved stone at Maubuisson or Moissac—into dematerialized representational forms. The projected inclusion within the museum of a subsection devoted to "materials," such as sample stone fragments from various regional quarries, reinforced the strong conceptual bifurcation within these walls between the

physical presence of a unique material thing and the reproduction of its iterable form: *les matériaux* were visibly abstracted from the casts and placed elsewhere within the galleries.[32] Certainly the casts on display did possess material substance—so much plaster (to be precise, plaster of Paris)—but that substance was of no import in the displayed replica since it lacked the essence, the material essence of the original. The form captured in the cast, abstracted from the source and constituting a surplus in relation to it, was all that counted in the Musée des Monuments Français—so that if any one cast were perchance to crumble it could be replaced by a new replica without regret. Indeed, an object's status as a copy stemmed not from its derivation from an original but from its character of being in surplus to it. "Please take note," insisted Deschamps, "that certain of these copies, either casts or paintings, have assumed the value of the original, since the authentic works have been destroyed."[33] With the unhappy loss of the original, the copy took up the role of the unique, authentic object.

Precisely this same difference between single original and iterable copies characterized the abstraction of the (medieval) good into a (capitalist) commodity. A peasant in the mythic medieval community consumed an actual loaf of bread, unique and specific; the urban merchant traded in wheat (an abstract collective noun), and it made no difference which actual kernels of grain constituted his tradable holdings. In order to enter the market, in fact, all material things had to become immaterial "values"—again, a form of surplus—so that they could be exchanged on commensurate terms. As Marx wrote: "The exchange of commodities is evidently an act characterized by a total abstraction from . . . the material elements and shapes [of] the product. . . . Its existence as a material thing is put out of sight."[34] The existence of a sculptural cast as a material thing was likewise put out of sight when this surplus form entered the representational field of the Musée des Monuments Français, a replaceable and thus exchangeable sign for a now absent authentic medieval essence.

The stones of the cathedrals may have spoken of hermetic communities, of balance without surplus, of presence without abstraction; but in the Musée des Monuments Français that voice could only be heard across the distance of time and the screens of surplus erected by the market economy and by the very process of replication. That voice could be heard only as the trace of a loss, an echo of a more perfect society reverberating through a modern world marked, it seemed in contrast, by absence and disequilibrium. The Christian God had departed, and, in 1937, all were awaiting some other restitutive actor from outside.

MAINTAINING ETHNOLOGIC INTEREST

Let us then, in the shoes of the visitor of 1937, step out of the Musée des Monuments Français, traverse the esplanade of Palais de Chaillot overlooking the Exposition Internationale des Arts et Techniques, and approach the new southern wing of the Palais. What do we find here? Nothing, actually; the doors are locked. Budget constraints and labor disputes have delayed the opening of the promised new galleries of the former

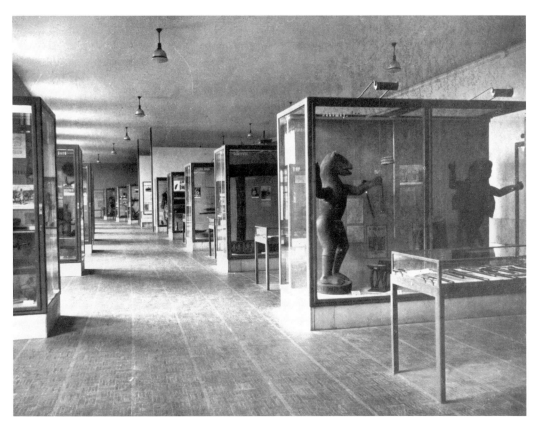

FIG. 16. *Interior, African galleries, Musée de l'Homme.* La renaissance 21 *(August 1938): 18.*

Musée d'Ethnographie. During the run of the Exposition Internationale des Arts et Techniques, the world explored by the ethnologist proved even less accessible than the civilizations studied by the medievalist.

By the following June, however, the doors of the newly rechristened Musée de l'Homme had swung open, revealing row upon row of vitrines filled with ethnologic displays.[35] Commencing with anthropological and paleontological galleries explicating in parallel the phylogenetic and ontogenetic origin and development of humans,[36] the museum gave over the greater part of its space to a continent-by-continent survey of cultures ostensibly authentic and stable, not yet buffeted by the forces of history. Not surprisingly the rooms devoted to Africa, believed to be home to many such cultures, assumed pride of place at the beginning of the circuit (fig. 16).

Here in the Musée de l'Homme the constraints that distanced the organic communities of the Middle Ages within the Musée des Monuments Français appeared to dissolve away, for the museum had the effect of drawing the past forward, out of the recesses of time and into the present. With remarkable ease, countless commentators in the 1930s, writing specifically about the museum or more generally about the type of African societies on display there, confused living cultures perceived to be untouched by history

FIG. 17. *Field photograph, Mission Scientifique Dakar-Djibouti, tempera mural, church of Saint Antonios, Gondar, Ethiopia. M[arcel] G[riaule], "Peintures abyssines,"* Minotaure, *special issue no. 2 (1933): 88.*

with the prehistoric origins of the modern West.[37] Paul Rivet, director of the Musée de l'Homme and parent of its transformation from the Musée d'Ethnographie, may have wished to disown this widespread retrospective interpretation,[38] but the galleries within the museum, where the progression of the geographic rooms beginning with Africa appeared to reiterate the chronological development of species and individuals presented in the introductory vitrines, clearly reinforced the sense that Africa preserved in the present humanity's collective past.

A refinement of this perception, situating the continent in the period preceding modern history rather than before history *tout court*, had Africa incarnate Europe's medieval era. We have already witnessed Mandel equate "Negro tribes" with "the duchies of the Middle Ages." Paul Perrin, a deputy for the city of Paris, fleshed out this concept in 1933 in his call for an international conference addressing Euro-African relations:

> While the Greco-Latin civilization soared upward almost without interruption until the present, Africa, as if stricken by an abrupt lethargy, saw its most advanced peoples immobilize themselves at a stage hardly more advanced than the Middle Ages.
>
> . . . Except in some isolated cases where Europeans have artificially introduced the seed, all concepts whose appearance postdates the Renaissance are more or less absent from the Dark Continent.[39]

Artifacts from East Africa and from Africa north of the Sahara were especially suscepti-
ble to this assessment. Thus the tempera murals from Gondar (fig. 17), sixty square me-
ters' worth obtained in Ethiopia in 1932 by the Mission Scientifique Dakar-Djibouti
which were hailed as among the treasures of the museum,[40] could be characterized by
the art critic Jean Gallotti in the following terms: "Everything here still has the rigidity,
the conventionality, the absence of modeling of the Byzantine High Middle Ages; every-
thing appears to date still from before Giotto; these religious images, posterior to Ber-
nini, have not yet been influenced by the Renaissance." The medieval world lost in the
Musée des Monuments Français, it seemed, was still living in Africa and thus could be
recaptured in the present in the Musée de l'Homme. The paintings from Gondar, con-
cluded Gallotti, were "at the same time archaic and recent."[41]

Much as the Musée de l'Homme overcame the chasm of time, so too it collapsed the
distance—gaping wide in the Musée des Monuments Français—between authentic ob-
ject and Parisian gallery. This was no museum of casts and reproductions; the vitrines
featured genuine artifacts gathered in foreign lands and distant colonies. The murals
from the church of Saint Antonios in Gondar present an especially elucidating case.
Whereas the curators of the Musée des Monuments Français left the medieval original
in its inviolable French site and brought the copy to Paris, members of Mission Dakar-
Djibouti persuaded local authorities in Ethiopia (so, at least, claimed Gaston-Louis
Roux, a painter attached to the expedition) to accept Roux's copies—reproductions ex-
ecuted in more durable oils—in exchange for the fragile tempera originals "acquired"
for the Musée de l'Homme.[42] The surplus generated by the replication of the image re-
mained behind in Africa; Paris obtained the authentic item (fig. 18).

More than simply the material objects traveled from remote parts of Africa to the
French capital. The ostensibly premodern societies from which they came had purport-
edly never passed through the various stages of capitalist development. Perrin, after
claiming that "all concepts whose appearance postdate the Renaissance are more or less
absent from the Dark Continent," proceeded to specify: "In particular that of capitalist
exploitation and the class conflict it engenders, and that of nationalism."[43] Mythically
harmonious groups, then; but also groups unburdened by the abstractions of the mar-
ket, the transmutation of material things into immaterial values.[44] Thus artifacts from
such societies—much like medieval objects—appeared to reflect directly, without sur-
plus, the material lives of their makers; they constituted a record of actual use rather
than of the detached speculations of exchange. "Each object speaks," enthused André
Dennery in his review of the reopening of the Musée de l'Homme in 1938, "since it is
shown, one could say, in activity; it is in the position of its use."[45] The *Instructions som-
maires pour les collecteurs d'objets ethnographiques*, a pamphlet issued jointly by the
Musée d'Ethnographie and the Mission Dakar-Djibouti, likewise presumed that arti-
facts unerringly expressed the activities of their source cultures. Advising researchers in
the field that "objects of daily use have an interest at least equal to that of objects of lux-
ury," the *Instructions sommaires* explained: "Almost all aspects of communal life are
capable of expressing themselves in certain objects, as a result of that drive that has al-

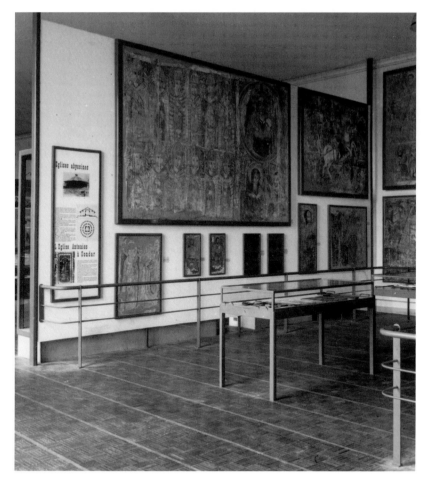

FIG. 18. *Tempera murals from the church of Saint Antonios, Gondar, Ethiopia, as installed in the Musée de l'Homme, 1939. Photo from the collection of the Musée de l'Homme, Paris.*

ways pushed men to impress into material things the trace of their activity. . . . There is no human activity that is not, in some regard, material, because it is a human drive to materialize everything."[46] With the distant culture ingrained ineluctably into the object of use gathered by ethnographers, the culture itself became directly present in the museum when the authentic artifact was placed on display.

Thus the Musée de l'Homme, one could believe, obliterated the barriers of both time and space, of economic and representational surpluses alike, to bring the authentic cultures of nonmodern societies to life in the heart of the modern metropolis. "If the idea of the museum too often reeks of boredom," began Magdeleine Paz's rave (and wonderfully overstated) review of the Musée de l'Homme in 1938, "that is because in practice it usually situates itself outside of time and outside of space." Claiming to have sampled all great museums of Europe and the Americas, Paz despaired: "I have not departed from any one of them without feeling, very strongly, a sense of separation from real

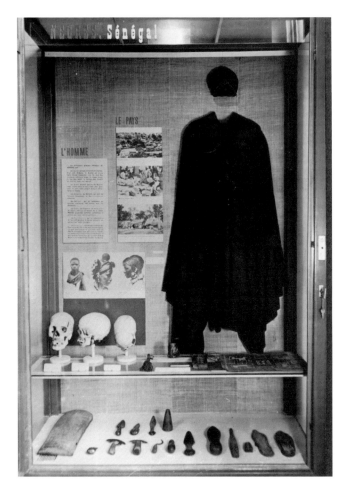

FIG. 19. *Vitrine, African galleries, Musée de l'Homme, 1942. Photo from the collection of the Musée de l'Homme, Paris.*

life." Only the Musée de l'Homme offered her respite: "Finally, finally, we enter here into a museum that, far from distancing us and cutting us off from multiform human life, engulfs us in its mystery, imposes its rhythm on us, restores its plenitude to us."[47]

And yet, paradoxically, precisely the focus on the quotidian utility of displayed objects simultaneously undercut the sense that remote cultures could attain full presence within the Musée de l'Homme. The artifacts resting in their sanitized vitrines were not, after all, actually being used at the time by the peoples who created them. In order to substantiate its contention that the inert objects expressed activities from their source cultures, therefore, the museum needed to document those objects in use; it needed to replicate the social context of the artifact. And that it did, "surrounding" (*entourer*, the verb of choice for commentators describing the practice) the ethnographic object on display with long explanatory texts, didactic graphics, and photographs taken in the field (fig. 19); enormous topographic maps of the continents and synthetic panels sum-

marizing "recent hypotheses formulated by experts" introduced and concluded each section.[48] More than any other change, such contextualizing devices distinguished the new Musée de l'Homme from the Musée d'Ethnographie of the pre-Rivet era, "full of heteroclite objects" but lacking any rigorous explanatory material.[49] Through the inclusion of supplemental information, explained Georges-Henri Rivière, Rivet's assistant director during the years leading up to the museum's reinstallation in the Palais de Chaillot, the museum strove to "restore" the artifacts in the vitrines "to their social setting."[50]

This reconstitution of an object's social context, however, allowed maps, graphics, and detailed texts to overwhelm the artifact, drawing away the attention of visitors. "Before taking interest in the exhibited objects," marveled René Benezech in his review of the new installation, "there is something that strikes even the uninitiated visitor. That is the method used for their presentation."[51] Surrounded by documentation, moreover, the artifact easily became a "document" itself, presented not for its own intrinsic interest but as a "witness" (*témoin*) of some distant culture.[52] As Jean Jamin has written about the Musée de l'Homme in the 1930s: "Since the ethnographic object is defined as a witness, the issue is, of course, to know of what, for what, if not for whom, it bears witness. . . . In this respect, the study of the museum collections only make sense in relation to that territory for which the object serves, for all intents and purposes, as the *pretext*: the object introduces it, testifies about it, illustrates it."[53] The museum-goer thus encountered in the Palais de Chaillot not the non-Western culture itself but a complex, multimedia representation of it. The new object of study—now the culture, not the artifact—receded into absence while only the method of explication—a product of French scientists, not indigenous peoples—remained present in the Musée de l'Homme. And that method of explication exemplified a type of scientific rationality— "a rational arrangement of work areas and a considerable task of classifying, identifying, and sanitizing the existing collections," in the words of André Dezarrois, a writer for *La revue de l'art* and a curator for the Musées Nationaux—lacking in both the source cultures and in the former Musée d'Ethnographie.[54] Concluded the journalist Georges Jubin, surprisingly: "The Musée de l'Homme . . . is . . . a fine intellectual manifestation of modern France."[55]

The Musée de l'Homme, in short, abstracted representations out of source cultures. Once again, I intend "abstraction" here in both of its senses: dematerialization into surplus form, and actual physical removal. In the Musée de l'Homme, moreover, the two senses imbricated in a potentially scandalous manner. The museum, in a first sense, replicated within its own halls an image of the social forms of a given society; its scientific method produced an immaterial reiteration (in the sense in which the casts of the Musée des Monuments Français were immaterial) that stood in surplus to the original. Accordingly, the artifacts on display, like the texts and graphics surrounding them, could replace one another in the task of representing an absent culture: "the most modest products of human industry are no less evocative than are the others," remarked one re-

viewer.[56] These objects *qua* documents were as interchangeable as the sculptural casts *qua* reproductions within the Musée des Monuments Français, as exchangeable as commodities *qua* values within the market. As it had been in the Musée des Monuments Français, the abstraction of unique things into exchangeable forms was troublesome enough in its own right: the method of presentation, predicated on the excess of a surplus, violated in principle the supposed organic hermeticism of the culture thus presented. This violation, here as there, meant nothing less than the loss of direct access by modern civilization to its seemingly authentic roots.

The problem only compounded in light of the second sense of abstraction, that of physical removal. The documentary displays in the Musée de l'Homme had the effect of projecting the source culture outward, far from the museum: *there*, where the photograph was taken; *there*, in the place designated on the large map. The vitrines, implicitly measuring that absence against the presence of their contents, thereby articulated a spatial displacement: the transportation of knowledge from an organic African community to the French metropolitan center. Within this process (in contrast to abstraction as the transmutation of things into exchangeable signs), not all items within the vitrines were commensurate, for whereas the maps and texts had removed only the surplus form from the source community, the artifacts—there was no getting around this fact—had been removed materially. In this regard, the extraction of artifacts to the Musée de l'Homme resembled less the lifting of casts for the Musée des Monuments Français than it did the appropriation of commodities from the countryside to the city at the mythic moment of the emergence of capitalism. Hence the emergence of the potential scandal: the museum could be seen to violate not only in principle but also in fact the hermeticism of the idealized organic community. In extracting objects of actual use, the ethnographer ran the danger of disrupting the perfect match between production and consumption that ostensibly characterized noncapitalist societies. The museum risked actuating in the field, not just representing in its galleries, the loss of a world without surplus.

As if in response, a great deal of rhetoric hovering around the Musée de l'Homme had the effect of extenuating such scandals—indeed, the best evidence we can have of a potential scandal successfully averted is the traces left by the efforts taken to cover it up. These efforts for the most part centered on the figure of the ethnologist, exculpating the activities of ethnographers in the field and granting ethnologists great responsibilities back in the scientific laboratory of the museum.

Ethnographers in the field did not remove objects of use from their closed and perfect circuit of production and consumption, it was purported, because they collected only objects already used up and discarded. "In excavating a pile of refuse, one can reconstitute the life of a society in its entirety," advised the *Instructions sommaires*,[57] and indeed field ethnographers claimed to discover the truth about the peoples under investigation by sifting, like so many tabloid journalists, through their garbage. The pronouncements of the Mission Dakar-Djibouti of 1931–33, charged with collecting eth-

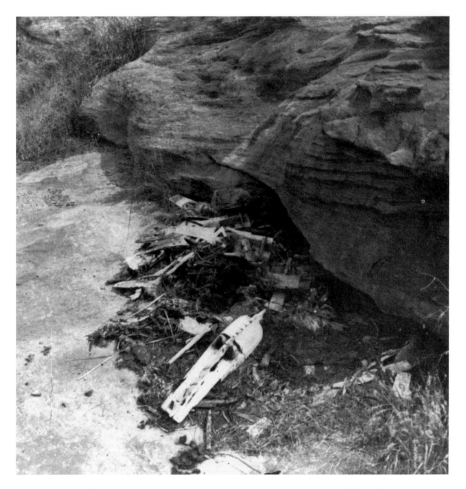

FIG. 20. *Field photograph, Mission Scientifique Dakar-Djibouti, published with the caption: "Used-up masks, abandoned under a rock." M[ichel] L[eiris], "Masques dogon,"* Minotaure, *special issue no. 2 (1933): 51.*

nographic objects for the Musée de l'Homme and copublisher with the museum of the *Instructions sommaires*, exemplify the conceit. "The masks reproduced in these pages were in active use [*en activité*] when the mission procured them," maintained Michel Leiris, a member of the expedition, in his article of 1933 on Dogon masks; this point conformed with the idea that cultures best expressed themselves in their objects of use. And yet after forwarding this claim, Leiris immediately shifted tack: "Nevertheless, the Degue mask was found in a cave and the Ka mask . . . in one of those rock holes where the Dogon customarily leave used-up masks [*masques usagés*] to rot or disappear, eaten by termites"[58] (fig. 20). Implicitly *all* masks were but one step from termite fodder—we can imagine ethnographers procuring masks immediately after a ceremony (Leiris's *masques en activité*) in the legitimating belief that, from the perspective of the Dogon, the objects were now *usagés*. The Africans, seemingly, did not value their masks as

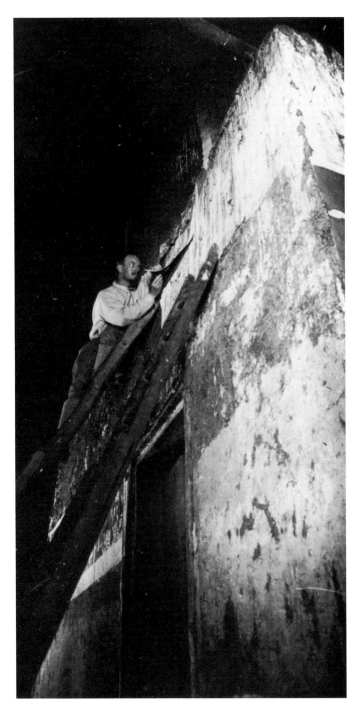

FIG. 21. *Field photograph, Mission Scientifique Dakar-Djibouti,
captioned: "... Marcel Griaule ... removing the north wall of the
church [of Saint Antonios]." Photo from the collection of the
Musée de l'Homme, Paris.*

precious objects worth saving—they produced no aesthetic surplus, they accumulated nothing[59]—and thus the acquisition by others of their purported discards in no way disrupted the economy, symbolic or material, of their ritual life.

Or, consider again the case of the murals from Gondar. The expedition obtained these paintings, we have seen, through the *de facto* establishment of a rudimentary market in which two items of ostensibly equal value, authentic originals and durable copies, were exchanged freely (so Roux purported) between parties. Yet, at the very least, the need to provide replacement images constituted an implicit acknowledgment on the part of the expedition that the originals still held some value for the Ethiopians, that they were still of some use to them. Ethiopian authorities, moreover, may actually have perceived the substitution as something other than an equal exchange. Leiris's diaries of his time as a member of the expedition reveal that, following the mission's removal of the murals (fig. 21; which, however, in the diary account the paintings seem self-reflexively to do to themselves: "The paintings of the Antonios church continue to peel themselves off," I translate literally; in French, *s'enlever*), the ethnographers' departure from Gondar was blocked pending the resolution of charges that, among other things, they had "lacerated" the Antonios paintings—which, Leiris admitted, had been "cut up so that they could be transported." Fearing a retaliatory "massacre," members of the expedition resorted to burning some incriminating wooden altarpieces in their possession and secreted the mural fragments in such places as the false bottoms of crates.[60] The equal exchange had degenerated into a flagrant act of smuggling, and the Ethiopians in Leiris's account came to assume the role of the chorus of vengeful Furies, demanding justice in the face of inequities inflicted.[61]

Whether or not the trade in the field was fair, however, held little consequence back in Paris during the public presentation of the murals in 1933, one of Rivet's early triumphs as he assumed the helm of the Musée d'Ethnographie. The exchange of copies for originals all but unmentioned, the expedition appeared to salvage abandoned paintings from the neglect of the natives. In the account of the murals penned by Marcel Griaule, head of the mission (and, in fact, one of Roux's amateur assistants conscripted into duty when the professional painter became overwhelmed by the task of producing sixty square meters of copied canvas on short order;[62] fig. 22), the switch appears only in a counterfactual hypothesis, invisible to anyone not already in the know: "In the current state of the country where misery gains ground every day, these paintings were doomed to rapid destruction; and even if better days had come, the paintings would have been ripped apart and thrown away in order to make room for modern works."[63] The Ethiopians, numerous reviews of the Parisian exhibition of murals recounted, could not be bothered to rescue their religious paintings when their rudimentary mud-and-thatch churches fell, quickly and inevitably, into ruin;[64] "an old thing," Griaule assured his readers, "has no value [to the Ethiopians] except that attributed to it by the incomprehensible Europeans."[65] Hence the remarkable conclusion—far indeed from the image of ethnographers in fear for their lives desperately dissimulating their acqui-

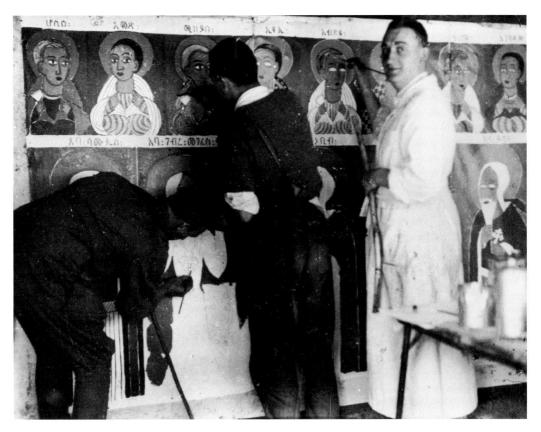

FIG. 22. *Field photograph, Mission Scientifique Dakar-Djibouti, captioned: "Marcel Griaule, E. Lutten, and G. Roux execute copies of the paintings of Saint . . . Antonios . . . July 1932." Photo from the collection of the Musée de l'Homme, Paris.*

sitions—reached by Jean Gallotti in his review of the show: "The ease with which the residents of Gondar let [the church of Saint Antonios] be stripped proves that they no longer attached any worth [*prix*] to it. And we can be glad, with no qualms, to see the frescoes that decorated it now sheltered in a more solid sanctuary."[66] *Sans scrupules*: we can see in this phrase the trace of the scandal finessed.

Once the ethnographic artifact had, in Marx's phrase, "fall[en] out of circulation and into consumption" and then beyond consumption into waste, the ethnographer found himself acquiring objects returned to the realm of nature, no longer engaged in the social sphere. Appropriately, contemporary descriptions of the ethnographer's activities "in the field" depended heavily on agricultural (or preagricultural) metaphors. The Mission Dakar-Djibouti had—in the overwhelming verb of choice—"reaped" (*récolter*) artifacts in its swath across Africa;[67] the less frequent but still common use of "harvest" (*moissonner*) reinforced the image.[68] In an even more basic operation, Griaule and compatriots were routinely seen to "gather" (*recueiller*) items; this appears to have been Griaule's own favored term.[69] Together with the "license for scientific cap-

ture" (*permis de capture scientifique*) issued to Griaule by the Ministry of Colonies,[70] the verb transformed the mission into a band of simple hunter-gatherers. Such a vocabulary turned back the clock not only on the ethnographers, who appeared as producers of the precapitalist variety, but also on the mode of economic analysis implied. In the manner of the Physiocrats (predating Adam Smith, let alone Karl Marx), wealth—in this case a wealth of scientific documents—derived exclusively from the land, not from the exploitation of people.[71]

Wealth from the land, then, but wealth nevertheless; and if the potential scandal of bald appropriation in the field had been cultivated away, the danger of the accumulation of a surplus in the city—a surplus of the scientific forms of knowledge—remained. Artifacts housed in a museum, especially, ran the risk of being abstracted from circulation. Fretted Michel Leiris in 1938 about the new name of the Musée de l'Homme (he's setting up a straw man): "One can ask oneself if there is not a contradiction in terms, inasmuch as this word 'man' appears surprising when placed against the dismal term 'museum,' for this latter word commonly designates the cold place where are found those objects that man is proud to have produced but that continue to exist only for their own sake, separated from him."[72] The museum, in short, risked hoarding its artifacts, removing its accumulated knowledge from human use.

If the ethnographer was a producer in the precapitalist manner, then, he needed an appropriate consumer to maintain the balance of production and consumption and thereby forestall the accumulation of surplus knowledge. The Musée de l'Homme, driven in large part by the political sentiments of the Popular Front, found that consumer in the common people of France. Whereas the old Musée d'Ethnographie was frequently decried for failing to attract visitors,[73] the new Musée de l'Homme aspired to distribute its resources widely, to, in the words of Leiris, "facilitate contact between specialist and museum-goer [*usager*]" (you can hear his straw man falling).[74] The ethnologist and socialist Jacques Soustelle, a vocal advocate of the museum's populist program and in 1938 the successor to Rivière's post of its assistant director, proclaimed in 1936:

> Parallel to the great political and social movement of the Popular Front, or rather constituting only one of its aspects, a vast cultural movement is unfolding in our country. Its motto could be this: let's open the gates of culture; let's demolish the walls that surround, like a beautiful park forbidden to poor people, a culture reserved for a privileged "elite." . . .
>
> We must lay claim to the heritage of culture, in order to make of it a collective good. . . .
>
> It is a fact: an admirable instrument remains unused. . . . The people of France do not want to allow themselves to be held away any longer from the cultural treasures accumulated by the nation.[75]

Ethnologic knowledge was to be put to use. It could—Leiris again—serve as the "concrete base for a new humanism";[76] or it could be marshaled, as it was by the critic J. Millot, to the laudable Popular Front goal of fighting fascism:

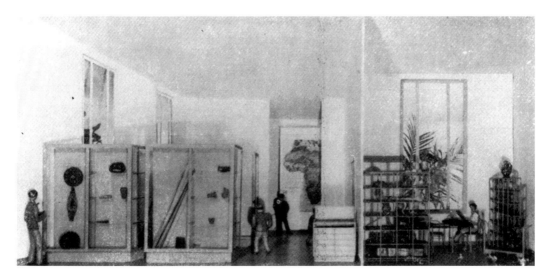

FIG. 23. *Maquette of proposed arrangement of galleries and laboratories at the Musée de l'Homme, displayed in the museological section of the Exposition Internationale des Arts et Techniques dans la Vie Moderne Paris 1937. L' amour de l'art 18 (June 1937): 21.*

> At a moment when, in certain of the most powerful nations of the world, ethnic mystique has reached its apogee, and when race, having become an idol, crushes the individual and dominates all spiritual and moral values, the Musée de l'Homme is here to demonstrate to all that the seeming diversity of human beings covers over a profound unity, that every original culture has its value and its merits, that even the most modest forms of life and civilization are not by consequence the least respectable, that, finally, there is no race that can legitimately arrogate for itself the right to disdain the others.[77]

Regardless of the specific end for which they were utilized, the "accumulated cultural treasures" of the new Musée de l'Homme were not meant to languish *hors d'usage*: a vast audience of Frenchmen and Frenchwomen awaited, ready to consume the "collective good" (*bien*, the word as productively ambiguous in French as in English) constituted by the objects on display.

The layout of space within the Musée de l'Homme—a topic generating significant journalistic treatment—reinforced the sense of a clear but balanced division between the production and the consumption of knowledge. "Of the 15,000 square meters reserved for the [Musée d'] Ethnographie, only 5,000 or 6,000 are open to the public," reported the pamphlet entitled *La colline de Chaillot et le nouveau Trocadéro*. "The greatest part is reserved for the 'departments,' which is to say, sections specializing in the study of a part of the world."[78] A maquette of the projected Musée de l'Homme in cross section showing public gallery and private laboratory cheek by jowl (fig. 23), on display in the museological section at the Exposition Internationale des Arts et Techniques, tipped the balance somewhat more in favor of gallery space, but the argument remained essentially the same: the avid public learning its populist message about the

unity of humanity stood in perfect complementary relation to the specialist working in the museum's laboratory producing that message—conserving objects, classifying them, comparing them, researching their source cultures in the library and in the photographic archives. Just as striking as the sharp bifurcation of space in the maquette is the proximity of the resulting compartments. Knowledge passes from its realm of production to its arena of consumption through the simple and immediate means of traversing a thin interior partition.

Together, then, the scientist studying artifacts in the laboratory and the museum-goer perusing vitrines in the galleries personified a model organic market for the circulation of ethnologic knowledge. In the Musée des Monuments Français, where the "greatest portion" of space constituted one enormous "department of public exhibition" with no significant room for laboratories, cathedrals from another time spoke on their own,[79] and—as Mâle bemoaned—no one listened: the truth about medieval society was neither produced nor consumed in contemporary Paris. In the Musée de l'Homme, experts—in the words of Adrien Fédorovsky, head of the laboratories at the museum, quoting his teacher Marcel Mauss—"kn[e]w how to 'make speak'" objects from another place, and a populist audience, in perfect correspondence, digested the words.[80]

And yet, here was the rub: the knowledge presented by ethnologists at the Musée de l'Homme may have been used by its audience, but it wasn't used up. Information embodied by the artifacts on display did not "fall out of circulation"—again, Marx's terms—with its reformulation into, say, an antifascist message. The abstraction of material things (*objets*) into forms of knowledge (*documents, témoins*) left a surplus of information—a surplus not depleted by a single act of use—in the ethnologist's hands.

What to do with this surplus? Simply coveting existing knowledge for its own sake would constitute an act of hoarding, similar to enjoying the possession of the coins of money while doing nothing with them. What to do with this surplus, except to reinvest it? "The collections only assume their full value through the research projects that they prompt," insisted Rivet and his staff in 1935. "This makes indispensable institutions where each [specialist] can present his ideas and the results of his research . . . [where] specialists . . . can exchange ideas."[81] Beyond its application to the ideological exigencies of the populist crowd, the surplus of knowledge entered a new marketplace of ideas where it circulated among experts. This group of experts, moreover, did not need to be limited to ethnologists working in the home country; knowledge could also be sent back to the colonies. The *Instructions sommaires* promised: "Ethnography . . . brings to the methods of colonization an indispensable contribution by revealing to the legislator, to the civil servant, and to the colonist the customs, beliefs, laws, and techniques of native populations, making possible a more fruitful and more humane collaboration with these populations, and leading thus to a more rational exploitation of natural resources [*richesses naturelles*]."[82] We should not be overly reassured by this reference to *richesses naturelles* rather than *humaines*, however, since—according to Lucien Lévy-

Bruhl, the elder statesman of the French sociological community and cofounder with Mauss and Rivet of the Institut d'Ethnologie in 1925—"the most important of the natural resources [once again, *richesses naturelles*] of the colonies," which ethnographers could "contribute to develop [*mettre en valeur*]," was nothing other than "the native population" itself.[83] Armed with the discoveries and methods of scientists trained or working in the laboratories of Paris, French colonists and ethnographers in the field alike could generate new information about native peoples.

Knowledge about non-Western cultures circulated in order to produce . . . more knowledge about non-Western cultures. Knowledge could fall out of circulation once and for all, could become obsolete, only if it was supplanted by new knowledge—more knowledge, better knowledge—generated by the successful venturing of the initial share. Among professionals, then, the abstracted forms of science functioned less like goods being passed between producers and consumers (Marx's C—M—C) than like capital accumulating through its interminable movement in and out of the marketplace (Marx's M—C—M′). I by no means wish to draw this parallel on a figurative level alone; consider the return on investment forecast by the *Projet de loi* authorizing funds for the Mission Dakar-Djibouti: "Endowed with the necessary resources, such an enterprise will be able, methodically and on the spot, to assemble collections of a value much greater than the sums dispensed."[84] The value of such objects (*mis en valeur* by ethnologists, no less)[85] lay in their interest, the ever increasing differential between, shall we say, K and K′—where, to paraphrase Marx, "K′ = K + Δ K = the original knowledge advanced, plus an increment." Capitalists and scientists alike strove to accumulate a surplus of surpluses by maximizing the interest to be derived out of the exchange of things. The *double entendre* works even better in French than in English: *l'objet ethnographique*, I would like to conclude with the knowing nod of a speculator, *c'était une chose vraiment intéressante*.

It follows that the realm of science where ethnologists sought interest was marked by the same structural instability as characterized the marketplace where capitalists worked to increase their capital. The willingness of capitalists to venture into the market, we have seen, depended on the faith that M would, more times than not, augment itself to become M′; Marx revealed the illogic of this concept when he quipped that with interest-bearing capital, "money . . . is worth more than money," that "value . . . is greater than itself."[86] I argued earlier that for the market to thrive, and especially to draw itself out of crisis, the capitalist therefore needed to do more than speculate as an actor within the market. He also had to embody, in the manner of the *deus ex machina*, faith brought to the market from outside that guaranteed it could always expand without limit.

The ethnologist at the Musée de l'Homme, in a similar manner, had to fill two roles. A speculator in knowledge, he also had to provide assurance that knowledge would never reach its end, that it would never exhaust its subject. Our hyperventilating reviewer Paz was one keeper of the faith: "It felt as if God the Father were taking me by

the hand and guiding me, from gallery to gallery and from station to station, across the light-years, by showing me with his fabulous finger, the mysteries of the creation, and the enormous work of the six days."[87] André Dennery, an enthusiastic reviewer at the time of the reopening, was another; the vitrines in the Musée de l'Homme, he argued, have "brought together fascinating documents that, the more they are detailed, compared, and annotated, the more they appear to conceal enigmas and mysteries. And these enigmas and mysteries, although veiled, are going to multiply themselves throughout the world, throughout all these other vitrines."[88] The greater the scientific discoveries, the more new enigmas emerged. The professional ethnologist, creator of rational displays and clear systems of classification, simultaneously embodied the irrational faith—irrational since the truth of the concept could never be ascertained from *within* the realm of science—that a perpetually mysterious world would always exist *beyond* the practices of ethnology to justify its investments, to guarantee the discipline ever greater returns of knowledge.

Allow me therefore, finally, to speculate: the Musée de l'Homme, far from reconstituting the organic precapitalist societies it claimed to present in its galleries, replicated instead the structures of the modern capitalist economy to which it pretended to offer an alternative. The many roles of the ethnologist—as he evolved from the natural "reaping" producer, to the provider of useful ideological goods, to the speculator in scientific interest, to the *deus ex machina* interceding to perpetuate returns on investment—retraced the mythic development from precapitalist community to modern economy, replete with its abstractions and potentially problematic surpluses. The realm of science embodied in the ethnologic museum atop the Trocadéro Hill, however, kept the faith where the economic arena represented by the Exposition Internationale des Arts et Techniques in the gardens below could not, for the discipline of ethnology had not been shaken to its core, as had the business community, by the disillusioning prospect of limited returns. Perhaps in 1937 Labbé would have been better advised to look for his *deus ex machina*, his "psychological shock," within the Palais de Chaillot rather than in the Champ de Mars. If the Musée des Monuments Français spoke (to no one) of a civilization of balance irretrievably lost to a modern society abandoned by God, the Musée de l'Homme exemplified (to many) a realm of abstractions that seemed, nevertheless, in the hands of the ethnologist to manage its surpluses to great profit.

To great profit, certainly; but also with the entailment of a concomitant loss. These ethnologists, unlike the various visitors to the esplanade of the Palais de Chaillot in 1937 who repeatedly witnessed the transcendent nation fleeing off elsewhere, could in their specialized discipline indeed lift themselves into the celestial spheres of the gods. They could, within their own professional realm, occupy that mobile spot at the ever receding terminus of abstraction and omniscience, the corresponding spot for which always eluded those souls-*cum*-bodies who during the world's fair looked down on the Champ de Mars and up to the Eiffel Tower. And yet these souls at the Exposition Inter-

nationale des Arts et Techniques—impossibly, at least provisionally—*did* have bodies; they could see themselves, seen from an abstracted elsewhere, staking a claim for actual presence within the material world, so many living and breathing consumers within a global market which, seen from on high, did manage to possess some attributes of the real. To the extent that ethnology left the dirt of ethnographic fieldwork in favor of the sanitary laboratory, to precisely the degree to which the likes of Griaule and Leiris ceded control over the organization and circulation of the knowledge they produced to men of Rivet's station, the discipline of ethnology abandoned its hold on the gritty stuff consti-tuting its ethnographic material foundation. Or, rather, it projected that essence of the real far away indeed, explicitly into that elsewhere beyond the realm of modern society defined by the major Euro-American nations and their colonies, implicitly into that other time preceding the integration of that world through its myriad imperialist link-ages. Places and times, in short, into which no contemporary Parisians floating high within the rarefied ethers of scientific knowledge and compounding economic value could even provisionally aspire to drop themselves. Transcendence beyond the field of ethnologic exchange found itself perfectly mirrored by a corresponding retreat from that same field, as if in the opposite direction, by the hard kernel of the material. Ethnol-ogists, in becoming gods, gained their souls and mastered their investments; it cost them only the body of the real.

ENTR'ACTE

POINT OF EXCHANGE

———

ART APPRECIATION

In 1930, at the beginning of the decade during which, as Rivet's deputy director, he would assist greatly in the transformation of the Musée d'Ethnographie into the Musée de l'Homme,[1] Georges-Henri Rivière published in the *Cahiers de Belgique* an article whose title promised all the pugnacity of a polemic: "De l'objet d'un musée d'ethnographie comparé à celui d'un musée de beaux-arts." And, indeed, the essay in its opening sentences wastes no time setting up two opposed camps, the artistically inclined facing off against the ethnographic professionals: "Ever since certain groups of ethnographic objects—in particular African and, later, Oceanic sculptures—were added to the realm of artistic curiosities some years before the war owing to prodding from artists of the School of Paris, a chasm has opened between the public converted to this taste and the curators of ethnographic museums."[2] Across this chasm, Rivière's words seem to portend, would be fought the battle over the proper manner in which to appreciate the ethnographic object.

Rivière's own post at the ethnologic museum would appear to have cast him as a partisan of the scientific cause, rather than the artistic one. On its credit line the journal identified him as a "deputy director at the Muséum National d'Histoire Naturelle," an affiliation only recently won for the museum at the Trocadéro when Rivet engineered its transfer in 1928 to bring it under the umbrella of the Ministère de l'Instruction Publique—away from its previous home under none other than the Ministère des Beaux-Arts. (The move from Beaux-Arts to Histoire Naturelle had, in fact, liberated the funds necessary to pay for Rivière's appointment as the first deputy director in the history of the previously underfunded institution.)[3] By these lights, it was only fitting that the loyal administrator direct his barbs against those viewers who dreamt of a purely artistic presentation of the artifacts—as Rivière phased it, of "a Louvre for . . . all the beautiful works of primitive art." Rivière mocked:

On mahogany pedestals, in splendid isolation, basking coquettishly in the most refined lighting, carefully depilated, trimmed, stripped, and polished, the masterpieces of Fang, Polynesian, and Aztec art (to mention only those most in fashion) would present themselves. Guide-poets would break out in dithyrambs, and teams of copyists would prepare to distribute to the four corners of the world the aesthetic of the primitive that regenerates.[4]

The artists of the School of Paris and their followers, indifferent to the myriad ethnographic discoveries concerning the meaning and use of the artifacts within their source cultures, attended strictly to the physical characteristics of the objects. While this attitude may have granted the objects a respect, not to say reverence, that Rivière felt was their due, it also insured that that appreciation could manifest itself only according to the precepts of a fashionable—Rivière's words imply faddish—primitivizing aesthetic of purely Occidental origins. Artists indulged in a neoromantic, solipsistic fascination with their capacity to appreciate that which the West wished to find in other cultures, and Rivière's text ridicules the resulting twaddle of formulaic poetry and hack visual copies.[5]

Given this bout of scathing wit, it comes as something of a surprise to discover that Rivière's article takes ethnographers—or more precisely, ethnographers of a previous generation—equally to task. And on matters artistic, no less. Such museum administrators, Rivière charged, "fail to discriminate between the *artistic* and the *nonartistic* and brutally mix, in an absurd bazaar, monuments of art equal or superior to those of Praxiteles and Verocchio with the most contemptible products of human industry."[6] The previous custodians of the Musée d'Ethnographie in Paris—for these were the true target of Rivière's critique—fundamentally lacked the capacity to assess the relative aesthetic merit of the objects they had assembled. This shortcoming, moreover, carried consequences much beyond the artistic realm. Not to evaluate the objects, not to discriminate between them, ultimately meant that the curators developed no real sense that the artifacts they had blindly amassed held any value at all, and Rivière regarded the resulting neglect of the collections a scandal. It was bad enough that the museum administration had failed to install a scientific apparatus capable of producing knowledge out of its materials, or to attract visitors sufficiently prepared to consume its lessons;[7] the "lamentable disgrace" that was the old Musée du Trocadéro could not even fulfill the minimal mandate to preserve the physical substance of its artifacts. "Within the shadowy interiors of display cases that are as practical as sarcophagi," complained Rivière, "dryness or humidity, dust, mites and worms zealously busy themselves with the slow but certain destruction of the collections."[8] Treated as without value and thus never properly exploited—*sans valeur et ainsi jamais mis en valeur*, as the French would have it, capturing a parallel missing in the English—the ethnographic objects at the old Musée d'Ethnographie fell into waste.

Intriguingly, Rivière's description of the old-school ethnographer in 1930 corresponds less, within the *dramatis personae* of Chapter 2, to the ethnologist at the Musée de l'Homme during the late 1930s—producer for a Popular Front audience, scientific

speculator, *deus ex machina* maintaining interest—than to the Dogon tribesmen encountered by the Mission Dakar-Djibouti in the early 1930s, who allowed their masks to rot in caves. The old museum, in fact, emerged within Rivière's account as just one more dark grotto where *objets usagés*, having passed through the seemingly natural cycle of production and consumption, having left the closed material and spiritual economies of indigenous use, deteriorated into nothingness. Whether in sub-Saharan Africa or within the dusty halls of the old Palais du Trocadéro, the factor allowing that deterioration was the same: the lack among original producers and ethnographers alike of the ability to abstract a lasting value from the objects in their hands; in a word, their shared inability to appreciate the artifacts.

On this score, Rivière's artists from the School of Paris actually fared rather better than his old-school ethnographers. The artists, at least, knew enough to appreciate the ethnographic artifacts—which is to say, they knew how to abstract value.[9] That which they had abstracted from—and valued in—these material objects was, to be sure, the "aesthetic of the primitive that regenerates" derided by Rivière. Yet Rivière's scorn stemmed from the solipsism implied by the word *régénérateur*—it was Europe, after all, that was being given new life, Europe for whom the revivifying act of cultural appropriation was being performed—rather than from the process of aestheticization itself. To differentiate and set off an aesthetic quality from the physical object in which that conceptual form materializes itself constituted, for Rivière, an intellectual accomplishment of no small merit, an accomplishment that distinguished Occidental observer from African or Oceanic observed. "In a primitive society of the past or the present," he argued,

> beliefs, customs, laws, and techniques are so closely conjoined that it is illusory to treat them separately. . . .
>
> As a result the aesthetic sentiment, which we tend to differentiate to an ever greater degree [a footnote here adds "art for art's sake"], in some sense to secularize, circulates in primitive societies, like blood in the body, closely linked to customs, to religion, and to material objects. How many thousands of years and miracles were necessary to arrive at the concept of a painting, whether a genre scene or a Cubist picture, considered in its own right as a work of art![10]

If old-school ethnographers shared with Dogon tribesmen an inability to abstract the idea of value from the material object, the artists of the School of Paris accordingly much resembled the ethnologists of the new Musée de l'Homme: both groups (I repeat my earlier formulations from Chapter 2) "abstracted representations out of source cultures" as they "dematerializ[ed]" ethnographic artifacts "into surplus form." Both groups, whether formulating scientific theories or fomenting aesthetic regeneration, appreciated the object for some quality that outlasted its immediate practical use.

This similarity of practice is more than simply a happenstance that I, from a position of historical hindsight, choose to abstract from the historical material of more than half a century ago. Rivière concluded his article in 1930 by revealing the necessary link he

wished to forge between aesthetic appreciation and ethnologic speculation: "From the abundance of legal, religious, and economic objects, and even from objects that appear to be of the most humble utility, we must extract aesthetic characteristics. It is up to the Musée d'Ethnographie to explicate these characteristics, to situate them, to restore them to their social setting."[11] The new style of ethnology, the type of ethnology that Rivière and Rivet would be laboring over the course of the coming decade to realize at the Musée de l'Homme, distinguished itself from the earlier discipline of ethnography owing to this assimilation of the aesthetic sensibility into its method: from artists the ethnologists could learn how to "extract"—I would say "abstract"—the lasting quality of value that made possible, beyond the simple accumulation of things, an assessment, a comparative discernment, an appreciation of the collected artifacts.

Rivière's program calling for the incorporation of the aesthetic into ethnology specifies a second step, as important as the first. Abstract aesthetic characteristics, by all means, Rivière insisted; but then "situate them . . . restore them to their social setting." Here the new ethnologist departed from his brethren of the School of Paris, for where the artists fell into the trap of discovering only themselves in their aesthetic abstractions, the ethnologists had the means—acquired from the established protocols of ethnography, no less—of reengaging the source cultures that had produced the material artifacts. Because indigenous societies lacked the capacity to abstract the aesthetic, and ethnography before ethnology's incorporation of the aesthetic likewise never distanced itself from the moment of original use, the artifact now in the custody of the new-style ethnologist still offered a seemingly direct window onto the truth of indigenous beliefs and mores. Thus Rivière's new ethnologists could both value the artifact as art by abstracting themselves from it *and* apprehend the character of the source culture through an investigation of the object in which social practice and aesthetic were selfsame. They could, in short, appreciate not just the object as plastic form, but also the society that produced it as social form—a society which solipsistic artists couldn't see and which old-school ethnographers couldn't appreciate. Despite the polemical pretense with which it begins, Rivière's article concludes by thus conjoining the ostensibly antithetical disciplines of art and ethnography into the common cause of ethnology.[12]

This confluence of aesthetic appreciation and ethnography, each properly conceived, entails an intriguing consequence. If the sort of ethnologic knowledge presented at the Musée de l'Homme by 1938 derived its means of abstraction from the mechanism of aesthetic appreciation, it should follow that the aesthetic held many of the same properties as the epistemic economy of ethnologic knowledge. The science of ethnology, I argued earlier, engaged in speculation: it expected a certain return on its investment—"the original knowledge advanced plus an increment" was my reformulation of Marx—when it ventured, over and again, into the marketplace of scientific investigation. Applying this same economic logic to the actors in Rivière's article from 1930, we could say that old-school ethnographers play the role of the precapitalist barterers who redistributed goods without ever abstracting value—value being money in one case,

and the aesthetic in the other. The artists of the School of Paris who interested themselves in ethnographic objects, correspondingly, behaved like misers when they tucked aesthetic value, like so many gold pieces, beneath the mattress of their own cultural maxims, failing to recognize that value can exist only when it continues to accrue through repeated speculations back into the material whence it was abstracted. And, like Labbé's confident businessmen reinfusing France with needed capital, like the Musée de l'Homme's scientists venturing their accumulated knowledge back into field research, Rivière's new-style ethnologists emerge as the heroes of their drama, reinvesting the aesthetic they had abstracted back into the material of ethnography.

It will be the reigning hypothesis for the second half of this book that in this manner the aesthetic, as it manifested itself in specific exhibitions of art in the late 1930s, did more than authorize the appreciation of the things from which it was abstracted; it also existed only to the extent that it enhanced in value, that it appreciated in its own right. I will be exploring the possibility that, though often presented as an eternal and immutable verity, the aesthetic in the exhibitions I examine constituted a form of surplus abstracted from its material, an unstable surplus caught in a constant cycle of speculation, and subject, like the other surpluses we have encountered, to the same potential crises of mismanagement and unanticipated returns.

In claiming this, however, I have rather exceeded the bounds of the analogy I initially extracted from Rivière's writings; for, once I have severed the necessary link between a material base grounded in the ethnographic and the abstractions of the aesthetic, certain pressing and fundamental questions arise. What does it mean to regard the aesthetic as a surplus, if that surplus is not to stand over and against the solid foundation of the ethnographic object? Surplus, in that case, in relation to what? What would be the field, if not that of ethnography, from which the aesthetic abstracts its forms? In what material marketplace—this is, in essence, the same question as the last—must the aesthetic reinvest in order to accrue value? (I do not mean this query in its usual pedestrian sense of financial return.) And, in the specific cases I examine, for whom, for what causes, did the aesthetic pursue its speculations? What interests were served by the aesthetic's compounding of interest?

Imagine[13] you and I were to strike out together across a busy avenue, when suddenly I were to shout: "Look out, a fire truck's comin'!" Hearing my warning you would presumably step back on the curb to safety. This exchange would constitute a linguistic transaction of seeming primal simplicity: I produce a message, you consume the information, and we both go about our way without taking any special notice of the medium through which the useful communication has occurred. Imagine if, however, in that same situation I were the poet William Carlos Williams and uttered: "*I saw the figure 5 in gold.*" You might well still give my warning heed and act upon it, to no small benefit to yourself. But after the speeding vehicle had passed we would both be left with some lingering awareness that a linguistic event of some gravity had transpired. We would both recognize the special form taken by that message, and our recognition of that

form, registered in our memory, would survive its moment of practice use. Unlike the information it imparts, the form isn't used up in the act of communication; we and others can appreciate its value after the fact.

I am, of course, here setting up a contrast between two linguistic economies, or, to generalize in such a manner as to admit the consideration of visual images, two semiotic economies. The former might be considered a "primitive" economy ("primitive" in the sense in which Rivière uses the word, in the sense evoked by the economic historians in Chapter 2 who described feudal society before the advent of capitalism), a mythic economy seemingly preceding (but in fact projected backward by) the abstraction of value or, to say the same thing in different terms, the appreciation of form. Here words such as "fire truck" and "comin'" are taken to correspond exactly with that to which they refer; analogically, images such as family snapshots can be, and in practice most often are, regarded as recording directly the real lived experiences of the people portrayed. We have previously encountered homologies for such a semiotic economy not twice, but thrice: not only in Marx's description of precapitalist mechanisms of exchange, not only in Leiris's account of the Dogon and in Rivière's depiction of old-school ethnographers, but also, in Chapter 1, in the beguiled voices at the Exposition Internationale des Arts et Techniques taken in by the fantasy of a complete and proximate world seemingly embodied directly by the assembled artifacts on the Champ de Mars.

The latter semiotic economy, in contrast, allows for the appreciation of a formal value abstracted from the practical use of language, and I would venture to label the register in which that act of appreciation takes place as "the aesthetic." Once the process of abstraction and appreciation commences, moreover, it becomes virtually impossible to return to a state of naïveté and not recognize, in any given example of communication, the form taken by the message:[14] the regional colloquialism of the elided "g" in "comin'," the predictable conventions of framing and lighting in the amateur photograph. Once again, we have seen homologies for this sort of complex economy: Marx's capitalists abstracting value that accrues out of the cycle of production and consumption, savvy new-style ethnologists at the Musée de l'Homme appreciating social form as they accumulate ever more scientific knowledge, the transcendent subject receding ever more from the field of visual interchange across which the Exposition Internationale des Arts et Techniques represented the commerce between producers and global clientele. Value, scientific knowledge, the disembodied subject, the aesthetic: all outlast, all claim to transcend, the passage of things in exchange—be that exchange economic, epistemic, visual, or semiotic.[15]

Within the aestheticizing process, the recognition of the inevitable mediating role of semiotic signs has the effect of projecting the world thereby signified beyond the representational field itself, projecting it elsewhere. Indeed, we may regard the real world considered as such—as a material entity existing prior to and independent of subsequent acts of representation—to be nothing other than this projection generated by the aesthetic's permanent disruption of the neat closure of the "primitive" economy of

semiosis. We have already seen this logic at work, when the fantasy of full presence gave way to the hard skepticism about the adequacy of the goods on display at the Exposition Internationale des Arts et Techniques, and when real ethnographic artifacts in the field transmogrified into representative "documents" within the vitrines at the Musée de l'Homme. But if the introduction of the sign sends the real world fleeing elsewhere, the aesthetic itself proves equally elusive. A surplus in relation to the material world from which it is ostensibly abstracted, the aesthetic can accumulate beyond all bounds, beyond all attempts to grasp it. This can happen—allow me to hypothesize—in one of two ways, each corresponding to one of the processes I described in the previous two chapters.

First, like the transcendent subject at the Exposition Internationale des Arts et Techniques, the aesthetic can never embody itself without immediately generating a new level of disembodied transcendence. Consider, as a case in point, the Cubist collages of Picasso. Art-historical scholarship has long built the argument, an altogether convincing one, that these pictures are principally an extended meditation on, and confoundation of, the standard pictorial means of Western representational painting: perspectival recession, anamorphic distortion, chiaroscuro modeling, the conventions of framing, of overlap. Picasso—the argument runs—recognized, even appreciated, the nature of these devices and with that greater insight made pictures working not within but rather on, as if from outside, the aesthetic of representational painting. Yet once Picasso's ideas realize themselves in his assemblages of paper and glue ("realize": make themselves real, project themselves beyond the realm of the semiotic into the material), it becomes possible to meditate on *their* pictorial means, to ruminate on the aesthetic of Picasso's ruminations on the aesthetic. The scholarship on Picasso constitutes precisely this sort of secondary meditation—though it has emerged as somewhat of a convention in the recent literature to attribute semiotic prowess to the transcendent subject Picasso, with whom the skilled scholar, like some visitor on the esplanade of the Palais de Chaillot looking up at the Eiffel Tower in 1937, then aspires to identify by replicating, and appreciating, the artist's sophisticated semiotic moves. In whichever manner the aesthetic materializes—as Picasso's paintings about Western painting, as scholarly words about Picasso's pictures, in the corporeal person of Picasso, in that of the scholar—a new level of disembodied appreciation of the aesthetic of that embodiment of the aesthetic awaits to push the transcendence of the aesthetic one step further away.

Second, if the aesthetic, like ethnologic knowledge at the Musée de l'Homme, can hope to realize its value only by reinvesting in the material world, each such venture holds the prospect of ever greater aesthetic returns. The capacity to appreciate the plastic form of things only increases with the consideration of ever more cultural material, ever more originality. I have been maintaining that during the late 1930s thinkers across a number of disciplines shared the common concern that surplus value in its various abstracted forms was not, in fact, being properly returned to the realms from which it was extracted, and this anxiety extended to the world of art. Listen, for instance, to Paul

Baudouin's wide-ranging yet not atypical diagnosis of the "French Problem" appearing in the *Revue de Paris* in February 1938. After fretting that "the stability of the economy" had been lost in the modern period owing to the replacement of "fortunes based on material things" by abstracted "fiduciary signs for which purchasing power is variable," after complaining that with "the development of the mechanical sciences" over the past century "man, in distancing himself from himself, has ceased to distinguish that which exists as real," Baudouin expressed a similar worry about the practices of art: "The Occident has betrayed its mission by fleeing from reality. . . . The tendencies of modern art have underlined this break with the permanent, which is to say, with life. Art is no longer the expression of the polis, even less is it theological instruction. The artist lives apart from the public; he is outside of social life."[16] Undoubtedly, Baudouin is here troubled by precisely the sort of abstracted and single-minded interest in artistic matters seemingly personified by Picasso and his like. As we have seen during our consideration of the Musée des Monuments Français, this writer was not alone during the 1930s in fantasizing about an impossible return to a "primitive" economy of semiosis appropriate to the ancient Greek and medieval worlds, devoid of all abstracted surpluses economic or otherwise. Nevertheless other theorists, as we shall see in subsequent chapters, proposed a variety of manners in which the abstracted aesthetic could be ventured back into life without being folded back fully into its materiality and thereby abolished. And here the aesthetic promised to appreciate to the greatest extent, to offer the greatest profit for a diversity of causes. Here, too, the scandal of an ever increasing surplus loomed large, and here the volatility of the abstraction most threatened to undo such happy returns.

Part Two of this book will explore specific instances from the late 1930s of such productive—and not so productive—ventures of the appreciating aesthetic, as it both returned continuously to the marketplace of semiosis and receded ever further from view. Works of visual art, we shall see, proved a remarkably efficacious means for such speculative activity. In part, because the act of seeing what a picture revealed—and not seeing what it concealed—reliteralized, in a spectacular fashion, the visual dimension already present in the concept of speculation; one ventures out of oneself in looking at a picture, and hopes to gain something in return. In part, also, because the unstable properties of the aesthetic I have been describing in this Point of Exchange, this passage between chapters, so closely resembles the character of certain entities of great political and social consequence likewise engaged in activities of speculation and appreciation, to whose interests the compounding powers of the aesthetic could be brought to bear. Two such entities which we have already encountered in Part One, the transcendent nation of France reinvested in the body of the "Frenchman" and the godlike subject personified by the ethnologist who intervened to guarantee a safe return of scientific knowledge, will each reemerge in new guises in Part Two. Chapter 3, addressing the two art exhibitions entitled the Chefs-d'œuvre de l'Art Français and the Maîtres de l'Art Indépendant held at the periphery of the Exposition Internationale des Arts et Techniques during its

run in 1937, examines the confluence of art and nation during a period when frightening developments across the Rhine potentially challenged many unquestioned French presuppositions about the nature, and proper location, of national identity. In Chapter 4, I regard the Exposition Internationale du Surréalisme, mounted in the private Galerie Beaux-Arts in January and February of 1938, as in part a parody of all the global posturing struck by the exhibitions and museum installations that preceded it in 1937 (and in this book); nevertheless, the exhibition also provided a forum for a high level of speculation—surspeculation of the abstracted aesthetic back into the surreal, as it were—that potentially defined an individual of seemingly surhuman powers. Except in the quite rare and extraordinary case where transcendence is scapegoated elsewhere, where the view from outside is willfully abjured, both nation and human subject in the end will emerge not as essences grounded in the material—though they will both on occasion pose as that—but rather as that which appreciates through and as art, in a constant cycle of transcendence and engaged speculation.

PART TWO

IN THE GALLERIES OF ART

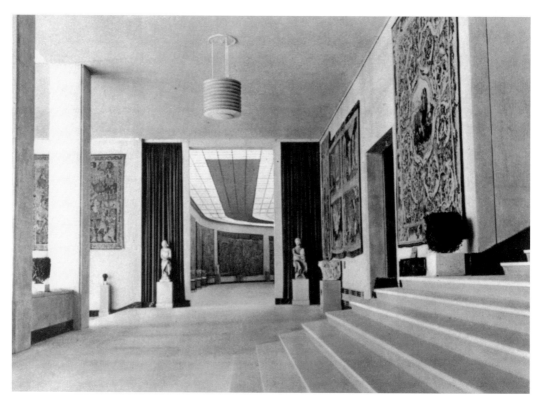

FIG. 24. *Entrance foyer, Chefs-d'œuvre de l'Art Français. Edmond Labbé,* Rapport général: Exposition internationale des arts et techniques dans la vie moderne, *11 vols. (Paris: Imprimerie Nationale, 1938–40), vol. 2, pl. 73a. Photo courtesy of the Getty Research Institute, Resource Collections.*

CHAPTER THREE

THE FRENCH MASTERPIECE

———

The national sentiment has become so widespread
and so familiar that no one considers
investigating the motivations behind it. . . .
The impression of familiarity indicates simply
that analysis has come to a halt.

Henri Lefebvre, *Le nationalisme
contre les nations*, 1937

It was an afterthought, no doubt; but it carried great exigency. At the end of 1936, the Socialist prime minister of the Popular Front government Léon Blum surveyed the preparations for the upcoming Exposition Internationale des Arts et Techniques, and detected a gaping hole in the program. At a world's fair devoted to marshaling the resources of nation and globe, no place had been reserved for what was widely perceived to be a virtually unrivaled domain of French strength: the accumulated heritage of the fine arts. A team of prominent cultural officials, enjoying the sanction of the highest reaches of government and able to draw upon the expertise of the curatorial staffs of the Musées Nationaux, quickly assembled to redress the deficiency. By late June of 1937, barely half a year after Blum's mandate and only a month after the official opening of the Exposition Internationale des Arts et Techniques, a massive retrospective exhibition of over thirteen hundred works of French art spanning almost two millennia opened in the west wing of the Palais de Tokio, a structure erected anew for the world's fair along avenue Wilson on the Right Bank just upstream from the Palais de Chaillot. The Chefs-d'œuvre de l'Art Français, in the words of the minister of national education and fine arts Jean Zay, offered "a census of our national artistic wealth."[1]

Though prompted by the Exposition Internationale des Arts et Techniques, the Chefs-d'œuvre de l'Art Français remained peripheral to the fair itself; peripheral in sev-

eral senses. The exhibition possessed its own entrance beyond the compound of the fair, and charged separate admission.[2] Its retrospective sweep transgressed the fair's strict temporal commitment to products and activities of "modern life"; several commentators labeled the exhibition a "preface" to the Exposition Internationale des Arts et Techniques.[3] And, of greatest significance, this collection of priceless masterpieces, borrowed from museums and collections from across the country and around the world, were certainly not to be mistaken for objects on sale: the timeless realm of art seemed to float above the more mundane commercial concerns of the world's fair mounted in the Champ de Mars.

I argued in Chapter 1 that the visual dynamic of the Exposition Internationale des Arts et Techniques projected the transcendent subject of the nation elsewhere, beyond the boundaries of the exhibition grounds. How fitting, then, that the nation could take up relatively secure residence in these halls outside the fair proper. Abel Bonnard of the Académie Française directed his readers: "Frenchman, you who search through the exhibition for the soul of your country, there is a place where it radiates, where it triumphs, where you will find it without fail: at the museum where the masterpieces of French art are reunited. Here the name of France seems to be written in stars."[4] In this space, it might seem, would be tested the proposition that "French" was a compelling and meaningful adjective to attach to the noun "Art," that the nation achieved a certain definition, a particular unity, through its collection of "Masterpieces."

Except that that proposition was not so much tested at the Chefs-d'œuvre de l'Art Français as it was simply swallowed whole. Despite the voluminous body of commentary generated by the show, despite the obvious critical temptation to measure the realizations of the display against its pretensions, to demonstrate one's own cleverness by outflanking the presuppositions announced in the exhibition's title,[5] virtually no published account went on record without tacitly accepting from the outset the notion that the Chefs-d'œuvre de l'Art Français expressed or embodied, in a more or less unproblematic manner, the nation of France. Criticism is hardly the word for this breed of laudatory writing; celebration more accurately captures its tone.

Just here, where the nation seemed most familiar, where (as Lefebvre would have it) analysis had come to a halt, we need to investigate with most care the formation of nation.[6] The Chefs-d'œuvre de l'Art Français, in essence, posed a question: "What makes art French?" or conversely (and the potential equivalence of these two queries will require some probing) "What makes France? Art?" While a great web of words could be spun in response—with, as we shall see, rather meager results, in any analytically productive sense—a major task, perhaps the most important one, had already been accomplished simply through the universal and silent assent that "nation" was indeed the right question to put to "art," and "art" the correct question to ask of "nation." And yet in 1937, when from French soil one could witness the growth of a competing nationalist sentiment of frightening belligerence across the Rhine, the very foundations of what constituted a country, a people, a nation—and when and why these entities developed pathological characteristics—urgently demanded reconsideration. Around the

Chefs-d'œuvre de l'Art Français, then, we will witness the paradoxical coupling of a Gallic cockiness about the absolute legitimacy of the French cultural enterprise, together with a deep underlying anxiety that the Germans, not the French, might somehow have gotten it all, horribly, right.

THE MEASURE OF PAINTING

In one important sense, the Chefs-d'œuvre de l'Art Français did not exist at all: virtually no one saw this exhibition. Which is to say, while thousands of spectators streamed through its galleries and nary a journal or newspaper of general or artistic interest failed to opine at considerable length about it, the exhibition as a specific method of presenting its materials attracted no sustained commentary. A complaint or two against the architects of the new structure for their failure to admit sufficient light into the galleries more or less accounts for the full critical assessment of this exhibition's installation (with one exception, about which more later). The practice uniformly followed in all periodicals that illustrated the exhibition through photographs—which were copious, routinely numbering half a dozen or more per review—exemplifies the journalistic conceit: the camera moved in close to the work, cropping the frame of a painting or the background behind a sculpture, editing from view the arrangement and manner of display. One cannot even be sure that the photographs for the retrospective were taken within the exhibition—indeed, we can be quite certain that most, shot previously in some photographic studio or another, were not. Photographers and writers alike treated the exhibition as a transparent medium, like the small quantity of air between lens and canvas, through which to see the real objects of attention: the works of art.

It was not as if contemporary professionals in the fields of journalism and museology were incapable of evaluating an installation, of recognizing the mediating mechanisms inherent in the public display of objects. The scientific rigor and pedagogic efficacy of the vitrines at the Musée de l'Homme, as we have seen, generated as much critical enthusiasm as their contents. Descriptions and illustrations of interior spaces and displays within the national pavilions at the Exposition Internationale des Arts et Techniques ranked second only to accounts and pictures of their external façades. And just across the courtyard from the Chefs-d'œuvre de l'Art Français in the east wing of the Palais de Tokio, the museological section of the Exposition Internationale des Arts et Techniques, in addition to displaying maquettes of various designs for museums and galleries from around the world,[7] mounted a model installation of the works of van Gogh—not for the sake of enhancing the glory of the already canonized Dutch modernist, but in order to parade before the public the accumulated skills of exhibitory practice that qualified as a "modern technique."

The Chefs-d'œuvre de l'Art Français solicited no such acknowledgment of its means; the installation tended, rather, to efface its own interpretive devices. A photograph of the entrance foyer of the exhibition (fig. 24) happens to capture just the spot where the circuit of the exhibition begins—"the visit commences to the left of the landing of the

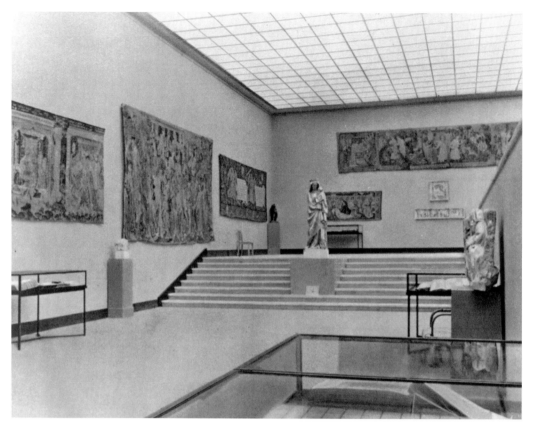

FIG. 25. *Hall 4, Chefs-d'œuvre de l'Art Français. Edmond Labbé,* Rapport général: Exposition internationale des arts et techniques dans la vie moderne, *11 vols. (Paris: Imprimerie Nationale, 1938–40), vol. 2, pl. 73b. Photo courtesy of the Getty Research Institute, Resource Collections.*

main stairway," pronounced the official *Guide topographique*[8]—yet no didactic panel offers an introduction to the approach or scope of the retrospective (neither, for that matter, did the *Guide topographique* itself). Only a handful of labels provide any information about the works visible in this image; judging from their size and from the single line of text discernible below the nearest tapestry, they must have been quite terse. A second photograph (fig. 25) confirms the impression: not a single tag, even within the vitrine of manuscripts filling the foreground, contributes to the elucidation of the score of works on display—the placard at the base of the socle that interrupts the stairway serves simply to designate room number 4.[9] The French masterpieces on display, it would seem, required no explanation or interpretation; the works of art were permitted to convey their meaning without curatorial interference. Robert Burnand, adjunct general secretary for the retrospective, boasted in the pages of *L'Illustration* about the organizers' ostensible refusal to use the show in the Palais de Tokio for their own didactic purposes: "Nothing systematic, nothing that smells of pedantry nor of the pitiless rigidity of certain methods."[10]

We have once before encountered this pretense that objects on display could speak for themselves: in the presentation of the casts of medieval architectural ornament in the Musée des Monuments Français. Those voices within the Palais de Chaillot, I argued in Chapter 2, purportedly fell on deaf ears, both because the message of a society based on precapitalist hermetic recirculation struck no resonance with an audience caught in the modern crises of abstracted economic value, and because the plaster casts in Paris constituted a compromising formal abstraction from the authentic materials of the original objects left behind in the provinces of France. The Chefs-d'œuvre de l'Art Français managed to sidestep each of these potential pitfalls.

Concerning the latter issue: the exhibition, by implicitly limiting the category of "masterpiece" to objects of reasonable portability, consisted entirely of authentic objects materially present in the galleries: paintings, drawings, sculptures, tapestries, manuscripts, and *objets d'art* of various sorts. Despite that authenticity, however, no scandal of unjust appropriation marred the presentation—as it had threatened to do at the Musée de l'Homme. The works in the retrospective had been willingly lent, and surely were to be returned safely after the exhibition to their homes around the world. Objects currently in heavy use were not to be removed from their active setting: numerous commentators reassured readers that the Chefs-d'œuvre de l'Art Français had compiled its survey of masterpieces entirely without recourse to the Louvre collections, which had need to remain intact for the crowds flowing into Paris for the Exposition Internationale des Arts et Techniques. "Without harm to our durable Louvre," extolled Raymond Lécuyer in *Le figaro*, "an ephemeral Louvre, a supplemental Louvre, has been created."[11]

Yet where the supplemental character of the maps and placards at the Musée de l'Homme or of the casts at the Musée des Monuments Français had transformed these two displays into abstracted representations scientific or historical, this second Louvre by no means removed itself from the productive circulation of genuine articles. To the contrary, it accomplished the healthy reintegration of forgotten works of art back into the cultural community of its French audience. Looking back on the exhibition, Burnand declared: "Visitors were enticed by the lure of unknown works, inaccessible for the most part, hidden in the mystery of private collections, in the shadows of cathedral treasuries, in crypts or obscure sacristies, in provincial museums of an often rather sleepy character."[12] So many dark African grottos, in other words; so many galleries like the empty halls of the old Musée d'Ethnographie. No works benefited from this recirculation more than those borrowed for the retrospective from overseas. "The exhibited works come from provincial museums as well as from the private and public museums of France and foreign countries," explained the essayist Paul Dupays. "This is the first time that these sister works, dispersed across our planet, find themselves reunited."[13] Far from alienating its material objects from their proper setting, the Chefs-d'œuvre de l'Art Français—however provisionally—returned them to, put them to use upon, their authentic native soil.

And concerning the former: no temporal break of nostalgic regret for the organic communities of a precapitalist era overshadowed this celebration of French cultural constancy. Unsullied by the historical vagaries that had radically transformed the production and distribution of material goods over the preceding several centuries, "art . . . this higher reverie on the destiny of man," in the words of the art historian Henri Focillon writing in the "Introduction" to the official catalogue of the exhibition, maintained throughout its history a "continuity"—this a term applied by Focillon as well as by countless reviewers to the art at the retrospective.[14] The layout of the exhibition (fig. 26), a chain of period galleries presenting in uninterrupted chronological order one French masterpiece after another like so many pearls on a string, certainly authorized this emphasis on continuity.

Focillon rendered explicit the temporal contrast between this artistic retrospective and the Exposition Internationale des Arts et Techniques outside its doors: "In this brilliant city assembled for several months along the banks of the Seine and entirely dedicated to the intensity of the moment, [art] represents the eternal present."[15] *L'actualité éternelle*: Focillon's paradoxical closing words recast the concept of the continuity of art, making it less about the maintenance of a set of values through time than about a stepping outside the mutabilities of time altogether. Louis Gillet, a sympathetic reviewer who in the pages of the solid *Revue des deux mondes* penned perhaps the longest essay on the retrospective, expanded on the notion:

> These five hundred years of French painting appear as works accomplished at one and the same time, or like a creation where there would be no "todays," nor yesterdays, nor tomorrows, but only one same instinct, immutable and always active like that of a swarm across generations of bees.
> We are, in some fashion, here in the domain of the permanent, in the kingdom of the present: an indeterminate space situated outside of time, that escapes history.

Nothing in art, then, risked being caught in some unfamiliar epoch, lost in the depths of time. This "sensation of the suppression of time, of immediate contact," in Gillet's words, implied that all works of art spoke to the audience in 1937 with the same clarity as they had to their original makers.[16]

If art registered something eternal rather than expressing its moment, Gillet's talk of bees hints whence that permanence might be derived. The biological collectivity of the swarm found its human correlate in the concept of race, or in that of national community. Not surprisingly, critics from the right of the political spectrum proved especially eager to discover within the Chefs-d'œuvre de l'Art Français the manifestation of some authentic French consanguinity. Wrote Lucien Rebatet in the *Revue universelle*, a journal expressing sympathy for the likes of Franco and the reactionary monarchist Charles Maurras: "French art enjoys the privilege of a continuity that none of its neighbors possesses, that derives essentially from the resilience, from the vigorous capacity to react, of the race. . . . There is no art, in comparison to that of France, for which tradition is more natural, that is more a matter of instinct, of blood. That is the essential secret of

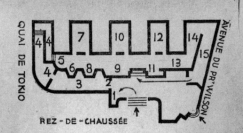

REZ-DE-CHAUSSÉE

SALLE 1. Art gallo-romain.

SALLE 2. Sculptures et tapisseries.

SALLE 3. Art mérovingien. Orfèvreries, sculptures, ta-
pisseries, manuscrits du moyen âge.

SALLE 4. Tapisseries, manuscrits du XVe siècle.

SALLE 5. Tapisseries des XVe et XVIe siècles.

SALLE 6. Peintures et dessins des XIVe et XVe siècles.

SALLE 7. Les Primitifs : Le Maître de l'Annonciation
d'Aix ; Nicolas Froment ; Jean Fouquet ;
Le Maître de Moulins ; Bellegambe.

SALLE 8. Corneille de Lyon ; les Clouet.

SALLE 9. Dessins des XIVe, XVe et XVIe siècles.

SALLE 10. Peintures des XVIe et XVIIe siècles : L'École
de Fontainebleau; les Le Nain; G. de La Tour;
Ph. de Champaigne ; Le Sueur.

SALLE 11. Dessins des XVIe et XVIIe siècles.

SALLE 12. Peintures du XVIIe siècle : Claude Gellée ;
Poussin ; Rigaud ; Mignard ; Le Brun ;
Vivien.

SALLE 13. Dessins du XVIIe siècle.

SALLE 14. Peintures fin du XVIIe siècle : Jouvenet ;
La Fosse ; Largillière ; de Troy.

SALLE 15. Tapisseries, argenterie, mobilier du XVIe au
XVIIIe siècle.

— 24 —

PREMIER ÉTAGE

SALLE 16. Peintures, sculptures, dessins du XVIIe siècle.

SALLE 17. Peintures et dessins du XVIIIe siècle :
M. Quentin de La Tour.

SALLE 18. Peintures : Watteau ; Lancret ; Boucher ;
Greuze ; Perronneau ; Pater ; Tocqué.

SALLE 19. Peintures : Nattier ; Fragonard ; Chardin ;
Saint-Aubin ; Duplessis ; Vigée-Lebrun.

SALLE 20/20 bis. David ; Gros ; Boilly ; Géricault.

SALLE 21. Ingres ; Delacroix ; Chassériau ; Prud'hon.

SALLE 22. Courbet ; Daubigny ; Daumier.

SALLE 23. Millet ; Rousseau ; Corot ; Manet ; Monet ;
Berthe Morisot; Sisley; Cézanne; Renoir ;
Degas ; Pissarro ; Gauguin ; Seurat ;
Toulouse-Lautrec.

SALLES 24-25. Dessins du XIXe siècle.

SALLE 26. Gravures, estampes.

— 25 —

FIG. 26. *Floor plan, Chefs-d'œuvre de l'Art Français.* Chefs d'œuvre d'art français: Guide topographique *(Paris: Palais National des Arts, 1937), 24–25. Photo courtesy of the Avery Architectural and Fine Arts Library, Columbia University.*

its admirable perpetuity."[17] No wonder that art from the past remained accessible to contemporary audiences, for little could have changed in the basic racial composition of the nation. These hidden masterpieces of French art were, in essence, already known by their native audience at the quai de Tokio.

This organic unity of the nation across time could subsume within it other potential divisions; listen, for instance, to the claims of François Fosca assessing the retrospective in *Je suis partout*, for which the fascist sympathizer Robert Brasillach served as editor in chief:

> Whether he works for the public or for his own pleasure, whether he wants to satisfy an aris-tocratic clientele or the most humble class, the French artist always remains the same. Whether it is Watteau or Le Nain, one discovers within him the same heritage, the same es-sential qualities. The idea of class conflict is one of the most false and inauspicious that ex-ists; and if there is a domain where its absurdity shines forth in the most evident manner, it is precisely in the domain of art.[18]

Yet the notion that art united the nation across class as well as across time was not pro-prietary to the right wing. When the art historian Elie Faure, in the Communist newspa-per *L'humanité*, wrote that "the continuity that French art presents since the introduc-tion of the Romanesque style in our cities and countryside . . . gives it its own character," or when he declared the art of the twelfth and thirteenth centuries to be "the most au-thentically national of our history," he assumed a national cultural community—the "we" of "our cities" and "our history"—that transcended more temporally local divi-sions generated by economics or politics.[19] National unity at the level of art was thus something not only proclaimed by this body of commentary, but also actively performed by its collective formulation of a critical consensus around the Chefs-d'œuvre de l'Art Français. If the authentic community had been compromised at the level of econom-ics—and many on both the left and the right believed, for differing reasons, that it had— all seemingly agreed that it remained intact within the timeless sanctuary of art.

We will certainly need to probe further this comfortably universal attribution of a specifically French national character to the immutable unity of art; but first we need recognize the remarkable set of contradictions that had to be ignored, or kept in suspen-sion, in order to achieve this sense of unity at all. A heritage of artworks spanning al-most two millennia and produced across a wide variety of social settings and geo-graphic locales undoubtedly had significant potential—to say the least—to evince attributes locked in profound opposition to one another. How, possibly, to recognize the variety of these attributes without running the risk of disaggregating the whole? Two case studies of the manner in which commentators treated specific sets of artifacts at the Chefs-d'œuvre de l'Art Français, one at the peripheral edges of the exhibition, one at its very epicenter, point the way toward an answer.

First, the tradition of French art needed an origin; yet then again, it couldn't really af-ford to have one. Certainly the story of the French masterpiece, like any good tale, had to begin somewhere. To name a point where French art commenced, however, was also

inevitably to delineate a threshold in time before which art was not French, and the recognition of that fact both threatened to challenge the eternal continuity of the national heritage and hinted at potential exterior sources for that heritage, the non-French origins of French origins.

The Chefs-d'œuvre de l'Art Français and its accompanying criticism, rather than tackling the issue of inception directly, tended to dodge it. The earliest items included in the installation consisted of a handful of bronze sculptures and a display case or two of metal ornament and armor dating from the Gallo-Roman period, the first several centuries C.E. Whether these artifacts fell under the rubric of French masterpieces, however, remained open to question. Tucked discreetly into an alcove off the main trajectory through the exhibition—we can discern the step down into the space and a single bronze head at the left edge of the photograph of the entrance foyer (fig. 24)—the Gallo-Roman items preceded the medieval sculptures of a falconer and a musician that, posed before draped walls and flanking a doorway, appear to mark the real commencement of the retrospective. That a gap of almost a millennium separated the ancient bronzes and ornaments from any other works of art on display only reinforced the notion that these artifacts, despite their inclusion in the retrospective, did not fully belong to the continuum of national art. Critics accommodated to this installation with a corresponding ambiguity: "The Gallo-Roman bronzes . . . constitute a historical preface," decided the critic for L'intransigeant, while Gillet equivocated by declaring "the dead corner" of the alcove "some sort of little Gallo-Roman preamble" that one could contemplate "before entering the circuit into which the exhibition invites us."[20] Like the prefatory material in relation to the body of a book, the Gallo-Roman side hall played a part in the retrospective of French art without quite being part of it.

These Gallo-Roman origins—or pre-origins, or proto-origins, what have you—would in any case hardly seem capable of providing solid footing from which—or on top of which, depending on the particular national compass claimed by a given interpretation—to build a French heritage. The name of the period itself implied a cultural crossbreeding that denied the univocality of an authentic and homogeneous civilization. And yet it was precisely the mixed nature of society in the ancient era of Romanized Gaul that allowed critics to finesse the issue of origins. Consider the slippery claims of Bernard Champigneulle, house critic for the established Mercure de France, who regretted the exhibition's "hiatus" between "our glorious Gallic vestiges" and "our first Romanesque flowering." He wrote:

> It is precisely [the] origins [of our national art] that would be the most intriguing and most exciting thing to study. . . . These excavated Gallo-Roman pieces, these figured bronzes, these items of jewelry preceding the twelfth century, mark the imperceptible transition between antique Greco-Roman art and Barbarian art; they lead to those ensembles of spiritualized forms [Romanesque art] that are the foundations of our tradition.[21]

The artifacts embodied not a culture but a passage between cultures; nevertheless their amalgamation during that mysterious period left unexplored by the retrospective mi-

raculously emerged as a heritage in its own right.[22] "Origins" belonging to others—to
the Greeks and Romans in the south, to the Celtic Barbarians in the north—recast
themselves to become "foundations" belonging to "our tradition," to us. And despite
Champigneulle's enthusiasm, the "transitions"—between Gaul and Rome, and be-
tween a secular ancient world and the spiritual era of the French Romanesque—could
not in fact bear much study, for it was nothing other than their "imperceptible" charac-
ter that permitted these transitions to obfuscate the contradictory propositions they
could never hope to resolve. The "preface" of Roman Gaul was both an origin and not
an origin, both French and not French. France had its foundations, but only by wishing
them into place and not subjecting them to too rigorous a scrutiny.

Second, if the Gallo-Roman period represented (or did not represent) origins at the
temporal periphery of the French heritage, where to locate its center? At what point
had French art attained its purest degree of perfection? Despite Faure's passing word of
support for the sculpture of the twelfth and thirteenth centuries, virtually all other com-
mentators worked from the assumption—voiced openly by several[23]—that the Chefs-
d'œuvre de l'Art Français correctly focused its visitors' attention on the era of oil paint-
ing, extending from the sixteenth century onward. During this period and in this
medium France had seemingly come into its own, a dominant cultural power in Europe
and in the world.

And yet this focus potentially raised as many thorny issues as it settled. Since at least
the great watershed of the Dreyfus Affair in the 1890s, the history of French painting
had been written as something other than the story of happy continuity; the partisan-
ship over competing preferred periods had served as the scantiest of cover for raging po-
litical controversy. Reactionary nationalist and monarchist circles centered around
Maurras's *Action française* had, since the first decade of the century, championed the
seventeenth-century painters Poussin and Claude, who, while themselves working in
Rome, had provided the artistic models upon which had been built the cultural machin-
ery of the absolute state of Louis XIV. Yearning of this sort for the *grande tradition* and
the authoritarian regime it implied continued to echo in Robert Rey's review of the
Chefs-d'œuvre de l'Art Français, appearing in the *Les nouvelles littéraires*: "It is clear
that our Occidental world has a great need for profound order and real authority. . . .
Perhaps for this reason the art of the seventeenth century appears to us as a kind of ma-
jestic haven."[24] Simultaneously, republican cultural commentators at the turn of the
century, beginning with the likes of Gustave Geffroy and Camille Mauclair, formulated
a canon of their own: they preferred the Impressionists and the Barbizon painters, for
whom they could declare a filiation to the realist masters of the Dutch republic (clearly
evident on this point were the influential ideas of the republican critic Thoré-Bürger
from the mid-nineteenth century). More surprisingly, the republicans also laid claim to
the French masters of the prerevolutionary eighteenth century. Chardin's links to Dutch
genre painters made him an obvious candidate, but Fragonard and Boucher also en-
joyed a recuperation—owing in part to their stylistic affinity with Impressionists (espe-

cially late Renoir), even more so to the critics' evident desire to produce the eighteenth century as a clear and immediate alternative to the authoritarian seventeenth. The reactionaries had paved the way for this interpretation by condemning the eighteenth century as period of decadence and corruption leading to the Revolution.[25] The polemics of the heated debate on the heritage of French painting had, over the several decades preceding the Chefs-d'œuvre de l'Art Français, often boiled down to this. Did one believe in the authoritarian seventeenth century, or in the individual idiosyncrasies—the republican recasting of aristocratic caprice—of the eighteenth? Did one endorse the principles of large-scale history painting derived from the Italian schools, or subscribe instead to the more intimate practices of realism stemming from the Low Countries? Where, between these two seemingly antithetical alternatives, did the essence of French painting lie?

The single critical voice recognizing that the Chefs-d'œuvre de l'Art Français as an exhibition actually formulated an interpretation of the past (the voice about which I hinted earlier) discerned within the installation, without reproaching it, a preference for the latter approach. "The selection of these 'masterpieces of French art' is significant," wrote Raymond Bouyer in *La revue de l'art*, "for it provides a new proof of the flagrant fondness of the contemporary elite for the painters of life. . . . We would willingly call this auspicious retrospective *The Painters of Reality in French Art*, with, here and there, very discreetly but eloquently, some nice idealist foils."[26] To a writer, however, all the other commentators not only failed to register a curatorial bias; they also refused to play the partisan game of pitting century against century, style against style. The Chefs-d'œuvre de l'Art Français emerged, rather, as the providential moment to proclaim a grand reconciliation of France's warring cultural factions, and one painter—indeed, one painting—served as the central device for the enactment of that rapprochement.

Jacques Lassaigne, writing on the eighteenth century in a special issue of *Beaux arts* devoted to the retrospective and reiterating much the same argument in his review of the entire exhibition appearing in *La revue hebdomadaire*, gave the most explicit form to the generally held argument. "All of French painting depends on Poussin," he conceded; "with Poussin French art becomes universal art." The first great master of the eighteenth century, however, did not refuse this legacy but rather extended it. "Watteau, in turn, is a true classic, even though he dares to borrow games of love and masquerades from the festivities of his century"—here Lassaigne is repeating the inherited critical line that Watteau was a painter strictly of his own affected age—"for he makes of it hardly a painting of manners but instead a vast celebration that unfolds in the eternal landscapes of life and in which men of all eras can recognize themselves." A classic, then; and thus a link in the continuous chain drawing France together between past and present. "We have seen Poussin founding classicism on antiquity, Watteau transporting it into his own lifetime by performing on it that superior temporal synthesis." The heritage pulled from the seventeenth century by Watteau can thus extend through the eigh-

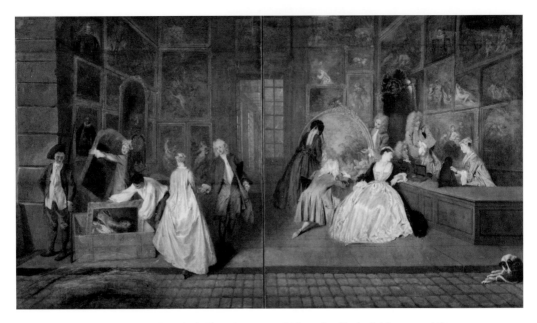

FIG. 27. *Antoine Watteau*, Gersaint's Shopsign, 1721. *Stiftung Prußische Schlösser und Gärten Berlin-Brandenburg, Schloß Charlottenburg.*

teenth century, known for its "unity and continuity," and beyond into the modern period. "Chardin completes the cycle and shows himself to be assured enough to prolong the art of Poussin all the way into the most humble realities from which that art had willingly distanced itself in order to accomplish its prodigious flight. In so doing, he integrates into classical art all of that old French heritage of the painters of reality." Praising "this great century where, between the fusion of the past traditions and the commencement of modern anxieties, art found an instant of plenitude and perfection," Lassaigne declared justified "the exceptional importance accorded by the exhibition on the quai de Tokio to the painters of the eighteenth century."[27]

Between the classicism of Poussin and the realism of Chardin, between the large-scale history painting of the seventeenth century and the genre pictures leading the way to the modern nineteenth, Watteau emerged as the felicitous middle term. The editors of *Beaux arts* made certain the point would be lost on no one leafing through the pages of their special issue on the retrospective, for they composed the minuscule words of Lassaigne's article, as if they formed a frame, around an imposingly large reproduction of Watteau's *Gersaint's Shopsign* (fig. 27), the only painting in the entire issue thus honored with a two-page spread (the placement also conveniently obscured the vertical seam between the two canvases that constitute the work). Critic after critic selected this painting—which, the room-by-room description in *Beaux arts* pointed out, "presided" over Hall 18, presumably from the gallery's commanding far wall (fig. 26)—as the centerpiece of the entire exhibition. "The celebrated *Gersaint's Shopsign* by Watteau . . . is really the 'star attraction' [«*clou*»] of this gathering of masterpieces," exalted one critic,

while another declared it "the capital work, perhaps, of the entire exhibition." Added Georges Huisman, general director of fine arts and president of the committee charged with mounting the retrospective: "It appears that with the *Shopsign* French art—or, quite simply, Art—has attained the summits."[28] The Chefs-d'œuvre de l'Art Français and its attendant criticism thus executed a subtle shift in emphasis: displacing Poussin without dethroning him, Watteau's *Gersaint's Shopsign* became the new center of French painting.

And for good reason, for *Gersaint's Shopsign* on its own, as a single work, happens to execute many of the pictorial reconciliations necessary to present to retrospective eyes of the sort exemplified by Lassaigne the image of a continuity in French culture, united across centuries and across differences of class. Thematically, this painting from late in the artist's career marks a radical departure from his preceding oeuvre, otherwise devoted predominantly to enigmatic scenes of aristocratic figures and *commedia dell'arte* players arrayed within scenes of *fêtes champêtres*. The well-mannered certainly still claim a place in *Gersaint's Shopsign*, but here it is as if gallant gentlemen and courtly ladies have embarked from Cythera to return to the prosaic setting of a Parisian picture shop—specifically, to the actual gallery of Gersaint on the pont Notre-Dame for which the painting briefly served as a billboard above the door. Absent from this closed interior are the lush greens and bluish atmospheric perspectives of Watteau's pleasure gardens, replaced by somber browns and ochers more typical of Chardin's simple domestic scenes. Indeed, Watteau's gentlewomen and their escorts need share this space with the sort of modest characters that people Chardin's genre canvases: the packers and porter to the left, the demure saleswoman showing a mirror to customers and an accompanying dog gnawing its haunch for fleas, to the right. Visitors progressing through the retrospective would have found the mirrored counterpart to this saleswoman in the lady, complete with a dog of her own, portrayed in Chardin's *Woman Sealing a Letter* (fig. 28), hanging just one room over in Hall 19. (The Chardin, an atypical early work, displays appointments of greater luxury and relies on a richer palette than would later become the artist's norm. The curators who selected works for the exhibition in essence allowed Watteau and Chardin each to meet the other more than halfway.) In this world of shopkeeper probity, Watteau may have had his moment of Doisneauesque fun at the expense of the aristocrats—the ornately bewigged gentleman closely scrutinizing the abundant nudes in the oval canvas to center right while his bonneted female companion concentrates on the chaste landscape elements—yet *Gersaint's Shopsign* never degenerates into bawdy class parody.[29] Rather, the picture plays on the practical indistinguishability between bourgeois and aristocrat, between *monsieur* and *seigneur*—best exemplified by the near-perfect mirroring between presumptive shopkeeper, the fashionable fellow showing the oval canvas, and one of his customers, standing while examining the small mirror; the two together serving as canted caryatids for the large mirror behind them, whose gilded frame grows out of the central parts of each man's wig. *Gersaint's Shopsign*, in short, performs the unity of the eighteenth century in a manner which

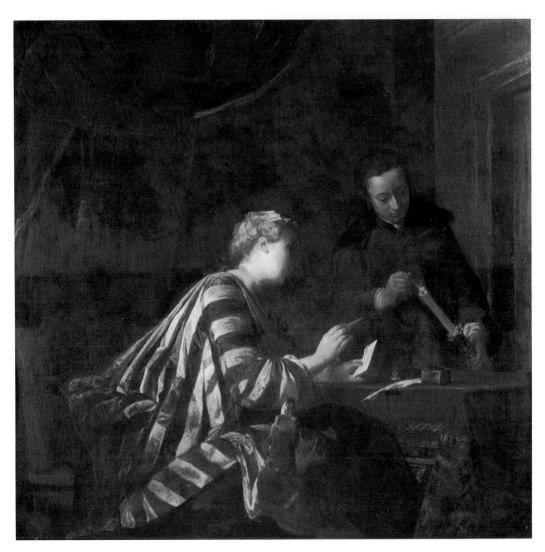

FIG. 28. *Jean-Baptiste Chardin*, Woman Sealing a Letter, *1733. Stiftung Prußische Schlösser und Gärten Berlin-Brandenburg, Schloß Charlottenburg.*

neither Watteau's *fêtes champêtres* or Chardin's genre pictures alone could hope to accomplish.

The transportation of Watteau's lords and ladies out of their usual landscapes of reverie and into this mundane scene gestures as well toward a reconciliation back in time with the seventeenth century. Nowhere other than in Watteau's painting, perhaps, could the Claudean legacy of Arcadia improbably meet on such equal terms with the principles of genre painting from the Low Countries. The pictures offered for sale in this house of commerce manifest compatibility across schools, for the display hangs Italianate mythological adventures cheek by jowl with Dutch portraits and still lifes. (The identifiable *Mercury and Argus* by Jordaens in the upper-right corner and the portrait in the upper-left looking suspiciously like a Velázquez *Philip IV* were certainly added by a later hand to Watteau's originally arched canvas, but this would not be knowledge held by the audience in 1937.) Just as the Gallic cultures from the north and the Roman tradition from the south fused to form the French heritage at its inception, in *Gersaint's Shopsign* artistic legacies both northern and southern conjoin on the common high ground of French artistic supremacy. "Dependent on the foreign, [French painting] oscillates until Watteau between Flemish and Italian influences," pronounced Jacques Guenne in his extended assessment of painting within the special issue of *L'art vivant* dedicated to the Chefs-d'œuvre de l'Art Français; "[Watteau] reconciles the spirit of the north with the Mediterranean spirit."[30]

Gersaint's Shopsign even finds an amicable place within its frame for the authoritarian legacy of Versailles. To the left, a packer lays hands upon a bust-length painted portrait of Louis XIV in the style of Rigaud, which juts out from a wooden case. Conceivably a commentator still wishing to articulate the well-rehearsed opposition between the seventeenth and eighteenth centuries could have alighted on this passage to suggest a stowing away of the bombastic past to make room for a more refined present, and it may be of some moment that no critic in 1937 chose to pursue that interpretative route. Watteau's painting actually argues against it: not only does an aristocratic lady, and perhaps her consort as well, take some considerable interest in this likeness of Louis XIV, but also a second packer holding a mirror of similar size to the portrait eyes the crate, for which he would otherwise have no interest, as if intending to reuse it once it has been emptied of the painting. Following in the circuit of the retrospective a pair of Rigaud portraits hanging in Halls 12 and 14 of the ground floor, this reprisal of the royal portraitist within Watteau's larger canvas would read as if the image of Louis XIV were being unpacked for a new and intrigued audience, from the eighteenth and twentieth centuries alike, after a short trip upstairs. Reading left to right, then, Watteau's *Gersaint's Shopsign* condenses into a single picture the retrospective's complete argument for the continuity of French painting: from the authoritarian past, through the aristocratic *and* bourgeois present, and onward through Chardin to the everyday scenes of nineteenth-century realism.

The legacy of Rigaud accommodates nicely within *Gersaint's Shopsign*, to be sure,

98

partially owing to a telling inversion of scale. The depicted Rigaud-derived portrait, bust-length and with a neutral background, stands in stark contrast to its best-known model, the large and allegorically laden full-length portrait hanging in the Louvre; the porter in Watteau's painting unpacks a picture that is closer to an intimate likeness of the man than to a symbolic rendition of the king. Meanwhile, Watteau's genre scene of a simple picture shop—this set of two canvases itself—explodes in size to assume the proportions, and heroic grandeur, of history painting. Each epoch, each genre assumes the characteristics of its customary opposite, and the antagonisms between them dissipate.

In this same manner, commentary on the Chefs-d'œuvre de l'Art Français played over and again on the theme of contraries folding back into each other in order to be able to declare the unity of French art. Most frequently the collapsing opposition took one form or another of what Faure called "the power to equilibrate [French] sensibility and [French] reason": the aging critic Claude Roger-Marx praised the French masters for their "wisdom more or less colored by sensuality or imagination," while the administrator Jean Zay, letting his adjectives perform the equivocation, lauded their "lucid and passionate will."[31] René Huyghe, curator of painting at the Louvre and a participant in the mounting of the retrospective, went so far as to formulate an elaborate description of the continual balance within French painting between a necessary but potentially dry male Cartesian rationalism and a female sensibility always ready to spring to its rescue.[32] Other suspended antagonisms could also be articulated: Gillet discerned a "tendency continuous and discontinuous at one and the same time," and Rebatet praised French art for possessing a "profound unity in its variety."[33] "What has the Frenchman been?" queried Huyghe by way of summary. "Each time he is one such thing, he is [also] some other thing that transforms it. . . . What, therefore, do all these painters have in common, if not precisely this sense, this instinct to compensate their dominant trait with that which tempers it, in order to make of it an element of equilibrium, of harmony?"[34]

Critics could even give a name to this ostensible French characteristic of always seeking balance between opposites. "Though the word may be emptied by usage," declared Jacques Combe in a book of a hundred-odd reproductions of French art clearly meant to appeal to the market of visitors to the Chefs-d'œuvre de l'Art Français, "the spirit of measure is, in spite of all the clichés, always present in this country." (He continues: "It is also, beyond doubt, a preference so precious, so indispensable to the French spirit, to consider the contrary doctrine to that which one advocates.")[35] And a cliché it was, as one critic after another isolated "measure" as the governing virtue of French art.[36] No work of art in the exhibition better embodied this principle than Watteau's *Gersaint's Shopsign*. "What intellectual bearing, what refinement of spirit," concluded Combe, "in the sensibility of Watteau."[37]

This emphasis on measure, however, begged all questions: it simply declared, by nothing more than the force of critical fiat, the capacity for French art to have it both ways—all ways—at the same time. No piece of evidence extracted from the works in

the retrospective (or imposed upon them, which is more or less to say the same thing) could refute the thesis, since the concept of "measure" could expand infinitely to encompass all potential antagonisms. Any artistic manifestation, extreme in any possible sense, immediately mandated a comforting search for its confirming opposite somewhere among the other thirteen hundred works on display. The concept preserved its elasticity only as long as it actually affirmed nothing of substance; Frenchness in art could mean all things only by meaning no one thing—no one thing, of course, other than the faith held by everyone that Frenchness in art could mean all things. The common element in all the works on display at the Chefs-d'œuvre de l'Art Français could thus be asserted, but never articulated with precision. "A secret unity joins together these works of all the ages," promised Gillet, "without anyone knowing how. . . . This essential unity is the great French mystery."[38]

In 1937 through the vehicle of the Chefs-d'œuvre de l'Art Français, in short, a decades-old critical regime founded on the polemics of heated political conflict had given way to a massive critical consensus ruled over by the rhetorical figure of the oxymoronic platitude. ("Measure," as it was deployed in the commentary, was an oxymoronic concept in its own right, for that which it brought into measure was nothing other than all potentially excessive elements in French art, *tous les éléments démesurés*.) Yet the vacuousness of this communal formulation, its lack of analytic rigor, its incapacity to generate any insight, should not blind us to its profound ideological efficacy. Through it, all fundamental antagonisms within the national cultural heritage had been brought—impossibly, miraculously—to a propitious halt. Through it, Frenchness in art could claim to embody all values and all virtues, each contributing its own bit to an all-encompassing national tradition. Through it, French art reached its greatest plenitude, precisely by becoming a thoroughly emptied entity.

DECLARATIONS OF INDEPENDENCE

The story of French art had (and did not have) a beginning in the smattering of Gallo-Roman artifacts in the alcove off the entrance hall, and it reached its dramatic zenith in Watteau's large picture reigning supreme in Hall 18. All that remained was to bring this masterful narrative to a felicitous close; and that task proved, in many respects, as tricky as launching it. The standard critical conceit maintained that the retrospective, on its own or in concert with the Exposition Internationale des Arts et Techniques, confirmed the continuity of French art extending from the its origins until the present moment.[39] That alleged terminus, however, somewhat overstated the scope of the exhibition, which actually concluded with the major Impressionist and Post-Impressionist artists working at the end of the nineteenth century. Cézanne emerged within the critical surveys of the retrospective as an opportune figure with whom to finish; his reputation as a modern classic with direct filiation to Poussin, well rehearsed in the critical literature since the turn of the century, made of him a fine summary affirmation of the constancy of the French cultural heritage.[40] By thus crowning the retrospective with the last artist whose mastery as a French artist lay absolutely beyond dispute, the organizers

may well have skirted the difficult and divisive undertaking of bestowing upon only a select group of more recent and still active artists the mantle of official national canonization. Yet they also opened up a gap of more than three decades yawning between the last resounding peal of French artistic genius and the present moment.

If in 1937 the cultural organs of the French state did not dare venture into such a potentially contentious period, those of the city of Paris leapt at the chance. Preceding the inauguration of the Chefs-d'œuvre de l'Art Français by a tactical week, an exhibition entitled Les Maîtres de l'Art Indépendant, covering the period from 1895 to 1937 with a total of more than fifteen hundred works, opened its doors in the Petit Palais, on the Right Bank farther upstream from the Palais de Chaillot and the Palais de Tokio.[41] The Petit Palais had, since its construction for the Exposition Universelle of 1900, served as the municipality's principal art gallery, facing off across avenue Alexandre-III with the state-controlled Grand Palais. (The Palais de Tokio, following the Exposition Internationale des Arts et Techniques, would replicate this twinning of state and municipal institutions; eventually, during the 1960s and 1970s, it would house in opposing wings the Musée Nationale d'Art Moderne and the Musée d'Art Moderne de la Ville de Paris.) And where the Grand Palais found many of its halls requisitioned into service as an official part of the Exposition Internationale des Arts et Techniques, the Petit Palais maintained its independence from the world's fair when it offered up an exhibition, municipally sponsored and organized, that heralded recent artistic accomplishments in the city.

There is no doubt that the municipal curatorial staff, headed by Raymond Escholier, conceived the show as a polemic, contrasting the city's presentation of seemingly advanced contemporary art against the failure of all other cultural institutions within the capital to do so. Where the Chefs-d'œuvre de l'Art Français gave no real play to the old chestnut about the battle between hackneyed academic technique and fresh artistic innovation—indeed, its defenders tended to discount the importance of the Academy in the development of true French art over the centuries[42]—the chief organizer of the Maîtres de l'Art Indépendant resuscitated that distinction in order to declare the city of Paris the defender of novel and important work produced since 1895. Escholier's preamble to the catalogue, printed in a bold and streamlined Peignot typeface that trumpets the self-conscious modernity of the argument, casts the Maîtres de l'Art Indépendant as a salvation of art from the tired academicism purportedly on display at the other venues where works by still-active artists might have been seen in Paris during the Exposition Internationale des Arts et Techniques:

> In this year of universal gathering, while the Artistes Français and the Société Nationale take stock at the Salon, while their disciplined troops fully occupy the Palais [sic] des Beaux-Arts built for the world's fair, it is reasonable to ask where one would be able to see the masterpieces of Maillot and Despiau, of Matisse and Picasso, of Bonnard and Vuillard, were it not for the Petit Palais, were it not for the city of Paris. . . .
>
> For Paris, it is a tradition to receive, with a great liberality, the most audacious tendencies of French art.[43]

Escholier is setting up a facile opponent: the exhibition which he disparages here in passing, a display of works in the fine and applied arts produced between 1925 and 1932 that occupied the temporary Pavilion des Beaux-Arts within the Centre des Métiers of the Exposition Internationale des Arts et Techniques, was an absolute non-event, fully ignored by all critics and commentators in 1937. Yet by thus evoking the names of the exhibition societies that had inherited the legacy of the statist Salon, he implicitly championed the city for offering that which the nation could not. And while the preamble refrains from finding fault with the Chefs-d'œuvre de l'Art Français (elsewhere, in fact, Escholier published a favorable if somewhat grudging review of it),[44] its praise for the city's indispensable contribution unquestionably raised the implication that the official national offering in the Palais de Tokio had somehow fallen short. By this account, it would seem, the state either rested uncourageously on the laurels of its past or offered up nothing more than formulaic and dated hackwork from the present.

Escholier's pantheon of recent innovators was, significantly, a list: the Maîtres de l'Art Indépendant proposed to measure the advancement of art, not through the evolution of a group or (decidedly not) of a race, but rather through the accomplishments of specific, named individuals. The distribution of works within the honeycomb of forty-odd small galleries making up the Petit Palais (the enormous number of paintings actually required the subdivision by partitions of some of its larger halls) resisted analytic consolidation into any category larger than the basic unit of the single artist's oeuvre. Chronology appeared to hold little sway: Vuillard and Bonnard, two of the more aged artists with works on display, were not featured until Halls 15 and 16; Rodin, the oldest sculptor by nearly a generation, occupied Hall 19. And the bunching together of like artists with like appeared haphazard at best: painters routinely considered members of the Fauve circle, for instance, showed up in Halls 5, 6, 7, 9, 14, and 18. The legend for the wall map providing direction through the Maîtres de l'Art Indépendant (fig. 29) labeled rooms exclusively with the names of artists, either one or two names for those artists enjoying near monographic treatment, or long lists—neither alphabetical nor chronological, nor seemingly grouped by school—for the large, subdivided galleries containing a handful of works each by many different artists. A striking contrast, indeed, to the floor plan printed in the *Guide topographique* for the Chefs-d'œuvre de l'Art Français (fig. 26), where most rooms bear a designation by century. Even for those few galleries at the Palais de Tokio not thus lined up in the neat roman-numerical sequence of passing centuries, the ordering of names clearly implied the continuing evolution of the French national school. The entry for Hall 23, for example, reads: "Millet; Rousseau; Corot; Manet; Monet; Berthe Morisot; Sisley; Cézanne; Renoir; Degas; Pissarro; Gauguin; Seurat; Toulouse-Lautrec." The Maîtres de l'Art Indépendant offered little sense of such cultural headway achieved by the collectivity: if the state formulated the spirit of a shared national sensibility, the city presented itself as the champion of unclassifiable, perhaps idiosyncratic, creative monads.

Where the disparity among artists forestalled easy generalizations about contempo-

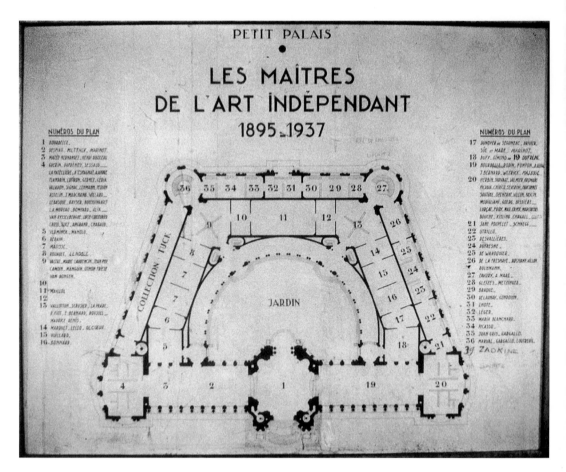

FIG. 29. *Floor plan, Maîtres de l'Art Indépendant, 1937 (as exhibited at L'Art Indépendent: Cinquantenaire de l'Exposition Internationale des Arts et Techniques dans la Vie Moderne, Musée d'Art Moderne de la Ville de Paris, 1987).*

rary artistic production, Escholier certainly thought it revealed an essential characteristic of the city that presented such variety. "In receiving today, at the Petit Palais, the most diverse tendencies of Independent Art," he wrote in the concluding lines of his preamble, "the city of Paris remains faithful to its highest traditions." Those traditions, maintained the curator, offered a savor more cosmopolitan than national; the sentence continues: "and Paris is happy to honor simultaneously these artists of the School of Paris [this label meant in its broadest sense, encompassing all artists included in the exhibition], many having come from all corners of the world, Parisians above all." It was not as if these arriving foreigners had failed to develop a proper chauvinism for their new residence: "When the great torment arrived," wrote Escholier, evoking the First World War (and rather generously augmenting the ranks of actual combatants), "[they] did not hesitate, for the most part, to risk their lives, to spill their blood for the defense of this center of incomparable art."[45] Yet the phrasing here makes clear that the *foyer d'art*

incomparable worth fighting for was, for these *parisiens avant tout*, not the nation of France but the city of Paris. Where the Chefs-d'œuvre de l'Art Français drew a picture of the eternal cultural continuity of the French national race, the Maîtres de l'Art Indépendant strove to present an antithetical image of a city whose broad tolerance of individual caprice made it the international capital for a great flashing moment of cosmopolitan creativity.

The municipality's polemical stance, however, registered only to a limited extent within the critical response to the exhibition. Strong individuality, certainly, was detected within its halls; "occasionally," in the words of the critic André Villebœuf writing in the conservative *Gringoire*, "individualism appears pushed to the extreme."[46] Much as the critics had reiterated as a self-evident verity the message of national cultural continuity formulated by the Chefs-d'œuvre de l'Art Français, virtually all reviews of the Maîtres de l'Art Indépendant blindly followed the show's organizational lead, discussing the great masters one by one as individual artists, in roughly the same unexplained order in which they appeared at the Petit Palais. The Maîtres de l'Art Indépendant, declared a pair of its critics, was "a succession of personal exhibitions," "an ensemble of retrospectives."[47]

Yet perhaps precisely because the reviews tended to accept the exhibition's presentation as a direct transcription of the true nature of recent art rather than as a product of the cosmopolitan tolerance of Paris, only a commentary or two managed to translate this manifestation of individuality into praise for the city's initiative—its general solicitude for advanced art, its sponsorship of this specific exhibition—in the face of a purportedly more conservative nation. The article signed by Jean-Jacques Brousson, appearing in *Les nouvelles littéraires*, was alone in drawing the comparison explicitly, and did so by quoting Escholier himself as he generalized from the city's sponsorship of the Salon d'Autumne since 1903: "Always, the municipality has proved itself more audacious, more liberal, than the state."[48]

Ironically, the greatest controversy generated by the exhibition's polemic against an academicism purportedly supported by the state took place not between municipal and national institutions, nor within the pages of the critical corpus striving to discern a newsworthy scrap between such governmental entities; it boiled over, rather, within the chambers of the city itself. Debate within the municipal council shortly before the opening of the exhibition reveals that pressure voiced in the name of artists from the Artistes Français and the Société Nationale forced, late in the planning stages, a change in title from Escholier's preferred Maîtres de l'Art Vivant, deemed offensive by those excluded traditionalists who considered themselves nevertheless still among the living.[49] (Escholier, a sore loser on this point, began his preamble with the phrase "Independent Art or, as André Salmon has baptized it, Living Art.")[50] The attack did not die with the closing of the exhibition in October: on 17 December 1937, the city councilor René Gillouin spat out a long, venom-filled denunciation of the biases of the exhibition, and—for fear, undoubtedly, that his carefully prepared words would sink without notice into the bu-

reaucratic morass of the *Bulletin municipal*—republished the gist of the diatribe in the issue of *La revue hebdomadaire* dated 15 January 1938. The Maîtres de l'Art Indé-pendant, charged Gillouin, offered up nothing more than a "handful of arrivistes with-out scruples, who, even as they continue to proclaim their fierce independence from the state, throw themselves under a much heavier and less honorable yoke: that of the ty-rant money." A cabal of nefarious dealers, in short, had cornered the market on contem-porary art, and—having hoodwinked Escholier—had filled the city's Petit Palais exclu-sively with their dubious wares. The nation was ill-served by injustice of this sort, for "hundreds of artists of the good French race, full of talent and knowledge, will vegetate their entire lives in an obscure mediocrity" while "aliens, having flocked to Paris from their native Lithuania, Podolsk, or Czechoslovakia where they would have had no chance to pursue the most minimal career" usurped the natives' rightful place in achieving governmental recognition. Indeed, all the "extremist forms of modern art" on display at the Petit Palais owed their aesthetic to a single foreign source, "German Expressionism," which the Germans since Hitler, at least, had had the good sense "lit-erally [to] vomit, at the same time as Marxism," out of its land.[51]

Every innovative artistic movement, presumably, needs just such a hysteric defense of tradition as an easy benchmark against which to measure its own ostensibly dangerous transgressions. Yet Gillouin's rabid pronouncement marks less an opening of debate over the virtues of the art on display at the Petit Palais than the closing of one. For by 1937 the battle between Independent Art and the remaining vestiges of the Academy— the battle over who was, in fact, still producing living art—had already been won, and won by a rout; Gillouin's words are really nothing more than a rite for the dead. Listen to the unequivocal final reckoning of Charles Fegdal, writing in *Semaine à Paris*, whose sentiments echo throughout the chorus of contemporary criticism:

> After forty years of incessant searching and struggling, the "Fauves," the "Nabis," the Cu-bists, Orphists, Expressionists, Constructivists, Irrealists, as well as the Divisionists and Post-Impressionists, have been reunited in an official exhibition of consecration and glory. We finally understand that, [even] if there exists a significant clientele for academic art skilled in copying and photographically flattering, its works of cold science count for noth-ing, or almost nothing, in the history of art. The history of art concerns itself only with the "creators"; it is these that the bold works present currently, and throughout the run of the Exposition Internationale, at the Petit Palais.[52]

Added Raymond Galoyer in the daily *L'aube*: "These tendencies have completely modi-fied the concept of painting, as it is understood in official artistic circles. . . . Today, [the independents] have largely left their detractors behind."[53] To the extent that the city of Paris required an academic antagonist to justify its own polemic, it had to manufacture one of its own: Escholier and Gillouin constituted two sides of the same municipal coin—a coin, in fact, with remarkably little public currency—that anachronistically valorized an ongoing antithesis between academy and avant-garde.

The academic foundations of the city's governing dialectic fundamentally undercut,

the critical corpus in practice found no reason to pursue the gambit of pitting city against state, or Maîtres de l'Art Indépendant against Chefs-d'œuvre de l'Art Français. Indeed, one review after another repeated the notion—it became a commonplace— that the city's display filling the Petit Palais nicely extended and complemented the national exhibition at the Palais de Tokio. "The proof has been made," trumpeted the well-known writer Francis Carco in *Les nouvelles littéraires*, "from Poussin to Cézanne, from Le Nain to Degas, from Manet to Matisse, from Corot to Derain, Independent Art continues. To realize this, one need only visit the two exhibitions that, from avenue Wilson to the avenue Alexandre-III, balance and complete each other in the same coherent manifestation of French pictorial genius."[54]

Nor did the Maîtres de l'Art Indépendant, as it easily could have done, occasion a re-articulation of the political antagonism between idiosyncratic individuality and authoritarianism—recently laid to rest, as we have seen, in historical accounts of the French tradition written in conjunction with the Chefs-d'œuvre de l'Art Français. Georges Besson writing in the leftist *L'humanité*, far from casting Independent Art as a means of breaking beyond the politics of monarchy and church embodied by paintings from the past, celebrated instead the continuity of French art; he treated the two exhibitions, in fact, as one: "A unique exhibition of masterpieces is currently assembled at the Petit Palais and at the museum at the quai de Tokio, which together group, with the old masters, the independent masters of modern art. . . . [The evolution of] French art realizes itself with a continual certainty and with a unique persistence of vitality."[55] Meanwhile, at the opposite end of the political spectrum, the archconservative Rebatet declared that "the large retrospective [of contemporaries] at the Petit Palais extends the museum at the quai de Tokio" (even as he fretted whether the "the miraculous flame" of French art would succeed in "shin[ing] forever, in spite of the stupidity and miseries of our time");[56] and even Brasillach's critic Fosca rather liked the show: "This exhibition will not only be a source of aesthetic pleasures; it [also] constitutes a sort of inventory of all contemporary production for the last forty years."[57]

No one, in short, took the city up on its polemical offering; no one turned Escholier's antithesis into a contentious vehicle for their own artistic or political causes. Even during the debate within the city council in December, Gillouin's pronouncement elicited an immediate rebuttal from his colleague Georges Prade, who, rather than perpetuating the opposition between past and present by heroizing those artists condemned by Gillouin, strove instead to defuse the conflict—the conflict between councilors as well as that between artists:

> I do not believe that the controversy in which we will engage very amicably from this tribune can be considered a new episode in the quarrel of the Ancients and Moderns. It is certainly not that, for you all, Sirs—and M. René Gillouin as well, without doubt—you must believe that artistic sensibility comes from a unity, that it is marked by a rare continuity. As far as I am concerned—this may be a personal eccentricity—I have the tendency to discover and to look for something akin to a family resemblance between painters of the past and the masters of the present.[58]

For virtually all commentators—even many within the institutions of the municipality itself—the Maîtres de l'Art Indépendant stood as the final happy chapter in the ongoing story of the continuity of French art that began down the street in the Chefs-d'œuvre de l'Art Français.

In order to have the Maîtres de l'Art Indépendant fulfill that valedictory role, it follows, commentary surrounding the exhibition had to induce the display to accomplish the same suspension of opposing tendencies as had the Chefs-d'œuvre de l'Art Français. Most reviews simply asserted that result: after surveying the works of the various individuals included, they concluded with some formulaic celebration of the shared artistic mission manifested by all at the Petit Palais. Only one reviewer, Louis Gillet writing in the pages of the prolix *Revue des deux mondes*, ventured a sustained analysis of the dynamics of the display; and it is an analysis that should strike a certain uncanny chord. The Maîtres de l'Art Indépendant, Gillet agreed with his colleagues, featured the accomplishments of individuals: "The ensemble, conforming to reality, presents itself less as a coherent history than as a collection of individual careers." And yet Gillet discerned within the Maîtres de l'Art Indépendant two general tendencies that clustered together such individual geniuses. The battle for modern painting, he argued, "has been fought on two fronts: two groups of painters have attacked it practically together, but in two different directions, members of the one group more attached to the culture of sensation, the others more reasoning, more cerebral, and more abstract."[59]

This familiar tension between sensibility and reason could, at the Maîtres de l'Art Indépendant, be personified in "the famous rivalry between Matisse and Picasso," and Gillet's two-part review structures itself accordingly, its first half centered on the French artist with its second half devoted to the Spaniard and his followers. Matisse, whose work "branches off from the classic oeuvre of the old Chardin" and who "borrows from the master of Aix his system of pure, unmixed brush strokes," spread the lessons of the French modern legacy across the world: "For thirty years now this great painter has been at the head of the movement and has never ceased to confront his generation with brilliant paradoxes, to invent new formulas, equally widespread and reproduced in foreign countries, from Moscow to Oslo, and from Berlin to Pittsburgh."[60] Picasso, on the other hand, with his chaotic admixture of disparate sources—"savage," "primitive," working class, Catalan, Italian, and above all, that ultimate trace of pathological deracination during the anti-Semitic late 1930s, "the ancient furious voice of Israel"—had challenged the very idea of a national base for culture:

> Until now, the artist was portrayed as an autochthonous phenomenon, like a natural plant from which could be expected only a specific type of product, just as a fruit tree does not indiscriminately yield cherries and apples. M. Picasso appears to have taken on the task of reversing all our ideas. He rejects all law. He claims to escape from all necessity. In place of the ancient, earthy, humble, quasi-horticultural notion of the artist that we had held—attached to a place and applying himself to grow there like a trained plant—[Picasso] has substituted the figure of the adventurer.

Nevertheless, in a move that complements the global dispersal of Matisse's French sensibility, Picasso's followers in Paris could bring the unruly foreign growth of Cubism back into the rational line of French art:

> It came to pass that some painters derived [from Cubism] some reflections and a course of instruction. They perceived in it—curiously, for it was that which [Cubism] perhaps least contained—the elements of a method. The French spirit is always the same. It takes with it everywhere its need for order. In that which was nothing but a shock, a type of catastrophe, [that spirit] discovered an architecture and a lesson of discipline, that rejoined—one hardly knows how—the guiding principles of Cézanne and the precedents of Poussin.[61]

Through the shared filiation to Cézanne, the Maîtres de l'Art Indépendant drew back together—amazingly, *on ne sait comment*—the French sensibility of Matisse and unreasonable reason of Picasso, with the same assuredness with which the antithetical characters of Chardin and Poussin conjoined, at the Chefs-d'œuvre de l'Art Français, in the figure of Watteau.[62]

These "two parallel histories," Gillet maintained, "unfold at the Petit Palais in two separate galleries, the interior [ring of] galler[ies] being reserved for the former, which is to say the Independents strictly speaking, the exterior [ring of] galler[ies] for the 'Cubists' and their disciples. . . . Thus, the division adopted by the topography of the exhibition is not artificial, and corresponds more or less to the actual progression of events."[63] This account of the layout, to say the least, stretched Escholier's actual order of presentation to its limits: the exterior gallery containing Picasso's works, in fact, lined up along the interior not against Matisse's rooms but rather against one of the subdivided galleries of heterogeneous minor artists and a hall filled with Maillol sculptures, while the two Matisse galleries in the inner circle faced off against the permanent and unrelated installation of the Collection Tuck; the outer ring included such obvious non-Cubists as Utrillo and Desvallières, a close follower of Denis; and those French artists who might have been championed for having performed a reasoned synthesis of Picasso's Cubism—the likes, presumably, of Braque and Gleizes, or perhaps Ozenfant, or Léger, or Lhôte and Metzinger, whom Gillet mentioned specifically in this context—all preceded Picasso in the itinerary of the exhibition (Picasso was followed by only one painter of note, his fellow Spaniard Gris). Yet Gillet rode roughshod over such bothersome details to reach his happy moment of national reconciliation—between tendencies, and between present and past. Numerous critics, all with less systematic thoroughness, joined him in drawing such linkages between the artists at the Maîtres de l'Art Indépendant and those representing the two strains of sensibility and reason at the Chefs-d'œuvre de l'Art Français: Matisse to Poussin, say, or Derain to "all the schools."[64] Maurice Raynal, in a shining moment of critical creativity, even managed to recast the antithesis between Fauvism and Cubism as a reprise of the slow and certain evolution within French culture from a pre-Romanesque period devoted to nature into the "constructive rigor" of the Romanesque and Gothic ages.[65] Little surprise, then,

that the word "measure"—with all its begging of questions—came to characterize the Maîtres de l'Art Indépendant as well as the Chefs-d'œuvre de l'Art Français; "measure," this time, perhaps, "allied with audacity . . ."[66]

Of course, the biggest question begged at the Petit Palais in this construction of yet another (or rather continued) image of the eternal continuity of French culture was precisely the question of nationality itself, for if all the artists shown at the Palais de Tokio had at least all been born on native soil, the Maîtres de l'Art Indépendant took great pride in the diversity of foreign origins of its participants. The politician Albert Sarrault, titular head of the exhibition's organizing committee and author of its preface, insisted that the imposition of influences from elsewhere distinguished the current phase of French art from all others:

> Our contemporary painting, so firmly rooted in the national soil, and whose blossoms are continuously nourished by the vital sap of tradition, sustains . . . perhaps more than during any other period, the effects of impregnations from outside; and, moreover, the presence of these foreign alloys, discernible to a greater or lesser extent in the evolutions of French painting, is hardly the least important subject in current aesthetic disputations.[67]

A strong national tradition, certainly; but one impinged upon, tried and tested (*éprouver*), by something outside itself (much as Sarrault's foundry metaphor intrudes upon his extended horticultural one). And while the mettle of art produced in Paris may have been strengthened by this amalgamation (unlike, perhaps, that of Sarrault's rhetoric), it would be a mistake to imagine, by this account, that French culture in any sense remained unadulterated.

Nonetheless, this interpretation celebrating Paris as cosmopolitan crucible underwent a subtle yet pivotal transubstantiation by the time it reached the pages of the critical reviews. "I believe we can be proud that all [these foreigners] are united in the School of Paris," declared Jacques Lassaigne, the house critic for *La revue hebdomadaire* writing in response to Gillouin's republished attack on the Maîtres de l'Art Indépendant, "the School of Paris that, like all the living schools in the history of art, knows how to remain profoundly national as it enriches itself with foreign assets."[68] Here the national legacy, rather than being acted upon by something outside itself, instead itself acts upon that foreignness. Potentially competing foreign cultures become so many exploitable overseas resources to be appropriated from afar and made French at the center of the cultural metropole. A confusion of compound and baser materials miraculously alchemize into the pure gold of French art. The Maîtres de l'Art Indépendant was "a significant demonstration of the incontestable mastery and global superiority of French painters," crowed the anonymous critic for the daily *Le matin*, before adding the wonderfully telling subordinate clause: "or, rather, of those foreigners who are no longer foreigners, but rather painters of the School of Paris."[69]

But one could go further: the French capacity to assimilate could become one of the culture's characteristic features. "It was one of the most remarkable tricks played by

French intelligence on a foreign doctrine," Gillet declared about the French assimilation of Cubism; "in adopting it, it adapted it, transforming it entirely. Like the difference between night and day. Cubism changed its 'charge': all that was negative about it become positive, changing itself into affirmation."[70] And while Gillet himself continued to cast Picasso as the Prince of Darkness, that which "French intelligence" had assimilated from the protean Spaniard was precisely his capacity for unlimited assimilation of foreignness. By the simple act of putting Picasso's tools of appropriation to use on Picasso himself, Picasso's French followers in essence made Picasso's own practice French. If the Petit Palais presented a group of "French artists who . . . fought for independence" apart from the official salons, argued the critic René Barotte, Picasso (and several other foreigners named by Barotte) were "so much the more ours for having actively participated in the projects of the School of Paris."[71] It was, indeed, with this critical reception of the Maîtres de l'Art Indépendant that Picasso began his remarkably rapid journey— assisted by the publication between 1943 and 1946 of Bernard Dorival's three-volume study *Les étapes de la peinture française contemporaine*,[72] and largely completed with the acquisition by the previously Picasso-impoverished Musée Nationale d'Art Moderne of ten paintings by the master in 1947—from alien provocateur to national genius. By way of the comprehensive display at the Petit Palais in 1937, Picasso—the deracinated adventurer, the profligate outlaw, the cultural chameleon—was soon to become the reigning figure in French high art.

Thus where Escholier sought the apotheosis of Paris and where Gillouin saw a pathological celebration of a now homeless German decadence, the preponderance of critical commentary—its virtually uncontested consensus—discovered in the Maîtres de l'Art Indépendant a further affirmation of the continuity and resilience of the French cultural heritage. Indeed, to the extent that the essence of French art had evolved in the contemporary period into nothing other than its wide-ranging international eclecticism, the critical platitude extending out from the Chefs-d'œuvre de l'Art Français to embrace the Maîtres de l'Art Indépendant moved ever closer to analytic emptiness—and became that much more ideologically effective. All acts of independent individuality confirmed the collective greatness of the nation, since the greatness of the nation lay in its collective encouragement of independent individuality. All foreign incursions confirmed the richness of French culture, since the richness of French culture lay in its capacity always to incorporate the foreign. The concept of the French nation as it had developed in the realm of culture had assumed such an unlimited elasticity that it could welcome all individuals, as well as encompass the globe.

MIRROR OF THE NATION

But then again, the Maîtres de l'Art Indépendant had perhaps not actually stretched the scope of the Chefs-d'œuvre de l'Art Français terribly far, for nearly identical claims about the international reach of art were already being voiced, and voiced copiously, in relation to the retrospective at the Palais de Tokio. Indeed, the assertions concerning the

state's exhibition only compounded the complex issue of art's proper extent, both because such expansive argument inevitably played off against the retrospective's ostensible focus on nation, and because commentary explored the question in terms of three distinct entities present or represented within the galleries of the Chefs-d'œuvre de l'Art Français: artists, artworks, and audience.

French artists all, born on native soil: this, the seemingly self-evident principle guiding the selection of the Chefs-d'œuvre de l'Art Français. Yet to what extent could the concept hold much meaning when applied to artifacts whose production preceded the formation of the modern nation-state? What of artists born in regions not at the time part of France but since incorporated into the nation (even Watteau's native Valenciennes had been French for only six years at the time of the artist's birth); or, conversely (though more hypothetically), in territory once French but French no longer? What of those, including the indispensable Poussin and Claude, who spent the greater part of their careers laboring in foreign lands, and thus potentially in foreign styles? Or those who, working at home, painted in a manner imported from elsewhere? Of those from elsewhere working within a French idiom while in France?

Clearly, the potential for tautology is enormous here: French artists are those who work in a French manner, which is defined as that which is produced in the manner of French artists. Tautology in such affairs is hardly crippling, however, especially when ambiguities at the hazy zones of the periphery allow the concept of French culture ever to expand as it reflects back upon itself, over and again. Consider, for instance, the remarkable collection of essays assembled, on the occasion of the retrospective, under the title *Cent trente chefs-d'œuvre de l'art français du moyen age au XXe siècle* (countless critics voice these same homilies). From the end of the Gothic era in the fourteenth century, Germain Bazin admitted in his contribution covering the twelfth through sixteenth centuries, French culture lost the "aesthetic hegemony" it had previously enjoyed: "For two and a half centuries, France would be a tributary to the two new artistic 'superpowers,' Flanders and Italy." Still, during this period France never sacrificed its cultural identity; it maintained one, in fact, strikingly similar to that achieved by the French Cubists in Gillet's account of the Maîtres de l'Art Indépendant: "Yet an essential quality of the race, that surprising faculty for assimilation that immediately naturalizes all borrowings from outside, would come into play and maintain the originality of French art."[73] Bazin was not yet through being astonished: writing just a couple of pages later about the painters imported to Fountainebleau in the sixteenth century—which is to say, during the height of Bazin's period of massive French assimilation of outside styles—he declared: "France attracted the most talented painters from foreign lands, yet by one of the most surprising phenomena in the history of art, one that attests to the power of its genius, France 'gallicized' them completely. . . . Are not the formal characteristics of all this painting executed by foreigners themselves French?"[74] "Gallicized" in this passage can, of course, only mean the willing adoption by these foreign artists of the authentically French practice of borrowing from elsewhere.

A century later under the regime of the Sun King, as Jacques Combe picked up the story in his essay on the seventeenth and eighteenth centuries, the French capacity for unlimited assimilation had become a veritable engine of cultural colonialism: "In the second half of the [seventeenth] century, something analogous to the exploitation of a country emerged. One knew how to assimilate all these precedents, all these foreign assets; from them was born a national art, which was already very strong."[75] French culture proved to be not only an imperialist force, it seems, but also a precocious infant: already a vital national style before being sired by foreign parentage. It was from this sort of contradictory yet fertile stance that Jacques Lassaigne could claim—you will perhaps recall the phrase—that "with Poussin French art becomes universal art"; the passage continues: "since Poussin succeeded in the miracle of henceforth giving to the French national style the very character of the universal."[76] The universe was, beyond a doubt, the proper cultural domain of nation full of artists of such boundless assimilative capacities.[77]

If the artists of France on display at the Palais de Tokio—like their contemporary colleagues at the Petit Palais—reached out across the world's cultures, so too, over the years and centuries, had the works of art they had produced. In contrast to the Maîtres de l'Art Indépendant which had borrowed its paintings and sculptures almost exclusively from French collections, the Chefs-d'œuvre de l'Art Français could boast of having reassembled French masterpieces from museums and private collectors spanning the globe. This daunting logistical feat not only bespoke a spirit of amicable international cooperation (at least in cultural affairs);[78] it also attested to the powerful expansiveness of the French artistic realm. "Nothing could demonstrate more clearly the prodigality of French art," exulted Rebatet, as he personified the accomplishment; "French art that, from Russia to the distant reaches of California, has populated [*peuplé*] the museums and the palaces of the universe."[79] Extending the colonial metaphor, a number of critics echoed Zay's words, from the foreword of the official catalogue, praising the valuable service performed by these expatriate artworks while overseas: "A Watteau or a Cézanne, generously lent [for the retrospective] by a foreign museum, will display before us the admirable pictures [*signes*] that are, in the universe, the interpreters and the missionaries of our national genius."[80] Much as a conquistador returned to his monarch with the happy news that the New World now belonged to cross and crown, the objects at the retrospective sent out *en mission* returned to the metropole to bear testament to the catholicity of the French aesthetic. In terms of art, the world *was* France. In this regard, Burnand articulated the following remarkable proposition, so reminiscent of the cliché-ridden accounts describing a visit to the Exposition Internationale des Arts et Techniques: "It is thus a true world tour that the visitors must take if they would like to admire, one after another, the marvels of France picked from throughout the universe."[81]

Artworks that were missionaries enjoyed many converts. Returning to their homeland on the occasion of the retrospective these precious objects could, of course, preach

to those already born into the church of French culture, thereby confirming their faith. Georges Huisman, writing after the fact, captured well the ecclesiastical tenor of the French citizen's ritual, as he or she encountered in the Chefs-d'œuvre de l'Art Français the cultural equivalent of the Shroud of Turin: "From the sight [*vision*] of so many unforgettable works, the face of our France revealed itself. And we found, in each of our galleries, a new reason to love our country more."[82] These glad tidings, moreover, could speak to an even larger audience in a Paris flooded by foreign visitors attending the Exposition Internationale des Arts et Techniques. In an earlier essay prognosticating the success of the retrospective he helped organize, Huisman confidently declared:

> What infinite happiness to think that, during all of the summer of 1937, the museum at the quai de Tokio will become, for the entire world, a reliquary of French humanism where each visitor will sample, in his own fashion, the lessons of an art that has for a long time been a universal art, and that will always remain, at the forefront of European civilization, an incomparable instrument of reconciliation and of peace![83]

If the artworks had traveled out from the homeland to impart the now universal message of French humanism, foreigners from afar could in 1937 reverse the trajectory to resubstantiate in the face of these repatriated works their own allegiance to that universal artistic patrimony which nevertheless always remained French. Since the aesthetic of these works enjoyed universal application, in other words, the members of the variegated audience standing before them could all claim citizenship in the great French republic of art. This, then, was perhaps the ultimate contradiction activated by, held in suspense through, the Chefs-d'œuvre de l'Art Français and the oxymoronic commentary surrounding it: France could be, in the words of Zay, both "rooted and radiating," both grounded to a place and expansive across the globe.[84]

As might be expected, difficulties bedevil an assertion as brazen as this; I will dwell on two. First, to the extent that French art and the humanism attendant to it claimed universal applicability, in what regard could that heritage still be considered particularly French? What connection should be seen to pertain between, on one hand, a specific delineated territory or its population—that *hexagone* excised from the surface of the blue globe on the cover of the *Guide officiel* to the Exposition Internationale des Arts et Techniques (fig. 6), for instance, or the resident visitors to the exhibition who saw in the foreign pavilions of the world's fair something other than a confirmation of their own Frenchness—and, on the other, a set of aesthetic practices of purportedly much greater compass? Where, in short, did the widespread assumption of French cultural expansiveness leave the relation between nation and art?

Second, if Huisman's prognostication envisioned a global democracy of French humanism, it also ascribed a role of leadership within that community of equals: those at the "forefront of European civilization" could utilize the rich cultural resources to which they enjoyed native access as "an incomparable instrument of reconciliation and of peace," presumably among those others in Europe and beyond less naturally en-

dowed with the spirit of civilization. All people were French, it would seem, but some were more French than others. Thus in the affairs of art the nation exerted a *pax franco-nia*; and only those at the heart of such an administration would have failed to perceive that that burden of beneficence, that *mission civilatrice*, also entailed the exercise of a certain power to compel: *Thou shalt be as we are!*[85] Setting aside for a moment the obvious difference in the means and devices for enforcing compliance (an issue to which we must return), the French visitors to the Chefs-d'œuvre de l'Art Français in this regard shared less with the French tourists on the esplanade of the Palais de Chaillot in 1937, who programmatically acknowledged the existence of other legitimate nationalities engaged in the fair play of cordial economic competition, than they did with the German Führer on that same spot in 1940, striving to impose an absolute singularity of national vision. Indeed, if the model of economic good sportsmanship propounded at the Exposition Internationale des Arts et Techniques was clearly meant to stand as an alternative to international relations of a more belligerent sort implied by the rise of fascism, so too the belief in the civilizing effects of an unchallenged French art manifested by the Chefs-d'œuvre de l'Art Français self-consciously offered itself as a more pacific alternative to the threat of German dominance. No artwork in the retrospective went further to blazon German subservience to France in artistic matters, no work made the choice between French and German preeminence more explicit, than the featured *Gersaint's Shopsign* by Watteau, lent as it was from Schloß Charlottenburg in Berlin. (Commentators generally could not bear to credit Hitler himself for owning, appreciating, or lending the painting; they designated instead such impersonal entities as "the government of the Reich" or the "collections of German art." At least one critic managed to imply that the painting's original collector Frederick the Great was the responsible agent, a wishful thought for an enlightened and Francophilic German ruler the likes of which in the modern period would have left the French, on the issue of aggression from the east, reassuringly *sans souci*.)[86] In 1937, however, simply waving the flag of artistic pacifism hardly laid indisputable claim to higher moral ground, for even Hitler was then voicing his belief in peace—on terms, of course, that justly recognized the inalienable right of *Lebensraum* for *das deutsche Volk*. Short of resorting to pure chauvinism (and bereft of the clarifying hindsight provided by the coming war), how then was one to go about the business of distinguishing between French hegemonic expansiveness and the German version of the same, each working from a base of perceived national strength? As it happens, resolutions to this second difficulty—not always felicitous ones—are found through an exploration of the first.

Any inquiry into the relation between art and nation undoubtedly depends on some notion of what constitutes a nation. Of course, it would be foolish to expect that any clear and univalent concept of that entity might be hanging ripe for the picking in the providential arbor of the French historical record; the serious repercussions of the issues engaged by nationality insured a diversity of opinion, while its ubiquity in one form or another within debates of the day meant that the precepts of those opinions were often

taken for granted, left unstated. Rather than attempt to isolate a single dominant for-mulation of the concept, then, let us sample some of that diversity; rather than deem some one theorist's explicit account to be definitive, let us probe some of the presuppo-sitions, investigate the structures, underlying the debates.

We might begin with a consideration of the argument forwarded in the only signifi-cant monograph around the time devoted explicitly to the subject, *Le nationalisme contre les nations* of 1937 by the philosopher and sociologist Henri Lefebvre (who, fol-lowing the war, was to emerge as a principal theorist of everyday life).[87] As a Marxist, Lefebvre appeared willing to make a significant concession to the nationalist tenor of the times: "It is in being truly and profoundly a member of the national popular com-munity that one is a man. And it is in that community that the individual . . . can . . . become a *person*, in a great alliance of men for life and against death." Nationalism, in its proper and wholesome version, provided the means by which isolated individuals identified their own particular interests with those of the larger social whole; it served as the basis of all sociality. Eventually (and this is where Lefebvre's concession to nation-alism reveals itself to be rather insignificant), that authentic sympathy for the group could expand beyond arbitrary boundaries—geographic, ethnic, and so forth—to en-compass the entire world of humanity. Lefebvre appealed to a higher authority to make the point: "The construction of socialism is 'the period of the blooming of national civi-lizations.' These national cultures must have the possibility to develop themselves fully, 'in order to attain the conditions [necessary] for their fusion into a common culture.' . . . Between now and then, nations are destined to be overcome. . . . They are destined to blossom as so many concrete differences within the universal."[88] The footnotes after the citations refer the reader to Stalin, leader of the nation ostensibly furthest along to-ward the accomplishment of the goal.

Short of that complete realization, nonetheless, nationalism according to Lefebvre could assume a more pathological form; or, rather, it could assume the pathology *of* form. In the preface to the original edition, Paul Nizan cut a lapidary summary of the argument: "[Lefebvre] remarks—and this remark is without doubt the central proposi-tion of the essay—that we need distinguish a form and a content for the nation. That which characterizes the development of reactionary nationalism . . . is the proliferation of formal elements at the expense of the content: 'symbol' and 'parade,' 'fetishism' take precedence over reality."[89] Bourgeois democracies such as France as well as fascist re-gimes, argued Lefebvre, could abstract from the "real nation" of the people the mere "*idea* of the nation," and then turn that empty representation back against the people once that population mistook the formal image for an actual entity that controlled its destiny. Hence Lefebvre's title: nationalism (as form) *against* (the "real" content of) na-tions. The tragedy of the current historical moment, according to the author, lay in this disjunction between form and content; its resolution lay in the trimming back of nation-alism's formal excess, its surplus nature as representation. "Nationalist sentiment should not be and cannot remain abstract," he insisted; "The universal must be con-crete."[90]

Or consider, to continue the sampling, the essay by Camille Schuwer entitled "Nation, dernière idole," published in the conservative "little" magazine *Volontés* in February 1938. Schuwer, like Lefebvre, endorsed the need to align the interests of individual and of universal community, but argued that—on a rational level at least, and as a mandate for international peace—the terms of that accord could already be clearly discerned:

> Assuming the principle that nations, like individuals, seek to maximize their happiness, the ambition to achieve that goal through armed conflict contradicts the principle [itself; it] becomes . . . unreasonable. . . . Modern wars . . . bring about the ruin of everyone. . . . Thus we have come to understand—and it is about time—that economic life has everywhere become internationalized, that exchange is reciprocal and interests intertwined, and we can witness arising hope for an ultimate wisdom.

And yet, it was precisely that axiomatic principle, Schuwer recognized, that could not be assumed (and thus that peace that could not be realized), since an irrational entity, the nation, intervened in the smooth and rational commensuration of individual and general interests. "When we are dealing with nations, egoism and passion are to such a degree innate that any consideration of the general (which is to say, the real) interest is automatically—we could say naïvely, honestly—withdrawn in face of the particular, and fictive, interest of the nation." The nation could command such allegiance, such sacrifice during the wars inevitably unleashed by patriotic passions, because it had displaced an entity that seemingly transcended mere earthly concerns: "The [religious] banner has everywhere ceded to the [national] flag; . . . all religions have paled before the latest one, that of the nation. . . . The new nation, with or without its gods, has in the end become the new divinity."[91] Inexplicable, irrational, ethereal, divine; the nation stood as some fantastic excess to the real world of rational interests. It engaged the passions of all since it served the particular interests of none, beyond its own fictive self.[92]

Or consider, the claims of Daniel Rops in *La revue hebdomadaire*, the same journal that had granted Gillouin space for his reactionary polemic against the Maîtres de l'Art Indépendant. "This inner knowledge that assures unity and permanence," Rops self-assuredly declared, "is not tied to the material conditions in which France lives; it embraces them." On this "spiritual" level the nation could resolve the many contradictory impulses of its citizens:

> These oppositions that we have discerned are . . . one of the determining elements of the historical process of France; every movement seems to go in the contrary direction from the preceding one. Rupture then stabilization; audacity then reaction; risk then prudence. Yet this pendular movement indicates a force that is behind it. The French tradition, as long as it is considered from a sufficiently high perspective, derives from a profound unity.[93]

Or consider, finally, the divergent yet intriguingly complementary ideas proposed by André Amar in these same pages. Under all regimes not controlled by overbearing dictators, Amar maintained, "the spiritual and temporal domains have remained dis-

tinct." With the state preoccupied principally with material concerns, the spiritual realm reverted to others: "Even outside of any visible opposition, the adhesion of the governed is never absolute and . . . there always remains a potential of nonutilized moral energy which can and should be called upon at exceptional moments." Political opposition as well as intellectual and artistic production emerged from the "luxurious and useless idleness that calls itself spirit."[94] Where Rops elevated the nation to a supplementary spiritual realm from which real contradictions could be resolved, Amar posited the spiritual as that realm from which could emerge the supplement that contradicted the real nation.

Enough. I do not wish to belabor the obvious resonances between this accumulating and varied rendition of the nation and contemporaneous commentary concerning French art: both formulate a middle term facilitating the expansion of the individual into the global, both imagine a unifying entity abstracted from and standing in excess to the more contentious material realm, and both wish the impossible resolution of fundamental contradictions within the vacuousness of an inarticulatable yet nonetheless self-evident formalized concept. (Nor should consonance with the creatures and concepts that populate the earlier chapters of this book—gods and other higher authorities, the negotiation between material embodiment and spiritual transcendence, the unstable productivity of the surplus, the projection of a realm of the real beyond the representations of it, the abstraction of surplus forms and values, the placing of intellectuals in a realm of excess—require much explication.) In 1937 the nation, no more nor less than the works on display at the Chefs-d'œuvre de l'Art Français, was spoken of through the empty figure of the oxymoronic platitude. " 'The Nation,' " quipped Marcel Martinet in 1934, "[is a] well-fortified fetish-word, an empty word that has resonated only because it has been empty."[95]

Given this striking structural similarity between cumulative accounts, no wonder, then, that nation and art found in each other such a commodious match. To return to the terms established in Georges-Henri Rivière's article "De l'objet d'un musée d'ethnographie comparé celui d'un musée de beaux-arts" (presented in the Entr'acte): if in "primitive" societies "customs" and "material objects" correspond exactly the one to the other since both inhabited the solid territory of the real, in advanced civilizations nation and art likewise coincided perfectly, but now because they both manifested themselves at the level of the abstracted and formal supplement. We might say that France discovered its own image mirrored in the world of art, but also that art found itself reflected in the universal humanistic values of the French nation. Gillet gave voice to the first half of this chiasmus: "It is this France seen from the outside, detached, delegated to be our image beyond our frontiers, that we see assembled at the quai de Tokio: a precious image, little known to ourselves, that reveals to us those features that sometimes escape us, like a woman learns of her powers in the mirror that love holds out to her."[96] And Joseph Csaky, joining Schuwer in the pages of *Volontés*, articulated the second: "Art is as strong as human life, of which it is the mirror, and it will revive when man wants to revive his humanity."[97]

A mirror, however, does more than just present a thing back to itself. It also always presents it again, redoubled; represents it now as something more beyond itself, as its image. And that image, abstracted from the original, is in turn more than just an unaltered iteration of its source: it has adopted the new attribute of being pure form. Thus even as nation and art each assumed the form of the supplement and the supplement of form, they also each stood as the supplemental form abstracted from the other. But, then again, each entity only existed in the first place—which is to say, only existed as an idealized form, which is the only form in which it could exist—owing to the existence of that formal supplement. Each only existed as the other, elsewhere. Art at the Chefs-d'œuvre de l'Art Français overcame the fragmentation of its internal contradictions to achieve a coherent wholeness *only because* it discovered itself in the idealized concept of the French nation; France achieved its unknown powers to inspire love, at home and worldwide, *only because* it had located its essence in a universal artistic patrimony. The form of France formed art rather than being formed by it; but also, the form of art was more constituent of than constituted by the nation.[98]

And there is more. Previously, I proposed (in the Entr'acte) that we regard the abstraction of form and its subsequent appreciation as a working definition for the aesthetic. Accordingly, we could, at a preliminary level, imagine the aesthetic of art at the Chefs-d'œuvre de l'Art Français to be such an abstraction from the semiotic field of exchange between visual signs; and, analogically, the aesthetic of the French nation to be an abstraction out of the social and political field of negotiation among individual interests. That both entities were appreciated goes without question; in the guise of the aesthetic we can also expect them to appreciate. They did so, first, in the relatively obvious manner of reaping a return on the investment of their abstracted resources back into the world of the ostensibly real. The works at the Palais de Tokio, Zay could boast without feeling an obligation to provide argument, "have become, while posted in foreign nations, the symbol and the summary of the most charming traits that are attributed to our race. Thus *Gersaint's Shopsign* will have appeared to gain, as a result of it sojourn in Berlin, a more significant grace."[99] But now, it follows from the preceding paragraph, the process only compounded as each aesthetic also aestheticized the other, over and again, to ever greater returns. To reshuffle our terms one last time: it was precisely in seeing itself in the humanism of France that art moved ever closer toward the universal; it was precisely in seeing itself in the spirit of art that France assumed ever expanding global aspirations. In 1937, then, we could say that French art was the most aesthetic of cultural patrimonies, and France the most aesthetic of nations.

This last claim is, of course, perilously incendiary. For, owing to the likes of Benjamin and Adorno, it has become within our own political rhetoric of the postwar era something of a platitude to regard fascist Germany, not France of the Popular Front, as that nation in the prewar period most encumbered—pathologically so—with the characteristics of the aesthetic. German national expansiveness, moreover, was a matter of great pressing concern around 1937: with the remilitarization of the Rhineland in 1936, the impending *Anschluß* with Austria in early 1938, and the Munich crisis over the an-

nexation of the Sudetenland rumbling on the horizon later in that year, the aggrandiz-
ing villain would seem simple to spot. Where, then, did Germany stand within these po-
litical and artistic debates concerning abstraction and expansion?

Some analysts managed to maintain a note of optimism. For the Marxist Lefebvre,
the fascist state was indeed an abstract form, and of the worst kind: it used its mystical
image of the nation to suppress all social contradictions that existed at the level of real
content. Only those contradictions, Lefebvre maintained, could serve as the propulsive
force of history, and thus the fascist repressive obliteration of any diversity among the
interests of individuals had the effect of turning off the dialectical engine, of stalling the
expansion of the nation toward the universal. "The totalitarian nationalist state is a
rigid and closed form, a form opposed to movement which tends toward self-sufficiency
by isolating itself."[100] Progress would come instead from those nations still capable of
advancing toward the eventual concretization of the universal in the real, to which the
static dead end of fascism posed no real threat.

Where Lefebvre took comfort in the idea that fascism abstracted too much, Amar be-
lieved its limitations stemmed rather from its reassuring incapacity to abstract suffi-
ciently, if at all. Through the "systematic elaboration of a science, a philosophy, a mo-
rality, and a metaphysics all in the service of political ends," through the total "union of
the spiritual and the temporal" in such a manner as to preclude the abstraction of the
one from the other, fascism had reabsorbed the "luxurious" excess of political opposi-
tion and independent intellectual and artistic production. A certain admirable effi-
ciency characterized this state of affairs—"No particle of energy is put in reserve; all
material and moral forces are utilized"—but at a prohibitive cost:

> The countries under dictatorship deliberately deprive themselves of a category, a caste of
> people whose sole activity consists of obeying spiritual rather than political rules. . . . The
> individual under the totalitarian states . . . is condemned to renew himself no longer; his
> philosophy and his morality are in some manner ossified; they no longer change; they no
> longer grow. . . . [Thought] no longer knows that indeterminate zone that gives rise to mys-
> terious generations.[101]

With no abstracted spiritual surplus to reinvest, there could be no productive gain.
Jacques Feschotte, writing in the *Mercure de France*, applied precisely this framework
of analysis to Nazi artistic policy, as it manifested itself in Germany's own set of paired
art exhibitions, the official Ausstellung der Deutsche Kunst and the Ausstellung der En-
tartete Kunst, both mounted in Munich in 1937. The first of these, Feschotte argued, re-
duced the "aesthetic" to a "doctrine of government" and nothing more: "The spirit
does not breath in this place. And, in art, is not the creative spirit everything? Does it
not give birth to all things?"[102] Meanwhile, the regime attempted in the second exhibi-
tion, to its own detriment, to round up all genuine traces of expansive individual cre-
ativity and, denigrating it with labels of foreignness such as "Jew" and "Bolshevist,"
expel it summarily from the cultural polity of the nation (Gillouin, you will remember,

wanted to regurgitate this sort of foreignness from France right back to Germany). No greater contrast, then, than between a Germany that seemingly used its two exhibitions to define a stark difference in such a manner as to strip itself of all powers of generative abstraction, and a France that through its two exhibitions, both of which appeared committed to the expansion of the individual into the universal, ostensibly put its contradictions to good use within the all-encompassing spirit of the nation's art.

So much whistling in the growing dark. Fascist Germany—need it be said?—hardly complied with the prognostications of these various comforting diagnoses. A young Emmanuel Lévinas (after the war to emerge as an influential philosopher and teacher in Paris) proved frighteningly prescient in his article "Quelques réflexions sur la philosophie de l'hitlerisme," published in 1934 in *Esprit*, a journal that combined socialist predilections with a neoanarchist distrust of central government and an ecumenical spiritualism to arrive at a political stance of moderate liberalism (although, I could add, the political scope of the journal was sufficiently wide to allow Lefebvre to publish there also). Lévinas's argument begins in a manner that prefigures the last half-dozen of Benjamin's "Theses on the Philosophy of History" of 1940, with the Judeo-Christian individual filling the role of the latter writer's Messianic historical materialist:

> Political liberties do not exhaust the full contents of the spirit of liberty, which for European civilization signifies a conception of human destiny. It is a sentiment for the absolute liberty of man in face of the world and for the possibilities that incite his actions. Man renews himself eternally before the Universe. To speak in absolute terms, there is no such thing as history. . . .
>
> True liberty, a true beginning, would require a true present that, always at the apogee of a destiny, eternally reactivates that liberty.
>
> Judaism delivers this magnificent message. . . .
>
> This infinite liberty from all determinations, according to which, in sum, no determination is definitive, is the basis of the Christian notion of the soul. . . . It has the austere purity of transcendence. . . . The detachment of the soul is not an abstraction, but a concrete and positive power to detach, to abstract oneself.[103]

The description may sound familiar, for it much resembles the standing granted to French artists in the two major art exhibitions in Paris in 1937: artists who blossomed in the *actualité éternelle*, who inherited from the national tradition the freedom not to be determined by a national tradition, and thus to strive after the universal.

Marxism with its doctrine of material determinism had, according to Lévinas, posed the first threat to this unfettering of the "human spirit" from the "real" of the "world"; yet fascism, carrying the principle of physical determinism still further with its talk of *Blut und Boden*, endangered the independent spirit even more. By its standards, "any social structure that permits an emancipation from the body and that does not enlist it becomes suspect as a repudiation, as treason. . . . A society based on consanguinity results immediately in this concretization of the spirit."[104] To the extent that Germany based its definition of nation (a concept not directly addressed by Lévinas, who spoke

rather of "societies" and "communities") on the physical fact of shared blood, the nation shed it capacity to transcend materiality and enter into the realm of spirit; rather, it dragged spirit back into the hard world of the real.

And therein lay the danger of the doctrine. According to Lévinas, ideas in the realm of the spirit—much like the aesthetic as I have described it—expanded without limit. But they did so without threat, for an idea aspiring toward the universal remained equally accessible to all—one of the purported virtues, you may remember, attributed to French humanism. "The idea that propagates itself," wrote Lévinas, "essentially detaches itself from its point of departure." We could say that it abstracts itself from its material origins. "It becomes, in spite of the unique accent given to it by its creator, a common patrimony. Those who accept it become its master, as was he who proposed it. The propagation of an idea thus creates a community of 'masters'—it is a process of equalization. . . . The universality of a system [*ordre*: with strong religious overtones] in Occidental society always reflects this universality of the truth." As it "concretiz[ed] the spirit," warned Lévinas, fascism embraced the spirit's aspiration toward the universal, but perversely transported that capacity for amplification into the material world, transforming it into raw force.

> The new type of truth would hardly renounce the formal nature of truth and cease to be universal. . . . [*Universality*] *must cede its place to the idea of expansion* . . . the expansion of a force. . . .
>
> Yet force is characterized by a different type of propagation. He who exercises it does not give it up. [*Ne s'en départ pas*: no transcendence here, as force does not "depart" from the body, nor the body from force.] Force does not lose itself among those who incur it. It remains attached to the person or society that exercises it; it aggrandizes them as it subordinates all others. Here, the universal order does not manifest itself in a manner corollary to that of the expansion of ideas—it is this [type of] expansion itself that constitutes the unity of a world of masters and slaves.

This politics of the body, of the refusal of transcendence, could realize "its own form of universalization" only through its own spiritually limited but materially effective and highly inegalitarian means: "war, conquest."[105]

The implications of this line of thought for the cultural aspirations of France articulated in and around the Chefs-d'œuvre de l'Art Français and the Maîtres de l'Art Indépendant are nothing short of catastrophic. On one level, the French nation may indeed have found in these exhibitions on the periphery of the Exposition Internationale des Arts et Techniques that flattering mirror of the aesthetic held out to it by love. And in that reflection all tensions social and political simply blurred away, tensions which continued to disrupt the view from the esplanade of the Palais de Chaillot at the heart of the Exposition Internationale des Arts et Techniques itself. Visitors from all corners of the globe, moreover, could in a relatively unproblematic manner identify with the principles of French humanism, without, as had the Frenchman on the esplanade, having to

glance over their shoulders—or over Hitler's soldiers—to acknowledge the emergence of competing nationalities. The aesthetic of France and of its art could resolve all contradictions, embrace all difference, within its universal umbrella.

Yet success on this level of pure form and transcendence only opened the way for great weakness on another, on that level marked by the contrasting solid figures of body, material, the real. Much as the complete ascension of ethnologists into the celestial spheres at the Musée de l'Homme had reciprocally exiled the real to distant places and times, the potentially full identification by the multinational visitors with the abstract and ethereal entity of nation at the Palais de Tokio and the Petit Palais risked conceding residence in the real, now as far removed from art as the African bush had become from the museum ethnologist in Paris, to others. Developments over the next half-decade would demonstrate the fear that a sanguine fascist Germany stood ready to rush in to fill the vacuum to be all too well founded. The fascist state, in one profound sense, could be seen during the late 1930s as an abject failure: it did not claim to abstract, it could not transcend. Or if it did, it always immediately shackled any abstracted excess back onto the real; it did not allow a surplus to accumulate in the realm of the spirit, in the forms of the aesthetic. The fascist state thus had not so much aestheticized the nation as it had nationalized the aesthetic—the nation now realized on the level of race and of earth. Here in that place where the difference marking the transcendence of expansive spirit seemed to collapse back into the real, an altered version of difference emerged with stark clarity; a lateral difference of kind, as it were, in place of a vertical difference between incommensurate realms abstracted one from another. Where the Frenchman on the esplanade of the Palais de Chaillot strove to accommodate differences of kind, where the exhibitions at the Palais de Tokio and the Petit Palais worked to wish them away, Germany exploited them to the hilt. Where the art of France offered the emptiness of an abstracted platitude under which to unite all of humanity, the armies of Germany prepared to march forward into the real world, driven by a clear sense of the differences of blood.

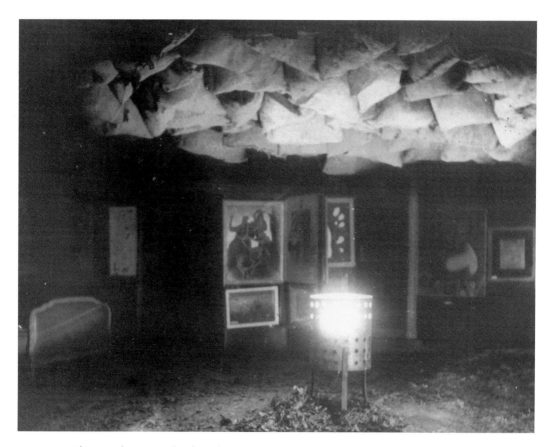

FIG. 30. *Photograph captioned "The ceiling and the brazier in the large hall," Exposition Internationale du Surréalisme, Paris 1938. Raymond Cogniat, "L'exposition internationale du surréalisme,"* XXe siècle *no. 1 (1 March 1938): 28.*

SHORT CIRCUIT

———

For what is the program of the
bourgeois parties? A bad poem on springtime,
filled to bursting with metaphors.
Walter Benjamin, "Surrealism: The Last Snapshot
of the European Intelligentsia," 1929

Where to locate the crossing of wires? Within the Exposition Internationale du Surréalisme, offered up for public viewing by the private Galerie Beaux-Arts on the fashionable rue du Faubourg-Saint-Honoré—an easy stroll inland from the Petit Palais, more of a hike or perhaps even a ride on the Metro from the Palais de Chaillot and the Palais de Tokio—during the months of January and February of 1938. But where then to situate that exhibition; how to register the spark of its brief luminescence? One could compare its flash to similar events in the same class of phenomena. This was, after all, one in a series of "international" Surrealist exhibitions claiming that title by name, exhibitions spanning the globe and traversing the years, from London in 1936, to Paris and Amsterdam in 1938, to Mexico City in 1940, and back to Paris and to Prague in 1947. And the show was full of artworks by the recognized masters of the movement—Dalí and Magritte, Ernst and Masson, Arp and Miró, Tanguy and Giacometti, Cornell and Matta—all of whom could with no great difficulty be taken as the various strong currents coursing through the circuits of Surrealism. Those currents in turn might be traced back—depending on one's preference in dynamo—to the literary and philosophical generators personified by the likes of André Breton and Georges Bataille. This would be to treat the exhibition as part of the general electromagnetic flow of the Surrealist movement in the plastic arts; attempts to chart the internal wiring of that flow have become frequent in our discipline.[1]

Alternatively, we might place the accent on the words "Exposition Internationale,"

123

rather than on "Surréalisme," in the title of the show. Opening but a matter of weeks after the shuttering of the world's fair, an art installation bearing that cosmopolitan epithet could not have helped but evoke in the minds of all its visitors the earlier "Exposition Internationale" that had so enthralled Paris for the better part of 1937, as well as the various art exhibitions, equally international in scope, that had accumulated on its periphery. "[Le] Surréalisme," it might appear, aspired to the same global reach as did "[L]es Arts et Techniques dans la Vie Moderne"; the exhibition in the Galerie Beaux-Arts might well seem to share the same goal of holding the world—or at least a representation of it—within its grasp as had the world's fair and the exhibitions of art attached to it.

And yet, Surrealism—as manifested in the plastic arts, as a trend in literature, as an intellectual movement—was markedly absent within the various displays of 1937. That the Chefs-d'œuvre de l'Art Français at the Palais de Tokio, terminating as it did with art around 1900, did not host such contemporary artists was to be expected. More noteworthy, Surrealist creations found no place in the ostensibly complete inventory of natural and cultural resources presented at the world's fair, nor—save a single canvas by Ernst—even within the Maîtres de l'Art Indépendant, which, after all, had claimed to be a survey of "the most audacious tendencies of French art" (Escholier's words, which I discussed in the second section of Chapter 3).[2] Situated within this broader Parisian milieu of international exhibitions, the exhibition in the rue du Faubourg-Saint-Honoré, rather than belonging as one part wired into the large whole of Surrealism, emerges instead as one effort juxtaposed against others in competing attempts to articulate the international. A rhetoric not of similarity, then, but of difference; perhaps the Exposition Internationale du Surréalisme even ventured a parody, an ironization, of the world's fair and the accessory artistic exhibitions of city and state.

To turn thus against its competitors, to insist that its surreality would not be part of the ostensible realities offered—or the realities ostensibly offered—by its predecessors in the Parisian network of exhibitions of 1937, the Exposition Internationale du Surréalisme had need to twist itself into something else, to jolt itself elsewhere. Where, then—and rhetorically how—to turn?

THE SNAIL'S TRAIL

The Maîtres de l'Art Indépendant, an exhibition of pictures and sculptures in the traditional media, may well have paid virtually no attention to Surrealist works made of oil on canvas; but, then again, in a certain sense, neither did the Exposition Internationale du Surréalisme. Let us take a quick look around the installation at the Galerie Beaux-Arts in search of paintings.

The main gallery promoted a lugubrious atmosphere (fig. 30). As a reputed twelve hundred coal sacks hung low from the ceiling, a central brazier cast its feeble light onto several unmade beds placed in the corners, at least one of which stood adjacent to the muck of a small artificial pond surrounded by thickets of transplanted ferns and reeds (fig. 31). Beyond the orb of dim, drum-encased firelight, one might discern a smattering

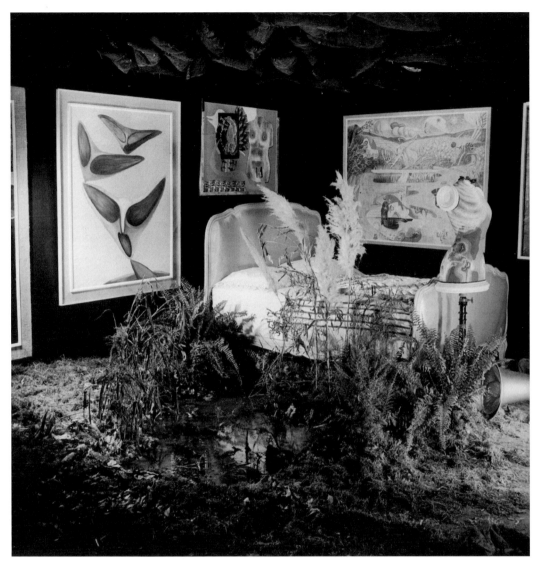

FIG. 31. *Denise Bellon, photograph of the main gallery, Exposition Internationale du Surréalisme, Paris 1938.*

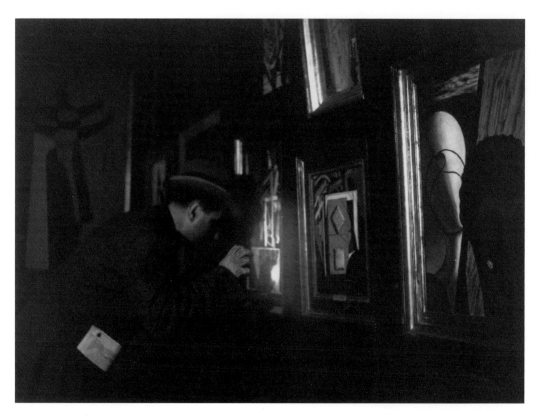

FIG. 32. *Josef Breitenbach,* Exposition Internationale du Surréalisme, Galerie Beaux-Arts, Paris 1938. *Copyright © The Josef Breitenbach Trust, New York. Photo from the collection of the Getty Research Institute, Resource Collections.*

of paintings decorating the distant walls: Ronald Penrose's *Real Woman* (actually, a collage) and André Masson's *Death of Ophelia* of 1937, for instance, above the mired bed.[3] Yet the photograph by Denise Bellon through which these identifications can be made is a rather deceptive document, for it was shot with the full advantage of supplemental photographic floodlights—we can clearly see the cones of their illumination cutting through the underbrush at left and right, their hot spots on the side and baseboard of the bed. Critics, undoubtedly distracted further during the opening by the aroma of roasting Brazilian coffee beans and the phonographic rendition of shrieks and howls filling the central gallery, complained about the impossibility of viewing the pictures. Indeed, the organizers resorted to a distribution of electric flashlights to those visitors attempting to eye the works hanging on the walls—it does not take much to imagine the resulting self-defeating shimmer of a weak spotlight across the gloss of surface varnish (fig. 32).[4]

Retreating up the corridor leading to the main gallery, as if walking back in time along the path laid out by the exhibition's visitors, we encounter a collection of female mannequins *habillés,* or frequently *déshabillés,* in exotic costumes fashioned by a select number of Surrealist artists (fig. 33). Above their heads, fictive Parisian street signs hint

at the unlikely habitats of these improbable ladies: rue Faible, rue de Tous-les-Diables, rue de la Transfusion-de-Sang. A mosaic of papers mounted behind plastic sheeting— posters and newspaper clippings from earlier exhibitions, some printed verse by Breton and Paul Eluard, and a few photographs by Man Ray and Hans Bellmer—fill the re- mainder of the wall.[5] By all indications, however, no paintings here. And farther back along the itinerary in the antechamber to the exhibition, Salvador Dalí's installation *Rainy Taxi* (fig. 40), likewise unencumbered by the presence of paintings, monopolized the scene.

These were the spaces of the critics' almost exclusive interest, often of their outraged rebuke. Yet in this brief tour of the highlights we have hardly traversed sufficient empty area on the surrounding walls to accommodate the many paintings, around a hundred and fifty of them, listed in the exhibition checklist. Only a single writer, it would appear, felt compelled to mention the existence of the two other rooms that undoubtedly housed a vast majority of the works in traditional media.[6] If, in a Surrealist spirit of our own, we were to anthropomorphize the installation by imagining the central dark hall as its head, the corridor of mannequins as the line of its spine, and Dalí's taxi as its nether parts, these two rooms would sprout like two protuberances—two ears, two cuckold's horns, two snaillike antennae—from the head of the beast. The organizers did little to direct attention toward the works contained in these two peripheral halls: the invitation to the opening, for instance, neither illustrated a painting nor even both- ered to mention the inclusion of any in the show alongside such enticements as "appari- tions of being-objects," "the most beautiful streets of Paris," the "Rainy Taxi," as well as general "hysteria."[7] With all this frenetic activity promised for the main halls, it is hardly surprising that the critics for the most part ignored the two extraneous architec- tural appurtenances and the works they contained. "The exhibition at the Galerie Beaux-Arts consists of two types of things," wrote François Fosca in his savage review appearing in the reactionary *Je suis partout*, " 'works of art' and accessories to the pre- sentation." Yet his next sentence implicitly transformed the "accessories" into the only thing deserving of comment—if for no other purpose than to characterize and thereby to mock the movement: "The works of art are worth exactly nothing."[8]

To declare with such resolution that painting counted for nil at the Exposition Inter- nationale du Surréalisme, however, inevitably also proclaimed that it counted for a great deal. Painting was there—undeniably, however shunted to the side by the organiz- ers, however left unremarked by most critics—in the exhibition's halls; even abun- dantly so. Why did the organizers include so many paintings in the first place? Why did Fosca bother to spill ink protesting their worthlessness? Or, more telling, why did so many reviews go to the trouble of illustrating Surrealist paintings—even if the particu- lar pictures they reproduced failed, with surprising frequency, to appear on the exhibi- tion checklist?[9] It hardly matters whether this discrepancy should be attributed to jour- nalistic oversight or to the dereliction of the list's compilers: someone engaged in the enterprise had need of a cipher, without much specificity, for the existence of Surrealist works on canvas. If painting was present in this manner as a general concept at the Ex-

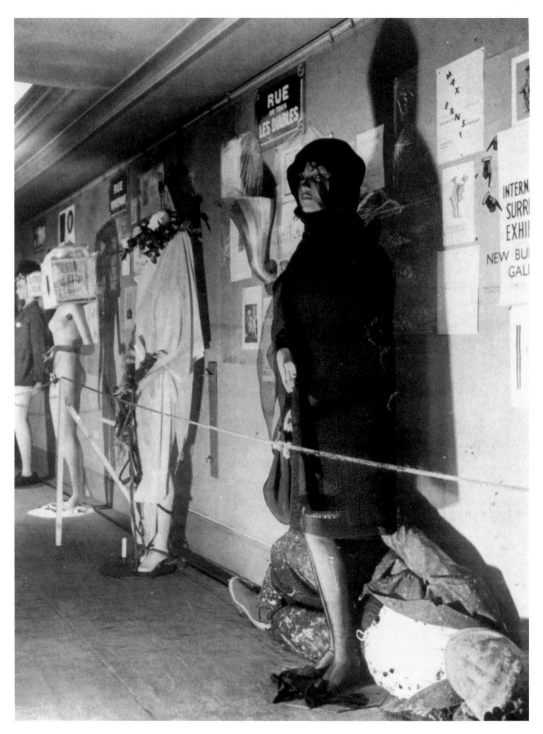

FIG. 33. *Photograph captioned "The corridor of mannequins," Exposition Internationale du Surréalisme, Paris 1938. Raymond Cogniat, "L'exposition internationale du surréalisme," XXe siècle no. 1 (1 March 1938): 27.*

position Internationale du Surréalisme and in its reviews, what then, in a word, was it supposed to represent?

The official cultural organs of the nation, as it happens, had just finished the task of providing a commanding appraisal of the status of painting in France in the year 1937: the Chefs-d'œuvre de l'Art Français. That assessment, moreover, had enjoyed the endorsement of a nearly complete critical consensus in its favor; platitude not disputation, you may recall, set the tone of the day. Without presuming the currency of the retrospective's terms within the more compact cultural setting of the Exposition Internationale du Surréalisme—that is a hypothesis that will require testing—let us revisit the Chefs-d'œuvre de l'Art Français to query its regard toward the practice of painting. In order to grasp the retrospective's operative concept of painting as a medium, we need during this return pay less heed to the message conveyed—that comforting if rather empty reassurance about art securing the continuity and unity of the nation—than to the rhetorical devices, the tropes, of its conveyance.[10]

Viewed each on its own terms, the paintings at the Chefs-d'œuvre de l'Art Français proffered an astounding collection of likenesses. The conflation of the classical with the real programmatically attributed to these works (I discussed this widespread interpretation in the first section of Chapter 3) may indeed have cast an idealist light on many of the scenes depicted, but it also inevitably tied the subject matter of these pictures down to some manifestation of physical reality. From the idealized Roman landscapes of Poussin and Claude to the Channel beaches of Monet and Seurat, from the aristocratic or pseudoaristocratic portraits of Rigaud and Ingres to the lowly peasants of Le Nain and Pissarro, from the virgins of the Master of Moulin and Fouquet to the *demoiselles* of Courbet and Degas, the works on display prompted a comparison—a projected one, to be sure—between the image and that which it ostensibly depicted: *this* picture and *that* stretch of land, *that* countenance and bearing, *that* exposed breast holy or profane. Once again, Watteau's featured *Gersaint's Shopsign* (fig. 27) stands as an archetype of the interpretive practice: the viewer need only imagine the actual boutique below for which the painting served as an enticement above in order to set up a neat correspondence between a place for the hawking of pictures and a picture hawking that place. Differences between image and its referent certainly emerged through such implied comparisons—the absolute difference between the fullness of material objects and the flatness of the picture plane; the relative differences introduced by the artists' technical mediations; the ideological difference, crucial in 1937, between a world riven with contradictions and a realm of art characterized by conciliation—yet the basic terms of the visual correspondence always remained steadfast: to some degree, the painting looked like that which it ostensibly depicted. The image, in other words, set itself up as a metaphor for some corner of the real world, a metaphor grounded on the supposed visual resemblance between that which was art and that which was not, but toward which art referred.

Viewed as an ensemble, however, an alternative rhetorical trope subsumed this meta-

phoric connection between the picture and the world posited beyond and other than art. All works in the retrospective, the organizers and the critics of the Chefs-d'œuvre de l'Art Français agreed, belonged as parts to a greater whole. Or rather, various wholes, mutually imbricated and often difficult to distinguish the one from the other: the whole of the artist's oeuvre, that of the national spirit, that of the universality of humanism inspired by French art (the ineffable and complex conflation of these wholes, we have seen, constituted the chief ideological accomplishment of the Chefs-d'œuvre de l'Art Français). Each work—some more than others, with *Gersaint's Shopsign* indisputably at the top of the list—embodied the essential aspect of the whole, while each whole existed only as the collective manifestation of its component parts. This rhetorical relation of parts to wholes, distinguishable from metaphor which finds similarity between commensurate terms not previously implicated in each other, goes by the name of synecdoche.

Fittingly, the Exposition Internationale des Arts et Techniques, against which the Chefs-d'œuvre de l'Art Français positioned itself as an aesthetic alternative outside the fair's strictly delimited sphere of commerce and contemporaneity, inverted the retrospective's deployment of tropes. (The Exposition Internationale des Arts et Techniques, no less than the Chefs-d'œuvre de l'Art Français, was always near to mind for the visitors at the Exposition Internationale du Surréalisme; the critic René Guetta, for instance, launched his review of the Surrealist display with the conceit that he had stumbled inadvertently upon the installation and was surprised by the existence of this *exposition* since "that of the *Arts techniques* no longer exists.")[11] Viewed each on its own terms, the artifacts and artisans imported to Paris for the Exposition Internationale des Arts et Techniques functioned as synecdoches for the activity of autochthonous production from which they were extracted to serve as its representation on the Champ de Mars. Viewed as an ensemble, however, the objects on display initiated a set of metaphoric comparisons: first, within the marketplace of economic exchange where all objects shared the similarity of possessing value (so many bottles of French wine, say, were worth so many meters of textile from Cochin China); and, second, within the gentlemanly arena of international economic competition where all amicable and commensurate nations ostensibly shared in the pursuit of similar goals (Germany, like Russia, like France, like the rest, all wished—at least in the high if misguided hopes of the organizers—to declare and compare their various industrial and agricultural achievements in a sportsmanlike manner). Commodities were like commodities; nations were like nations. The greater purpose of these metaphoric turns at the world's fair subsumed the synecdoche of the individual artifact, which had enabled the metaphoric comparisons—metaphors between synecdoches—in the first place.

These tropes operating within the two exhibitions need hardly be considered as rigid, either in their contemporary deployment or in our subsequent analysis of them; they can, in fact, be seen as constantly collapsing back into each other. For instance, to the extent that a painting at the Chefs-d'œuvre de l'Art Français did not so much visually

resemble that which it purported to depict as constitute that other entity elsewhere as that thing absent at the moment of its visual representation in the halls of the Palais de Tokio (an argument developed in the first section of Chapter 1 about the artifacts on the Champ de Mars but equally applicable to the pictures in the retrospective discussed in Chapter 3), the purportedly real object against which the image could metaphorically compare itself transmogrifies instead into a partial aspect, a synecdoche, of its representation; specifically, that aspect of the representation that posits something outside itself.[12] Or, we could imagine Hitler's initiative upon the esplanade of the Palais de Chaillot (fig. 14; discussed at the end of Chapter 1) as an attempt to convert the metaphors comparing commensurate nations at the world's fair into a single synecdoche positioning this individual human body as the representative of a triumphant and incommensurate master race. Inversely, the synecdoches at both the Exposition Internationale des Arts et Techniques and the Chefs-d'œuvre de l'Art Français could recast themselves into metaphors: the foreign pavilion in plaster at the world's fair becomes, at the moment of disillusion, something that visually resembles without being part of a distant land; art and nation at the retrospective each become less the constitutive part of the imagined wholeness of the other than its likeness by sharing between themselves the characteristic of being a formal supplement. Confusions and reversals such as these, indeed even the underlying inversion of dominant and subordinate tropes between the retrospective and the world's fair, actually reinforced the fundamental tropological propensities of the two exhibits: through constant slippage back and forth along an axis marked out by metaphor at one pole and synecdoche at the other, these artistic and commercial displays of 1937 made this specific tension between rhetorical turns their defining dynamic, to the exclusion of other alternative tropes.[13]

Over and again, the Exposition Internationale du Surréalisme refused, as if programmatically, to align itself along this particular tropological axis. Consider, for instance, the manner in which the checklist, on the page of the pamphlet positioned on the inside of the cover sheet as if a frontispiece, went about the business of documenting the international character of the exhibition (fig. 34). On the top half of the page, a strictly alphabetical roster of "Participating Artists"; below, a shorter list, likewise in alphabetical order, of "Countries Represented." That which the dual list will not do, however, is articulate a clear relation between the two registers. Which artists belong under which countries? If these are the nations to be represented in the exhibition, then specifically each by whom? The various texts accompanying the installation never get around to addressing, much less resolving, the ambivalence first formulated here. The remainder of the checklist enumerates works by artist but makes no further mention of nationality. The cryptic *Dictionnaire abrégé du surréalisme*—published in lieu of a catalogue and, according to one critic at least, carted around by the well-heeled on opening night—frequently avoided the pertinent information when offering definitions of the artist's names; the term "PAALEN (Wolfgang)," for instance, conveys the sense: " 'The beaver of the thirteenth dynasty.' Painter. He joins Surrealism and adheres to it in 1935."[14] And I

ARTISTES EXPOSANTS :

Eileen Agar	Max Ernst	Okamoto
Hans Arp	Espinoza	Erik Olson
John Banting	Freddie	Meret Oppenheim
Hans Bellmer	Alberto Giacometti	Wolfgang Paalen
Wilh. Bjerke-Petersen	S. W. Hayter	Roland Penrose
Victor Brauner	Maurice Henry	Benjamin Péret
André Breton	Georges Hugnet	Olivier Picard
Serge Brignoni	Marcel Jean	Pablo Picasso
Bernard Brunius	Humphrey Jennings	Man Ray
Edward Burra	Rita Kernn-Larsen	Remedios
Harry Carlsson	René Magritte	Kurt Seligmann
Leonora Carrington	André Masson	Max Servais
Giorgio de Chirico	Matta Echaurren	Styrsky
Ann Clark	E.L.T. Mesens	Yves Tanguy
Joseph Cornell	Joan Miró	Sophie Taüber-Arp
Salvador Dali	Henry Moore	Esaias Thoren
P. Norman Dawson	Stellan Mörner	Elsa Thoresen
Paul Delvaux	Paul Nash	Toyen
Oscar Dominguez	Nina Negri	Raoul Ubac
Marcel Duchamp	Richard Oelze	Gérard Vulliamy

PAYS REPRESENTES :

Allemagne	Danemark	Italie
Angleterre	Espagne	Roumanie
Autriche	Etats-Unis	Suède
Belgique	France	Suisse
Tchécoslovaquie	Japon	

FIG. 34. *Frontispiece,* Exposition internationale du surréalisme *[checklist] (Paris: Galerie Beaux-Arts, 1938). Archives Wildenstein Institute. Photo courtesy of the Getty Research Institute, Resource Collections.*

speculate with some certainty that the wall labels, if they existed at all (I discern none in figs. 30 and 31), never bothered to impart—with that rectitude that characterizes curators and government clerks alike—such mundane information as the official birthplace of individual artists.

We can well imagine, in contrast, how such an introductory listing of artists and countries would be formulated according to the logic of the world's fair: a series of national headings under each of which individual names would appear, each artist a synecdoche for the culture of the country, each country subject to metaphoric comparisons with the others based upon its sampling of representative artists. And we needn't even trouble ourselves to hypothesize such a roster according to the precepts of the national and municipal art exhibitions of 1937: we have it precisely (only the names have been changed) in the form of the text accompanying the floor plan for the Maîtres de l'Art Indépendant (fig. 29), where all artists can be compared within the field of general equivalence generated by their universal incorporation into the larger whole of the glorious French *qua* global campaign for great and lasting art. The frontispiece to the Surrealist checklist offers no such principles of proper subordination; it sets no such grounds for the comparison of like entities. We have, rather, a juxtaposition of two lists of incommensurate things: individuals and nations. By consequence, whereas "international" by the fair's logic signified a place of friendly exchange between commensurate nations, and by the logic of the art exhibitions the shared enterprise on the part of a certain group of people for the attainment of cultural universality, at the Exposition Internationale du Surréalisme it came to mean—well, what, precisely? Something spawned out of the jarring contiguity of these two lists, of these people without nations and these nations without people, yet never really managing to be either one or the other; the product instead, perhaps, of their odd plane of forced collision.

We could, expanding our taxonomy of rhetorical devices, label these particular turns. The Exposition Internationale du Surréalisme obviously did not want to be considered national, or, for that matter, international in the conventional senses of the term (in Chapter 3, we've seen two such) wherein Frenchness participated equally in or fully constituted the concept. And for the most part it succeeded, as the critic Raymond Lécuyer, writing in the conservative *Le figaro*, insisted: "This sort of Romanticism is hardly French. [Used in this manner the term "romanticism" carries strong connotations of the *outre-Rhin*: one can all but feel the descent of a Teutonic fog.] To pull it off requires a turn of spirit that people of our race can only acquire artificially. . . . An exhibitor, as a joke, speaks in the name of the 'Minister of National Imagination.' National? No, my dear, not much."[15] Turning the words against their usual Francocentric selves, the exhibition ironized—it activated the trope of irony against—the national and the international. The frontispiece to the checklist nonetheless accomplished this negating turn primarily through the deployment of yet another trope. The abrupt abutment of unlike lists, this juxtaposition of incommensurate entities not safely contained (as with synecdoche) the one within the other, gives birth to a metonymy. The Exposition Internatio-

nale du Surréalisme, in short, ironized the metaphoric nature of nationalism and internationalism at the Exposition Internationale des Arts and Techniques by kicking them aside with a metonymic jolt. If in 1937 the world's fair and the art exhibitions at its periphery enacted nation and internationalism along the axis of metaphor and synecdoche, the display at the Galerie Beaux-Arts in early 1938 instead played out its versions of such entities along a competing axis of irony and metonymy.

That particular constellation of tropological axes, as it happens, returns us squarely to the issue of painting. For that which the initiators of the Exposition Internationale du Surréalisme most feared about the medium, that aspect of it against which they voiced a desire to turn, was—if not explicitly, then by implication—painting's predilection for synecdoche and metaphor, to which irony and metonymy would come to the rescue. Breton, listed on the cover of checklist along with Eluard as "organizers" for the installation (fig. 41), begins his definition of painting in the (un)official (non)catalogue, the *Dictionnaire abrégé du surréalisme*, with the following statement:

> "The only domain exploitable by painting today is that of pure mental representation insofar as it extends *beyond* regular perception, without thereby dealing only with the hallucinatory domain. The calling upon mental representation (without the physical presence of the object) provides, as Freud said, 'sensations connected to processes unfolding in the most diverse—indeed, the most profound—layers of the psychic apparatus.' . . . It is for the painter to offer himself [*Au peintre s'offre*] a world of possibilities that range from pure and simple abandonment to the graphic impulse, to the fixing in trompe l'oeil of dream images, and including in between all the 'paranoid-critical' means of interpretation . . . Surrealist paintings and constructions have allowed, around subjective elements, the organization of perceptions with an objective tendency. These perceptions reveal an upsetting character, revolutionary in the sense that they imperiously call upon something in exterior reality that responds to them. That something *will be*."[16]

This complicated passage will require some teasing apart, an extended exegesis enhanced by ancillary texts, in order to disclose its ultimately quite inflexible set of tropological injunctions and prescriptions. The analytic route will, by necessity, prove circuitous, since Breton, rather than defining what painting was, hinted at that which Surrealist painting should be; but accomplished this task through irony by declaring that which Surrealist painting should not be, thus implying what regular painting was.

Surrealism in painting, first if not foremost, was not to be an artistic style. Breton's opening prohibition, "The only domain exploitable by painting today is that of pure mental representation," unambiguously declares out of bounds any special occupation with the technical means used for rendering the Surrealist image. Painting, in other words, should not take itself for its own subject; it should not care about that aspect of itself that makes it art. Raymond Cogniat, editor in chief of *Beaux arts*, to which the gallery of the same name was affiliated, and thus in practice an uncredited coconspirator in the exhibition and one of its frequent unofficial cheerleaders in the pages of his cultural weekly (though he is here writing in the journal *XXe siècle*), drove the point

home: "Since its beginnings, Surrealism has been something entirely other than an aesthetic or plastic theory. . . . Painting . . . is not [in the exhibition] to illustrate a technique, an aesthetic system; it can welcome all formulas, it could be Fauve, Cubist, Pointillist."[17] The revealing word in Cogniat's passage is "illustrate." When painting adopted a certain style it came to stand in as a figure for the larger whole of which it was then only a part: an aesthetic theory, say, or a specific art movement; the oeuvre of an individual, or ultimately the culture of a nation. And these forms of excess beyond the picture itself—indeed, the excess of the picture itself as a form—Breton could not countenance. "It makes no difference whether there remains a perceptible difference between beings which are evoked and beings which are present," he had written in *Le surréalisme et la peinture* of 1928, a monograph of sufficient programmatic import and influence to have wended its way into the repertoire of received ideas accessible to viewers of the exhibition a decade later; "[it makes no difference] since I dismiss such differences out of hand at every moment of my life." The differences thus dismissed, of course, were nothing other than the painting's mediations, its style. "This is why it is impossible for me to envisage a picture as being other than a window, and why my first concern is then to know what it *looks out* on."[18]

No synecdoche activated by style, then; no abstraction of the aesthetic. But this "look[ing] out" upon was nonetheless also not to make Surrealist painting into an imitation of things. To produce an image of something already visible through the mechanisms of "regular perception" was to provoke a wasteful redundancy—two things that appear the same—and thereby to open the door to the metaphors of resemblance haunting pictorial realism. Whereas Breton had been uncharacteristically lucid about this injunction on the profligacy of representation in 1928—"To make the magic power of figuration with which certain people are endowed serve the purpose of preserving and reinforcing what would exist without them anyway, is to make wretched use of that power"[19]—the definition in the *Dictionnaire abrégé* achieves the same ends through the indirection of adding conditional clauses that perform ironic turns on the basic concept of the image: mental representation "insofar as it extends *beyond* regular perception"; mental representation "without the physical presence of the object." The Surrealist painting must look out its window, but onto a world that does not exist.

Or rather, a world that does not exist in reality, independent of the image. Breton's definition hints where such an alternative world might be located: in the "hallucinatory domain," in Freud's "psychic apparatus"; to which we could add terms from Cogniat's antiphonal essay to constitute the familiar promiscuous list used so ubiquitously, then as now, to characterize Surrealism as a movement: intuition, instinct, the subconscious, the incomprehensible, the inexplicable, the strange, phantoms, dreams, nightmares, the phantasmagoric, the unlikely, the unexpected.[20] Yet Breton offers only a hint, and any one of these terms—or all of them together—remain subject to Breton's twisting formulation, "pure mental representation *without thereby dealing only with* . . ."; you fill in that terminal ellipsis with the locution of your choice. No one word, no collection

of them, ever exhausts the field; they are but paltry and widely spaced survey markers in the land of the *that* which is not *this* (the terms themselves, more often than not, depend on the internal turns of irony: the *sub*conscious, the *in*explicable, the *un*expected). That onto which the window of Surrealism gives can never, in Breton's definition of painting or elsewhere, be named with the satisfying *click* of the perfect lexigraphic match, for any such perfect affirmative naming would render the name (or, alternatively, the named) redundant, and thus the relation between them would be flawed by the same sort of wastefulness characterizing the metaphor of visual resemblance.

No, redundancy would be banished from the Surrealist image. By drawing instead upon that which without the image remained *in*visible, upon that which purportedly inhabited the unfathomable region without a precise name, the Surrealist work could avoid the difficulty. Painting was thus not to depict something, to represent it, to present it again. Painting was rather to present it for the first time. Painting was to realize it. Painting was to make it real. Breton's monograph from 1928, once again, ventures the explicit statement: "Our eyes, our *precious* eyes, have to reflect that which, while not existing, is yet as intense as that which does exist, and which has once more to consist of real visual images, fully compensating us for what we have left behind."[21] Yet this formulation, with its *images optiques réelles*, somewhat betrays itself by giving a name, a redundant verbal designation, to that which, "while not existing," comes to exist in the painting. The definition in the *Dictionnaire abrégé*, more careful not to replicate in words that which should be brought forth afresh in pictures (Breton's frequently baroque verbal convolutions can, more often than not, be attributed to this need not to name the unnamed), relies more on indirection. "Surrealist paintings and construction have allowed, in proximity to subjective elements, the organization of perceptions with an objective tendency": objective not by lying in the realm of the real beyond the rhetoric of the image, but objective in the sense of realizing itself within the image in such a manner that the division between object and subject, founded on the potential gap between a real thing and its derivative visual interpretation, never has a chance to open in the first place. "These perceptions . . . imperiously call upon something in exterior reality that responds to them": perception makes the call on reality, not the reverse; reality answers to the image. "That something *will be*": a "something," denied any specificity by this placeholder of a word, that achieves existence once in the picture—and not in the real preceding it, nor in Breton's words. This Surrealist manifestation of the real within the image much resembles the dynamic we witnessed earlier at the Musée des Monuments Français, where, in those cases where the source sculpture had been tragically obliterated, the plaster cast—no longer superfluous—attained the status of the original (see the first section of Chapter 2).[22] With this significant difference: Surrealism had no need to depend on the capricious strike of annihilation to guarantee that the (nonexistent) source of its originals, a source by (lack of) definition bereft of any affirmative attributes, bore no resemblance to its realization in the work of art.

By now, I hope, it should not prove much of a leap to the contention that that which

the definition in the *Dictionnaire abrégé du surréalisme* most adamantly prohibited in art, that which painting as normatively practiced represented for Surrealism, was the generation of a surplus. Or, to be more precise, the deleterious generation of the surplus of form.[23] Whether objecting to the excessive wholes evoked by the synecdoches of style or the visual redundancies activated by the metaphors of resemblance, Breton voiced an abhorrence of anything that could assume a formal coherence that allowed it in some manner to distinguish itself from—or match itself to, which is more or less the same act—"objective" reality. (Indeed, the only difference between Breton's prohibitions on manifest style and those on a content of imitation may be one of emphasis: he wanted neither the *form* of the thing, nor the form of the *thing*.) Whereas the Exposition Internationale des Arts et Techniques traded in surpluses, whereas the Musée des Monuments Français regretted the loss of a world free of surpluses and the Musée de l'Homme harvested and reinvested surpluses from and back into such a world, whereas the Chefs-d'œuvre de l'Art Français and the Maîtres de l'Art Indépendant piled the surplus of art upon the surplus of nation and the surplus of nation upon the surplus of art, the Exposition Internationale du Surréalisme purportedly dispensed with surpluses altogether.

According to this line of thinking, it would be an error of the most fundamental sort to regard the *sur* in "Surrealism" as the declaration of a programmatic intent to transcend the merely real in order to enter into a heightened state of consciousness; or, alternatively, to rewrite it as a signpost spelled *sous* pointing toward the profound depths lying beneath the surface appearances of reality. Either of these two interpretations (they are, in fact, the same, the transcendence of heightened awareness mirroring itself perfectly in the fathoming of the deep); either of these two versions of the same interpretation, then, in fixing the surreal somewhere, casts it as supplement to the real, or (if you prefer; it makes no difference one way or the other) casts the real as a supplement to it. Surrealism was not to be above the real, or below it, or for that matter to the side, or anywhere else. Surrealism could claim no such location because to do so would be to take on a designation of place that constituted a surplus to the thing itself. The *sur* in Surrealism thus does not—cannot—name an attribute of that to which the term Surrealism refers; it refers instead to the process—Breton's process, our process—of circling with irony around *and* within the reality of Surrealism by naming that which it is not. "[Surrealist] painting was to make [something] real," I wrote earlier, paraphrasing Breton; but this also is to say, Surrealism is not the real. Surrealism is not like the real; it is not a part of the real, nor is the real part of it. Surrealism is not a surplus, nor does it bear a surplus in relation to itself. Surrealism is not a thing that can be affirmatively described (the phrase "it is not like the real," for instance, cannot be translated into either of the affirmations "it is like the not-real" or "it is that thing, which the real happens not to be like"). Surrealism is not what one calls it.

If this was the program—stated ironically as that which it was not, since to state it straight out would itself be to generate a surplus—how, prescribed Breton, might one

go about realizing it not in word but in painting? The definition in the *Dictionnaire ab-régé* offers several alternatives, which, despite Breton's rather inappropriate phrasing which lines them up in a linear spectrum, would probably best be regarded as, again, so many markers within a larger field of possibilities. First on Breton's list, the "pure and simple abandonment to the graphic impulse": this, a reference to the plastic equivalent of Breton's poetic "automatic writing," whereby the painter turns not only against all lessons received from the traditions and conventions of art but also against any form of conscious control of the brush altogether, in order to allow the canvas to become the direct expression of an underlying psychic state. "Expression," however, should be taken here not as the replication of some inner image upon the surface of the canvas, but rather as the exteriorizing press of a psychic need until it registers a suitable response in the realm of the visible outside of the mind. Which is to say, in tropological terms: automatic painting does not metaphorically match the psychic state by resembling it; it instead assumes a position of metonymic contiguity to it by directly satisfying its demands.[24]

Second, the definition in the *Dictionnaire abrégé* recommends "the fixing in trompe l'oeil of dream images." Such "fixing" of extant "images"—extant since a dream already exists as a perception, visually if not physically manifest, in a manner in which a psychic drive does not—would seem to reintroduce the visual metaphor of resemblance: the picture indeed looks like the dream.[25] Breton, however, specifies a "fixing in *trompe l'oeil*," a genre of painting that always involves the two-step process of deceiving the eye but then revealing its own deceptions; accordingly, we need to inquire of this type of Surrealist painting as evoked by Breton, Which step does it do when, and for whom?[26] Clearly, Breton at one level (I will shortly suggest a second) wanted himself and other sympathetic viewers to be taken in by the conceit, to forget for a moment the devices of framing and the conventions of depiction that make a painting a painting, to accept the image presented on canvas as if it were itself the actual dream rather than its replication. And in this state of willed self-deception, the metaphors of resemblance—which completely cease to exist when the painting *is* the dream—relinquish the stage fully to the metonymies of juxtaposition that make this type of Surrealist painting seem such perfect fodder for Freud's *Interpretation of Dreams*: giraffes and fire, the recesses of hearth contrasted to the phallic thrust of a train, ants in hand.[27]

The act of interpretation applied to such images, however, permits the emergence of a surplus to the dream: the interpretation is like the dream in what it says; the dream is part of a larger psychic structure revealed by its interpretation. This possibility, moreover, potentially mars Breton's first alternative for painting as well; one could, rather than simply use the automatic painting to satisfy one's own psychic need, venture a symptomatic reading of the image as a means to interpret, as if from outside the self, an underlying psychic state. As if in perfect response to this impending analytic need, Breton presents a final alternative, consisting of "all the 'paranoid-critical' means of interpretation." The idea, expressed as a quotation within a quotation, is of course bor-

rowed, from Dalí, whose constant repetitions (and Breton's) of the concept in word and in painting since the late 1920s had made common currency of it within advanced cultural circles by the time of the exhibition. The *Dictionnaire abrégé*, in any case, provided a definition by Dalí, under the heading "paranoia," for any visitors to the Exposition Internationale du Surréalisme who had been deaf to such developments for a decade: "*Paranoiac-critical activity*: Spontaneous method of *irrational knowledge* based on the critical and systematic objectivization of delirious associations and interpretations."[28] The practice—I abbreviate away its many self-conscious yet ultimately inconsequential permutations and complexities—avoids the abstraction of interpretation by entering the delirious sensibility of a paranoiac for whom all things in the world are already replete with their meaning, for whom interpretations are already fully reinvested back into the objects that prompt them.[29] Just as, with Breton's second alternative, the painting does not resemble the dream because it *is* the dream, with his third alternative (which is to say, with Dalí's), the interpretation does not resemble its object—it is not part of the object, nor the object a part of it—because the interpretation *is* the object, and the object its interpretation. Grasping the meaning of a painting thus involves the collapse of any potential distance pried open by a trope between a depicted object and its interpretation (or, for that matter, between that depiction and the object it depicts) in favor of registering the significance inherent in the juxtaposition of various objects arrayed across the canvas. In all three alternatives, then, the tropes of metaphor and synecdoche associated with conventional painting cede to the dominant turn performed by metonymy.

Now, it would be work of a short order to demonstrate, provisionally, how certain paintings displayed at the Exposition Internationale du Surréalisme realized these various alternatives. How, for instance, the mottled and streaked lower half of Max Ernst's *Zoomorphic Couple* of 1933 (fig. 35), which enjoyed pride of place in the main gallery (fig. 30), seemed to register the impress of the artist's psychic turmoil, the painting's apparent tactility the repudiation of the visual foundations of metaphoric resemblance. How René Magritte's *Key of Dreams* of 1930 (fig. 36) juxtaposed words and images with all the arbitrariness of somnolent reverie. How Salvador Dalí's *Invisible Man* of 1929 (fig. 37), also featured in the main hall,[30] both insured that this fellow—defined largely through irony as the space of absence between the various objects present in this airless landscape—exists only as this manifestation on canvas and not elsewhere, and also actuated a paranoiac sensibility in such details as the motif in the upper left announcing that woman is both horse and lion.[31] All this would be true. But to stop here would also be to betray fundamentally the tropological mandate of Breton's words and these paintings alike by discovering no more than a metaphoric similarity, a redundancy, between the program prescribed by the *Dictionnaire abrégé* and the program accomplished in painting at the Galerie Beaux-Arts. Certainly this approach cannot represent the limits of the interpretation of Surrealist painting in early 1938.

And indeed—judging from the criticism generated by the Exposition Internationale

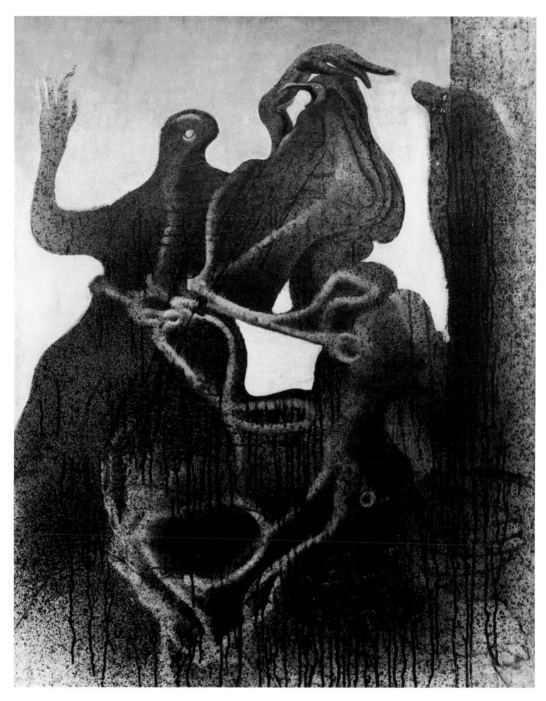

FIG. 35. *Max Ernst,* Zoomorphic Couple, *1933. The Peggy Guggenheim Collection, Venice. Copyright © 1997 Artists Rights Society (ARS), New York/ADAGP, Paris. Photo by Carmelo Guadagno © The Solomon R. Guggenheim Foundation, New York.*

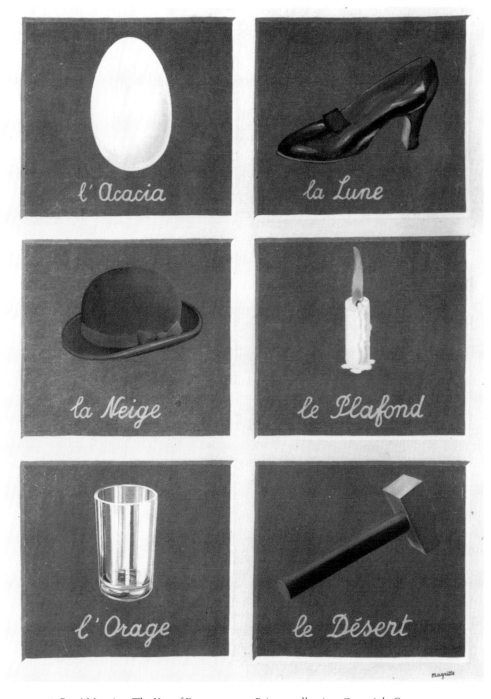

FIG. 36. *René Magritte*, The Key of Dreams, *1930. Private collection. Copyright © 1997 C. Herscovici, Brussels/Artists Rights Society (ARS), New York.*

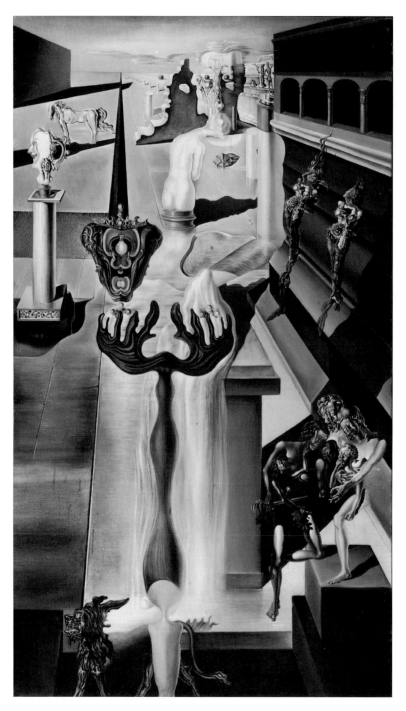

FIG. 37. *Salvador Dalí,* The Invisible Man, 1929. *Museo Nacional Centro de Arte Reina Sofía, Madrid. Copyright © 1997 Demart Pro Arte ® / Artists Rights Society (ARS), New York. Photo from the Archivo fotográfico Museo Nacional Centro de Arte Reina Sofía.*

du Surréalisme, which initially seems so often to miss the point entirely—it does not. "The most significant Surrealists," vociferated Pierre du Colombier in *Candide* with painters such as the Magritte and Dalí undoubtedly in mind, "have a mania for the driest imitation[;] . . . they paint, in their details, with the meticulousness of English old maids."[32] This was nasty stuff from a voice that presumably imagined itself speaking from the heart of French artistic vitality: the twofold insult of Englishness and spinsterhood offered no hope of doubling its negations over into an affirmation. Numerous critics joined Du Colombier in faulting the Surrealist paintings at the Galerie Beaux-Arts for practicing "a pallid academicism" of this sort: when he could see it at all in the gloom, Jean Bazaine found the painting "disappointing"; Lécuyer felt that it "did not distinguish itself"; and Albert Flament declared that he "feared only one thing: that [the exhibition] returns us to *Meissonier, Detaille, Aimé Morot* and the thousands of other artisans without talent."[33] All these critics, in short, cast the paintings in the rue du Faubourg-Saint-Honoré not as the fulfillment of the Surrealist program but rather as its opposite, the return of the repressed of conventional painting. We might describe this assessment as a double negative that actually works: Breton's Surrealist program turned ironically on conventional painting, yet Surrealist painting ironically turned back upon Breton to represent, within the Exposition Internationale du Surréalisme, conventional painting.

I do not mean to suggest that this sort of critical sniveling would have overjoyed the organizers or artists of the Surrealist exhibition. Still, the organizers did have need for works on canvas to do more in the Galerie Beaux-Arts than simply execute the Surrealist brief. As Cogniat explained: "In all of this, painting, without being an accessory element, nevertheless counts only to the extent that it takes part in the ensemble; it participates in a totality." This might sound at first like the formulation of a synecdoche, the part of painting speaking for the whole of the exhibition. Except that according to this passage the partial element of painting could not, in the end, adequately represent the exhibition; it took its meaning only in relation to the whole, not as a congruent part of it. And to the extent that Surrealism promised "the vitality of an aesthetic contrary to everything that has been accepted until today"—another promotional claim by Cogniat—we can well divine what that *rôle à part* for painting might have been: it could, as indeed the critics came to see it, represent the conventions of traditional painting, against which the remainder of the exhibition could turn.[34]

Certainly the paintings themselves, even as they effected Breton's program on one level, invited such a contrary reading on another. The silhouetted protuberances at the top of Ernst's *Zoomorphic Couple* (fig. 35) do, undeniably, resemble the heads and hands of so many strange beasts; the canvas figures the figurative at its top even as it crushes the image beneath its touch below. With its illusionistic grid of a multicompartmental frame painted across its surface, Magritte's *Key of Dreams* (fig. 36) transports the deceptions of trompe l'oeil away from the elements of the dream and onto the means of their representation: the compartments now patently framed by a pictorial device,

their contents regain their status as images that merely resemble that which they depict (this is the inevitable second moment of trompe l'oeil, about which I hinted earlier). Within each compartment, moreover, the painting's juxtaposition of words to images simply highlights the characteristics of each as an independent sign system and thus the conventionality and arbitrariness of both. Finally, the veristic technique in both Magritte's work and in Dalí's *Invisible Man* (fig. 37) owes an obvious debt to the principles of illusionistic oil painting developed and passed on over the centuries through the academies and ateliers of Europe, and that debt brands the means of rendition of these two paintings as part of that continuing heritage. Where Ernst's picture pitted the conventions of content against Surrealist innovations in technique, the canvases by Magritte and Dalí allowed conventional technique to vie against Surrealist content.[35] The paintings at the Exposition Internationale du Surréalisme, in short, did double work: they both embodied what Surrealism could be and represented that which it was not. " 'Too bad there are paintings [here]' you constantly say to yourself when you visit the current exhibition," reported Du Colombier, and to the degree to which the paintings actually implemented Breton's mandate—or, for that matter, to which they internally turned their Surrealist components ironically against their conventional ones—he was right: painting became mere surplus, metaphorically resembling the written doctrine or synecdochically representing the exhibition as a whole.[36] To the extent, however, that the paintings manifested the foil of convention against which the other aspects of the installation could turn—those aspects which garnered the preponderance of critical attention—the works on canvas proved indispensable.

We can witness that turn, in stark relief, on the night of the vernissage. The invitation cryptically promised, and by all accounts the soirée delivered, a dance entitled *The Unconsummated Act* executed by Hélène Vanel upon the featured main bed in the exhibition's main gallery (fig. 38). Though by now facts about the performance may be scant (and the surviving photograph of it quite grainy), surely our reconstructed account of the choreography practically writes itself: a gyrating body conferring glimpses of its naked breasts and torso beneath the fluttering shards of a ravished costume, a hysterical countenance to match the shrieks and howls emanating from the phonograph, disheveled bedclothes hinting at a lascivious act attempted if ultimately left *manqué*, the mud of surrounding plants and pond to remind one of the animalistic nature of that act despite the civilized trappings of an ornamented bed.

All of this played out against, upstaging, a backdrop provided (literally and figuratively) by painting. The specific pictures visible beyond Vanel seem to coordinate thematically with the performance: Penrose's *Real Woman*, though revealing breasts fully, shares with the dancer a predilection for keeping pudenda covered (but maybe not: a scenic photographic postcard mounted vertically with rounded corners provides that cover, and the dark slit defined by the distant blue mountains on its horizon puns anatomically to suggest a beauty spot *qui vaut le voyage*), while Masson's *Death of Ophelia* portrays a hysterical woman driven to madness by an unconsummated act of her own.

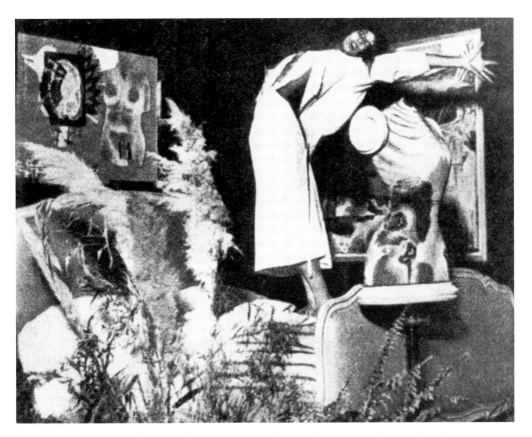

FIG. 38. *Hélène Vanel dancing* The Unconsummated Act *at the Exposition Internationale du Surréalisme, Paris 1938. Robert Benayoun,* Erotique du surréalisme *(Paris: Editions de Jean-Jacques Pauvert, 1965), 81. Copyright © 1978 Société Nouvelle des Editions Pauvert. Photo courtesy of the Department of Special Collections, Davidson Library, University of California, Santa Barbara.*

Both pictures, however, refer to women not actually present, to women elsewhere: the fair maiden of distant Elsinore floating across the pages of Shakespearean tragedy, some idealized Greek beauty called forth by a pencil drawing of a torso fragment (on what appears to be some Picassoesque wood-grained wallpaper) evocative in turn of the fractured remnants of classical sculpture. A collage that looks like a drawing that looks like a sculpture that, finally, looks like a body; the French telling in paint of an English stage retelling of a tale of lost love from Denmark undoubtedly once sung by bards.

In contrast to all these layers of deferred reference and metaphoric resemblance, Vanel's body, not the one represented by Penrose, claims the mantle of the "real"; a body realized, moreover, within a world defined by myriad metonymic or ironic juxtapositions: the verticality of the body against the horizontality of the bed, the civilization of that bed against the nature of the surrounding undergrowth, the unconsummated contiguity of male to female flesh. And as if to accentuate that triumph of the real body over its rendition in image, as if to register that ironization of the metaphors of representa-

tion by the metonymies of life, the dancer's body inverts the polarities of cloth and flesh operative in the pictures: whereas the paintings strive to reveal flesh by displaying its visual replication upon their canvas surfaces, Vanel's movements locate the real body—fleetingly, with a tease—beneath the torn strips of rough cloth. (Marcel Jean's sculpture *Horoscope* of 1937, appearing before Vanel in the photograph, only reinforces this order of things as it, a representation, spreads its globelike imagery across the cloth surface of a dressmaker's dummy, covering over that humanoid shape.) The "act" within this dance may have remained "unconsummated," but it qualified as an act nonetheless, in contrast to the mere repetition of one upon the redundant surface of the image.

If Vanel's dance turned against the metaphors of painting, André Masson's contribution to the corridor of mannequins (fig. 39) set out to kill metaphor straight out. A mannequin is, in its habitual role as the commercial figuration of the human, an object of metaphoric emulation: "you can look like me," it whispers through the plate glass of the shop window, "if you just step inside to buy these clothes." Masson's assemblage not only rescued the mannequin from the exchanges of the market—"these same figures that in the windows of the department stores are merely seductive and ordinary," Cogniat pledged, "sometimes assume here a more hallucinatory character of phantoms, of frozen dreams"[37]—it also stripped the body bare of all garments, leaving nothing for a fashionable lady to replicate. Even the exposed corporeal form—with its articulated waistline and its nippleless breasts; in short, with all the mechanisms and feints of its act of human figuration now fully exposed—less resembled the women outfitted in "evening dresses" that stood before it during opening night than set up a marked contrast with them: nude against clothed, corporeal artifice (abstracted from the commercial field of fashion) against gown-bedecked living flesh (still fully invested there).[38]

The torso, in any case, is not completely stripped bare, for a dark patch of cloth covers over the mannequin's sex—or rather that which the figure would offer, or fail to offer, by way of a representation of one. Around the perimeter of the patch, a ring of glass eyes looks out at the crowd. That part of the artificial body perhaps most capable of attracting the prurient gaze (curious to assess the figure's finesse of the touchy issue of anatomical similitude) instead cuts off the circuit of sight in favor of a directional reversal of the visual apparatus and its placement in odd physical contiguity to the pelvis. The eye metonymically juxtaposed against the sex of woman, then, or ironically turned away from woman; certainly not (as happens so easily with, say, the mouth) metaphorically equated with it.

None of this faces Masson's mannequin head on, however; for it is indeed the head of this assemblage that received from the artist—and still solicits from its viewers—the greatest attention. A birdcage made of wicker encases the head of woman, whose eyes look out of its opened door even as her mouth suffers the indignity of a cloth gag stretching from ear to ear—the gag embellished, no less, by a real or artificial pansy at its center. The pair of curling feathers that jut upward from the loincloth below suggests the making of a possible metaphor here: woman is like a bird. That particular simile

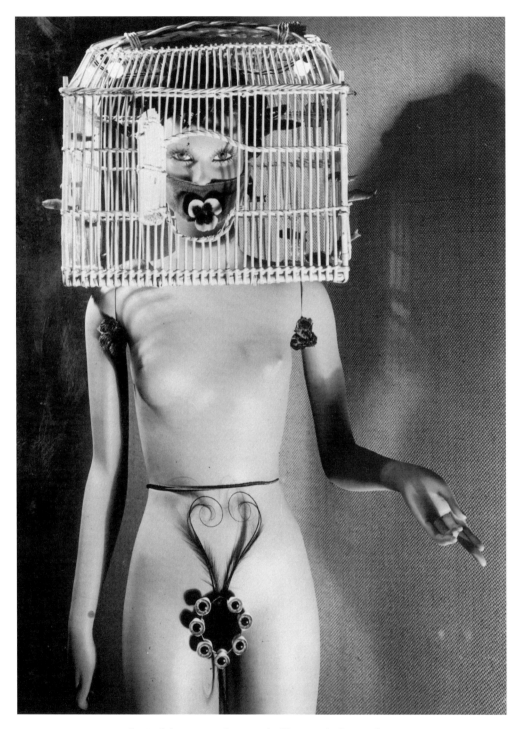

FIG. 39. *Mannequin by André Masson, photographed by Raoul Ubac, at the Exposition Internationale du Surréalisme, Paris 1938. Copyright © 1997 Artists Rights Society (ARS)/ ADAGP, Paris. Photo from the collection of the Getty Research Institute, Resource Collections.*

had, in fact, recently been actuated in the medium of the popular cinema when a singing Josephine Baker in full feather descended perched within a giant birdcage at the beginning of the climactic musical number in the film *Zou-Zou* of 1934. Masson's woman, however, is no bird. If this gagged woman were to sing, she would have to do so with her distinctly nonavian fingers—of which those of her left hand are eloquently posed as if from an illustration for Quintilian's *Institutio Oratoria*. Moreover, whatever strange items she has wrapped in her hair—peppers? mussels? fish such as those swimming through the bars of the birdcage? the snakes of Medusa?—indicate a monster to be caged fully in its own right. And what to make of that pansy? Something a bird might light upon within the wild, but hopelessly beyond the limits of possibility within a cage. The metaphor dies beneath this battering of incongruent juxtapositions, these myriad visual elements wrenched from their common usage.[39] Or perhaps the trope succumbs to a different demise: perhaps the gag hides not the pursed lips of a stifled whistle but rather the smile of the catachresis that swallowed the canary.[40]

And then finally—which is to say, initially, for the viewers in 1938—Dalí's *Rainy Taxi* in the antechamber (fig. 40), a work of straightforward inversions and stark discrepancies. In its front seat, a driver (or not: judging from the photograph he seems to be sitting on the wrong side), his head bagged or perhaps burned,[41] his goggles upside down, his sharklike teeth outside his head. (This last item, for those sophisticates who recalled the revival of Brecht's *Dreigroschenoper* at the Théâtre de l'Etoile in September 1937, would have added a savor of German Marxism to the exhibition's decidedly non-Francocentric mix: *Und der Haifisch hat die Zähne*.) In its back seat, the model of a woman of some refinement finds herself drenched with rain pouring through tubes imbedded in the vehicle's ceiling. The umbrella that she so obviously lacks coupled with the sewing machine next to which she sits certainly evoked for many literate viewers that oft-repeated line by Lautréamont from the *Chants de Maldoror* of 1869, about the meeting of those very two items upon a dissecting table, which had over the years underwritten so many odd juxtapositions performed in the name of Surrealism.[42] More startling than all these tricks, however, must have been the disturbing contiguity of this cultivated and sheltered lady confronted by the grimy forces of nature nurtured by the abnormal rain: ivy, brambles and, above all, the scores of snails slithering across her now glistening porcelain surfaces. Here, then, was the ultimate realization of the Surrealist rhetorical turn in early 1938: meaning stripped of its likenesses, meaning deprived of its connection to the whole, meaning reduced to that thin film marking the plane across which inappropriate things, discordantly and unfathomably, meet.

REFLECTING FURTHER, REFLECTING BACK

If Breton's program for painting turned Surrealism against conventional art, if the paintings at the Exposition Internationale du Surréalisme could be seen to turn against that program to serve as the exhibition's figure for conventional art, if, in turn, the installations of juxtaposed things and the performance of opening night turned against

FIG. 40. *Salvador Dalí*, Rainy Taxi, *photographed by Denise Bellon, at the Exposition Internationale du Surréalisme, Paris 1938. Copyright © 1997 Demart Pro Arte ® / Artists Rights Society (ARS), New York.*

those same paintings that stood as their backdrop, it follows that those assemblages and that act had turned themselves back into, precisely, Breton's program for Surrealist painting. The assemblages of Masson and Dalí and the dance of Vanel, in brief, had eschewed the tropological axis of metaphor and synecdoche in favor of that consisting of irony and metonymy. These works had not resolved the looming crisis of a potential redundancy between the Surrealist idea and its material realization; they had, rather, only deferred it, for that all-too-brief respite (it comes to an end here, with the *click* of a new perfect congruence) offered by the clever execution of one more ironic inversion. The paradox is inescapable: to the extent that the idea of Surrealism proscribes the abstraction of a surplus—of a representation in relation to the real, or of the real in relation to representation—the actuation of Breton's program within the unconventional rooms of the Galerie Beaux-Arts constitutes, can only constitute, that program's betrayal. In Surrealism's success resided its ultimate and inevitable failure.

A dismal conclusion, it would seem; but one that may be subject to yet one more, somewhat ironic, turn. When Surrealism's success entails its eventual failure, its failure may correspondingly ensure it a certain success. Rather than regret the dogged persistence of a damning redundancy at the Exposition Internationale du Surréalisme, rather than recognize with reluctance the exhibition's intrinsic incapacity to purge all surplus from its midst, let us inquire instead into the specific nature of its favored forms of abstraction. Just as did the texts accompanying the exhibition in early 1938, we can give its principal version of that abstracted surplus a name. Or rather names, proper names; names upon names, names stacked high.

Consider, once again, the mannequin not-in-commerce topped-with-birdcage that lined up with the rest along the corridor of the Galerie Beaux-Arts (fig. 39). How might we account for this negation of the commodity form, for this odd juxtaposition of elements; how might we go about divining a redundant figure for this figure? Well, we could name the name of its ostensible proximate cause: that *drôle d'oiseau* escaped from his cage, the artist André Masson. It is he, after all, who facilitated—nay, authorized—this strange meeting of things, he who stripped this porcelain body of its commercial function. And though we get in the habit of saying (I just did) that the work is a product of the artist, it is equally true that the artist—our understanding of him, that aspect of him that survives the work, survives even his own death—is a trace left after by the work (this work and others), which we view only after the fact. Similarly, while we form our image of the character of the artist in part by distinguishing him from that which he created, it is equally true that the work of art takes on the defining characteristic of being something other than the person who made it—while the corporeal form of the human eventually expires, for instance, the work of art may last. Thus, Masson the agent of this work (for whom the work is equally an agent) can serve as an obvious figure for the manipulated mannequin that he encountered (and that encountered him) in a corridor of the Galerie Beaux-Arts in January 1938, a mannequin that was something other than the artist. Indeed, virtually every caption to the many photographic repro-

ductions of this assemblage, to say nothing of the Artists Rights Society with its enforcement of author's copyright that recommodifies this image of things constructed by Masson, insists on that figuration.

And there he is in 1938, on the cover of the exhibition's checklist (fig. 41), as that document's only representation of the mannequin-and-birdcage in the corridor (it is not listed again later in the body of the text): following the phrase "Mannequins of the P.L.E.M. Concern dressed by," the name "André Masson" appears second in a list of artists, lined up like the mannequins themselves. To be sure, the catalogues of the Chefs-d'œuvre de l'Art Français and the Maîtres de l'Art Indépendant likewise had provided lists of comprising artists, had thereby figured the displayed works through the names of their creators. With this crucial difference: the large exhibitions sponsored by the state and city used those accumulated names primarily to represent a social collectivity, a polity, larger and greater than the individual artist. In 1937, the appellation "Watteau" designated, more than the lingering memory of some long-deceased painter, the idea of "eternal and harmonious French culture"; to praise "Matisse" and "Picasso" by that year was quite unambiguously to declare a faith in the concept of "cosmopolitan Paris," which in turn the critical corpus could transform without difficulty into an affirmation of the continuity of that same French national artistic heritage.[43] If the individual looking into the mirror held up by the Chefs-d'œuvre de l'Art Français and the Maîtres de l'Art Indépendant saw in them the nation as that something that was more than art, the viewer who gazed into the mirror of the Exposition Internationale du Surréalisme saw reflected further there, as that thing that supplemented the thing itself, the individual Surrealist artist.

If the government-sponsored exhibitions of 1937 produced the uncertain entity of the global nation of France, this Surrealist individuality was the principal excessive outgrowth of the installation in the rue du Faubourg-Saint-Honoré. Indeed, precisely on such grounds, it would seem, the organizers of the Maîtres de l'Art Indépendant excluded Surrealism from its halls. F. Gilles de la Tourette, one of Escholier's assistant curators at the Petit Palais and author of the preface to a volume of illustrations intended to accompany the exhibition there, defended the individuality of his featured "independent" artists by forwarding the proposition that each, in their own fashion, maintained a meaningful balance between the materiality of nature and the mental abstractions of civilization—this was his own version of the perennial antithesis between sensibility and reason. In contrast, he complained (and the emphasis of the final adjective is his), "Surrealism . . . [is] a mental operation suitable for certain imaginative capacities. . . . A pure Surrealist . . . would inevitably belong to a society civilized to the extreme, for he would be cut off from any direct contact with nature. . . . Being cut off from direct participation with the exterior world, he can create associations of images of the strangest, of the most *individual* sort."[44] Individuality had its merit, certainly; but left to their own devices and bereft of the counterweight of reality, the Surrealists had simply taken individuality too far. They had abstracted it from the real world, quite in the same

EXPOSITION
INTERNATIONALE
DU
SURRÉALISME

Janvier-Février 1938

ORGANISATEURS ⟨ André Breton.
Paul Eluard.

GÉNÉRATEUR-ARBITRE : Marcel Duchamp.

ASSISTANT : Claude Le Gentil.

CONSEILLERS SPÉCIAUX ⟨ Salvador Dali.
Max Ernst.

MAITRE DES LUMIÈRES : Man Ray.

EAUX ET BROUSSAILLES : W. Paalen.

Mannequins de la Maison P. L. E. M. habillés par Yves Tanguy, André
Masson, Kurt Seligmann, Sonia Mossé, Hans Arp, Oscar Dominguez,
Léo Malet, Max Ernst, Marcel Duchamp, Joan Miro, Marcel Jean,
Man Ray, Espinoza, Matta Echaurren, Maurice Henry, Salvador Dali.

Plafond chargé de 1.200 sacs à charbon
Portes « Revolver »
Lampes Mazda
Échos
Odeurs du Brésil
et le reste à l'avenant.

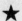

GALERIE BEAUX-ARTS
140, Rue du Faubourg Saint-Honoré — PARIS

FIG. 41. *Cover,* Exposition internationale du surréalisme *[checklist] (Paris: Galerie Beaux-Arts, 1938). Archives Wildenstein Institute. Photo courtesy of the Getty Research Institute, Resource Collections.*

manner as the Chefs-d'œuvre de l'Art Français (I argued at the end of Chapter 3) aestheticized the nation. Through a curious twist of fate, then, Surrealist works of the type endorsed by Breton, of the type on display in the Galerie Beaux-Arts, may have had the effect, even as they strove to rid themselves of any aesthetic surplus, of aestheticizing instead the individuality of the artist's self.

Like any aesthetic surplus, individuality of this excessive sort could appreciate; it could become ever more individual, ever more surreal. We can see it do so when we work our way up the cover of the checklist (fig. 41): those Surrealist individuals who arrange things then find themselves to be things arranged—not by, say, the spirit of the nation, but by Surrealist individuals higher up the hierarchy. From groups of individuals emerge individuals who control groups; from the Surrealist managers of real materials emerge the Surrealist surmanagers of Surrealist managers.

Printed at the bottom of the page, providing the foundation for the hierarchy, appear simply the mundane geographic coordinates of the event—"Galerie Beaux-Arts, 140, rue du Faubourg-Saint-Honoré, Paris"—and a sampling of the sorts of materials to be presented there: "Odors of Brazil," "Echoes," "Flashlights," " 'Revolving' Doors," "Ceiling bearing 1,200 sacks of coal," and, of course, the "Mannequins."

Next, working up, gathered the men who dirty their hands with the manipulation of such physical objects: the sixteen makers of mannequins (some of whom appear again higher up in the hierarchy) and Wolfgang Paalen, charged with the placement of "Water and Underbrush." Though near the bottom of the list, these manual laborers nonetheless have already attained a certain extraordinary designation; mere painters and sculptors, artists working in conventional media, do not appear until the subsequent pages.

Next, Man Ray, the "Master of Lights," illuminated the physical objects created by others; he, along with Dalí and Ernst in their listed roles as "Special Advisers," occupied themselves more with the presentation of Surrealist artifacts than with the actual production of them.

Next, the "Generator-Arbiter" Marcel Duchamp masterminded the entire installation in the Galerie Beaux-Arts, directing the combination of its various parts into a coherent, or perhaps purposefully incoherent, whole. (We may take the inclusion of his "Assistant," listed immediately below as "Claude Le Gentil," in all likelihood some nice fellow with a hammer who helped put up the walls and hang the hooks, as a gentle jest at this emerging hierarchy itself.)

At the top of the list, Breton and Eluard, "Organizers" who initiated, facilitated, and authorized the exhibition without necessarily troubling themselves over the strategy, much less the tactics, of execution. The same Breton, who, infamously for the preceding decade and a half, had been initiating and excommunicating members of the Surrealist congregation with the fervor and iron hand of a Counter-Reformation cardinal in constant vigilance for heretics.

Although we have reached the top of the pile of names printed on the cover of the checklist, the hierarchy may well rise onward from here. There may be others, present

immanently—in the theological, not the Kantian sense of the word. Perhaps Cogniat, the editor in chief of the journal *Beaux arts* affiliated with the gallery, who, while maintaining the pretense of journalistic impartiality within his own pages, elsewhere rather extravagantly claimed the role of organizer for the exhibition.[45] Or Georges Wildenstein perhaps, director of the journal, owner of the gallery, the *éminence grise* of virtually everything between the wars bearing the label "Beaux Arts"; Georges Wildenstein, from a family line of such hidden movers in the arts, potentially the unseen First Cause of all that happened in the halls in the rue du Faubourg-Saint-Honoré. And perhaps beyond, to unseen agents controlling these agents unseen, vanishing beyond even the ostensibly broader horizon offered by our own historical perspective.

All this fuss over the exhibition's arrangement and the potentially infinite regress of individuals in charge of it, and in charge of them, resembles nothing so much as the attention lavished on the hierarchy of scientists and the displays they produced at the Musée de l'Homme; together the two institutions stand in marked contrast to such installations as the Musée des Monuments Français, the Chefs-d'œuvre de l'Art Français, and the Maîtres de l'Art Indépendant, all of which worked to efface the mechanisms and personnel of their presentation. And as with the Musée de l'Homme, the hierarchy at the Surrealist exhibition quickly escalated from those performing mundane tasks— digging in the dirt, say; mounting the displays—to those beyond human witness interceding to guarantee a felicitous outcome: a return on the investments of ever greater knowledge, of ever greater individuality. If at the Chefs-d'œuvre de l'Art Français the "banner" of the church had ceded to the "flag" of the nation (Schuwer's words, from the final section of Chapter 3), at the Exposition Internationale du Surréalisme the standard returned to those priests and demigods who silently ratified the antinationalist Surrealist cause. No wonder, then, that Cogniat could marvel in 1938 that, even after ten years, "the group maintains a strange cohesion as if obedient to a mysterious cult."[46]

But, then, given the tight closure of this group of the select, why proselytize? Why spread the good word of Surrealist individuality? For certainly that was what mounting a public exhibition—in a fashionable *quartier*, no less—would seem to be all about. This was an installation meant to draw a crowd, and draw a crowd it did. Jacques d'Antibes of *Candide* reports live from the opening: "[Neighborhood of] Saint-Philippe du Roule, 10:00 P.M. Emergency Police. A double line of policemen in front of the Galerie Beaux-Arts. A crowd flocks around, jostling, wanting to know, wanting to see, wanting to get through."[47] A sophisticated and cosmopolitan crowd, no less, dressed to the nines in evening dresses and *les smokings*. "*Tout Paris* squeezed in until two in the morning," boasted the anonymous "Jolly Grumbler" in the house organ *Beaux arts*, "Czechs, Germans, Japanese, Englishmen; even some Parisians."[48] A descriptive listing such as this transformed the audience at the opening into yet one more representational figure, in the spirit of the frontispiece to the exhibition checklist (fig. 34), of a lack of Francocentric core at the Exposition Internationale du Surréalisme, distinguishing that private installation still further from the likes of the Chefs-d'œuvre de l'Art Français.

The organizers of the exhibition could voice a role for this international mass of followers without thereby compromising the higher knowledge, the privileged individuality, of the Surrealist priesthood. After repeating his claim that Surrealism was neither works of painting and sculpture nor an aesthetic theory, as if those were the things the large audience would be expecting, Cogniat continued: "It is a deeper disturbance that should be extricated from the Surrealist exhibition; it is the accession to a world of mystery where burlesque has a lesser place than anguish, where the laughter of the visitors dissimulates their apprehension, where even their anger expresses their bewilderment."[49] A sly and incontrovertible thesis, this: the crowd when it laughs reveals that it has missed the deeper mystery in favor of the burlesque, yet were it to manifest instead a seething fury it would not be exhibiting the true agony underlying the comic but rather demonstrating its fundamental incapacity to apprehend its own emotions. Presumably Cogniat and his brethren, unbewildered, could in the face of such confusion continue their righteous plumbing of the depths. Much as the conventions of painting functioned as the foil of representational excess against which to measure the neat economy of the realizations of Surrealist assemblage, this falsely gleeful cosmopolitan crowd was to serve as the foil of ignorance against which to register the profundity of rare and true Surrealist insight. As Breton himself was to admit a decade later (in a formulation that itself requires the capacity to discern the deep meaning generated by an incongruous and somewhat disturbing juxtaposition of images): "Surrealism *calls* for that degrading attack against itself in the same way that man cannot do without the vulture of his shadow in full Promethean light."[50]

In the Galerie Beaux-Arts, then, the presentation of the altars and icons of individuality by the Surrealist hierarchy of priests and demigods before the sophisticated world of *Tout Paris* may have had less to do with attracting a new generation of converts than with the self-righteously reassuring task of identifying a body of pagans not yet enlightened—indeed, perhaps incapable of being enlightened—by the closely held higher truth. Is this not, indeed, always the two-track dynamic of proselytization? Here again a comparison with the Musée de l'Homme is apt—although revealingly less than parallel. In the spirit of the Popular Front, Rivet's and Rivière's new ethnologic museum had committed itself to the mission of spreading, with the authority of the gods, its scientific message of liberal cultural relativity to the earnest workers of France, a salubrious dose of antifascist inoculation. And yet the enterprise of thus redistributing the accumulating surplus value of ethnologic science back through the French populace also had the effect, necessarily, of positing peoples lying irretrievably beyond this economy of scientific information: specifically, those ostensibly primitive and unchanging cultures free of abstraction and surplus that the Musée de l'Homme took as its objects of study. Members of those cultures would never be in a position to visit the galleries in Paris, to learn the lessons of French ethnology. Indeed, we might now recognize the political task of the museum at the Palais de Chaillot to have been the recruitment of the French working class away from the dangerous lure of this sort of *volkisch* ignorance and into an economy of science, and a scientific economy, where they could expect their just return. (The

resulting implied conflation of an irrational and antiscientific fascism with instinctual and surplus-free societies of the sort studied by ethnology both disparaged the frightening fascist movement across the Rhine and, as we have seen at the end of Chapter 3, granted it its terrible force.)

The Exposition Internationale du Surréalisme pared down the players in this scenario: *Tout Paris* performed both as the audience to which the installation preached the catechism of Surrealist individuality and as Surrealism's necessary foil of irredeemable pagan ignorance. To the extent that Breton was right, that the Surrealists needed the presence of this vulture of an audience cast in shadow to attain their own godlike aspirations for all-illuminating fire, the installation in the rue du Faubourg-Saint-Honoré had indeed succeeded in turning its failure to root out all surplus into a triumph of its particular version of an abstracted excess: Surrealist individuality. Yet to the extent that that audience actually attended to the ritual to which they were to serve witness, the Exposition Internationale du Surréalisme ran the risk—in a manner in which the Musée de l'Homme did not—of allowing its designated pagans to overhear the whispering of secrets between initiates. *Tout Paris*, once through the doors of the Galerie Beaux-Arts, was not to be condescended to; it would happily make its own meaning out of—and standing in a relation of excess to—the display.

Worse (or perhaps not worse; perhaps this is to say the same thing): that audience could label Surrealism's tropes. "The devices of Surrealism could be enumerated without much difficulty," Du Colombier affirmed. "The most apparent consists in diverting [*détourner*] objects from their conventional use. . . . These are not whimsical artists, these are mathematicians of the absurd, who operate with a method that is the inverse from conventional methods, but one even more rigorous."[51] Whereas this writer detected the Surrealist habit of ironically being that which convention was not, Lécuyer described with mordant wit the standard procedure repeatedly demonstrated in the Galerie Beaux-Arts for producing the strange juxtapositions of metonymy: "Surrealist art and interior decoration thus understood can be taught in many fewer than twenty-five lessons. The apprenticeship is quite quick. During your days of vacation, when it rains, you will be able to do Surrealism of the highest quality with the detritus of modern life to be discovered in your attic." In the end, the presentation at the Exposition Internationale du Surréalisme proved no more difficult for its sophisticated audience to peg than was the regimented program of the Academy of yore; indeed, by these lights, Surrealism had become rather academically rigid in its own right. "From all this," Lécuyer continued, "[comes] that artificial Surrealism, by recipes, by formulas, by *poncif* [an untranslatable term redolent of the Academy] . . . that turns into an atelier 'assignment.'"[52] In a similar vein, numerous commentators drew the easy parallel between the petty outrages perpetrated at the Galerie Beaux-Arts and those allowed to erupt at those traditional fora for the release of the pent-up spunk of the young students of the Academy: the atelier farce and the Bal des Quat'z-Arts.[53]

It was not just that Surrealism thereby lost its ironic difference from convention, that

it lost its enigmatic indecipherability, its esoteric exclusivity. It also became fully legible in terms of class. And thus the movement risked being dragged back from the position outside the usual field of social intercourse to which it undoubtedly aspired. "This minor mixing of genres and sexes doesn't go very far," wrote the house critic for *La revue hebdomadaire* Jacques Lassaigne, summarizing the exhibition's mechanisms of juxtaposition with remarkable economy; "the formula is there, the proportions are exact, only life is missing." But then the commentary takes a clever turn: "It is indeed for that very reason that the Surrealist exhibition at the Galerie Beaux-Arts . . . enjoys a truly extraordinary success. . . . Everyone can accept it; it is for the bourgeoisie nothing more than a delightful transgression."[54] *Une adorable violence*: how scandalously unscandalous! This exhibition belonged, not as Breton might have wanted it, to the revolutionary unconscious of the proletariat, nor as I described it a moment ago to a cabalistic priesthood, but rather to a world-weary and decadent bourgeoisie. That audience looked in the mirror of the Exposition Internationale du Surréalisme and saw nothing so much as itself. "[A] young poet . . . dispiritedly declared to me," reported our ostensible man-on-the-spot Jacques d'Antibes, "that he had never before spent such a bourgeois evening."[55]

We could speculate—with some certainty, without venturing much—on that which this poet, these critics, that audience in tuxedos and evening dress espied in the Galerie Beaux-Arts that struck them as so tediously familiar. Was not Surrealism's infinitely regressing hierarchy of individuality precisely that class's own version of the ever transcending individual, oft rehearsed in such venues as the Exposition Internationale des Arts et Techniques and the Musée de l'Homme? Was not the Surrealists' individualistic refusal and reversal of convention nothing other than the antiacademic tactics of the Maîtres de l'Art Indépendant simply taken one step further? In a similar manner—and here we need recognize a secondary form of abstraction at the Exposition Internationale du Surréalisme that complemented its principal one of individuality—did not the movement's professed, indeed denominative, internationalism ("Surréalisme Internationale," declared the frontispiece to the checklist, is not *just* French, not *just* German or English, not *just* Japanese), did not all this posing much resemble the ultimately global reach of the Chefs-d'œuvre de l'Art Français (where French culture was not *just* French) or the Maîtres de l'Art Indépendant (where cosmopolitan art produced in Paris was also not *just* French), again taken one step further through the gesture of riposting the explicitly national and metropolitan cores of those earlier attempts at worldly compass? Globally ambitious internationalism of the type manifested in this installation was, to be sure, hardly foreign to the visitors of many nationalities who stopped by the Galerie Beaux-Arts; the world in 1938 was full of such acts of geographic hubris. Whether grasping onto the concept of compounding individuality, or that of expansive internationality, or perhaps even onto some other similar transcendent device, members of the audience at the Exposition Internationale du Surréalisme knew, more than would excluded pagans, more than would merely servile acolytes; knew on their own

terms, before having entered the Galerie Beaux-Arts, before having struggled with the catalogue's opaque exegeses; knew, intrinsically and intimately, the sort of thing they were about to encounter in these halls.

A critic from outside the Surrealist cult and an advocate from its inside, in fitting concordance, alike recognized the potentially mortal consequences for the movement. A. M. Petitjean ruminated about the installation in *La nouvelle revue française*: "An avant-garde . . . which loses in intensity that which it gains in extension and in expanding its audience, comes eventually to toe the line. . . . [Surrealism's] audience . . . is [now] fully realized."[56] And the "Jolly Grumbler," in *Beaux arts*, showed himself on this point to be more curmudgeonly than mirthful: "It had to happen. It is even the worst thing that could have happened. Surrealism passes into the public domain. It could die from it—not the public domain, naturally."[57] *Tout Paris* had caused the Surrealist gods to fall, to become *mondain* and mundane, as were its members themselves. And with that turn of events, the installation in the Galerie Beaux-Arts came to realize—not represent—the world in which that audience lived every day, the site of its own ritualized extravagance. Thus even as the Exposition Internationale du Surréalisme turned the failure to purge surplus into the success of attaining the sacred and compounding distance of Surrealist individuality—and, in addition, of achieving the global expanse of an enhanced internationalism—its success in performing these tasks necessarily transmogrified back into its failure to transcend the very fields of conventional social and political exchange from which it had seemingly hoped to extricate itself through its tropological maneuvers.

Yet therein lies a success, and a failure, of a different order; an order more abstracted yet also more real. Throughout this book, we have witnessed how the seemingly inevitable generation of surpluses abstracted out of and thereby transcending various fields of exchange had the effect of projecting the real world elsewhere, reciprocally—as if in a mirror image, on the other side—beyond those same fields of exchange, which consequently became merely stages for the interplay of redundant figures for that lost world. We have seen, for instance, how at the Exposition Internationale des Arts et Techniques the figure of the French nation, ever receding from the Palais de Chaillot to the Eiffel Tower and still further on from there, exerted a comprehensive grasp meant to encompass the world, only to find itself embracing instead the crumbling stucco of the temporary pavilions lining the Champ de Mars, the fading image of a globe upon the cover of the *Guide officiel*. How the gods within the Palais de Chaillot, respectively anachronistic Christian and contemporary ethnologic, looked down upon the plaster casts of the Musée des Monuments Français and the cluttered vitrines of the Musée de l'Homme to behold the worlds of natural economy therein represented recede into the medieval past and the distant territories of sub-Saharan Africa. How the universal Frenchness manifest at the Chefs-d'œuvre de l'Art Français and the Maîtres de l'Art Indépendant claimed all the globe's fine arts under its aesthetic mantle only to discover the world of the real thereby left open for others of less morally high-minded character to conquer as

their own. Concerted efforts to reinvest these various abstracted surpluses back into their respective fields of exchange, I have repeatedly argued, only augmented the distance between the point of perspective assumed by transcendent gods and the real world from which they rapidly flew.

In the face of this compelling system of logic so pervasive at the end of the 1930s, the Exposition Internationale du Surréalisme constituted, at the most fundamental level, a short circuit. The movement on display in the Galerie Beaux-Arts did indeed transcend its own society; but in so doing it most perfectly realized that very society by reinvesting that society's most sacred abstractions back into this collection of material detritus used to perform its mundane rituals and then left to rot in this dark and dusty cave. Highly aestheticized entities such as individuality and internationality here attained their greatest and most intangible heights, and thus they were here most concretely embodied. At this exhibition, in short, to transcend was to realize; to realize to transcend. The Exposition Internationale du Surréalisme was real precisely to the degree that it was not real; abstract to the extent that it was not abstracted. It was both the greatest refutation of the shared logic governing the various fields of exchange activated by the myriad exhibitions of 1937, and also that logic's greatest affirmation. Or rather, Surrealism's crossing of the wires confounded the very prospect of distinguishing subversion from replication, aesthetic abstraction from material investment, transcendence from realization; even success from failure, or the surreal from the real.[58] Surrealism in the rue du Faubourg-Saint-Honoré could be any one of these things—precisely to the extent, in each case, that it was *not* it. In a world in which the abstraction of a surplus had proved ineluctable and the loss of the real inevitable, this mutual implication of the transcendent and the real (and all the rest), this convoluted crossing-over of polar opposites that verged on their confused mutual identification was perhaps the best that could be hoped for.[59]

We might then locate, within the pages of this book, the most apt analogue for the product of the Exposition Internationale du Surréalisme not in the various abstracted and transcendent entities we have encountered—gods, the nation, the international, the individual, the work of art, and so forth—but rather in that other remarkable entity whose efficacy depended fundamentally on the contradictory nature, the logical impossibility of its accomplishment: the "spectator" on the esplanade of the Palais de Chaillot, the "Frenchman"—incompletely personified by the various visitors to the world's fair in 1937, manifested to greater effect by Hitler several years later (fig. 14). Just as the belligerently imperialistic nation of Germany implausibly invested its abstractions into the individual body of Hitler on the esplanade, the Exposition Internationale du Surréalisme impossibly realized the expansive surpluses of its versions of individuality and internationality in this collection of material objects on display. In drawing this parallel, I would not wish to imply that the installation in the Galerie Beaux-Arts was, in a reductivist sense, metaphorically like Hitler. If anything, we should regard Surrealism in these halls as an ironized alternative version of that impossibility which, in the manner

of the fascist leader at the Palais de Chaillot, both transcended the material world and realized the abstracted spirit at one and the same moment.[60] We would, in any case, fare better to regard both of these competing impossible entities not as a pair of synecdochic instances exemplifying either their respective disembodied ideals or the material stuff of their real histories, but rather as cases of the metonymic juxtaposition, over and again, of the most inappropriate of polar-opposed elements. In early 1938, which of these two types of impossibility, which spark of the improperly closed circuit, would ultimately prevail remained—yawning wide and deeply disturbing—an open question.

EPILOGUE

———

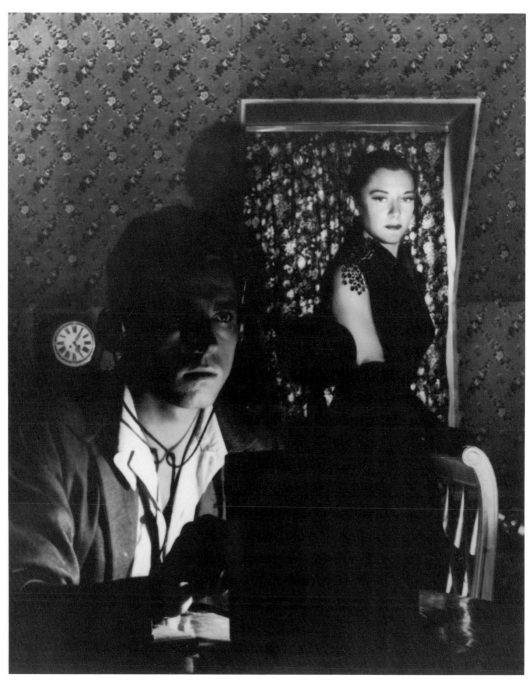

FIG. 42. *Still from the film* Orpheus, *dir. Jean Cocteau, 1950. Photo from the collection of the Academy of Motion Picture Arts and Sciences. Copyright © 1997 U.G.C. (Union Générale Cinématographique), Paris.*

JUPITER MAKES WISE
THOSE HE WOULD LOSE

———

"In a world in which the abstraction of a surplus had proved ineluctable and the loss of the real inevitable," I wrote a moment ago about the Exposition Internationale du Surréalisme, "this convoluted crossing-over of [the] polar opposites [of the transcendent and the real] that verged on their confused mutual identification was perhaps the best that could be hoped for." A rather inauspicious state of affairs, this: in France in 1938, haunted by the all-too-material specter of a waxing fascism, one could counter the inexorable logic of the day with nothing more promising than the rather mechanical confoundation of its precepts, and to uncertain effect. Herein lies, perhaps, the tragedy of all historical actors (but also their enabling condition): all of them, even the Surrealists, seemingly must operate within an inescapable ideological terrain of frightening immutability.

And yet it is refreshing to be reminded how quickly the purportedly inherent and permanent limitations of a given historical moment, how quickly a given constellation of rigid ideas, can with the simple passage of time cede to an entirely different set of imperatives and constraints. Many of the unresolvable anxieties generated within the logic of the late 1930s—concerns about the dangerous alienation of abstracted form in its various guises, say, or about the burdens of excess value or knowledge—had, by all appearances, virtually vanished in many a discipline little more than a decade later. The defeat of fascism and the concomitant termination of the global economic depression undoubtedly contributed substantially to this fundamental conceptual reorientation; but we might detect its trace much beyond the overtly political and economic spheres. From the powerful emergence of structural anthropology in texts such as Claude Lévi-Strauss's *Structures élémentaires de la parenté* of 1949, to the establishment of full convertibility of world currencies underwritten by Bretton Woods in 1944, to the transportation from New York back across the Atlantic to France of a purely autoreferential program for the media of high art, actors from many sectors of the postwar world seemed

somehow to thrive entirely within their own fields of abstraction, without either the certainty of solid reference to the real world or the epistemic assurance provided by the gods.[1]

I cannot hope to give justice to these complex developments following the war in just a few short lines; indeed, the facility and gross generalizations with which I have concluded the preceding paragraph may already have grated on more than a few readers. I have no doubt that the immediate postwar period could sustain its own independent study of disciplinary competition and complementarity, even if that later era lacks the convenient forum for institutional comparison presented by the displays in Paris in 1937 and early 1938.[2] Nevertheless, I would like to close this book with a hint at the magnitude of the change following tight upon the events I have been describing—and thus of the reassuring contingency of their bleak and ostensibly unalterable terms. What, then, if we were to juxtapose this entire collection of Parisian exhibitions and installations dating from 1937 and early 1938 against a single artifact from after the war, against Jean Cocteau's film *Orpheus* of 1950? If one so desired, one could cobble together a genealogy linking Cocteau to the Surrealists in order to justify a metaphoric comparison across time between two like cultural entities: already in the late 1930s—and despite the Surrealist's general disdain for the slightly older artist—the critic F. Gilles de la Tourette in his survey of contemporary artistic trends had opined that "Jean Cocteau seems to me to represent in literature a perfect example of the Surrealist," while Jacques d'Antibes had referred to the "bourgeois beds" in the main hall of Exposition Internationale du Surréalisme as being for " 'Newlyweds of the Eiffel Tower,' " the title (slightly altered) of a Cocteau play from 1921.[3] Rather than pursue this analytic tack, however, let us instead borrow a turn from the Surrealists of 1938. Let us see what happens, let us query how the displays of the late 1930s might be perceived anew from an odd perspective, when we incongruously abut later film against earlier exhibitions, with no more explanation or justification than that which accounted for the confrontation of mannequin and snail in the humid back seat of a taxi.

The action of the film—a recasting of the classical myth within a contemporary French setting—commences when Orpheus, a middle-aged poet past his creative prime, witnesses the mortal wounding of a brilliant young rival named Cégeste, who is run down by a pair of black-clad motorcyclists after he attempts in a drunken stupor to break free from the police following their dispersal of a café *bagarre*. A foreign princess (identified as such early on by a minor character), likewise dressed in black, takes forceful command amid the confusion and has the limp body carried to her large black chauffeured Rolls Royce, ostensibly for transport to a hospital; she orders Orpheus to accompany, claiming she will require him as witness. The severe yet beautiful princess is, in fact, an emissary from Death, sent out by him to reap the young poet; the motorcyclists, like the chauffeur, are in her service. Once in the passenger compartment, Orpheus realizes that the limousine is heading away from hospital and that Cégeste has already expired; the princess curtly rebuffs his entreaties for an explanation. "The radio!"

she demands of the chauffeur, Heurtebise. But this is no ordinary apparatus: the ponderously serious voice it emits, meticulous in its articulation, can be heard in no other vehicle or building:

> *L'oiseau chante avec ses doigts.*
>
> *Attention, écoute.*
>
> *Les miroirs feraient bien de réfléchir davantage.*
>
> *Une fois.*
>
> *Jupiter rend sages ceux qu'il veut perdre.*[4]

Within Cocteau's narrative (as well as in the pages of the last chapter or so) these words and phrases, like the radio signal that carries them, have a propensity to drift in and out of intelligibility. They appear, first, to be pure nonsense: collections of words oddly juxtaposed in poetic caprice. So much indecipherable Surrealist prose. The medium of radio, however, hints at a possible meaning for these phrases; more, at a specific social function, an imperative one, they perform. "The messages . . . are inspired by the radio from England during the Occupation," explicated Cocteau in his preface to the printed film script; but only five years after the end of hostilities that overt statement hardly needed to be made.[5] To the upper echelons of the Resistance command—the movement's "Generators-Arbiters," so to speak—each coded locution broadcast during the war across the Channel signified, unambiguously, one thing: "Blow up that bridge!" "Meet your contact at midnight!" Like the strange assemblages at the Exposition Internationale du Surréalisme as described by the movement's priests, these cryptic messages were meant to be grasped by only a small elite at the time of their production—indeed, the messages, like the assemblages, strove to preserve and reinforce the exclusivity of that select number. And yet, just as Surrealist meanings became as obvious to *Tout Paris* as the message of global cultural nationalism was meant to be to the audience at the Chefs-d'œuvre de l'Art Français, virtually everyone in Cocteau's film audience after the war undoubtedly claimed personal allegiance—retrospectively, at least spiritually—with the leaders of the Resistance all along: all could recognize that the radio messages from England were directed toward the benefit of everyone.

Within the narrative of *Orpheus*, however, the coherence of these phrases drifts away once again. Orpheus, his own inspiration shriveled, becomes entranced by the words as a new, albeit borrowed, source for his poetry. Following the disposal of Cégeste (about which more in a moment) the poet, with the silent authorization of the princess, secretes the limousine and its driver Heurtebise in his own garage in order to spend as much time as possible transcribing the words spurting intermittently from the radio. As he does so, Orpheus forsakes the coded yet potentially certain meaning of the phrases' content in favor of the mystery of their enigmatic form as language; he hears them, again, as poetry.

And then, once again, coherence. When the princess returns to claim Orpheus's wife

Eurydice, ignored and verbally abused by her husband newly obsessed with the magic of words, a resurrected and somnolent Cégeste, now serving among the dead as the lowliest of the princess's minions, mans a portable transmitter to broadcast to Orpheus lines of poetry Cégeste himself had penned while still a living poet (fig. 42). The reading, like the coded messages of the Resistance, serves a specific purpose: Orpheus is to be diverted while the princess—without the sanction of Death himself, it turns out, for against all laws of the dead she has fallen in love with Orpheus and wishes to thin out the competition for his attentions—removes Eurydice from the living.

And then, again, nonsense. The poetry he read on the air, Cégeste later reveals, was not all from his previously living hand; indeed, to have broadcast words of such earthly origin rather than texts handed down from the deep recesses of Death's unfathomable administration constitutes a punishable transgression of the protocols of that regime. Cocteau's claim for lucidity in the preface to the effect that "the messages sent by Cégeste that dupe [Orpheus] come from Cégeste and not from the beyond" is, on the face of it, absurd.[6] Not only do the phrases normatively come from elsewhere, but the broadcasts also begin before Cégeste's resurrection, when he lies dead and unmoving in the back of the limousine.

Can the poet Orpheus, or the film *Orpheus*, lead the audience to that place where such strange events and dangling inconsistencies can be explained away? Not with propriety. To seek such a place—and Orpheus does indeed try—would be to violate the line, or rather the plane, properly separating the living from the dead. The princess, on her initial assignment, takes the dead Cégeste to a dilapidated manor, in one room of which she resuscitates the young poet in front of a full-length mirror. Newly pledged to obey his mistress's commands, the walking-dead prodigy follows the princess, along with the two motorcyclists, through the rippling surface of the mirror into what the script labels as "the Zone . . . between life and death."[7] Orpheus, stepping into the room just in time to witness the end of this spectacle, is naturally astounded. He attempts to follow but, still living, cannot pass: striking against the reflecting surface, he collapses (fig. 43). Later in the tale after Orpheus returns home, a solicitous Heurtebise, warranted by the princess's lack of authorization in seizing Eurydice and aided by Cégeste's oversight in leaving behind a pair of enchanted gloves, helps Orpheus traverse the threshold of the mirror in Eurydice's bedroom to enter into the Zone for the sake of recuperating his wife unjustly spirited away (fig. 44). The chauffeur explains: "I will reveal to you the secret of secrets . . . Mirrors are the portals through which death comes and goes. Moreover, if you look at yourself in a mirror your entire life you will see death at work, like bees in a glass hive."[8] Mirrors reflect further than one may know: Death is there for those who know how to see him. And in that exceptional circumstance justified by the princess's transgression and Orpheus's own special prowess—"ORPHEUS: No man can do it . . . ; HEURTEBISE: A poet is more than a man"[9]—this man who is more than himself can venture into that realm that lies beyond, in a relation of excess to, the closed circuit of a mirror's reflection.

FIG. 43. *Still from the film* Orpheus, *dir. Jean Cocteau, 1950. Photo from the collection of the Academy of Motion Picture Arts and Sciences. Copyright © 1997 U.G.C. (Union Générale Cinématographique), Paris.*

FIG. 44. *Still from the film* Orpheus, *dir. Jean Cocteau, 1950. Photo from the collection of the Academy of Motion Picture Arts and Sciences. Copyright © 1997 U.G.C. (Union Générale Cinématographique), Paris.*

Venture there, but not far. For once anomalously in the Zone, Orpheus—and the audience—discovers that Hades has many circles, certainly an infinite number. At the end of the film, the princess and Heurtebise, for their various infractions against the orders of life and death, are arrested and transported to some deeper recess of Death's catacombs, but neither Orpheus nor Cocteau's camera can follow them there. Unseen Death himself appears to reside at the impossible bottom of the bottomless pit, and at the end of the infinite regress of Hades's abyss. Consider the earlier dialogue between Orpheus and the princess when, reunited again in the Zone, they confess to each other their mutual love. Only one of them, however, has the wisdom to know that the injunction against such a passion across the barrier of the mirror brooks no appeal:

> PRINCESS: I don't have the right to love anyone . . . and I love [you].
> ORPHEUS: You are all-powerful.

PRINCESS: In your eyes. Among us, there are innumerable faces of death, the young, the old, who receive orders . . .

ORPHEUS: And if you were to disobey those orders? They can't kill you . . . You are the one who kills.

PRINCESS: That which they can do is worse . . .

ORPHEUS: Where do these orders come from?

PRINCESS: They are passed on from sentry to sentry, as with the tam-tams of your Africa, the echo of your mountains, the wind in the leaves of your forest.

ORPHEUS: I will go to him who gives these orders.

PRINCESS: My poor love . . . He occupies no place [*nulle part*]. Some believe that he thinks about us [*il pense à nous*]; others that he thinks us up [*il nous pense*]. Others that he sleeps and that we are his dream . . . his bad dream.[10]

Like France at the Exposition Internationale des Arts et Techniques, Death in *Orpheus* is everywhere and nowhere; like the nation at the Chefs-d'œuvre de l'Art Français, were one magically within the fiction of this film to occupy his place of impossible transcendence, the mundane world on this side of the mirror from which one set out would inevitably become as ephemeral as a nightmare. One cannot know him, cannot encounter him. Neither Orpheus nor the audience ever do; to do so, in any case, would be to lose one's grasp on the real.

The audience, nevertheless, receives the gift of an implied name for that transcendent and elusive entity at the end of the infinite regress of Hades, for he has left his traces all over Cocteau's film. Machine-gun-toting motorcyclists in black shirts, a big black car that whisks the unsuspecting off into the night (one rather regrets the lack of scowling chevrons across the grill of a Citroën, or the ominous trisected ring of a Mercedes), a tribunal of faceless men in an improvised setting for the summary judgment of the accused, the ruins of Saint-Cyr bombed during the war in which the scenes of the Zone are filmed. Hitler, that impossible individual behind the profound bureaucracy of death which had spread itself across Europe less than a decade before, Hitler, who in 1940 upon the esplanade of the Palais de Chaillot had claimed to embody a triumphant race, Hitler, whose machinery of national expansion slipped in to assume control over the real when France's version of nation retreated at the Chefs-d'œuvre de l'Art Français into the realm of the aesthetic; in the aftermath of his defeat, Hitler here implicitly becomes the personification of the transcendence attained by evil. In 1950 in Cocteau's *Orpheus*, his is the name of that which cannot be named.

And what becomes of our hero, Orpheus? With the transcendent knowledge of Death now unobtainable and undesired, a willed ignorance of that which lies beyond releases Orpheus back into the world of humans, into the reign of life. The princess had all along been warning of the dangers of knowing too much, counseling quite harshly against Orpheus's probing into unfathomable secrets:

When will you concentrate on that which concerns you? When will you stop troubling yourself about other people's business?

> You are trying too hard to understand what is happening, my dear sir. That is a serious mistake.

> I ask of you, one more time, not to try to understand what I am doing. For, in truth, it would be difficult to understand it even in our world.[11]

In the end, Orpheus submits to the princess's will, and in order to save him she wills ignorance upon Orpheus. With the assistance of Heurtebise, she undertakes the excruciating task of thinking Orpheus back in time; this is their greatest crime—"HEURTEBISE: Nothing is more serious, in any world"[12]—the one that condemns them to transportation into the unseen depths. The screen displays Orpheus's countertrajectory by the means of projecting in reverse the earlier shot of his entrance into the Zone; Orpheus returns through the ruins as if walking backward down the corridor of an art gallery in the rue du Faubourg-Saint-Honoré. (The audience for the film cannot similarly roll back its recently acquired knowledge, of course, but at least that which it has learned is the importance of forgetting.)

Leaping backward through the mirror that stands next to his wife's bed at the end of this passage, Orpheus finds Eurydice restored to life. Or rather, she was never dead at all, for with the reversal of time all that has happened previously has now ceased to have happened. The princess never unjustly claimed Eurydice, Orpheus never passed through the mirror. He knows nothing, sees nothing in the mirror other than his own reflection. Moreover, he now abandons his earlier narcissistic obsession with his own reflected image—treated in the film as the pathology of a solipsistic poet overly fond of himself and his own words—in favor of lavishing his attention instead on his long-suffering and well-deserving wife. Here, finally, the consummated act, the salubrious contiguity of male and female replacing the redundancy of the mirrored image.

The lovers coo. They kiss. Perhaps a drop of saliva passes between their lips, the liquid trace of this encounter between incongruous sexes. Spit, Marcel Griaule had once argued in the pages of Georges Bataille's journal *Documents*, was magic and transcendence, the stuff of spirit and gods:

> Spittle is more than the product of a gland. It must possess a magical nature because . . . it is . . . a miracle-maker: Christ's saliva opened the eyes of the blind, and a mother's "heart's balm" heals the bumps of small children.
> Spittle accompanies breath, which can exit the mouth only when permeated with it. Now, soul is breath . . .
> The mouth—magically the body's chief aperture—is humid from the to and fro of the soul, which comes and goes in the form of breath.
> Saliva is the soul distilled; spittle is soul in movement.[13]

Griaule's miraculous spittle has landed on many pages of this book: on the Eiffel Tower, on the Christian God of Gothic cathedrals, on the full good faith of ethnologic science, on the French nation of art and the French art of nation, on the hierarchy of individualistic priests and demigods in charge of the Exposition Internationale du Surréalisme. But

FIG. 45. *Still from the film* Orpheus, *dir. Jean Cocteau, 1950. Photo from the collection of the Academy of Motion Picture Arts and Sciences. Copyright © 1997 U.G.C. (Union Générale Cinématographique), Paris.*

not on Cocteau's film. Transcendence here has departed elsewhere; it has been driven back into the depths of Hades, or back before 1945 and across the Rhine. And with that exiling of evil—much as the aesthetic transcendence of France at the Palais de Tokio had facilitated Hitler's advances into the real—the supplement of the surplus suddenly becomes possible, without abstraction and its vertical movement, laterally within the world of mundane human exchange. For more than spit has passed between these lovers: Eurydice is pregnant. If the limousine's radio offers only the abstractions of nonsense mathematics—"Two and two make twenty-two"[14]—upon the moisture of the culminating kiss in *Orpheus* is to be reckoned the future of humanity: one plus (a different) one equals three.

Heurtebise, in this book as in *Orpheus*, has the final word. Affirming to the princess the necessity of their shared heroic effort to return Orpheus and Eurydice to the material world at the cost of their own condemnation to a deeper, more abstract circle of Hades (fig. 45), he declares: "They had to be returned to their mire."[15] And if this book has born witness to frequent instances of Griaule's account of transcendent spit, it has also presented an equal number of the chauffeur's version of such dirty waters: on the esplanade of the Palais de Chaillot where Parisian jostles tourist from distant climes, perspiring elbow against perspiring elbow; in the Musée des Monuments Français, where wet plaster meets the mold lifted from the original in the provinces; in the Musée de l'Homme, where sanitized cloth dipped in distilled water wipes grime from some "harvested" African mask; at the Chefs-d'œuvre de l'Art Français and the Maîtres de l'Art Indépendant, where a thin layer of congealed translucent vegetable fat laced with pigment smears across the plane that separates the mundane world of spectators from the eternal realm of the aesthetic spectacle, a layer spreading laterally with such expansive power that it requires thick wooden molding just to frame it; and, to be sure, the mucus of Dalí's mollusk. The fluid rhetorical transition at a Point of Exchange between two halves of a book; the once-wet printer's ink now dried upon this page to embody the abstract meaning of an argument as it passes from the producer to the consumer of words.

World's fair; museum; gallery; film. Snail; artisan; Eiffel Tower; cheek. Plaster; porcelain; canvas of a painting; glass of a vitrine. The dampness in-between. -

NOTES

INTRODUCTION: GLOBAL SPECULATIONS

1. This, I take it, is much of the point of Jacques Derrida in *Memoirs of the Blind: The Self-Portrait and Other Ruins*, trans. Pascale-Anne Brault and Michael Naas (Chicago: University of Chicago Press, 1993), 44–53. Derrida in turn builds his case in part by making reference to Maurice Merleau-Ponty's *The Visible and the Invisible*, trans. Alphonso Lingis (Evanston, Ill.: Northwestern University Press, 1968); undoubtedly, Paul de Man's *Blindness and Insight: Essays in the Rhetoric of Contemporary Criticism* (Minneapolis: University of Minnesota Press, 1983) also exerts its considerable influence.

2. "The invisibility at the core of visible . . . [and] the visible . . . surrounded and confined by the invisible." This doubled figure of failed figuration, Lacanian in derivation, will reemerge in Chapter 1.

3. Pierre Bourdieu famously addressed the former parallel in *Distinction: A Social Critique of the Judgement of Taste*, trans. Richard Nice (Cambridge: Harvard University Press, 1984); while the latter emerges as a principal theme in Jean Baudrillard's *For a Critique of the Political Economy of the Sign*, trans. Charles Levin (St. Louis: Telos Press, 1981).

CHAPTER 1: THE VIEW OF THE ESPLANADE

1. M.-L. Berot-Berger, *L'atout-maître de la vie: Echos de l'exposition arts et techniques* (Paris: Bibliothèque du Progrès, [1937]), 83. See also Paul Dupays, *Voyages autour du monde: Pavillons étrangers et pavillons coloniaux à l'exposition de 1937* (Paris: Henri Didier, 1938); S. G[ille] D[elafon], "L'inauguration officielle de l'exposition arts et technique [*sic*]: Ce que le Président de la République a vu," *Beaux arts*, 28 May 1937; Louis Gillet, "A l'exposition: Architecture et formes," *Revue des deux mondes*, 8th period, vol. 42 (1 November 1937): 91; Raymond Lécuyer, "Pomenade à travers le monde," *Plaisir de France* 4 (August 1937): 34–37, 40; Georges Oudard, "L'univers dans Paris," *Miroir du monde*, Easter 1937; Géo-Ch. Véran, "44 nations vivent dans l'enceinte de l'exposition," *Miroir du monde*, 18 June 1937; and André Warnod, *Exposition 37: La vie flamboyante des expositions* (Paris: Les Editions de France, 1937), 7.

2. Marc Chadourne, "Arts, artists, et artisans de la France d'outre-mer," in *Livre d'or officiel*

de l'exposition internationale des arts et techniques dans la vie moderne (Paris: [Imprimerie Nationale], 1937), 213–14.

3. See, for instance, the comments of Edmond Labbé, general commissioner of the Exposition Internationale des Arts et Techniques: "This is precisely the role that we anticipate for our Exposition, which will stimulate French production, provide the best forum for serious publicity, pull inactive capital out of its torpor, help in the expansion of domestic trade, and perhaps even in an intensification of international exchange that will contribute, in a word, to 'reviving the economic vitality of France,' in the words of President [Albert] Sarraut." This aspect of the fair will return as a topic in the first section of Chapter 2. Edmond Labbé, "Ce que sera l'exposition internationale de Paris 1937," in *Le régionalisme et l'exposition internationale de Paris 1937* (Paris: Imprimerie Nationale, 1936), 122.

4. Warnod, *Exposition 37*, 67.

5. Robert de la Sizeranne, "L'art à l'exposition coloniale I: Le temple d'Angkor et l'art khmer," *Revue des deux mondes*, 8th period, vol. 3 (15 June 1931): 803, 805, 809; first ellipsis in the source text. The Exposition Coloniale Internationale also featured a reconstruction of Angkor Wat, larger and more accurate than the one situated on the Ile des Cygnes during the Exposition Internationale des Arts et Techniques in 1937 (fig. 1). Herman Lebovics provides an extended analysis of this colonial fair in *True France: The Wars over Cultural Identity, 1900–1945* (Ithaca: Cornell University Press, 1992), 51–97.

6. La Sizeranne, "L'art à l'exposition coloniale," 805.

7. We could give this contradictory belief a name: the fetish consists of precisely this combination of the enchanted disavowal of loss and the recognition of ineluctable separation. It is thus especially fitting that the pavilions at the Exposition Internationale des Arts et Techniques were filled principally with objects intended for commercial exchange; objects, in short, that were commodities. Marx first expressed the contradictory character of the commodity fetish: the commodity gave concrete form to abstract social relations and thereby disavowed their elusiveness— "a definite social relation between men . . . assumes, in their eyes, the fantastic form of a relation between things"—while it also recognized the unbridgeable gap between social form and material thing—"in so far as [the single commodity] remains an object of value, it seems impossible to grasp it." Karl Marx, *Capital: A Critique of Political Economy*, 3 vols. (New York: C. H. Kerr & Co., 1906–9), 1:83, 55. Subsequent commentaries on the commodity fetish have frequently lost sight of the inexorable nature of this contradiction, treating the fetish instead as a device of mystification, as a form of false consciousness, that can be overcome in a moment of true recognition.

8. The capacity for projection demonstrated by the commodity fetish so closely resembles the doubled belief invested in the representations of the Exposition Internationale des Arts et Techniques that I could have written this entire first section around the figure of commodification rather than that of representation, with little change in result.

9. Here I am, of course, working from the ideas of Jacques Lacan, and I intend my argument, like his, to invert the commonsense view of the relation between the real world (Lacan's "Real") and representation (Lacan's "symbolization"). Rather than antecedent to its representations, the real world emerges largely as their product; it occupies the blank space that the social practice of symbolization attempts to encompass but can never quite grasp. Slavoj Žižek provides a concise exegesis of the Lacanian logic: "The Real [is] something which on a strictly symbolic level does not exist at all . . . it is something that persists only as failed, missed, in a shadow, and dissolves

itself as soon as we try to grasp it in its positive nature. . . . The Real is *nothing but* [the] impossibility of its inscription: the Real is not a transcendent positive entity, persisting somewhere beyond the symbolic order like a hard kernel inaccessible to it, some kind of Kantian 'Thing-in-itself'—in itself it is nothing at all, just a void, an emptiness in a symbolic structure marking some central impossibility." Slavoj Žižek, *The Sublime Object of Ideology* (London: Verso, 1989), 79, 169, 173.

10. Labbé, "Ce que sera l'exposition internationale," 122.

11. Quoted in Edmond Labbé, *Rapport général: Expostion internationale des arts et techniques dans la vie moderne*, 11 vols. (Paris: Imprimerie Nationale, 1938–40), 1:239.

12. As Lacan, in his famous passage, would have it: "It [the sardine can] was looking at me at the level of the point of light, the point at which everything that looks at me is situated." Jacques Lacan, *The Four Fundamental Concepts of Psycho-Analysis*, ed. Jacques-Alain Miller, trans. Alan Sheridan (New York: W. W. Norton & Co., 1978), 95.

13. Robert Lange, *Merveilles de l'exposition de 1937* (Paris: Les Editions Denoël, 1937), 87.

14. Louis Gillet, "Coup d'œil sur l'exposition," *Revue des deux mondes*, 8th period, vol. 39 (15 May 1937): 329.

15. *Exposition internationale arts et techniques Paris 1937: Guide officiel* (Paris: Société pour le Développement du Tourisme, 1937), 29. See also "Trocadéro," *Le temps*, 8 July 1937.

16. *Exposition internationale de Paris 1937, arts et techniques dans la vie moderne: Plan directeur* (Paris: Imprimerie Nationale, 1934), 4.

17. *La revue de l'art* 71 (September 1937): 127.

18. Gillet, "Coup d'œil sur l'exposition," 325–26.

19. "Le palais du Trocadéro," in *Exposition internationale des arts et des techniques dans la vie moderne Paris 1937: Catalogue général officiel*, 2 vols., 2d ed. (Paris: R. Stenger, [1937]), 2:148.

20. "If what Petit-Jean said to me, namely, that the [sardine] can did not see me, had any meaning, it was because in a sense, it was looking at me, all the same." Lacan, *The Four Fundamental Concepts of Psycho-Analysis*, 95.

21. Gillet, "Coup d'œil sur l'exposition," 331. See also Alf. Agache, "La leçon de l'exposition de 1937," *L'architecture d'aujourd'hui* 8 (August 1937): 6, cited in *Le livre des expositions universelles, 1851–1989* (Paris: Editions des Arts Décoratifs, 1983), 146.

22. Roland Barthes, "The Eiffel Tower" (1964), in *A Barthes Reader*, ed. Susan Sontag (New York: Hill & Wang, 1982), 250.

23. E. de Gramont [Elisabeth de Clermont-Tonnerre], *Mémoires de la Tour Eiffel* (Paris: Editions Bernard Grasset, 1937), 9, 245, 223.

24. Barthes, "The Eiffel Tower," 236–38.

25. *Guide officiel*, 59.

26. An indication of the radicality of that regress: the lack of a position of omniscient knowledge in 1937 has become apparent only from my analytic position of omniscient knowledge outside 1937; but the moment I say that, I become an object of your knowledge, the book you now hold becomes the embodiment of my ideas. I leave it to you to imagine whichever divinities may be glancing over your shoulders.

27. Examining a passage in Sartre's *Being and Nothingness*, Lacan recapitulates this logic: "In so far as I am under the gaze, Sartre writes, I no longer see the eye that looks at me, and if I see the eye, the gaze disappears." Lacan challenges this analysis precisely to reformulate the image of the

voyeur, for according to Lacan, the voyeur is seen by this gaze: "At the moment when [Sartre] has presented himself in the action of looking through a keyhole[, a] gaze surprises him in the function of voyeur, disturbs him, overwhelms him and reduces him to a feeling of shame." Yet even this gaze is not to be seen, by Sartre or by Lacan, who continues: "The gaze I encounter—you can find this in Sartre's own writing—is, not a seen gaze, but a gaze imagined by me in the field of the Other." All passages from Lacan, *The Four Fundamental Concepts of Psycho-Analysis*, 84. Given this analysis, I speak of the "*classic* position of the voyeur" in order to evoke that entity that has been—at least since Laura Mulvey's pathbreaking article "Visual Pleasure and Narrative Cinema," *Screen* 16 (Autumn 1975): 6–18—such an active player in art-historical analysis, while nevertheless distinguishing this type of voyeur from Lacan's. Seeing without being seen—in Lacan's analysis and in mine—cannot be done by living beings, even those at the keyhole; it can only be done by "a gaze imagined by me in the field of the Other." My "transcendent subject," in short, is, within Lacan's vocabulary, not the voyeur but rather something akin to the "Big Other."

The lack of embodiment I attribute to the transcendent subject is also the defining characteristic of the gaze of surveillance emanating from the tower at the center of Bentham's Panopticon, a model of vision resuscitated to great effect in Michel Foucault's *Discipline and Punish: The Birth of the Prison* (New York: Pantheon Books, 1977). Art historians have, I believe, frequently misapplied Bentham's penal paradigm by placing actual historical actors—people or classes—in the position of the tower. The power of the gaze in Foucault's account derives from its disembodiment: the prisoners in the cells below—by extension, everyone in modern disciplinary society—cannot know who is in the tower, or even if the tower is occupied. No one—or, more precisely, no *body*—enjoys the unrestricted power of the gaze; that power lies elsewhere.

28. In Lacan's technical language, the *mise en abîme*.

29. Barthes makes a similar, if less paradoxical, argument about the interpolative powers of a visit to the Eiffel Tower: "For the tourist who climbs the Tower, however mild he may be, Paris laid out before his eyes by an individual and deliberate act of contemplation is still something of the Paris confronted, defied, possessed by Rastignac . . . The Tower is indeed the site which allows one to be incorporated into a race, and when it regards Paris, it is the very essence of the capital it gathers up and proffers to the foreigner." Barthes, "The Eiffel Tower," 247.

30. These two perspectives on the same process serve nicely to mark out the difference between Lacan and Althusser on the interpolation of the subject (which I call the Frenchman). In Lacan's terms, the visitors on the esplanade misrecognize themselves in the mirrored image of the ideal state; in Althusser's terms, the state's ideological apparatus hails the individual ("Hey, you there!" call out the "police" in his famous example; "police," an extraordinary collective noun that itself performs the disembodiment of authority from the blue-uniformed man into the *politia* of government). The relevant texts are Jacques Lacan, "The Mirror Stage," in *Ecrits: A Selection* (New York: W. W. Norton & Co., 1977), and Louis Althusser, "Ideology and Ideological State Apparatuses," in *Lenin and Philosophy and Other Essays* (New York: Monthly Review Press, 1971).

31. Labbé, "Ce que sera l'exposition internationale," 126.

32. Labbé, "Ce que sera l'exposition internationale," 122, 123, 124, 127. I explore in much greater depth the role in economic revitalization envisioned for the capitalist, and the need to enthrall him with the spectacle, in the first section of Chapter 2.

33. Lucien Corpechot, "Notes sociales: Autour de l'exposition," *La revue universelle* 69 (1 June 1937): 634.

34. Labbé's disquisition from 1936 already had the tendency to regard workers as one of the nations resources: "It is necessary that France here show . . . its true force, the peaceful force of a working people." Labbé, "Ce que sera l'exposition internationale," 127.

35. Raymond Isay, "Panorama des expositions universelles VI: De 1889 à 1937," *Revue des deux mondes*, 8th period, vol. 39 (1 May 1937): 186–87, 190, 201.

36. Isay, "Panorama des expositions universelles VI," 186.

37. Gillet, "Architecture et formes," 110.

38. Gillet, "Coup d'œil sur l'exposition," 321.

39. Pierre d'Espezel, "L'exposition internationale des arts et des techniques dans la vie moderne," *Revue de Paris* 44, pt. 4 (15 August 1937): 936. See also Albert Flament, "Tableaux de l'exposition," *Revue de Paris* 44 (15 June 1937): 948; and Gillet, "Coup d'œil sur l'exposition," 330.

40. A number of critics explicitly disparaged these signs: Espezel, "L'exposition internationale," 936; Flament, "Tableaux de l'exposition," 948; Jean Galotti, "Splendeurs de l'art ou la beauté pour tous," *Vu*, 2 June 1937; Jacques Lassaigne, "Chronique de l'exposition: L'architecture (II)," *La revue hebdomadaire* 46, pt. 6 (19 June 1937): 303; and Lucien Rebatet, "Sur l'exposition de 1937," *La revue universelle* 71 (1 November 1937): 280.

41. *Guide officiel*, 28.

42. Lange, *Merveilles de l'exposition*, 15, 41.

43. Labbé, for instance, called for a "reconciliation between peoples" and a "demonstration of peace" in face of the "venomous leaders" of those nations that had not weathered "the Great Test" and its aftermath with the same "dignity" and "calm" as had France. Labbé, "Ce que sera l'exposition internationale," 129–31.

44. *Guide officiel*, 50–51.

45. Gillet, "Architecture et formes," 90–112.

46. Labbé, "Ce que sera l'exposition internationale," 127; Warnod, *Exposition 37*, 67–68. See also Marcel Prévost, "L'exposition de 1937," *La revue de France*, 17th yr., vol. 2 (1 April 1937): 544. A further complication resulting from the multiplication of like nationalities: if the Germany of Speer's pavilion could assume the subjectivity of a nation, if the England and the America implied by the English captions in the *Album officiel* could, why not the Algeria and the Indochina of the Ile des Cygnes as well? It is perhaps for this reason that Isay, writing in 1937 when nationalist movements were gaining momentum in the colonies, waxed nostalgic about 1889 as an era not only when social peace purportedly reigned in France but also when one could proclaim: "'Here are our slaves' . . . with a smile, in the presence of the peoples of color that had been transported from the distant shores of the Niger or the Mekong to the banks of the sovereign river." Isay, "Panorama des expositions universelles VI," 189.

47. Espezel, "L'exposition internationale," 938.

48. *Guide officiel*, 25.

49. Flament, "Tableaux de l'exposition," 948. Philippe Diolé expressed much these same sentiments in the title of his article appearing in *Les nouvelles littéraires* on 30 October 1937: "Les pavillons allemand et russe à l'exposition marquent la même «volonté de puissance»."

50. Espezel, "L'exposition internationale," 936. See also Flament, "Tableaux de l'exposition," 950. And from the mouths of babes: the caption for the centerfold photograph featuring the

view from the Trocadéro that appeared in the souvenir album assembled for the schoolchildren of Bordeaux in commemoration of their visit to Paris marveled about how "the monumental towers of Germany and the USSR . . . confront each other so strangely." *Expo 1937* (Bordeaux: La Petite Gironde, 1937), unpaginated.

CHAPTER 2: GODS IN THE MACHINE

1. Several additional collections—the Musée de la Marine, the Musée des Arts et Traditions Populaires (relocated after the war to the Bois de Bologne), and eventually a Cinémathèque—joined these two museums in the Palais de Chaillot. The Musée des Monuments Français and the Musée de l'Homme, however, received substantially greater allocations of space, about 15,000 square meters each, than did the others, which combined enjoyed less than 12,000 square meters. Of these various collections, the two major museums attracted significantly greater attention in the press, and to this day the Palais de Chaillot is known principally for its displays of French sculptural casts and ethnologic artifacts.

2. Although he makes a minor error concerning the name of the museum of sculptural casts within the old Trocadéro, Denis Hollier establishes much this same point in his excellent article "The Use-Value of the Impossible," trans. Liesl Ollman, *October* 60 (Spring 1992): 11. As will become evident as this chapter proceeds, I "harvest" Hollier's application of "use-value" to this context, but utilize it to different effect.

3. The frontispiece of this book documents that strange moment in 1935—worthy of Lautréamont's image of an umbrella and a sewing machine meeting on an operating table (which we will encounter again in the first section of Chapter 4)—when the ethnographic collections found temporary sanctuary in the closed galleries of the Musée de Monuments Français while awaiting reinstallation in the Musée de l'Homme.

4. Paul Deschamps, *Le musée nationale des monuments français: Son origine, son programme, ses nouveaux aménagements* (Compiègne: Imprimerie de Compiègne, 1939), 3–4.

5. Paul Deschamps, "Historique," in P[aul] Deschamps, M[arc] Thibout, and F[rançois] Souchal, *Palais de Chaillot: Monuments français* (Paris: Les Editions de l'Illustration, 1965), 8.

6. P[aul] Deschamps, "Le musée de sculpture comparée," in *Les musées de Paris présentés par leurs conservateurs* (Angers: Editions Art et Tourisme, [1937]), 18; and Denise Jalabert, "Le musée des monuments français," *La Renaissance* 21 (August 1938): 15.

7. Deschamps acknowledges that these galleries were still closed as of May 1939, as do newspaper reports from the end of that year. Given the financial demands on the national government once hostilities had broken out to the east, it is virtually impossible to imagine that funds to provision these halls would have been forthcoming between that date and the fall of Paris in June 1940. Like the rooms allotted to the copies of frescoes, the sculptural galleries upstairs undoubtedly did not open until after the war. Deschamps, *Le musée nationale des monuments français*, 6; "Aujourd'hui, réouverture de musée national des monuments français au palais de Chaillot," *L'intransigeant*, 3 October 1939; and Georges Godcaux, "Le musée des monuments français au palais Chaillot," *L'œuvre* [Liège], November 1939 (clipping in the Archives, Musée des Monuments Français).

8. Deschamps, *Le musée nationale des monuments français*, 12.

9. *La colline de Chaillot et le nouveau Trocadéro* (Paris: Imprimerie Georges Lang, 1937), 17, 6. I document similar claims about the French character of the Palais de Chaillot in first section of Chapter 1.

10. Joan Evans, *La civilization en France au moyen âge* (Paris: Payot, 1930), 41, 42.

11. Henry Mandel, *La Crise: Ses causes, ses remèdes* (Strasbourg: Imprimerie et Editions des Dernières Nouvelles de Strasbourg, 1932), 5. Mandel's inclusion of "Negro tribes" in this list will gain added resonance as I progress into the second section of this chapter.

12. Henri Pirenne, *Les villes du moyen-âge: Essai d'histoire économique et sociale* (Brussels: Maurice Lamertin, 1927), 187.

13. Pirenne, *Les villes du moyen-âge*, 193.

14. Pirenne, *Les villes du moyen-âge*, 191–93; inconsistency of verb tense in the source text. See also Evans, *La civilization en France*, 273.

15. Karl Marx, *Capital: A Critique of Political Economy*, 3 vols. (New York: C. H. Kerr & Co., 1906–9), 1:167, 170.

16. Marx, *Capital*, 1:168, 169.

17. On the exclusion of the museums from the Exposition Internationale des Arts et Techniques, see *Exposition internationale arts et techniques Paris 1937: Guide officiel* (Paris: Société pour le Développement du Tourisme, 1937), 29; and "Trocadéro," *Le temps*, 8 July 1937. On the status of the Palais as a permanent monument of the Exposition, see "A l'exposition: Les nouveaux musées," *La Revue de l'art*, 3d period, vol. 71 (April 1937): 49; *La colline de Chaillot et le nouveau Trocadéro*, 22; and Robert Gallerand, "Les expositions: Les monuments historiques au palais de Chaillot," *L'amour de l'art* 18 (November 1937): 307.

18. Quoted in Edmond Labbé, *Rapport général: Exposition internationale des arts et techniques dans la vie moderne*, 11 vols. (Paris: Imprimerie Nationale, 1938–40), 1:239.

19. Mandel, *La crise*, 1, 3.

20. Edmond Labbé, "Ce que sera l'exposition internationale de Paris 1937," in *Le régionalisme et l'exposition internationale de Paris 1937* (Paris: Imprimerie Nationale, 1936), 122–23.

21. Mandel, *La crise*, 6. See also Labbé, "Ce que sera l'exposition internationale," 123: "There cannot be an indefinite disjunction, or disequilibrium, between the prodigious forces of production that are, one could say, under our control, and the capacity of the masses to consume, which is currently very limited."

22. Marx, *Capital*, 1:171.

23. Labbé, "Ce que sera l'exposition internationale," 123.

24. Along these lines, Pirenne observed how medieval theology underwrote the closed economy of the manor, in Henri Pirenne, Gustave Cohen, and Henri Focillon, *La civilisation occidentale au moyen âge du XIe au milieu du XVe siècle* (Paris: Les Presses Universitaires de France, 1933), 17.

25. Labbé, "Ce que sera l'exposition internationale," 123–24.

26. Karl Marx, "Critique of the Gotha Program" (1875), in *The Marx-Engels Reader*, ed. Robert C. Tucker (New York: W. W. Norton & Co., 1972), 388.

27. François Simand, *De l'échange primitif à l'économie complexe* (Paris: Editions de la Pensée Ouvrière, 1934). Simand expounded: "Evolution starts from the state of civilization where there is no exchange, where groups of men—spread out, constituted broadly, to greater or lesser degrees—live on that which is obtained from inside the group, consuming that which they produce, also producing for themselves the tools—simple ones, moreover—that allow them to obtain those results. In such groups thus there is no exchange; it is a *closed economy* or *economy without exchange*. . . . Life in a 'closed' economy . . . extends to a group of greater or lesser size: here the family, there the village; in other forms of civilization, the tribe; or the 'familia' of antiq-

uity . . . or the monastery of the Middle Ages that would produce practically everything consumed by the monks and the dependents of the monastery; or the feudal manor, the lord, his family, his tenants, his serfs" (6–7).

28. Emile Mâle, *Art et artistes du moyen âge* (Paris: Librairie Armand Colin, 1927), v.

29. Deschamps, "Historique," 8. Self-evidently, the following several paragraphs benefit from a recent spate of insightful articles addressing the complex interplay between the copy and the original, for which Rosalind Krauss's "The Originiality of the Avant-Garde: A Postmodernist Repetition," *October* 18 (Fall 1981): 47–66, reprinted in Rosalind Krauss, *The Originality of the Avant-Garde and Other Modernist Myths* (Cambridge: MIT Press, 1985), and Richard Shiff's "Mastercopy," *IRIS* 1, no. 2 (1983): 113–27, might serve as representative texts.

30. Deschamps, *Le musée national des monuments français*, 12.

31. Jean Maréchal, "Le musée des monuments français," *Le petit parisien* (undated clipping, probably early September 1937, from the Archives, Musée des Monuments Français).

32. On this "musée des matériaux," see Jalabert, "Le musée des monuments français," 16.

33. Deschamps, "Historique," 8. Yet even Deschamps's formulation is riven with contradiction, for the copy takes the "value" (a surplus) of the "original" (in essence, without surplus). Similar sentiments expressed by Emile Mâle in 1905, cited in Deschamps, *Le musée national des monuments français*, 8–9; and by P. F. Marcou in 1918, cited in Jean Verrier, "Introduction," in *Choix de relevés de peintures murales de la collection des monuments historiques: Catalogue de l'exposition* (Paris: Musée des Monuments Français, 1945), 2.

34. Marx, *Capital*, 1:44. Since Marx, this passage and others like it have often been taken—mistakenly, I believe—as an expression of regret over the loss during the modernist period of the authenticity of a nonalienated precapitalist era, as if that era really allowed a direct and unmediated experience of the world. It is crucial to keep in mind that the image of authentic premodernity is as much a product of capitalist commodification as is the lament over alienation: the hard skepticism that sees through the illusions of the commodity perceives nothing other than the fully present world that the commodity claims to embody in its moment of fantasy. This is, of course, the logic of doubled belief activated in the commodity fetish, which I discuss in the notes to the first section of Chapter 1.

35. While I am primarily concerned with the character of the museum after its reinstallation and change of name in 1938, the transformation of the institution had actually begun, within its old galleries, in 1928 following the incorporation of the Musée d'Ethnographie into the Muséum National d'Histoire Naturelle and the appointment of Paul Rivet as its director and Georges-Henri Rivière as its assistant director. These two men envisioned and then realized the substantial conversion to the Musée de l'Homme over the course of a decade. Consequently, a number of comments by critics concerning exhibitions at the Musée d'Ethnographie during the early 1930s pertain to the new program of the Musée de l'Homme.

Terminologically, I will follow the lead of Rivet, for whom the umbrella term "ethnology" encompassed such subdisciplines as anthropology (the study of physical and physiological characteristics), ethnography (the study of living cultures), and prehistory (the study of extinct cultures). This differs from current English usage.

The Musée de l'Homme and the earlier Musée d'Ethnographie have, of late, become the object of much scholarly attention. Beyond a body of art-historical essays tracing the engagement of the artifacts at the Trocadéro by modern European artists, the crucial texts remain James Clifford,

"On Ethnographic Surrealism," in *The Predicament of Culture: Twentieth-Century Ethnography, Literature, and Art* (Cambridge: Harvard University Press, 1988), and Jean Jamin's three excellent articles: "L'ethnographie mode d'inemploi: De quelque rapports de l'ethnologie avec le malaise dans la civilisation," in *Le mal et la douleur*, ed. Jacques Hainard and Roland Kaehr (Neuchâtel: Musée d'Ethnographie, 1986); "Le musée d'ethnographie en 1930: L'ethnologie comme science et comme politique," in *La muséologie selon Georges-Henri Rivière* (Paris: Dunod/Bordas, 1989); and "Les objets ethnographiques sont-ils des choses perdues?" in *Temps perdu, temps retrouvé*, ed. Jacques Hainard and Roland Kaehr (Neuchâtel: Musée d'Ethnographie, 1985). Nélia Dias, in *Le musée d'ethnographie du Trocadéro (1978–1908): Anthropologie et muséologie en France* (Paris: Editions du Centre National de la Recherche Scientifique, 1991), provides an important prehistory to my study.

36. René Benezech, "Le musée de l'homme," . . . *et Rolet un fripon* 1, no. 22 (17 September 1938): 12.

37. See, for example, Jean Gallotti, "Au musée du Trocadéro: La mission Dakar/Djibouti," *L'illustration*, 26 August 1933; Daniel Halévy, "Au Trocadéro: Le musée des sauvages," *Est républicain* (Nancy) [and other regional newspapers], 15 August 1938; Michel Leiris, "Phantom Africa" (1934), in *Brisées: Broken Branches*, trans. Lydia Davis (San Francisco: North Point Press, 1989), 46; Fernand Lot, "L'art nègre au Trocadéro," *Monde et voyages*, 15 June 1933; *Projet de loi* no. 4841, Chambre des Députés, 24 March 1931, 2; and "Rapport sur la mission Dakar/Djibouti," 8 January 1932 (Archives, Musée de l'Homme).

38. Paul Rivet, *L'anthropologie et les missions* (Paris: Société des Missions Evangéliques, 1931), 8: "When you are among these peoples so different from us—I do not mean different in essence, but in the direction that the evolution of their civilization has taken—do not believe that you have found in them the primitive stage of humanity. For they, also, have evolved."

39. Paul Perrin, "Pour un congrès paneurafricain, ou l'expansion européenne en Afrique," *La concorde*, 3 October 1933; and *Les échos*, 7 October 1933. The article makes passing reference to the Musée d'Ethnographie. See also Michel Leiris, "L'Abyssinie intime," *Mer et outre-mer* 1 (June 1935): 43–44; this passage concludes: "The social system [in Abyssinia] is so similar to our feudalism."

40. Philippe Diolé, "Quatres expositions et cinq salles nouvelles seront inaugurées le 1er juin du Musée d'Ethnographie," *Le rampart*, 29 May 1933. Concerning the Mission Scientifique Dakar-Djibouti, also known informally as the Mission Griaule after the expedition's leader Marcel Griaule, Clifford and Jamin again provide the crucial texts: James Clifford, "Power and Dialogue in Ethnography: Marcel Griaule's Initiation," in *The Predicament of Culture*; and Jean Jamin, "L'objets trouvés des paradis perdus: A propos de la mission Dakar-Djibouti," in *Collections passion*, ed. Jacques Hainard and Roland Kaehr (Neuchâtel: Musée d'Ethnographie, 1982).

41. Jean Gallotti, "Les collections de la mission Dakar-Djibouti," *L'art vivant* 9 (October 1933): 421. See also Jean Gallotti, "Les peintures abyssines de la mission M. Griaule," *Art et décoration* 62 (September 1933): 282–84; and Perrin, "Pour un congrès paneurafricain."

42. Gaston-Louis Roux, "Un peintre français en Abyssinie," undated manuscript (Archives, Musée de l'Homme). "Acquis à Gondar," is the phrase used to label photographic reproductions of the paintings accompanying the article by Marcel Griaule, "Peintures abyssines," *Minotaure*, special issue no. 2 (1933): 83–88.

43. Perrin, "Pour un congrès paneurafricain."

44. Even African religion remained material since the practices of fetishism, frequently attributed to Africans by Europeans, guaranteed the physical presence of the god once the wooden totem came to embody the deity. Indeed, religious fetish and object of use became indistinguishable, as spirituality materialized itself in all things. See, for example, Marc Chadourne, "Arts, artists, et artisans de la France d'outre-mer," in *Livre d'or officiel de l'exposition internationale des arts et techniques dans la vie moderne* (Paris: [Imprimerie Nationale], 1937), 214–15: "In front of the clay that he models or the wood he sculpts into a crude tool, the primitive artist hardly asks himself 'Are you a god, a table, or a basin?' since that table and basin are automatically deified by him. Everywhere where man has preserved the sense of the invisible and considers himself in relation with the spirits of the earth and of the water, of hail and of fire, with the animals, and with the dead, every product of his hands, even those of the most common use, is impregnated with magic. His religious conceptions, the naïve or tormented representation that he formulates of the natural and supernatural worlds, intervene in every one of his creations."

45. André Dennery, "Les expositions: Le musée de l'homme," *L'amour de l'art* 19 (October 1938): 325. See also G. Ch., "Le musée d'ethnographie au palais du Trocadéro," *Le journal des débats*, 3 June 1933: "Negro sculpture is a nearly exact exteriorization of a very primitive civilization that expresses itself naïvely, placing on display its distrust and its savagery."

46. *Instructions sommaires pour les collecteurs d'objets ethnographiques* (Paris: Musée d'Ethnographie, 1931), 9, 6, 11. Jamin states that the *Instructions sommaires* were "conceived by Marcel Griaule and written by Michel Leiris." Jamin, "L'objets trouvés des paradis perdus," 71. See also J. Millot, "Le musée de l'homme," *Revue de Paris* 45, pt. 4 (1 August 1938): 692.

47. Magdeleine Paz, "Le musée de l'homme à Paris," *Le populaire de Paris,* 19 June 1938.

48. Jacques Soustelle, "Le musée de l'homme," *La renaissance* 21 (August 1938): 20. In addition to Soustelle's article, *entourer* appears in J. de la Cerisaie, "Le musée de l'homme," *Nature*, 15 August 1938; and J. Millot, "Le musée de l'homme," 689. See also Boulos, "Le musée de l'homme," *Vogue*, October 1938.

49. A[ndré] D[ezarrois], "Le musée de l'homme," *La revue de l'art*, 3d period, vol. 71 (April 1937): 56. See also Halévy, "Le musée des sauvages."

50. Georges-Henri Rivière, "De l'objet d'un musée d'ethnographie comparé celui d'un musée de beaux-arts," *Cahiers de Belgique* 3 (November 1930): 314. I discuss this article in greater detail in the Entr'acte.

51. René Benezech, "Le musée de l'homme," 11. See also Paz, "Le musée de l'homme Paris": "That which is striking, from the first glance, is not the documentary richness but rather the genius for classification and simplification."

52. References to the artifacts in the Musée de l'Homme as *documents* or *témoins* abound in the literature. See, for example, Georges-Henri Rivière, "Au musée d'ethnographie: La mission Dakar-Djibouti," *L'intransigeant*, 29 May 1933; and the *Instructions sommaires*, 8.

53. Jamin, "Les objets ethnographiques sont-ils des choses perdues?" 68–69. This article provides a thorough and insightful analysis of the concept of the *objet-témoin*.

54. Dezarrois, "Le musée de l'homme," 57.

55. Georges Jubin, "Au musée de l'homme," *Lyon-soir*, 11 August 1938.

56. Millot, "Le musée de l'homme," 692. Jamin argues on this point: "At the museological level, the idea of the object-witness implies that the objects are in a relation of equipollence, which is to say that a Baule spoon or clyster have the same representational value as a Baule mask or sculpture." Jamin, "Les objets ethnographiques sont-ils des choses perdues?" 61.

57. *Instructions sommaires*, 9.

58. M[ichel] L[eiris], "Masques dogon," *Minotaure*, special issue no. 2 (1933): 51.

59. On this point, see Michel Leiris, "Bois rituels des falaises," *Cahiers d'art* 11 (1936): 194: "Among the Dogon . . . there is not, as in our industrial world, this divorce, this division (or better: this dispersion) of beings and things in such a manner that, for better or worse, the work of art, cut off from its roots in immediate use, finds itself reduced, once it leaves the hands of its creator, to being only a diversion for aesthetes." I will argue in the Entr'acte that the aesthetic consists of nothing other than the accumulated surplus value of the abstracted forms of semiosis.

60. Michel Leiris, *L'Afrique fantôme* (Paris: Editions Gallimard, 1981 [1st ed. 1934]), 428, 574, 580. Revelations of the expedition's frantic dissimulations appear on pages 579–83.

61. Correspondence between the mission and the Musée de l'Homme substantiates the gravity of the situation in late 1932. A heated letter dated 6 February 1933 from Henri de Monfreid, a French national working in Ethiopia, to Rivet (Archives, Musée de l'Homme) indicates that the scandal followed Griaule to his meeting with Emperor Haile Selassie on February 4; Monfreid feared that the activities of the mission had damaged the reputation of France in Ethiopia at a diplomatically delicate moment.

62. On Griaule's—as well as Leiris's—participation in the painting of copies, see Leiris, *L'Afrique fantôme*, 412, 418–19.

63. Griaule, "Peintures abyssines," 84.

64. For a sampling of this argument, see R. G., "Sondages sur trois continents," *Miroir du monde*, 10 June 1933; Gallotti, "Les peintures abyssines," 281–82; G.-H. Laquet, "La mission Dakar-Djibouti au musée d'ethnographie du Trocadéro," *Nature*, 15 October 1933; and Thiébault-Sisson, "Art et curiosité: Au musée d'ethnographie, la peinture abyssine," *Le temps*, 25 July 1933.

65. Griaule, "Peintures abyssines," 85.

66. Gallotti, "Les peintures abyssines," 282.

67. Instances include Jean Archambard, "Les nouvelles salles du musée du Trocadéro et l'exposition de la mission Dakar-Djibouti," *Le petit journal*, 7 June 1933; "Chronique du musée," *Bulletin du musée d'ethnographie du Trocadéro*, no. 2 (July 1931): 61; M. H. Ducos, *Rapport* no. 4877, Chambre des Députés, 26 March 1931, 2; "Exposition de la mission Dakar-Djibouti" [press release] (Archives, Musée de l'Homme); Marcel Griaule, "Comment nous avons étudié les Dogons, peuplade du Sangha," *Lyon-républicain*, 16 July 1933; Adolphe Hodée, "Le musée d'ethnographie," *Le peuple*, 9 May 1931; *Instructions sommaires*, 5, 8; Michel Leiris, "Rhombes dogon et dogon pignari," *Bulletin du musée d'ethnographie du Trocadéro*, no. 7 (January–June 1934): 3; *Projet de loi* no. 4841, 2; P[aul] Rivet, P[aul] Lester, and G[eorges]-H[enri] Rivière, "Le laboratoire d'anthropologie du muséum," *Archives du muséum d'histoire naturelle*, 6th series, vol. 12 (1935): 526; Paul Rivet and Georges-Henri Rivière, "La mission ethnographique et linguistique Dakar-Djibouti," *Minotaure*, special issue no. 2 (1933): 3; and H. V. V[allois], "Au musée d'ethnographie du Trocadéro," *L'anthropologie* 43 (1933): 639.

68. Dezarrois, "Le musée de l'homme," 57; and Lot, "L'art nègre," 363.

69. "Exposition de la mission Dakar-Djibouti" [press release]; Gallotti, "Les collections de la mission Dakar-Djibouti," 421; Gallotti, "Les peintures abyssines," 281; Marcel Griaule, *Masques dogons* (Paris: Institut d'Ethnologie, 1938), passim; Marcel Griaule, *Mission Dakar-Djibouti: Rapport général (mai 1931–mai 1932)* (Mâcon: Protat Frères, 1932), passim; G.-H. Laquet, "La mission Dakar-Djibouti au musée d'ethnographie du Trocadéro," 368; M[ichel]

L[eiris], "La sculpture au musée de l'homme," *XXe siècle* 2 ([May] 1939): 55; and Vallois, "Au musée d'ethnographie," 639. The term was also used extensively by Griaule in his periodic field reports sent to the Musée de l'Homme (Archives, Musée de l'Homme).

70. *Les annales coloniales* presented this permit as an amusing oddity. "Les evenements et les hommes," *Les annales coloniales*, 12 May 1931. Jamin mentions the permit in "L'ethnographie mode d'inemploi," 53.

71. The only significant exception to the Physiocratic tenor of the vocabulary was the occasional appearance of the word "booty" (*butin*) to describe the artifacts collected. Gallotti, "Les collections de la mission Dakar-Djibouti," 421; Lot, "L'art nègre," 363; and Rivet and Rivière, "La mission ethnographique et linguistique Dakar-Djibouti," 5.

72. Michel Leiris, "Du musée d'ethnographie au musée de l'homme," *La nouvelle revue française* 51 (1 August 1938): 344.

73. Benezech, "Le musée de l'homme," 10; and Jubin, "Au musée de l'homme."

74. Michel Leiris, "Le musée de l'homme," *Avant-garde*, 14 August 1937.

75. Jacques Soustelle, "Musées vivants: Pour une culture populaire," *Vendredi*, 26 June 1936. See also Soustelle, "Le musée de l'homme," 21; and Jacques Soustelle, "Le musée de l'homme, outil de l'enseignement populaire," *L'ecole libératrice*, 1 October 1938.

76. Leiris, "Le musée de l'homme."

77. Millot, "Le musée de l'homme," 694. See also Georges-Henri Rivière, "Dans le nouveau Trocadéro s'ouvrira le musée de l'homme," *Les nouvelles littéraires*, 9 January 1937.

78. *La colline de Chaillot et le nouveau Trocadéro*, 21. See also Dennery, "Le musée de l'homme," 325.

79. *La colline de Chaillot et le nouveau Trocadéro*, 21. There is some indication that the organizers of the Musée des Monuments Français may have wanted somewhat more public instruction. See Bernard Champaigneulle's complaint on this score, in "Art," *Mercure de France* 280 (15 November 1937): 186; and Paul Deschamps's response, printed in Bernard Champaigneulle, "Art," *Mercure de France* 281 (15 January 1938): 415. Nevertheless, as financial resources remained scarce, it became clear that Deschamps placed greater emphasis on opening new galleries than on equipping the existing rooms with extensive didactic materials. To this day, the Musée des Monuments Français offers virtually no explanatory materials in its halls, especially in comparison to the pedagogical clutter filling the vitrines across the esplanade in the Musée de l'Homme.

80. Adrien Fédorovsky, *La conservation et la restauration des objets ethnographiques: Le laboratoire du musée d'ethnographie* (Paris: Vernière, [1936]), 10.

81. Rivet, Lester, and Rivière, "Le laboratoire d'anthropologie du muséum," 526.

82. *Instructions sommaires*, 5–6.

83. Cited in Jamin, "L'ethnographie mode d'inemploi," 46–47.

84. *Projet de loi* no. 4841, 3. This same phrase reappears several days later in Ducos, *Rapport* no. 4877, 3.

85. The phrase appears, among numerous other places, in P[aul] Rivet and G[eorges]-H[enri] Rivière, "La réorganisation du musée d'ethnographie du Trocadéro," *Bulletin du muséum national d'histoire naturelle*, 2d ser., vol. 2, no. 5 (1930): 10.

86. Marx, *Capital*, 1:173.

87. Paz, "Le musée de l'homme à Paris."

88. Dennery, "Le musée de l'homme," 325.

ENTR'ACTE: POINT OF EXCHANGE

1. Rivière left the Musée de l'Homme to become the founding director of the new Musée des Arts et Traditions Populaires in 1937. Herman Lebovics, in his study of the development of the discipline of folklore in France, devotes considerable attention to Rivière's trajectory through the 1930s and into the war years. Lebovics, *True France: The Wars over Cultural Identity, 1900–1945* (Ithaca: Cornell University Press, 1992), 149–56, 163–71, 179–88.

2. Georges-Henri Rivière, "De l'objet d'un musée d'ethnographie comparé à celui d'un musée de beaux-arts," *Cahiers de Belgique* 2 (November 1930): 310.

3. Rivet and Rivière describe the new administrative structure in "La réorganisation du musée d'ethnographie du Trocadéro," *Bulletin du muséum national d'histoire naturelle,* 2d ser., vol. 2, no. 5 (1930): 2. Jean Jamin discusses the transfer of the museum from the Ministère des Beaux-Arts to the Ministère de l'Instruction Publique in "Le musée d'ethnographie en 1930: L'ethnologie comme science et comme politique," in *La muséologie selon Georges-Henri Rivière* (Paris: Dunod/Bordas, 1989), 116–17.

4. Rivière, "De l'objet d'un musée d'ethnographie comparé à celui d'un musée de beaux-arts," 310, 311.

5. As I write, the Musée de l'Homme faces an almost certain reversal of its institutional move of 1928: the Conseil des Ministres announced on 7 October 1996 that a presidential commission had decided to remove the collections from the administrative control of the Muséum National d'Histoire Naturelle (still part of the Ministère de l'Education Nationale, successor to the Ministère de l'Instruction Publique) and return them under the umbrella of the Ministère de la Culture (successor to the Ministère des Beaux-Arts). Under this plan even the name of the museum would change, to the Musée des Civilisations et des Arts Premiers. The rapidly formed Comité de Défense du Musée de l'Homme, in protesting this transfer, has formulated an argument quite reminiscent of Rivière's critique of the aesthetic approach from 1930: "The collections of the Department of Ethnology, containing over 300,000 objects, would be assigned to the Ministry of Culture and hence *diverted from their scientific function.* The new museum would *reduce the artifacts to only their aesthetic dimension,* thus removing them from their historical and cultural context. The *origins and biological diversity* of humans would no longer appear as the essential explanatory framework for the development of their civilizations, cultures, and arts." [Declaration of the] Comité de Défense du Musée de l'Homme, October 1996, http://anthropologie.unige.ch/cdmh/.

6. Rivière, "De l'objet d'un musée d'ethnographie comparé à celui d'un musée de beaux-arts," 310.

7. Rivet and Rivière decry these shortcomings in "La réorganisation du musée d'ethnographie," 1.

8. Rivière, "De l'objet d'un musée d'ethnographie comparé à celui d'un musée de beaux-arts," 312.

9. They also, apparently, knew how to abstract in the more literal sense of the term. Immediately after the passage in which he decried the destruction of artifacts subject to parasites and the elements, Rivière continued: "Our innovators assumed in these places the role of pioneers, striving to discover, in the general obscurity and overcoming many obstacles, that which would give them quite rare sensations. Should it surprise us, therefore, that some among them attempted— and succeeded to the point of boasting about it—to extract certain objects that they coveted away from a miserable fate!" Just as the members of the Mission Scientifique Dakar-Djibouti would be

justified in salvaging Dogon masks from certain destruction in the caves of Africa, these artists had legitimate grounds for rescuing favored ethnographic artifacts from a negligent Musée d'Ethnographie. Rivière, "De l'objet d'un musée d'ethnographie comparé à celui d'un musée de beaux-arts," 312.

10. Rivière, "De l'objet d'un musée d'ethnographie comparé à celui d'un musée de beaux-arts," 314.

11. Rivière, "De l'objet d'un musée d'ethnographie comparé celui d'un musée de beaux-arts," 314.

12. In his essay "On Ethnographic Surrealism," James Clifford instead aligns the aesthetic—specifically, a Surrealist aesthetic that valued the unanticipated meaning generated by the random juxtaposition of things—with the old heteroclite Musée d'Ethnographie, and argues that the rational and overly authoritative humanism of the Musée de l'Homme stifled any such creative sensibility. Indeed, Clifford reports in a footnote: "According to Michel Leiris (personal communication) in the Musée de l'Homme, Rivet issued a formal injunction against treating artifacts aesthetically." Reported thirdhand, this injunction loses any precise meaning. In Clifford's narrow sense of the word "aesthetic," it may well be true that Rivet discouraged irrational or incongruous arrangements of artifacts. It was also undoubtedly true that Rivet wished to avoid an overly embellished presentation—lights, glass, polish—of the sort ridiculed by Rivière in 1930. But it would be hard to imagine how any museum director could hope to expunge his museum of all possible forms of the aesthetic. Certainly Rivet would have had great sympathy for Rivière's two-step program of appreciating the aesthetic of the objects and then integrating that artistic sense into a more comprehensive ethnologic presentation; I suspect that what Rivet, like Rivière, wanted to avoid was the treatment of ethnographic artifacts as *exclusively* works of art. Clifford, *The Predicament of Culture: Twentieth-Century Ethnography, Literature, and Art* (Cambridge: Harvard University Press, 1988), 140.

13. We here enter temporarily into a mythic and impossible economy of language from which, except in such moments of willed ignorance as this, the insights of the linguist Ferdinand de Saussure (whose *Cours de linguistique générale* appeared in Paris in 1916 and was first translated into English in 1959) have permanently exiled us. Do not worry, the illusions of this projection, akin to that formulated in the late 1930s of a balanced hermetic society of the Middle Ages, will quickly fade.

14. *Pace* Saussure, for whom language is never anything but a play of values from the moment of its emergence.

15. Here—indeed, throughout all of this book—my use of an overarching metaphor positing and exploring parallels between the economies of money, knowledge, vision, and signs is indebted to Jean-Joseph Goux's pathbreaking book, *Symbolic Economies: After Marx and Freud*, trans. Jennifer Curtiss Gage (Ithaca: Cornell University Press, 1990).

16. Paul Baudouin, "Les données du problème français," *Revue de Paris* 45, pt. 1 (1 February 1938): 574–75, 577.

CHAPTER 3: THE FRENCH MASTERPIECE

1. Jean Zay, "Avant-propos," in *Chefs d'œuvre de l'art français* (Paris: Palais National des Arts, [1937]), vii. An aging Louis Vauxcelles echoed this formulation in "Les chefs-d'œuvre de l'art français au musée du quai du [*sic*] Tokio," *Le monde illustré*, 3 July 1937.

2. On the placement of the art exhibition outside the perimeter of the world's fair, see A[ndré] D[ezarrois], "La rétrospective des chefs d'œuvre de l'art français," *La revue de l'art*, 3d period, vol. 71 (April 1937): 7. On the charging of a separate admission, see Louis Gillet, *Essais sur l'art français* (Paris: Flammarion, 1938), ix.

3. Paul Alfassa, "Chefs-d'œuvre de l'art français," *Revue de Paris* 44, pt. 5 (15 October 1937): 920; and Paul Vitry, *La sculpture française du XIIme a XVIme siècle: Les chefs d'œuvre de l'art français à l'exposition internationale de 1937* (Paris: Librairie des Arts Décoratifs, [1938]), unpaginated.

4. Abel Bonnard, "Le génie français," *Candide*, 22 July 1937.

5. We have witnessed Leiris practice such a move in his initial probing of the name for the Musée de l'Homme. See the second section of Chapter 2.

6. The role of culture in the constitution of modern national identities has of late been a topic generating much scholarly interest. Benedict Anderson's pathbreaking and highly influential *Imagined Communities* (London: Verso, 1983) initiated this analytic trend, and countless writers have since used his model to propose ways in which specific cultural artifacts have served to "imagine" the "communities" of various nations. My argument in this chapter is obviously of a piece with this body of scholarship. Yet I am troubled by a tendency manifested in many of the less sophisticated of these accounts, in which works of art or literature come to embody, in a straightforward and rather unproblematic manner, an unambiguous and consistent image of the social collectivity. "Here," these essays seem propose, "here, in *this* artifact, we can see the nation at work!" As will become clear during the argument to follow, I strongly question whether the nation is ever thus "here" in "this" to be perceived; it is rather an entity of such complexity and contradiction—indeed, contradiction is its constitutive element—that no work of art could ever actually realize it. Homi Bhabha's many writings on nation—for example, his contribution entitled "DissemiNation: Time, Narrative, and the Margins of the Modern Nation" in the volume he edited under the title *Nation and Narration* (London: Routledge, 1990)—argue along parallel lines for the necessary incoherence and inconsistency of the nation. In one important sense, I will be insisting, the nation remains fundamentally *unimaginable*.

7. The maquette of the twinned exhibition galleries and laboratories at the Musée de l'Homme (fig. 23) was part of this display.

8. *Chefs d'œuvre d'art français: Guide topographique* (Paris: Palais National des Arts, 1937), 1.

9. The existence of these two photographs, I need add, does not refute the lack of journalistic attention to exhibition's installation. They were published not at the time in a periodical, but rather after the fact, in the multivolume set of weighty tomes in which the organizers of the Exposition Internationale des Arts et Techniques hoped to document its accomplishments. The primary purpose of the photographs thus was not to commemorate the retrospective, which remained extraneous to the fair, but to herald the Exposition Internationale's gift to France of a new museum building. Hence the greater concern manifested by the pair of plates with setting up a contrast between two varied architectural spaces than with sampling different types and periods of artifacts in the retrospective.

10. Robert Burnand, "Dans les musées d'art moderne: La rétrospective de l'art français," *L'illustration*, 14 August 1937.

11. Raymond Lécuyer, "Treize cents chefs-d'œuvre de l'art français," *Le figaro littéraire*, 31 July 1937.

12. Robert Burnand, "Rétrospective de l'art français," in *Livre d'or officiel de l'exposition internationale des arts et techniques dans la vie moderne* (Paris: [Imprimerie Nationale], 1937), 66.

13. Paul Dupays, *L'exposition internationale de 1937: Ses créations et ses merveilles* (Paris: Henri Didier, 1938), 123.

14. Henri Focillon, "Introduction," in *Chefs d'œuvre de l'art français* (Paris: Palais National des Arts, [1937]), xiii, xiv. See also Burnand, "Dans les musées d'art moderne"; Claude Roger-Marx, "Les chefs-d'œuvre de l'art français, foyer de vie spirituelle," *Le jour*, 3 July 1937; and Georges Wildenstein, "Introduction," *Beaux arts*, special issue entitled "L'art français" (August 1937): 5.

15. Focillon, "Introduction," xiii.

16. Louis Gillet, "Chefs-d'œuvre de l'art français I: La peinture," *Revue des deux mondes*, 8th period, vol. 41 (15 September 1937): 277, 283.

17. Lucien Rebatet, "Les chefs-d'œuvre de l'art français," *Revue universelle* 70 (15 August 1937): 447, 451.

18. François Fosca, "Les beaux-arts à l'exposition," *Je suis partout*, 2 July 1937.

19. Elie Faure, "Splendeurs de l'art français," *L'humanité*, 10 July 1937.

20. G. Brunon Guardia, "Venu de tous les points de la France, de l'Europe et du monde: 900 chefs-d'œuvre de l'art français (de ses origines á la fin de l'impressionnisme) sont exposés quai de Tokio dans un incomparable ensemble," *L'intransigeant*, 26 June 1937; and Louis Gillet, "Chefs-d'œuvre de l'art français II: Sculpture et objets d'art," *Revue des deux mondes*, 8th period, vol. 41 (1 October 1937): 577. In the catalogue Georges Huisman, general director of fine arts and head of the organizing committee for the retrospective, likewise labeled the room a "preface to the exhibition" that preceded "the exhibition proper." Huisman, "Avertissement," in *Chefs d'œuvre de l'art français* (Paris: Palais National des Arts, [1937]), xiii.

21. Bernard Champigneulle, "Art: Treize cents chefs-d'œuvre de l'art français," *Mercure de France* 278 (15 September 1937): 636–37.

22. Gillet formulates a similar argument positing an admixture of Gaul and Rome, while adding in the third element of the Orient. "These three series of objects were juxtaposed, before merging together." Gillet, "II: Sculpture et objets d'art," 579.

23. Bonnard, "Le génie français"; Champigneulle, "Treize cents chefs-d'œuvre de l'art français," 638; and Philippe Diolé, "On verra á l'exposition de 1937 mille chefs-d'œuvre de l'art français," *Les nouvelles littéraires*, 15 May 1937.

24. Robert Rey, "1.350 chefs-d'œuvre de l'art français," *Les nouvelles littéraires*, 3 July 1937.

25. I discuss the emergence after the Dreyfus Affair of this reactionary support for artists of the Latinate *grande tradition* and the concomitant disparagement of the eighteenth century, as well as the corresponding republican advocacy of Impressionism and the positing of its links to the eighteenth century, in James D. Herbert, *Fauve Painting: The Making of Cultural Politics* (New Haven: Yale University Press, 1992), 19–20, 124–28, 133–35.

26. Raymond Bouyer, "L'art l'exposition de 1937," *La revue de l'art* 71 (September 1937): 165–66.

27. Jacques Lassaigne, "Le XVIIIe siècle," *Beaux arts*, special issue entitled "L'art français," 12–13; and Jacques Lassaigne, "Chronique artistique: Le triomphe de l'art français," *La revue hebdomadaire* 46, pt. 8 (21–28 August 1937): 373. These two articles share many passages.

28. Jean-Gabriel Lemoine, "L'exposition des chefs-d'œuvre de l'art français," *L'écho de Paris*,

7 July 1937; G. Brunon Gaurdia, "L'art français quai de Tokio: Voici maintenant les chefs-d'œuvre des 18e et 19e siècles," *L'intransigeant*, 27 June 1937; and Georges Huisman, *Chefs-d'œuvre de l'art français: Paris 1937*, 2 vols. (Paris: Editions des Musées Nationaux, [1937]), 1:ix.

29. "Doisneauesque fun": Robert Doisneau's photograph *An Oblique Look* of 1948 enjoys its current familiarity within academic circles owing to the fine discussion of it in Mary Ann Doane, "Film and the Masquerade: Theorising the Female Spectator," *Screen* 23 (September–October 1982): 84–87; reprinted in Mary Ann Doane, *Femmes Fatales: Feminism, Film Theory, Psychoanalysis* (New York: Routledge, 1991), 28–32. Griselda Pollock, citing Doane, reproduces the image again in *Vision and Difference: Femininity, Feminism and Histories of Art* (London: Routledge, 1988), 86.

30. Jacques Guenne, "La peinture français des origines à 1900," *L'art vivant* 13, special issue on "Les chefs-d'œuvre de l'art français" (1937): unpaginated.

31. Faure, "Splendeurs de l'art français"; Claude Roger-Marx, "Les arts et la vie: Les chefs-d'œuvre de l'art français, foyer de vie spirituelle," *Le jour*, 3 July 1937; and Jean Zay, [préface], special issue on the "Chefs-d'œuvre de l'art français," *La renaissance* 20 (July–September 1937): 2.

32. René Huyghe, *La Peinture française du XIVme au XVIIme siècle: Les chefs-d'œuvre de l'art français à l'exposition internationale de 1937* (Paris: Librairie des Arts Décoratifs, [1938]), unpaginated.

33. Gillet, "I: La peinture," 278; and Rebatet, "Les chefs-d'œuvre de l'art français," 449. See also the claim voiced by the painter Amédée Ozenfant in "Notes d'un tourist l'exposition," *Cahiers d'art* 12 (1937): 246.

34. René Huyghe, "Chefs-d'œuvre de l'art français," *Marianne*, 21 July 1937.

35. Jacques Combe, "XVIIe et XVIIIe siècles," in René Huyghe, Germain Bazin, Jacques Combe, and Maurice Raynal, *Cent trent chefs-d'œuvre de l'art français du moyen âge au XXe siècle* (Paris: Arts et Métiers Graphiques, 1937), 19.

36. Burnand, "Rétrospective de l'art français," 64; Faure, "Splendeurs de l'art français"; René Huyghe, "L'art français," in Huyghe et al., *Cent trent chefs-d'œuvre de l'art français*, 3; and "Les musées d'art moderne," in Edmond Labbé, *Rapport général: Exposition internationale des arts et techniques dans la vie moderne*, 11 vols. (Paris: Imprimerie Nationale, 1938–40), 4:180.

37. Combe, "XVIIe et XVIIIe siècles," 19. In a measured fashion of his own, Combe also here praised the inverse balance in Watteau's illustrious predecessor from the seventeenth century: "Few painters . . . have known how to be abstract with as much sensibility as Poussin managed to do."

38. Gillet, "I: La peinture," 277, 282.

39. See, for example, the unsigned preface to the special issue of *L'art vivant* devoted to the retrospective: "The Exposition Internationale of Paris . . . will above all else have revealed, for the first time, the marvelous continuity of French art, from its origins until the present day."

40. Jean Bazaine, "La peinture à l'exposition," *Esprit* 6 (1 December 1937): 451; and Waldemar George, "Le XIX siècle," *Beaux arts*, special issue entitled "L'art français," 18.

41. A certain confusion lingers over the time span claimed by the exhibition: while the title page of the catalogue and the wall map for the exhibition (fig. 29) both declare 1937 to be the terminal date, the preparatory discussions and even the preamble and preface to the catalogue mention 1925 as the end date for the exhibition. Bernadette Contensou speculates—she is almost certainly correct—that this discrepancy emerged owing to the precipitous speed with which the

exhibition was assembled: the first meeting of the organizing committee did not take place until 20 January 1937, five months before the opening. Contensou, "Autour de l'exposition des maîtres de l'art indépendant en 1937," in *Paris 1937: L'art indépendant* (Paris: Musée d'Art Moderne de la Ville de Paris, 1987), 14. The meeting date in January, moreover, reinforces the sense that the city's cultural institutions conceived of the Maîtres de l'Art Indépendant as a response to the state's Chefs-d'œuvre de l'Art Français, about which word had begun to circulate in the last months of 1936.

I also need to modify, slightly, a claim I made a moment ago. The state did in fact venture into the contemporary period in 1937, but only a bit. An exhibition entitled Origines et Développement de l'Art Internationale Indépendant opened on 26 July 1937 on the second floor of the Jeu de Paume, which fell under the administrative umbrella of the Musées Nationaux. This was, however, a comparatively small exhibition; it contained, in addition to a number of African and Oceanic sculptures, only around 180 works of modern European art. In the face of the many hundreds of works on display at both the Chefs-d'œuvre de l'Art Français and the Maîtres de l'Art Indépendant, the temporary exhibit at the Jeu de Paume could hardly hope to garner much critical attention as a display with aspirations toward comprehensiveness; and indeed it did not. The title of Raymond Cogniat's assessment appearing in *Beaux arts* on 6 August 1937, one of only a handful of reviews, captures a sense of the show's shortcomings: "Un titre trop important, une exposition insuffisante." The exhibition, in any case, was probably generated in even greater haste than the Maîtres de l'Art Indépendant as a weak riposte to the city's earlier initiative in claiming the contemporary period as its own. The show at the Jeu de Paume should thus probably be considered more a spontaneous reflex reaction on the part of the national cultural institutions to defend cultural territory on principle (from the incursions of its rival municipal counterparts) than a program prompted by some national ideological imperative to champion contemporary art.

42. Gillet, "I: La peinture," 281: "It follows that the official art of the Court almost never was the true art in France (at least in the case of painting). . . . Accordingly, all those who have felt in themselves the [true] character of a painter, all those who have been original, all those who have had something personal to say, have found themselves early on excluded from that tradition."

43. Raymond Escholier, "Préambule," *Les maîtres de l'art indépendant, 1895–1937* (Paris: Editions Arts et Métiers Graphiques, 1937), 5.

44. Raymond Escholier, "Les chefs-d'œuvre de l'art français au quai de Tokio," *Le journal*, 25 June 1937.

45. Escholier, "Préambule," 6.

46. André Villebœuf, "Les arts: Au Petit Palais," *Gringoire*, 16 July 1937.

47. G. Brunon Guardia, "Au Petit Palais: Le 17 juin, overture de «L'exposition des maîtres de l'art indépendant»," *L'intransigeant*, 11 June 1937; and "Au Petit Palais: L'exposition des maîtres de l'art indépendant," *Le matin*, 21 June 1937.

48. Jean-Jacques Brousson, "Raymond Escholier nous présente l'exposition de l'art indépendant," *Les nouvelles littéraires*, 19 June 1937.

49. *Bulletin municipal officiel de la ville de Paris*, 16 June 1937.

50. Escholier, "Préambule," 5.

51. René Gillouin, "La farce de l'art vivant," *La revue hebdomadaire* 47, pt. 1 (15 January 1938): 271, 282–83. See also the *Bulletin municipal officiel de la ville de Paris*, 18 December 1937.

52. Charles Fegdal, "Chefs-d'œuvre indépendants, au Petit Palais," *Semaine à Paris*, 30 July–5 August 1937.

53. Raymond Galoyer, "Chronique artistique: Les maîtres de l'art indépendant," *L'aube*, 30 June 1937.

54. Francis Carco, "Les maîtres de l'art indépendant: Matisse, Derain, Vlaminck, Picasso . . . orneront-ils un jour le Salon Carré du Louvre?" *Les nouvelles littéraires*, 3 July 1937; ellipsis in the original title.

55. Georges Besson, "Une exposition unique de chefs-d'œuvre," *L'humanité*, 10 July 1937.

56. Rebatet, "Les chefs-d'œuvre de l'art français," 456. In a shorter review of the maîtres de l'Art Indépendant, Rebatet answers this concluding rhetorical question with a guarded affirmative; the second review itself concludes: "French painting almost in its entirety, unfortunately, had to pay its tribute to these dangerous abstractions. It was thereby much weakened. The convalescence will be long. But the organism remains healthy. The yield of these forty years is modest indeed. . . . However, nothing is lost. A secular plant such as French art does not die from the slight wounds inflicted upon it by a troupe of disorienting intellectuals and errant Jews." Lucien Rebatet, "L'art indépendant au Petit Palais," *Revue universelle* 70 (15 September 1937): 712.

57. Fosca, "Les beaux-arts à l'exposition."

58. Georges Prade, *[supplément au] Bulletin municipal officiel de la ville de Paris*, 19 December 1937.

59. Louis Gillet, "Trente ans de peinture au Petit Palais I," *Revue des deux mondes*, 8th period, vol. 40 (15 July 1937): 322, 321.

60. Gillet, "Trente ans de peinture au Petit Palais I," 322, 333, 331.

61. Louis Gillet, "Trente ans de peinture au Petit Palais II," *Revue des deux mondes*, 8th period, vol. 40 (15 August 1937): 564, 569, 573, 577, 579–80.

62. If I am here telling the tale of the critical end to the "the famous rivalry between Matisse and Picasso," a principal theme of the conclusion to my book *Fauve Painting* is its initial formation in the first decade of the twentieth century. Herbert, *Fauve Painting*, 174–83.

63. Gillet, "Trente ans de peinture au Petit Palais I," 321–22.

64. G.-J. Gros, "Salle 6: Derain," and Louis Vauxcelles, "Salle 7: Henri Matisse," in "Les maîtres de l'art indépendant au Petit Palais," *Beaux arts*, 2 July 1937.

65. Maurice Raynal, "Abrégé de l'art français de ses origines à demain," *Verve* 1 (December 1937): 108.

66. Guy Monnereau, "Une magnifique exposition: Cinquante ans d'art indépendant," *L'époque*, 17 June 1937; terminal ellipsis in the source text.

67. Albert Sarrault, "Préface," *Les maîtres de l'art indépendant, 1895–1937* (Paris: Editions Arts et Métiers Graphiques, 1937), 5.

68. Jacques Lassaigne, "Chronique artistique: A propos de «l'art vivant»," *La revue hebdomadaire* 47, pt. 2 (5 February 1938): 117.

69. "Au Petit Palais: L'exposition des maîtres de l'art indépendant," *Le matin*, 21 June 1937.

70. Gillet, "Trente ans de peinture français au Petit Palais I," 580.

71. René Barotte, "L'expo de 37: Protectrice des arts," *Paris-soir*, 30 June 1937.

72. Bernard Dorival, *Les étapes de la peinture française contemporaine*, 3 vols. (Paris: Gallimard, 1943–46).

73. Germain Bazin, "Du XIIe au XVIe siècle," in Huyghe et al., *Cent trent chefs-d'œuvre de l'art français*, 13. See also Raymond Galoyer, "Chronique artistique: Les chefs-d'œuvre de l'art français au nouveau palais des beaux-arts," *L'aube*, 28 July 1937.

74. Bazin, "Du XIIe au XVIe siècle," in Huyghe et al., *Cent trent chefs-d'œuvre de l'art fran-

çais, 15. See also Burnand's oxymoronic formulation from "Dans les musées d'art moderne": "Marvelous continuity of an art that always remains original, that places its particular mark even on that which it has borrowed from foreign lands."

75. Combe, "XVIIe et XVIIIe siècles," in Huyghe et al., *Cent trent chefs-d'œuvre de l'art français*, 19.

76. Lassaigne, "Le XVIIIe siècle," 12.

77. The chronicle in *Cent trent chefs-d'œuvre de l'art français* continues into the nineteenth century by positing a relation between individuality and nationality during the nineteenth century quite similar to that formulated by critics of the Maîtres de l'Art Indépendant concerning cosmopolitan artists working in Paris during the early twentieth century. France, wrote Raynal, "has created an autochthonous art, even as its artists have had the liberty to follow their instincts. . . . There has been a rather egotistical cult of the self, the expression of which was to transform the art of the nineteenth century." Maurice Raynal, "Le XIXe siècle," in Huyghe et al., *Cent trent chefs-d'œuvre de l'art français*, 24. More generally, many commentators, after having established the centrality of the seventeenth and eighteenth centuries in the expression of French culture, treated the nineteenth century as a period of unbridled individual liberty, an individuality that nevertheless confirmed the continuity of the French national legacy into the twentieth century.

78. See, for instance, Gillet, "I: La peinture," 275: "Foreign countries . . . have rivaled each other in their complaisance and generosity."

79. Rebatet, "Les chefs-d'œuvre de l'art français," 446.

80. Zay, "Avant-propos," in *Chefs d'œuvre de l'art français*, viii. See also Gillet, "I: La peinture," 275: "It is a second Louvre, momentary and as beautiful as the other one, a Louvre scattered, *en mission* in the various countries of the world."

81. Burnand, "Dans les musées d'art moderne."

82. Huisman, *Chefs-d'œuvre de l'art français: Paris 1937*, x.

83. Georges Huisman, "Préface," *L'amour de l'art* 18 (April 1937): 1. See also Galoyer, "Les chefs-d'œuvre de l'art français."

84. Zay, "Avant-propos," in *Chefs d'œuvre de l'art français*, vii. In his "Introduction" to this same catalogue, Focillon explicitly articulated the connection between the types of contradiction I examined earlier and this purported French universalism: "This richness is itself a permanent character, and from it derives the intelligibility of French art. French art has attempted to grasp man in all his aspects, and that is why all men can recognize themselves in it" (xxii).

85. It would, once again, be a profound mistake to imagine that this logic appealed only to the authoritarian right. Huisman, after all, was a member of the Popular Front cabinet, and even Elie Faure could write in the pages of *L'humanité*: "As original as the French schools have been, we must still remark that the position of France at the crossroads of Europe has constantly conferred upon it a regulating role in the artistic and moral destinies of the Occident." Faure, "Splendeurs de l'art français."

86. René Barotte, "Six siècles d'art français de Fouquet à Cézanne sont évoqués à l'exposition," *Paris-soir*, 25 June 1937; Lemoine, "L'exposition des chefs-d'œuvre de l'art français"; and Pierre du Colombier, "Chefs-d'œuvre d'art français," *Candide*, 1 July 1937.

87. As we shall witness simply in the existence of the writers that follow, Lefebvre somewhat overstated the uniqueness of his product when he recalled in 1988: "There were not, to my knowledge, other works in France devoted to this fundamental question. . . . The book did not generate

many echoes, even in the form of refutation or critique." Lefebvre, "Postface" (1988), in Henri Lefebvre, *Le nationalisme contre les nations* (Paris: Méridiens Klincksieck, 1988 [1st ed. 1937]), 189.

88. Lefebvre, *Le nationalisme contre les nations*, 184–85.

89. Paul Nizan, "Préface" (1937) in Lefebvre, *Le nationalisme contre les nations*, 22.

90. Lefebvre, *Le nationalisme contre les nations*, 52, 54, 185.

91. Camille Schuwer, "Nation, dernière idole," *Volontés*, no. 3 (20 February 1938): 74, 72–73, 71–72.

92. On this final point, see also the long argument of Georges Izard (who similarly fretted over the deification of the nation) that appeared across several issues of *Esprit*: "It seems that, to agree to the necessity of giving all for the country, one must first empty it of all meaning." Izard, "La patrie et la mort V: Ce qui est à César," *Esprit*, no. 3 (1 December 1932): 400.

93. Daniel Rops, "Espoir en la France III: Trouver la France," *La revue hebdomadaire* 46, pt. 9 (11 September 1937): 169, 175, 178.

94. André Amar, "L'état, puissance spirituelle," *La revue hebdomadaire* 47, pt. 12 (3 December 1938): 37, 39, 45.

95. Marcel Martinet, "Le chef contre l'homme: Nécessité d'un nouvel individualisme," *Esprit*, no. 16 (1 January 1934): 551.

96. Gillet, "I: La peinture," 276.

97. Joseph Csaky, "L'unité en art, ou l'inconvenient du genie," *Volontés*, no. 2 (20 January 1938): 22.

98. "The fact is that the total form of the body by which the subject anticipates in a mirage the maturation of his power is given to him only as a *Gestalt*, that is to say, in an exteriority in which this form is certainly more constituent than constituted, but in which it appears to him above all in a contrasting size that fixes it and in a symmetry that inverts it, in contrast with the turbulent movements that the subject feels are animating him. . . . The *mirror stage* is a drama whose internal thrust is precipitated from insufficiency to anticipation—and which manufactures for the subject, caught up in the lure of spatial identification, the succession of phantasies that extends from a fragmented body-image to a form of its totality." Jacques Lacan, *Ecrits: A Selection*, trans. Alan Sheridan (New York: W. W. Norton & Co., 1977), 2, 4.

99. Zay, [préface], special issue on the "Chefs-d'œuvre de l'art français," *La renaissance*, 2.

100. Lefebvre, *Le nationalisme contre les nations*, 183.

101. Amar, "L'état, puissance spirituelle," 37, 38, 40, 43–44.

102. Jacques Feschotte, "Art officiel et art 'dégénéré' à Munich: Peut-il y avoir une esthétique de gouvernement?" *Mercure de France* 281 (15 February 1938): 107, 99–100.

103. E[mmanuel] Lévinas, "Quelques réflexions sur la philosophie de l'hitlérisme," *Esprit*, no. 36 (1 November 1934): 200–201. See Walter Benjamin, "Theses on the Philosophy of History" (1940), *Illuminations*, ed. Hannah Arendt, trans. Harry Zohn (New York: Schocken Books, 1969).

104. Lévinas, "Quelques réflexions sur la philosophie de l'hitlérisme," 206.

105. Lévinas, "Quelques réflexions sur la philosophie de l'hitlérisme," 207–8.

CHAPTER 4: SHORT CIRCUIT

1. Over the past decade or so, influential and perspicacious writers within the discipline of art history have hot-wired the Surrealist movement, so to speak, by tracing its lines back more to the

intellectual charge flowing from Bataille than to the currents originating from the more tradition- ally assigned source of Breton. Rosalind Krauss's many essays on the topic can be considered to have pioneered this line of interpretation: "Giacometti," in William Rubin, ed., *"Primitivism" in 20th Century Art*, 2 vols. (New York: The Museum of Modern Art), reprinted as "No More Play," in Rosalind Krauss, *The Originality of the Avant-Garde and Other Modernist Myths* (Cam- bridge: MIT Press, 1985), represents an early and influential contribution; while her recent "Mi- chel, Bataille et moi," *October* 68 (Spring 1944): 3–20 draws the point into her title with satisfy- ing clarity. Hal Foster's *Compulsive Beauty* (Cambridge: MIT Press, 1993) constitutes an important book-length study along these same lines. I would hope that my chapter here might have the effect of returning some of the spark to Breton.

2. Bernadette Contensou similarly remarks on "the virtual lack of representation . . . of Surre- alism"; although she manages to discern a total of four names at least tangentially associated with Surrealism—Ernst, Chirico, Picabia, and an obscure Pierre Roy—within the gathering at the Petit Palais. Contensou, "Autour de l'exposition des maîtres de l'art indépendant en 1937," in *Paris 1937: L'art indépendant* (Paris: Musée d'Art Moderne de la Ville de Paris, 1987), 14.

The exhibition entitled Origines et Développement de l'Art Internationale Indépendant, which opened at the Jeu de Paume in July 1937, offered a larger sampling of Surrealist works, but—as I argued in the notes to the second section of Chapter 3—that installation was small and went virtually unnoticed. A good number of Surrealists, moreover, did not consider that display an acceptable presentation of the movement: a letter appearing in *Beaux arts* with the first signa- ture of Breton followed by some thirty names including Arp, Paalen, Seligmann, and Tanguy pro- tested that the show featured unrepresentative works, suffered from a weak text in the catalogue, and was marred by important exclusions. Breton et al., "Une lettre ouverte au président du con- seil," *Beaux arts*, 20 August 1937.

3. William S. Rubin provides these identifications in *Dada, Surrealism, and Their Heritage* (New York: Museum of Modern Art, 1968), 157. On the exhibition checklist, the Masson is given the title *Ophélie* while the Penrose collage does not appear by name. *Exposition internationale du surréalisme* [checklist] (Paris: Galerie Beaux-Arts, 1938).

4. Various critics comment on the brazier, the flashlights, the beds, the coal sacks, the smell of roasting coffee, or the phonograph: Jacques d'Antibes, "La foire surréaliste," *Candide*, 20 Janu- ary 1938; Jean Bazaine, "La peinture: Exposition surréaliste," *Esprit*, no. 66 (1 March 1938): 951; Raymond Cogniat, "L'exposition internationale du surréalisme," *XXe siècle*, no. 1 (1 March 1938): 26; Pierre du Colombier, "Chez les surréalistes," *Candide*, 3 February 1938; Albert Fla- ment, "Tableaux de Paris: Surréalisme," *Revue de Paris* 45, pt. 1 (1 February 1938): 711; François Fosca, "Les arts: La duperie du surréalisme," *Je suis partout*, 28 January 1938; Jean Fraysse, "Pour le surréalisme: Un art d'insolite grandeur," *Le figaro*, 29 January 1938; Le Grincheux Jovial [Jolly Grumbler], "Surréalisme," *Beaux arts*, 4 February 1938; Le Grincheux Jovial, "Le surréa- lisme à 'Beaux-Arts,'" *Beaux arts*, 14 January 1938; Le Grincheux Jovial, "Le vernissage de l'ex- position surréaliste," *Beaux arts*, 21 January 1938; René Guetta, "L'expo de rêve," *Marianne*, 26 January 1938; Maurice Henry, "Le surréalisme dans le décor," *Marianne*, 26 January 1938; Ray- mond Lécuyer, "Une charge d'atelier," *Le figaro*, 22 January 1938; and Claude Roger-Marx, "Les arts et la vie: Un gala surréaliste à «Beaux-Arts»," *Le jour*, 18 January 1938. In the article of 21 January 1938, Le Grincheux Jovial writes that the phonograph "sang hysteria at us," and refers to its "howlings"; Rubin claims the phonograph played "German marching songs," but I have been unable to locate the source of this claim. Rubin, *Dada, Surrealism, and Their Heritage*, 154.

5. Breton lists the street names in André Breton, "Devant le rideau" (1947), in *La clé des champs* ([Paris]: Editions Jean-Jacques Pauvert, 1967), 105–6; one of them is visible in fig. 33. Although I can discern only exhibition posters in this image, René Guetta mentions the poetry and Man Ray photographs in "L'expo de rêve"; photographs of the installation taken by Josef Breitenbach, now in the Resource Collections of the Getty Research Institute, show a number of newspaper clippings as well as a framed set of Bellmer photographs. The Breitenbach photographs also reveal additional street names: rue de la Glacière, rue Albert-Tison, and passage des Panoramas.

6. Guetta, "L'expo de rêve."

7. I consulted the invitation contained in the Fonds Vauxelles, carton 149, Bibliothèque d'Art et d'Archéologie, Fondation Jacques Doucet; the Resource Collections of the Getty Research Institute also lists a copy in its catalogues.

8. Fosca, "La duperie du surréalisme." The review begins: "The exhibition of Surrealism at the Galerie Beaux-Arts allows one to grasp a very clear idea of Surrealism and demonstrates fully that this supposed 'art movement' is nothing but a scam."

9. Examples include Dalí's *Giraffe on Fire*, in R[aymond] C[ogniat], "L'exposition surréaliste," *Beaux arts*, 14 January 1938; Dalí's *Specter of Sex Appeal* in Cogniat, "L'exposition internationale du surréalisme," 29; and Penrose's *To See Is to Believe*, in Henry, "Le surréalisme dans le décor."

10. The quartet of terms for the labeling and analysis of tropes upon which I will rely—metaphor, metonymy, synecdoche, and irony—is age-old, but probably owes its current vitality, on this side of the Atlantic at least, to its resuscitation by Kenneth Burke's *A Grammar of Motives* (New York: Prentice-Hall, 1945) within the discipline of literary criticism, and by Hayden White's *Metahistory: The Historical Imagination in Nineteenth-Century Europe* (Baltimore: Johns Hopkins University Press, 1973) within the field of historiography; countless scholars across the spectrum of the humanities have since built upon their insights. My own application of the terms is different in crucial respects from that of either Burke or White, as I hope will emerge with a decent degree of clarity as we proceed.

11. Guetta, "L'expo de rêve."

12. This misleadingly convoluted formulation obscures the true simplicity of the idea, which emerges with elegant clarity when expressed in the vocabulary of semiotics: whereas the iconic signifier and its signified are linked metaphorically by their visual likeness, the signified is synecdochically part of the sign. Confusions bedevil the nontechnical formulation owing to two factors: first, the inevitable conflation of the concepts of signifier and sign when the two are not lexigraphically distinguished (they are, in fact, incommensurate entities); and, secondly, the plodding habits of mind (I speak from personal experience, but speculate that the tendency is widespread) that rebel at the notion that the signified, as much a partial aspect of the sign as is the signifier, can serve equally well as a synecdoche of it.

13. I am borrowing the image of tropological poles from Roman Jakobson's "The Metaphoric and Metonymic Poles," in Roman Jakobson and Morris Hall, *Fundamentals of Language* (The Hague: Mouton Publishers, 1956), conveniently reprinted in *Critical Theory since Plato*, ed. Hazard Adams (New York: Harcourt Brace Jovanovich, 1971). White provides a excellent and pithy discussion of this essay, and its similarities to the use of the "Metaphorical-Metonymical dyad" in other theorists such as Lévi-Strauss and Lacan, in White, *The Historical Imagination*, 31–33.

I should take a moment here to insist on the modesty of my claims. I am not wishing to defend the proposition that painting, or for that matter commerce, always aligns along a metaphoric-synecdochic axis. Jakobson, for instance, maps painting onto the metaphoric-metonymic axis he uses to account for the difference between romantic and realist literature. Indeed, Surrealist painting serves as his example of metaphoric painting in the face of Cubism's metonymies; later, I will again briefly touch upon this formulation in relation to my own. I have little doubt that at different times and places the practices of painting—or any other type of cultural production, for that matter—might well be found to coordinate with any two (or more, or fewer) poles in the tropological schema. My argument here is simply that painting within the specific local cultural environment of Paris during the late 1930s took on the attribute of (or "was attributed with"—to whom or what one attributes agency is of no consequence) playing along the particular axis of metaphor and synecdoche, and that that tropological predilection was something the Exposition Internationale du Surréalisme in 1938 could, in its turn, turn against.

14. *Dictionnaire abrégé du surréalisme* (Paris: Galerie Beaux-Arts, 1938), 20. Jacques d'Antibes comments on "all the elegant ladies, who lack a Molière to portray them browsing *Le Dictionnaire abrégé du surréalisme*," in Antibes, "La foire surréaliste."

15. Lécuyer, "Une charge d'atelier." See also Flament, "Surréalisme": "It is true, if we consult the catalogue, that this exhibition, felicitously *international*, hardly includes any French names."

16. I have shortened the definition slightly, though the second ellipsis given here derives from the source text. The initial and concluding quotation marks indicate that Breton is being quoted from some earlier essay, but I have not identified that earlier source. *Dictionnaire abrégé du surréalisme*, 20.

17. Cogniat, "L'exposition internationale du surréalisme," 26, 28.

18. André Breton, *Surrealism and Painting*, trans. Simon Watson Taylor (New York: Harper & Row, 1972 [1st French ed. 1928]), 2.

19. Breton, *Surrealism and Painting*, 4.

20. List culled from Cogniat, "L'exposition internationale du surréalisme," 26–28; in many cases I have transformed the varied grammatical forms of Cognait's terms into nouns.

21. Breton, *Surrealism and Painting*, 5.

22. It is, in these terms, fitting that I have not been able to locate the source text from which the definition in the *Dictionnaire abrégé* had been lifted and placed in quotation marks: Breton's passage thus, for our purposes at least, becomes an original.

23. Walter Benjamin, who provided the epigraph that opens this chapter likewise feared a surplus, but of a somewhat different sort: the surplus of a politically stultifying false consciousness. The passage immediately continues: "The socialist sees that 'finer future of our children and grandchildren' in a condition in which all act 'as if they were angels,' and everyone has as much 'as if he were rich,' and everyone lives 'as if he were free.' Of angels, wealth, freedom, not a trace." But the difference between Benjamin and Breton may not be great: the critique of this type of false consciousness can undoubtedly be phrased as a faulting of its existence *only as* a form, with no connection to the world in which one searches out the "traces" of the real. Benjamin, "Surrealism: The Last Snapshot of the European Intelligentsia," in *Reflections*, ed. Peter Demetz, trans. Edmund Jephcott (New York: Harcourt Brace Jovanovich, 1978), 190.

24. Some years earlier, in his answer to an inquest appearing in *L'esprit français* concerning the nature of intellectual work under capitalism, Breton described just such a perfect metonymic

correspondence between the production and consumption of the cultural artifact at the level of personal need, and in the process left remarkably explicit his concomitant distrust of the generation of surpluses, metaphorically both economic and psychic: "To avoid *a priori* all confusion, it is necessary to distinguish two principal modes of 'intellectual' production: first, that which has as its goal the satisfaction for the man of his *appetite of the spirit*, as natural as hunger; second, that which has as its goal the satisfaction for the producer of an altogether different set of needs (money, honor, glory, etc.). . . . This second group of producers . . . attempts to enhance [*faire valoir*] [the forces of] capital, in taking on every day the defense of its army, of its church, of its police, of its system of justice, of its morality. . . . The [true] intellectual producer . . . I would like to consider to be the one who, by his product, strives to satisfy above all the needs of his spirit." The echo of this idea remains in the definition from the *Dictionnaire abrégé* in the form of the phrase *Au peintre s'offre*. André Breton, "Rapports du travail intellectuel et du capital" (1930), in *Point du jour*, rev. ed. (Paris: Editions Gallimard, 1970), 83–84.

25. I mentioned earlier that Jakobson used Surrealism as his example of metaphoric painting; I take it that he had this sense of resemblance in mind.

The argument might be made that such painting, at least, fixes the dream for others to see, to their benefit; but that would implicate the "producer"—no longer producer and consumer at one and the same moment, as Breton would like—into precisely the sort of marketplace for the ideological exchange of intellectual products to satisfy the needs of others—including the "other" of capital—that Breton had condemned in 1930. See preceding note.

26. It is remarkable how infrequently the literature on trompe l'oeil bothers to address these basic questions, as if the deceptions and revelations of the genre took place on some abstract and immutable plane of the truth of the image and thus independent of specific acts—actual or projected, historical or imagined—of viewing and interpretation. A notable exception, which has much influenced my own thinking on trompe l'oeil, is Cécile Whiting's article, "Trompe l'oeil Painting and the Counterfeit Civil War," *The Art Bulletin* 79 (June 1997): 251–68.

27. Intriguingly, this is precisely the tropological dynamic activated by the *Dictionnaire abrégé* itself. The quotation marks and authorial initials that serve to frame so many of the definitions declare that these passages resemble some others that exist outside of the covers of the *Dictionnaire abrégé*: "this text is like that." Yet once we are within the passage itself and ignore those framing devices, we tend to regard the definitions in the *Dictionnaire abrégé* as if they were the text, rather than just something resembling it. And within this interpretive state, much of the meaning of the *Dictionnaire abrégé* seems to result from the odd juxtaposition of incongruous definitions brought into contiguity through the arbitrariness of alphabetization: "VIERGE [virgin]: ' . . . I found a sweaty virgin at the back of an ice cave.' (*Maeterlinck*). VILLE [city]: 'It was a magnificent city; a seasonal model.' VIOL [rape]: love of speed. VIOLET [violet]: double fly." *Dictionnaire abrégé du surréalisme*, 29; ellipsis in the source text.

28. *Dictionnaire abrégé du surréalisme*, 20.

29. In Dalí's own convoluted formulation: "Once again in this regard, need I remark, to anticipate the useless alarm over the hypothetical complaint concerning the lofty notions of 'directed thinking,' that the presence, noted above, of the fact of systematicity in no manner implies the coercion of thinking by a system or reasoning intervening after the fact. Rather, to the contrary, since that systematicity takes the form of the paranoiac phenomenon that is consubstantial with the fact, it is necessary to see in the system a consequence of the development itself of the delirious

ideas—these ideas, delirious in the very moment when they occur, presenting themselves as *already* systematized. . . . Far from constituting a passive element fit for interpretation and suitable for intervention . . . paranoiac delirium already constitutes in itself a form of interpretation. . . . All of the critical preoccupation of the Surrealists is precisely directed toward valorizing, beyond any facile paradox, dreams (as well as all other passive and automatic states) at the level of 'action' itself, to make them intervene, in particular, 'interpretively' in reality, in life." Salvador Dalí, "Interprétation paranoaque-critique de l'image obsédante *L'angélus* de Millet," *Minotaure*, no. 1 (1933): 66.

30. The painting appears there within a photograph published in *Duchamp* (Madrid: Caja de Pensiones, 1984), 24.

31. Dalí: "By a strictly paranoiac procedure it has been possible to obtain a double image: which is to say, the representation of an object that, without the slightest figurative or anatomical modification, is at the same time the representation of an absolutely different object." Salvador Dalí, *La femme visible* (Paris: Editions Surréalistes, 1930), 15.

32. Du Colombier, "Chez les surréalistes."

33. Du Colombier, "Chez les surréalistes"; Bazaine, "Exposition surréaliste," 951; Lécuyer, "Une charge d'atelier"; and Flament, "Surréalisme," 712.

34. Cogniat, "L'exposition internationale du surréalisme," 28, 25.

35. This difference, I believe, accounts for the radically different critical (if not necessarily commercial) fortunes after the war of Ernst on one hand and Magritte and Dalí—especially Dalí—on the other. Ernst's worried surfaces parsed quite nicely within the syntactics built by postwar criticism that placed such high value on metonymic relations between formal elements, while the remnants of figurative content in his work could assume the role of atavistic illusionism within that larger narrative chronicling the progress of art toward its grand culmination in American postwar abstraction. Magritte's plays with words and pictures offered him the salvation of limited postwar resuscitation at the hands of the structuralists; Michel Foucault's *Ceci n'est pas une pipe* (Montpellier: Editions Fata Morgana, 1973) exemplifies the interpretative practice.

Dalí, however, has proved (with few notable exceptions) beyond recuperation. It appears simply never to have occurred to most writers working in the area of Dalí scholarship (to the extent that that designation is not hopelessly oxymoronic, Dalí having been ignored—nay, shunned, shrilly repudiated—by most of serious art history in a manner that can only be regarded as itself symptomatic for the discipline) that Dalí's parodically perfect academic technique might in fact serve within the canvas to figure the metaphoricity of illusionism against which the content of the work ironically turns, to placing itself instead under the spell of the metonym.

36. Du Colombier, "Chez les surréalistes." Du Colombier spins off this quip with different purpose than I here imply is his: he felt that Surrealist painting—which, you recall, he considered academic—was redundant to the exhibition in its entirety because he thought the show as a whole failed to break from convention. Bear with me: this is a possibility I will entertain in the next section of the present chapter.

37. Cogniat, "L'exposition internationale du surréalisme," 26.

38. As Le Grincheux Jovial remarked in "Le vernissage de l'exposition surréaliste": "There were too many tuxedos, too many evening dresses not to give Surrealism a scent of the mundane. Too many women, as well, whose pure aesthetic was patently opposed to Surrealist ideas."

39. "Surrealism is, first, as our editor in chief Raymond Cogniat has written in these pages,

'the drama of objects without necessity and without reality, their hopeless and mysterious expression when one makes them serve ends for which they were not intended . . . ' " Le Grincheux Jovial, "Le vernissage de l'exposition surréaliste"; ellipsis in the source text.

40. Of course, in another sense, this collapse of metaphor opens up the possibility for a metaphor of a different order: the mannequin becomes a metaphor for the uninterpretable itself. This seems to have been Breton's drift when he wrote in 1939: "Technically, the means of progress, of propulsion, is provided here by plastic metaphor in its pure state, by which I mean a literally uninterpretable metaphor. The perfect example of this was the mannequin's green gag with a pansy for mouth shown by Masson in January 1938 at the International Surrealist Exhibition and rightly considered to be the most brilliantly original object in the whole display." A phrase preceding this passage by several lines fleshes out the metaphor of uninterpretability: "In Masson's work, eroticism must be considered the keystone . . ." And while Breton continues by discussing the erotic charge of men's and women's bodies, the concept of eroticism when raised in relation to Masson's mannequin of a nude woman could well constitute the formulation of a metaphor equating, say, female sexuality and the indecipherable. It is also true that in declaring Masson's mannequin to be "the most brilliantly original object in the whole display" Breton activates the synecdoche by which this single work exemplifies the precepts of the entire Exposition Internationale du Surréalisme. Masson's mannequin, in short, did not so much extinguish the tropes of metaphor and synecdoche as go through the rhetorical moves of representing—provisionally, for the moment—their dissolution. But that is precisely my argument, as should become clear at the beginning of the following section of this chapter. André Breton, "The Magical Eloquence of André Masson" (1939), in Breton, *Surrealism and Painting*, 154.

41. Fraysse refers to him as "a burned man [who] takes the wheel of an old car for hire." Fraysse, "Pour le surréalisme."

42. Fraysse, in "Pour le surréalisme," mentions the sewing machine on the back seat; both Fosca in "La duperie du surréalisme" and Henry in "Le surréalisme dans le décor" quote or paraphrase the line from the poet: "Il est beau . . . comme la rencontre fortuite sur une table de dissection d'une machine à coudre et d'un parapluie!"

43. That the names in the checklist from the Galerie Beaux-Arts figured alternatively that larger collectivity that goes by the title of "International Surrealism" is a possibility we will need to explore further in a moment. Yet to the extent that the category "International Surrealism" served primarily to designate a type of autonomous individuality operating on a global scale, rather than to designate a certain geographic territory of culturally privileged soil, even the fulfillment of that possibility would still return us tautologically to the individual.

44. F. Gilles de la Tourette, "Sur quelques tendances de la peinture contemporaine," in *La peinture française contemporaine: Les maîtres de l'art indépendant* (Paris: Librairie des Arts Décoratifs, [1937]), unpaginated.

45. See Raymond Cogniat, "Pourquoi j'ai organisé l'exposition du surréalisme," *Les nouvelles littéraires*, 26 February 1938.

46. Cogniat, "L'exposition internationale du surréalisme," 25.

47. Antibes, "La foire surréaliste."

48. Le Grincheux Jovial, "Le vernissage de l'exposition surréaliste."

49. Cogniat, "L'exposition surréaliste." In this same spirit, the passage from Le Grincheux Jovial quoted a moment ago continues: "also some Parisians . . . curators from the museum . . . who

have very kindly attempted to comprehend Surrealism." Le Grincheux Jovial, "Le vernissage de l'exposition surréaliste"; final ellipsis in the source text.

50. André Breton, "Devant le rideau," in *La clé des champs*, 105; English translation by Michel Parmentier and Jacqueline d'Amboise, as "Before the Curtain," in André Breton, *Free Rein* (Lincoln: University of Nebraska Press, 1995), 80.

51. Du Colombier, "Chez les surréalistes."

52. Lécuyer, "Une charge d'atelier."

53. See, among others, Antibes, "La foire surréaliste"; Flament, "Surréalisme," 711; and Fosca, "La duperie du surréalisme."

54. Jacques Lassaigne, "Chronique artistique: Les adieux du surréalisme," *La revue hebdomadaire* 47, pt. 2 (26 February 1938): 490. On the widespread popularity of the exhibition, see also Du Colombier's witticism: "That which pleases me about the Surrealist exhibition is that it is absolutely unnecessary for me to give a description of it. There is no one in Paris even a bit informed who doesn't know of it." Du Colombier, "Chez les surréalistes."

55. Antibes, "La foire surréaliste."

56. A. M. Petitjean, "A propos de l'exposition surréaliste," *La nouvelle revue française* 50 (1 March 1938): 515–16.

57. Le Grincheux Jovial, "Surréalisme," *Beaux arts*, 26 February 1938.

58. "An indication of the radicality of [the] regress [from the esplanade of the Palais de Chaillot to the Eiffel Tower and onward]" I wrote in the notes to the second section of Chapter 1: "[would be that] the lack of a position of omniscient knowledge in 1937 has become apparent only from my analytic position of omniscient knowledge outside 1937; but the moment I say that, I become an object of your knowledge, the book you now hold becomes the embodiment of my ideas." In a similar manner, the confoundation here is equally radical, extending to my position of articulation and yours of observation. I cannot say whether the Exposition Internationale du Surréalisme succeeded in realizing its program without, by that very act, causing its program to fail, since through my simple declaration I would necessarily thereby be formulating a position of transcendence for myself from which the real truth of the exhibition could be known. Similarly, you cannot know whether I have succeeded or failed in writing a true account of the exhibition in the Galerie Beaux-Arts. If I am right about Surrealism or you are right about me, we are both wrong; if we are wrong, we are right. We are all fallen gods. And we all, no matter how caught up in our systems of representation, are also thus real.

59. Throughout this paragraph, I must admit, my argument has often eerily echoed Breton's formulations from the "Second manifeste du surréalisme" of 1929: "From the intellectual point of view, it . . . is . . . a question of testing by any and all means, and of demonstrating at any price, the meretricious nature of the old antinomies hypocritically intended to prevent any unusual ferment on the part of man. . . . Everything tends to make us believe that there exists a certain point of the mind at which life and death, the real and the imaged, past and future, the communicable and the incommunicable, high and low, cease to be perceived as contradictions. Now, search as one may one will never find any other motivating force in the activities of the Surrealists than the hope of finding and fixing this point. From this it becomes obvious how absurd it would be to define Surrealism solely as constructive or destructive: the point to which we are referring is a fortiori that point where construction and destruction can no longer be brandished one against the other. . . . Surrealism's confidence cannot be well or ill placed for the simple reason that it is not

placed. Neither in the palpable world, nor palpably outside this world . . . " And as if this were not enough (as an interlocutor has recently pointed out to me, long after I had written this chapter), hidden deep within a long paragraph somewhere near the middle of this same lengthy manifesto appears the following metaphor: "We can easily recognize [inspiration] by that total possession of our mind which, at rare intervals, prevents our being, for every problem posed, the plaything of one rational solution rather than some other equally rational solution, by that sort of short circuit it creates between a given idea and a respondent idea (written, for example). Just as in the physical world, a short circuit occurs when the two 'poles' of a machine are joined by a conductor of little or no resistance. In poetry and in painting, Surrealism has done everything it can and more to increase these short circuits." I don't want to insist overly on the parallel between Breton's formulations and my own, however, for fear of (once again) turning my whole account of the Exposition Internationale du Surréalisme into nothing more than a redundant representation of Breton's program. And yet "a fortiori" that moment of compromising duplication will never actually be attained, for surely the lesson is that "the point" where Breton's program and my account "can no longer be brandished one against the other" can only be sought after yet never fixed. André Breton, *Manifestoes of Surrealism*, trans. Richard Seaver and Helen R. Lane (Ann Arbor: University of Michigan Press, 1969), 123–24, 131–32, 161.

60. Need I preempt the simpleminded objection? The fact that Dalí has been accused of holding fascist sympathies and that he demonstrated a fascination with the charismatic figure of Hitler as early as the mid-1930s bears no relation of substance to the deployment and significance of *Rainy Taxi* in 1938.

EPILOGUE: JUPITER MAKES WISE THOSE HE WOULD LOSE

1. Although, admittedly, the dollar serving as the monetary benchmark under Bretton Woods preserved a firm "referential" tie to its value in gold, an anachronistic connection finally severed in 1971 with the universal floating of all currencies. Brian Rotman offers an insightful analysis of the logic of money without a reference, in his deliciously entitled *Signifying Nothing: The Semiotics of Zero* (New York: St. Martin's Press, 1987).

2. Kristin Ross, though quite naturally building her own analytic model rather than conveniently (and with prescience) fulfilling the terms of my own, provides an intriguing interdisciplinary study of the postwar period in France: *Fast Cars, Clean Bodies: Decolonization and the Reordering of French Culture* (Cambridge: MIT Press, 1994).

3. F. Gilles de la Tourette, "Sur quelques tendances de la peinture contemporaine," *La peinture française contemporaine: Les maîtres de l'art indépendant* (Paris: Librairie des Arts Décoratifs, [1937]), unpaginated; and Jacques d'Antibes, "La foire surréaliste," *Candide*, 20 January 1938. The actual title of the play was *Les mariés de la Tour Eiffel*.

4. Jean Cocteau, *Orphée: Film* (Paris: La Parade, 1950). In constructing this sampling, I have taken the liberty of assembling radio emissions from various points in the narrative.

5. Cocteau, *Orphée*, unpaginated prefatory pages.

6. Cocteau, *Orphée*, unpaginated prefatory pages.

7. Cocteau, *Orphée*, unpaginated prefatory pages.

8. Cocteau, *Orphée*, 67; ellipsis in the source text.

9. Cocteau, *Orphée*, 68; ellipsis in the source text.

10. Cocteau, *Orphée*, 82–83; all ellipses in the source text.

11. Cocteau, *Orphée*, 12, 18–19, 110. Consider, in this same spirit, Raymond Cogniat's instructions on how to experience the Exposition Internationale du Surréalisme: "It is not about explaining [it] or understanding [it] but above all about submitting [to it]." Cogniat, "L'exposition internationale du surréalisme," *XXe siècle*, no. 1 (1 March 1938): 26.

12. Cocteau, *Orphée*, 109.

13. M[arcel] Griaule, "Crachat," *Documents* 1, no. 7 (December 1929): 381; English translation (slighty modified) by Dominic Faccini, as "Spittle," *October* 60 (Spring 1992): 29.

14. Cocteau, *Orphée*, 100.

15. Cocteau, *Orphée*, 116.

INDEX

———

Numbers in bold indicate the page numbers of illustrations.

204

Carco, Francis, 105

Cézanne, Paul, 99, 106, 107, 111

Chadourne, Marc, 14

Champigneulle, Bernard, 91–92

Chardin, Jean-Baptiste, 92, 94, 106, 107; *Woman Sealing a Letter*, 95, **96**

Charensol, G., 13

Chefs-d'œuvre de l'Art Français, 4–5, 78–79, **82**, 83–100, **86**, **89**, 101, 105, 107, 109–13, 120–21, 124, 129–31, 133, 137, 151, 154, 157, 158, 165, 172; display practices in, 85–88; general critical treatment of, 84–85, 90, 93, 99; international aspects of, 109–13; national aspects of, 90–99, 112–13, 169; temporal aspects of, 88–92

Chefs-d'œuvre de l'art français: Guide topographique, 85–86, **89**, 101

class conflict, 29–31, 90

Claude Lorrain. *See* Gellée, Claude

Cocteau, Jean: *Orpheus* (film), **162**, 164–72, **167**, **168**, **171**

Cogniat, Raymond, 134–35, 143, 146, 154, 155

La colline de Chaillot et le nouveau Trocadéro, 43, 63

Combe, Jacques, 98, 111

contradictory belief, 18, 26, 27–28, 98–99, 106–9, 112, 116–17, 159

Cornell, Joseph, 123

Corpechot, Lucien, 29–30

Csaky, Joseph, 116

Cubism, 107, 109

Dalí, Salvador, 123, 139, 143, 153; *The Invisible Man*, 139, **142**, 144; *Rainy Taxi*, 127, 148, **149**, 172

Death, 164, 166, 168, 169

Dennery, André, 53, 66

Depression (economic), 6, 41, 46, 47, 163

Depuys, Paul, 87

Derain, André, 107

Deschamps, Paul, 42–43, 49, 50

Desvallières, Georges, 107

deus ex machina, 42, 48, 65, 66

Dezarrois, André, 23, 56

Dictionnaire abrégé du surréalisme, 131, 134–39

Dogon masks, 58, **58**, 73

Dorival, Bernard, 109

Dreyfus Affair, 92

Duchamp, Marcel, 153

Du Colombier, Pierre, 143, 144, 156

Ducos, M. H., 41

Dutch painting, 92, 97

Eiffel Tower, **24**, 25–28, 30–31, 37, **38**, 77, 158

Eluard, Paul, 127, 134, 153

Ernst, Max, 123, 124, 153; *Zoomorphic Couple*, 122, 139, **140**, 143–44

Escholier, Raymond, 100–101, 102–3, 104, 109, 124

Espezel, Pierre d', 31, 36

ethnologist, role of, 57–67, 72–73, 74–75, 76, 78

Evans, Joan, 43

Exposition Coloniale Internationale, 16

Exposition internationale arts et techniques Paris 1937: Guide officiel, 22, 26, 33, 36, 158; cover, 19, 20, 23, 27, 112

Exposition internationale des arts et techniques appliqués à la vie moderne, Paris 1937: Album officiel, 33, **35**

Exposition Internationale des Arts et Techniques dans la Vie Moderne Paris 1937, 3–5, 13–42, **15**, **23**, 45–46, 48, 49, 63, 66, 67, 76, 77, 78–79, 83–84, 85, 88, 99, 100–101, 112, 113, 120, 123–24, 130–31, 133, 137, 157, 158; Centre Régional, 14, 19; German Pavilion, 14, 33, **35**, 36–37, **37**; Ile des Cygnes (colonial section), 14, 16, **17**; Indochina Pavilion, 2, 3, 14; Monument de la Paix, 31–33, **32**, 37; museological section, **63**, 85; Pavilion des Beaux-Arts, 101; Soviet Pavilion, 14, 36–37, **37**; Spanish Pavilion, 33, **34**

Exposition Internationale du Surréalisme, 4, 79, 123–29, **126**, 130, 131–63, **149**, 164, 165, 170; antinational aspects of, 133–34, 157–58; checklist, 127, 131–33, **132**, 151, **152**, 153–54; corridor of mannequins, 126–27,